The Great LIFE Photographers

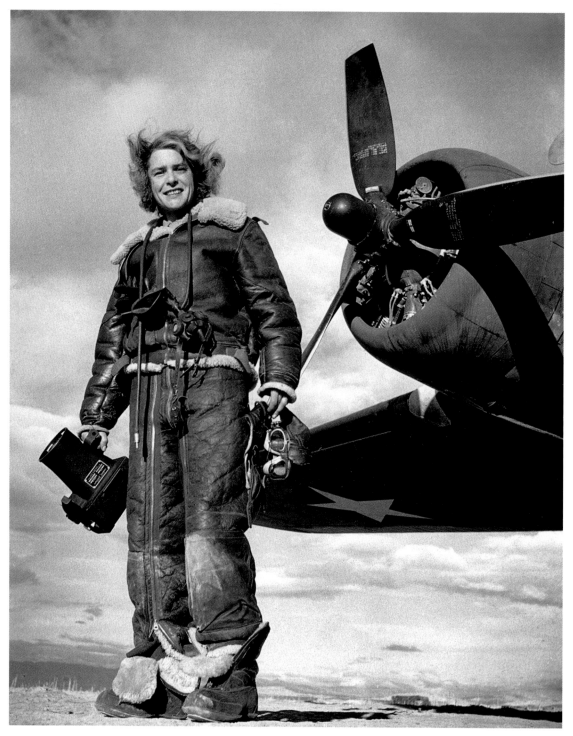
LIFE photographer Margaret Bourke-White, Algeria, 1943

The Great LIFE Photographers

The Editors of LIFE

Introduction by John Loengard

A Reminiscence by Gordon Parks

LITTLE, BROWN AND COMPANY

New York • Boston • London

LIFE

Editor Robert Sullivan
Creative Director Ian Denning
Picture Editor Barbara Baker Burrows
Executive Editor Robert Andreas
Associate Picture Editor Christina Lieberman
Writer-Reporters Hildegard Anderson (Chief), Carol Vinzant
Copy JC Choi (Chief), Mimi McGrath, Wendy Williams
Production Manager Michael Roseman
Picture Research Rachel Hendrick
Photo Assistant Joshua Colow
Consulting Editor John Loengard

Publisher Andrew Blau
Finance Director Craig Ettinger
Assistant Finance Manager Karen Tortora

Special thanks to Bob Adelman, whose untiring efforts helped see this book through. LIFE would also like to thank Maryann Kornely, John G. Morris and Tala Skari for their able assistance, and former managing editors Ralph Graves and Richard B. Stolley for their insights. And LIFE acknowledges the National Archives and the Black Star, Magnum, Popperfoto, AP and UPI photo agencies for their contributions.

Time Inc. Picture Collection

Director Kathi Doak
Deputy Director Daniel Donnelly
Picture Research for this book Robert Brow, Arnold Horton, Vivette Porges, Joan Shweky
Picture Research Liz Brown, Penny Hays, Cornelis Verwaal
Cataloging Phil Brito, Gay Gillman, George Hogan, Beth Passaro
Picture Collection Scanning George Jinks
Traffic Amy Holderness, Marcos Rodriguez
Life Gallery of Photography Amy Wong

Editorial Operations

Director Richard K. Prue
Manager Richard Shaffer
Supervisors Brian Fellows, Raphael Joa, Stanley E. Moyse
Imaging Keith Aurelio, Gregg Baker, Charlotte Coco, Scott Dvorin, Kevin Hart, Rosalie Khan, Po Fung Ng, Barry Pribula, David Spatz, Vaune Trachtman, Sara Wasilausky, David Weiner

Project Manager Bob Adelman

LITTLE, BROWN AND COMPANY
Executive Vice President and Publisher Michael Pietsch
Vice President, Editor-In-Chief Geoff Shandler
Vice President, Paperback Publisher Terry Adams
Executive Editor Michael Sand

Photographs from the LIFE Picture Collection are available for purchase. Go to LIFEphotographs.com where you can choose from over 40,000 images and decorate your home with your favorite iconic LIFE photos. Numbered and signed limited edition prints are also available. Go to LifePhotoGallery.com and see what you can add to your collection.

Little, Brown and Company
Hachette Book Group
237 Park Avenue, New York, NY 10017
www.hachettebookgroup.com

Originally published in hardcover by Bulfinch Press, October 2004
First paperback edition, October 2010

Little, Brown and Company is a division of Hachette Book Group, Inc. The Little, Brown name and logo are trademarks of Hachette Book Group, Inc.

ISBN 978-0-8212-2892-0 (hc) / 978-0-316-09793-2 (pb)
LCCN 2004105727

Printed in China

Contents

The Ambition Behind This Book *by John Loengard*

Photographers working for LIFE like to photograph the world around them, especially the people in it and what those people do. Each of us believes we do it better than anyone else (even if we can't all be right). A few of our photographs stick in the mind and become classics. Why? I suppose it is because they retain their power to surprise.

The written word may be quickly out of date—old news is an oxymoron. But old photographs can hold our attention. This fact, more than any other, I suspect, separates the ambition of photographers from the goals of the writing press. That ambition, to produce something of lasting interest, is the bedrock of this book.

It has been the writer's job since ancient times to describe the way people behave. With the invention of photography, it became the business of the photographer, too. But while writers can gather material simply by talking with people, even on a telephone, photographers cannot. Photographers and their subjects must interact. The subject must do something of

Margaret Bourke-White Lifeboat, the Mediterranean, 1941

interest, smack-dab in front of the camera—or there is no picture. Luck is important, certainly, but it is equally important for photographers to know what to bring out in a subject. To know that, they must have their own point of view. "We were all individualists," said Alfred Eisenstaedt (the dean of LIFE photographers, if we had a dean).

Eisie was describing the photographers who had been on the magazine's staff since 1936—a number that would eventually grow to 90. It was, and is, a very exclusive club, though not a social one. "Photographers are like spiders," said Eisenstaedt. "They don't come together often." In part, that was because most LIFE photographers didn't work where they lived, but where their subjects lived. The LIFE photographers' business was, as Henry Luce put it in his prospectus for the magazine, "to see life; to see the world; to eyewitness great events"—and to do that, we had to be on the scene. When we were not doing business—when we were, say, hanging around an office—we were fish out of water.

LIFE photographers witnessed events, and they witnessed them up close. Twenty-one of them covered fighting in World War II as war correspondents for the magazine. None of them photographed a general's strategy, or the tactics of a platoon. No one could do that. But they proved that the expression on the face of a single soldier could describe war best. And what was learned in World War II became part of the magazine's tradition in subsequent conflicts. Consider David Douglas Duncan's corporal under fire, striding over a corpse lying across a trail, in Korea. Think of Larry Burrows's helicopter crewman reacting to a young lieutenant's death in Vietnam.

Of LIFE's many photographers, few had more adventures in war than one of the women on the staff, Margaret Bourke-White. She photographed the German bombardment of Moscow in 1941, spent a harrowing night in a lifeboat after evacuating a torpedoed ship in the Mediterranean Sea (Tallulah Bankhead played her in the movie), flew in combat

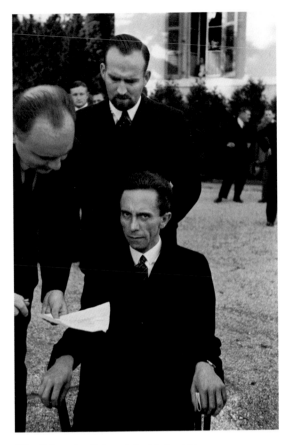

Alfred Eisenstaedt Joseph Goebbels, 1933

he photographed Joseph Goebbels, the Nazi minister of propaganda, and the picture casts a spell more than 70 years later. The fierce arrogance of power, normally covered by a false grace of good humor, shone through miraculously onto Eisenstaedt's film. Eisenstaedt's picture and others like it that were taken at the time convinced the editors who were planning to start LIFE that photographs themselves could tell the story, not merely illustrate or adorn the story. That core belief attracted an extraordinary group of photographers to the magazine.

Early LIFE photographers took advantage of improvements in photographic technology that were then being introduced. Newspaper photographers had routinely used large cameras, and they synchronized flashbulbs to fire as the shutter opened. This provided contrast between light and dark and allowed the image to reproduce with a modicum of clarity even in the muddy newspaper printing of the day. Such photographers could not use the new Leica and Contax cameras or the high-speed lenses designed for them because the shutters of these cameras could not be synced readily with flashbulbs. However, when new high-speed film emulsions began appearing on the market, these small, precision-made German cameras allowed photographers to record human activity in normal room light for the first time. In 1935, a soon-to-be LIFE photographer took a series of pictures of President Franklin D. Roosevelt as the press gathered at his desk. There the great man is: coughing, joking, signing papers. Since no one expected that photographs could be taken in such dim light, they didn't notice Thomas McAvoy's camera. After the pictures appeared, candid photography was banned in the White House.

But, starting the next year, the extraordinary, instant popularity of LIFE magazine would open doors, and give photographers the license to photograph the way people actually lived. In 1948, to use just one year as an example, Leonard McCombe spent the better part of a month recording

out of North Africa, covered the fighting in Italy and Germany, and witnessed the liberation of Buchenwald in 1945.

LIFE photographers risked their lives to bring intimacy to war coverage. Robert Capa, who reached Omaha Beach with the first wave at dawn on D-Day, once famously said, "If your pictures aren't good enough, you're not close enough." Getting close enough means putting oneself in harm's way. Except for W. Eugene Smith, who was seriously wounded on Okinawa, Capa, Bourke-White and the others came through World War II unharmed. Then, in 1954, Capa stepped on a land mine in Indochina. He died. Paul Schutzer was killed in the Negev desert on the first day of the Six-Day War in 1967. Four years later, Larry Burrows lost his life when his helicopter was attacked over Laos.

Eisenstaedt, who lived to be 96 years old, said, "I never photographed a war, thank goodness. I can't look at blood and I suffer when I see dirty people and misery." However, in 1933,

the life of a young woman beginning a career at an advertising agency; Gordon Parks gained the trust of members of a street gang in Harlem; and W. Eugene Smith followed the daily rounds of a country doctor—Ernest Ceriani of Kremmling, Colo., population about 1,000—at a time when such general practitioners still did occasional surgery. Smith was with Ceriani for five weeks; the good doctor's wife thought he'd never leave. In 1965, Bill Eppridge would hang out for a month

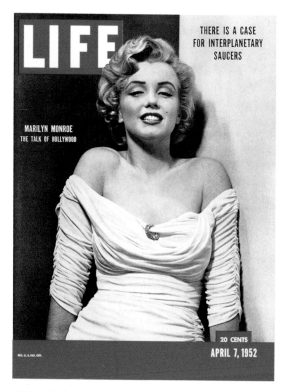

Philippe Halsman Marilyn Monroe, 1952

or so with two heroin addicts in New York City; in Vermont, Grey Villet caught the ways in which a grand old family passed its traditions to younger generations; and Larry Burrows discovered the frightening new air war in Vietnam. What they produced are called photographic essays. Henry Luce coined that term to describe the camera's ability to capture elusive qualities in a subject, and to construct a narrative. In 1937, Luce wrote that a picture story on Vassar College left "mountains to be written about Education in general and Vassar in particular . . . [but] it tells the kind of thing that only the most skillful . . . literary essayists have hitherto managed to tell in words."

If I were speaking in literary terms, I'd say most LIFE photographers took photographs in the third person—again, as narrator—and not in the first person, where the photographer asks the subject to look at the camera and being photographed becomes the main event. Indeed, much of a LIFE photographer's energy was spent trying to remove from the scene any trace of his or her presence. LIFE photographers most often focused on human expression and gesture. These might be coaxed from a subject but never demanded. Most often, it was simply a matter of waiting. Subjects became bored. Their minds turned to things they found more intriguing than the photographer sitting in the corner. Snap!

What subject did the greatest number of LIFE photographers snap? I wouldn't know; but a favorite of many was an actress named Marilyn. Philippe Halsman photographed Ms. Monroe first, when she was a starlet in 1949. He told editors, "I think she has a lot of potential. I'd love to photograph her again." (He did.) Four years later, Ed Clark showed her with costar Jane Russell on the set of *Gentlemen Prefer Blondes*. Eisenstaedt, the same year, asked LIFE's bureau chief in Los Angeles to arrange a photographic session, "I got along fine with her," he reported. "I have pictures of where she sits on my lap—and I sit on her lap." Milton Greene

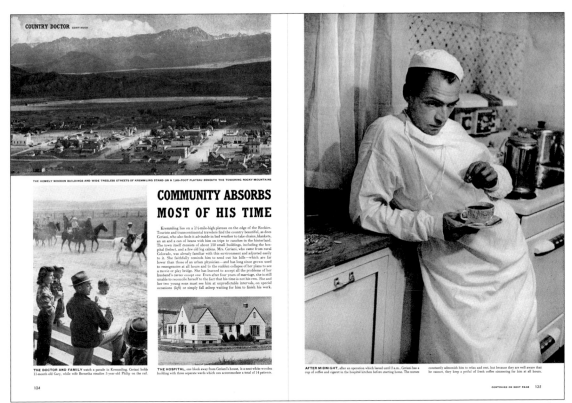

W. Eugene Smith "Country Doctor" Ernest Ceriani, Kremmling, Colo., 1948

was Monroe's business partner in the mid-1950s, photographing her often. Their production company produced *Bus Stop* in 1956 and *The Prince and the Showgirl* the next year. Bill Ray caught her as she sang "Happy Birthday, Mr. President" to John F. Kennedy, in Madison Square Garden in 1962. (Just by the way, JFK himself appears more than half a dozen times in this book.)

By the 1950s, LIFE's darkroom technicians had acquired extraordinary skill working with black-and-white printing paper. They blended their efforts with those of the best photographers and knew that the carefully exposed negative taken by a science photographer such as Fritz Goro was different from the candid exposures of McCombe—who went under contract for LIFE at the age of 23 with the stipulation that he never be required to use artificial lighting. By knowing a photographer's work well, technicians in the lab could bring out the proper values in a print. There was pride in the craft: pride of authorship. The technicians stamped PRINT BY and their own names on the back of each photograph when it was dry. It

is something of a paradox that, while color photographs might have seemed more realistic, those presented in black-and-white were often more convincing.

The majority of pictures in this book are black-and-white, but LIFE reproduced color photographs, too, of course; there were some in the magazine's very first issue in 1936. At that time, however, printing color halftones was a slow, laborious and expensive process. Even a decade later, not much progress had been made. In 1946 a black-and-white picture of a consistory at the Vatican ran in LIFE one week after the event; the full-color version of William J. Sumits's picture ran five weeks later. As late as the early 1960s, the color films that were most sensitive to light had only a tenth the speed of the fastest black-and-white. This severely limited the use of color indoors.

So in the beginning and for much of its history, LIFE, particularly in its role as a chronicler of the world's news—a role that put a premium on speed—was a largely black-and-white publication. In its photojournalism, LIFE had a symbiotic relationship with radio. Radio's nationwide audience heard the

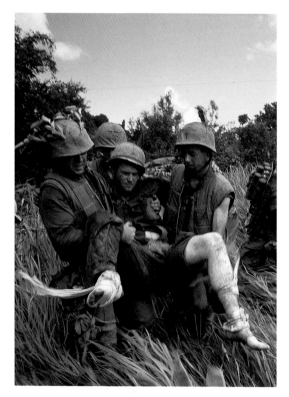

Larry Burrows South of the DMZ, Vietnam, 1966

news but couldn't see it. LIFE filled that void—as quickly as was possible. Later, when radio got pictures and became television, LIFE had a problem. In the 1960s, at great expense, the editors decided to combat television by using more color. Burrows, in Vietnam, began the first extended coverage of war in color. Eliot Elisofon, for one, had been exploring the emotive qualities of color for years and had advised movie director John Huston on its use for the 1952 film *Moulin Rouge*. Elisofon, the color specialist, was often called when the editors were seeking more color stories. That happened all the time: Photographers were pegged. Dmitri Kessel once used a colleague's experience—and his own—to explain: "Eisenstaedt took a picture of a dog lifting his leg. Then, because he took that famous picture, when they have a story about Niagara Falls, they say, 'Ah, water,' and they think of him." For his part, Kessel had photographed Hagia Sophia, the famous basilica in Istanbul, in 1949. "They came again to a church, and they said, 'Ah, Dmitri Kessel.' . . . From then on, whenever there was a church, I would do it."

The great LIFE photographers were stylists. After he

recovered from his war wounds, Smith became the most pictorially eloquent of them all. He composed dramatic images that generate remarkable empathy for his subjects. Light and shadow achieved a lyric quality in his prints. His style is quite different from the casual-appearing photographs of McCombe. If McCombe's pictures seem artless, the photographer was, in fact, intent that every gesture and expression he captured bring out some human quality. His pictures are refined in ways not instantly apparent. Then there's Eisenstaedt, a pictorialist, a Sunday-photographer from heaven with a ticket to search the earth for pictures. There's Nina Leen, whose wit is the sort that doesn't wait around to see whether you get it—or not. There's Eppridge, nipping away at his subjects like a terrier at a bone until the thing he's looking for suddenly appears. There's Lennart Nilsson, exploring a world not normally seen, spending decades photographing the human embryo at various stages of growth. There's the fiercely imaginative Gjon Mili, conspiring with another artist, Pablo Picasso, to create the portrait of a painter with a penlight for his brush.

The photographer as artist? Well, most photojournalists see too much of the world to take themselves that seriously. David Scherman said, "In as much as I can evoke emotion, I think I am an artist, but I don't think I'm a very good artist." Ed Clark put his journalistic success this way: "I don't know what made a good picture. I never did know. I made a lot of them. But I never did figure that out." At LIFE, it wasn't necessarily the photographer's job to produce pictures that were artistic but it was to make ones that were striking, even unforgettable. If they were beautiful, too, so much the better.

And often they were. Some of the pictures were recognized as superb just as soon as they appeared. The value of others has become much more clear over time. The best work of any one of the photographers who worked for LIFE is remarkable. The best work of the best of them is as good as any photograph ever made.

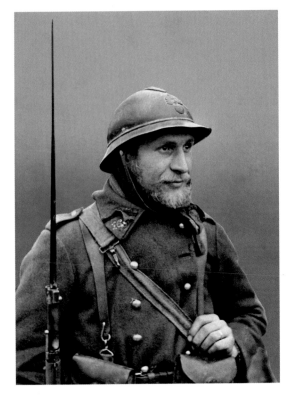

Stedman Jones Sentry, the Maginot Line, France 1940

Boris Paschkoff Orphanage, France, 1940

Note: This book includes biographical sketches of 88 of the 90 photographers who have been on LIFE's staff and 11 others who had a special relationship with the magazine—Benson, Greene, Grehan, Halsman, Larsen, Leen, Mili, Nilsson, Shaw, Uzzle and Zimmerman. The two missing staff members are Stedman Jones, who joined the magazine in Paris on January 1, 1940, and Boris Paschkoff, who joined, also in Paris, on June 1. Both left after France surrendered to Germany on June 28. Other details of their lives are not known. One photograph by each appears on this page.

Most photographs printed in this book were taken when LIFE published weekly (1936–1972). To keep the book a reasonable size, freelance photographers are not represented herein; but a number of them, who consistently (at one time or another) did assignments for the weekly LIFE, should be mentioned. They include: Slim Aarons, Peter Anderson, Lee Balterman, Phil Bath, Derek Bayes, Dominique Berretty, Howard Bingham, Charles Bonnay, Pierre Boulat, Dennis Brack, Brian Brake, Jon Brenneis, Bill Bridges, Gerald Brimacombe, John Bryson, David Burnett, Henri Cartier-Bresson, Joe Clark,

Howell Conant, Jerry Cooke, Gordon Coster, Don Cravens, Frank Dandridge, Eileen Darby, Henri Dauman, Bruce Davidson, Toni Frissell, Ormand Gigli, Burt Glinn, Bob Gomel, Henry Grossman, Otto Hagel, Declan Haun, Fritz Henle, Bob Henriques, Ken Heyman, Carl Iwasaki, Victor Jorgensen, George Karger, Yousuf Karsh, Heinz Kluetmeier, Hubert Le Campion, Bud Lee, David Lees, Frank Lerner, Jay Leviton, Lee Lockwood, Fred Lyon, Jim Mahan, Richard Meek, Jun Miki, Wayne Miller, Charles Moore, David Moore, Truman Moore, Paolo Muniz, Arnold Newman, Marvin E. Newman, A. Y. Owen, Tim Page, Norman Parkinson, Lynn Pelham, Hy Peskin, Bob Peterson, Robert Phillips, Ted Polumbaum, Priya Ramrakha, John Reader, Harry Redl, Verner Reed, Vittoriano Rastelli, Charles E. Rotkin, Kosti Ruohomaa, Ted Russell, John Sadovy, Andrew St. George, Enrico Sarsini, Richard Saunders, Steve Schapiro, Herb Scharfman, Arthur Schatz, Larry Schiller, Flip Schulke, Brian Seed, Sharland, Art Shay, Bob Sherman, Terence Spencer, Phil Stern, Richard Swanson, Gordon Tenney, Don Uhrbrock, Fred Ward, Leigh Wiener and Werner Wolff... and others whom I have inadvertently left out. — J.L.

To Have Been a **LIFE Photographer** *by Gordon Parks*

For me, the time was difficult. America was swathed heavily in racial turmoil. I was black, and found myself aswirl in the position of being the very first photographer of color to be placed on the masthead of the most prestigious magazine in the universe. I admit that I questioned what kind of acceptance my presence might gain from my coworkers. Doubts and worries were short-lived. From the first week, it seemed as though the entire staff was extending one big, welcoming hand. It was as though they had been waiting for me to arrive, to thrust my camera toward things and into places that had not been welcoming to the camera—toward crime, poverty, big-city gang wars. There were, as well, the world's famous fashion houses in Paris and New York and London. Along with my baptism in the violent fire, I was sent to capture the more honeyed subjects. I was a LIFE photographer. It was time to rejoice.

Later, stories came and stories went. Some were challenging and delightful. Others weren't, and many of these died in the killing box on the 31st floor. There were days when all that had, only moments before, seemed good, suddenly was awful. I was not alone in being disappointed. Some other photographer or reporter suffering a similar problem would join arms with me, and off we went to fill our glasses at Michael's Pub. As we drank, we left our dismay at the bar. By the time our glasses were empty for the final time, our complaint had died. "All's well that ended well." Then back up we would go, to hang out near the managing editor's door, anxious for what was next.

Twenty-odd years at LIFE taught me how to take measure of the world that surrounds us. It taught me to see situations that, at an earlier time in my own life, I might have given slight notice. I saw intelligent people taken in by swindlers, good ones swindled by crooks, hungry ones hunting for food in the rubbish, rich ones robbing the poor. A murderous one, about to meet death in a San Quentin gas chamber, causes me to remember, all these many years later, the chilling answers that he gave to questions I asked before he died.

"Why did you kill the boy?"

"Don't know. Never seen him before. Just felt like killing somebody. So I take out my knife and cut his throat."

"How do you feel about your going tomorrow morning?"

"Don't feel no sorrow for myself. I killed him. Now they're gonna kill me. That's the way things go."

The Bible he had asked for dropped from his hands to the cell floor when the gas reached his heart. And from that morning on, I became a student of death.

If there are many things about my years at LIFE that escape my memory, the experience taught me that there are other things I should never forget. Some of these, at the time, seemed to say very little—and now say everything. My mind's eye sees very clearly many small scenes from those two blissful years I was assigned to Paris. My office faced the beautiful Place de la Concorde, where my children and their mother walked daily in the glorious light of the wonderful city. And there was the River Seine, and the sun with its atomic mane reflecting upon it, flowing between the shaded wood-sides. I remember the velvet soft evenings that fell on the city during spring. Such a blessed assignment.

Many ancient issues of the magazine lie in my closets, eyeing me. They force me to recall appointments I had with their pages, and tell me that, now, I should take it easy, take long walks, maybe even run around the block. (My legs don't agree with them; my feet insist on being patient.) I can't put those old issues out of my mind. In these late days, those ragged LIFE covers imprison some of the best years of my life.

The magazine gave me things I needed. It lifted me out of obscurity. It taught me truth. The things it gave me eventually, in a turnabout, amounted to what the magazine would mean to me. LIFE. Truth. Enlightenment. Or what could be called . . . Wisdom.

The Photographers

Carlo **Bavagnoli** 1932–

Postwar, Italian Style

A smart young man from Piacenza, Italy, Bavagnoli was heading for a career in law when he met the storied LIFE photographer David Douglas Duncan at the equally storied Milan opera house, La Scala. Duncan explained his craft to Bavagnoli, who was fascinated by this "new means of expression, new means by which I might see the world." Bavagnoli first trained his camera on the streets of Rome, and his neorealistic postwar pictures were the frozen-frame equivalents of Rossellini's films, and they often graced the pages of the Italian journal *Epoca*. Whenever Bavagnoli felt he had gotten something particularly right—his shots of the laughing Luisa Pierotti, for instance—he went to the editors in LIFE's Rome bureau; he finally joined the staff in 1964. Since then, he has also made television documentaries: Hearkening back to his fateful meeting at La Scala, he specializes in films on classical musicians.

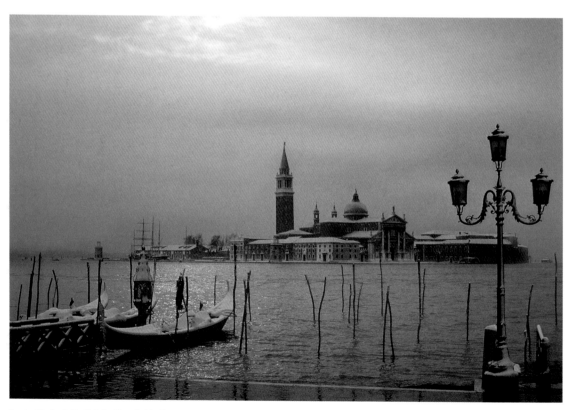

Santa Maria della Salute Church, Venice, 1964

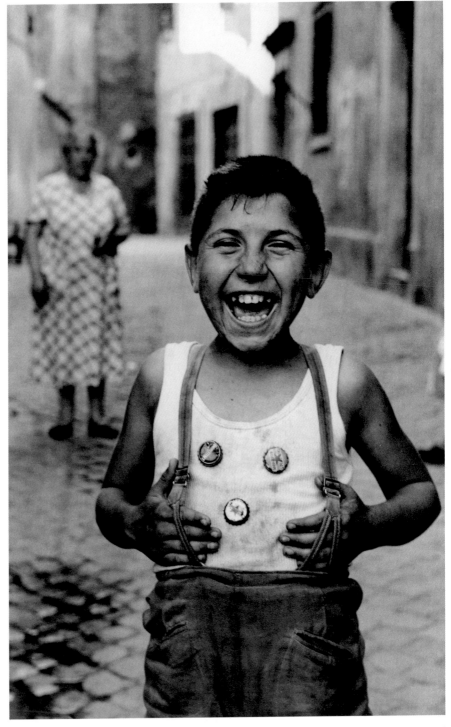

Rome, 1958

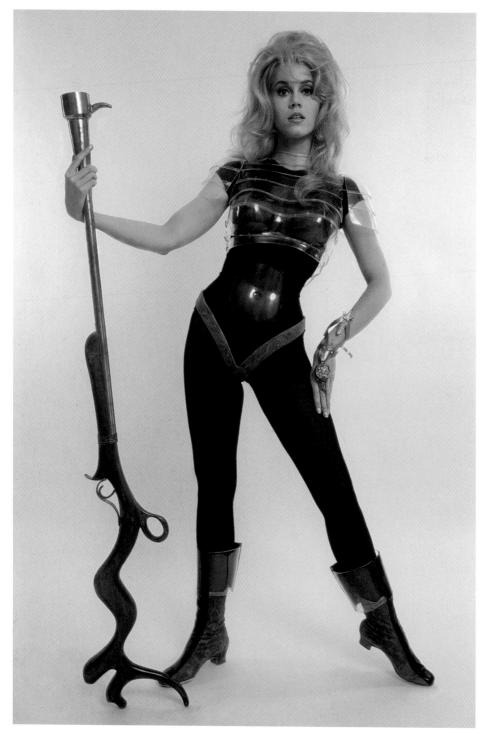

Jane Fonda as Barbarella, 1967

Luisa Pierotti in a wine shop, Rome, 1958

Harry **Benson** 1929–

Gigi Benson

Preparation and Intent

Many a photographer has trotted the globe, and many a photographer has shot the fabulous, the famous and the infamous. But then there's Benson, singular among many. From his boyhood in Glasgow to, first, the RAF, then to wedding snapshots; Fleet Street; Lord Beaverbrook; John, Paul, George and Ringo; New York City; LIFE; Jack and Jackie; Muhammad Ali; the Ku Klux Klan; Bobby Kennedy; Rev. Martin Luther King Jr; Johnny Carson; Germaine Greer; Pacino; Nixon; Dolly Parton; Halston; Truman Capote; Solzhenitsyn; Astaire; Somalia; the Irish Republican Army; the Reagans; Caroline Kennedy; Mark David Chapman; "We Are the World"; Tracy Ullman; George Burns; Oliver North; Princess Di (of course); Elizabeth Taylor (of course); Jerry Garcia; Jack Nicholson; Linda and Paul McCartney; Gen. H. Norman Schwarzkopf; Kate Moss; Michael Jackson; Andrew Wyeth; Bosnia; Al Sharpton and James Brown; President George W. Bush . . .

Cartoonist R. Crumb, New York City, 1968

Christy Turlington, backstage at the Paris collections, 1994

Caroline Kennedy, Hyannis, Mass., 1986

Oliver North, 1987

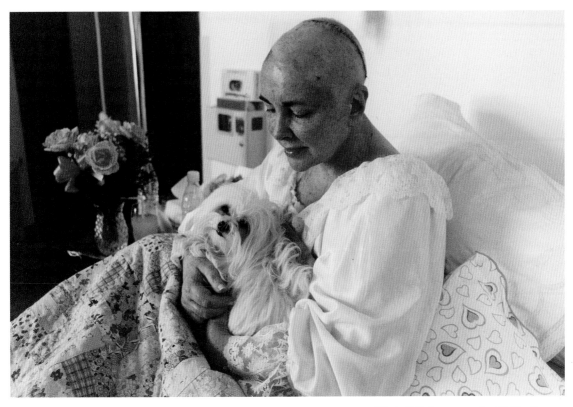

Elizabeth Taylor recuperating, California, 1997

When Taylor was about to have a brain tumor removed, Benson called her publicists for a photo session. They scoffed at the idea. Benson countered with, "Just ask Elizabeth, she marches to her own drum." He soon received word that he "could be there before, during and after the operation . . . I photographed an X-ray of her brain as well." Of Oliver North, Benson said, "I wanted the photograph to look like the Hitler propaganda pictures . . . sort of the storm trooper."

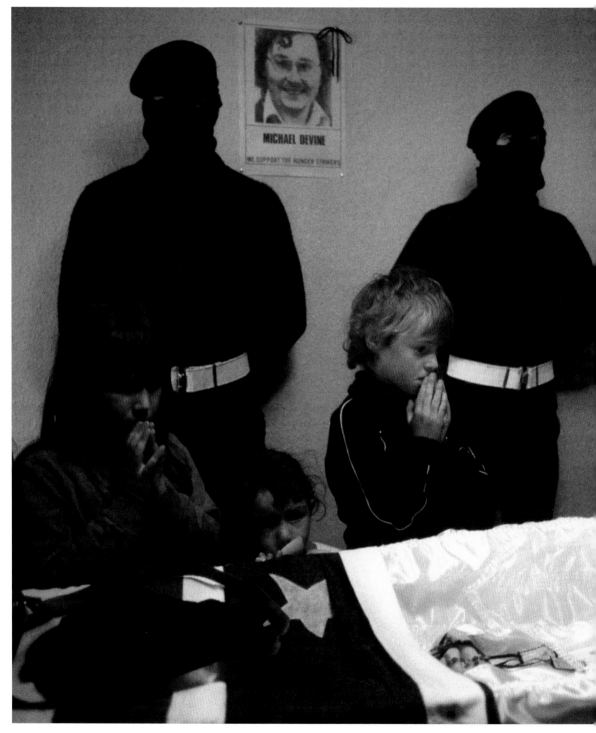

Hunger striker Mickey Devine's wake, Londonderry, Northern Ireland, 1981

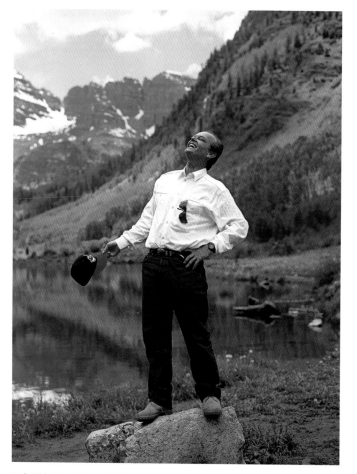

Jack Nicholson, Aspen, Colo., 1990

"The first time I saw Alexander Solzhenitsyn,
the dissident Russian writer living in exile in
America, I thought he looked like the lion in
The Wizard of Oz, with his mop of hair and red
beard. He was not a particularly pleasant man."

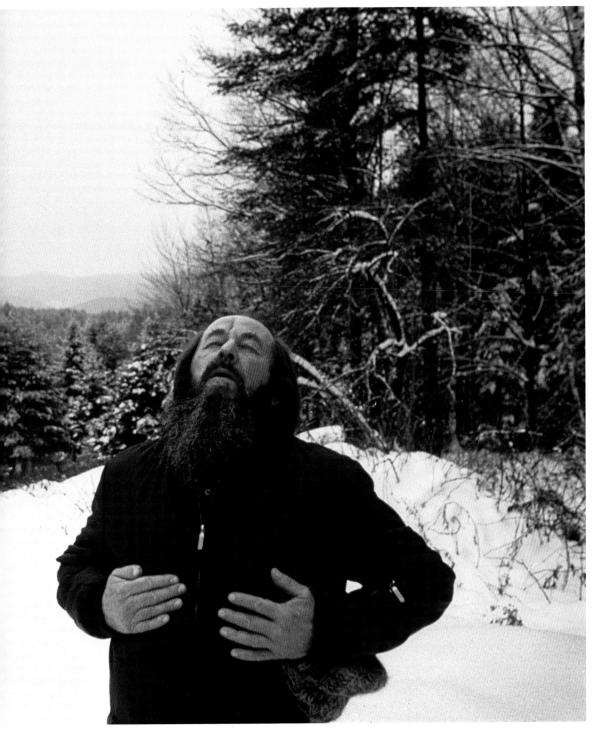

Alexander Solzhenitsyn, Vermont, 1981

Jack **Birns** 1919–2008

Drawing a Bead on China

In 1947, Birns embraced a childhood dream when he sailed across the Pacific with a LIFE contract and three 10-year-old German cameras. He shot in several Asian lands but most importantly in China, where he captured Shanghai's poverty and social chaos, which derived from the long battle between the ruling Nationalist Party and the insurgent communists. Interestingly, Birns's Chinese images often clashed with the ardent anticommunist views of publisher Henry Luce. As a consequence, many of his pictures didn't receive a wide audience until 2003 when *Assignment: Shanghai, Photographs on the Eve of Revolution* was published to critical acclaim by the University of California Press. Birns also had a good eye for business: In 1954 he colaunched the profitable Birns & Sawyer, a firm that imported Arriflex cameras and manufactured the Omnitar telephoto lens, which was frequently used at rocket launches.

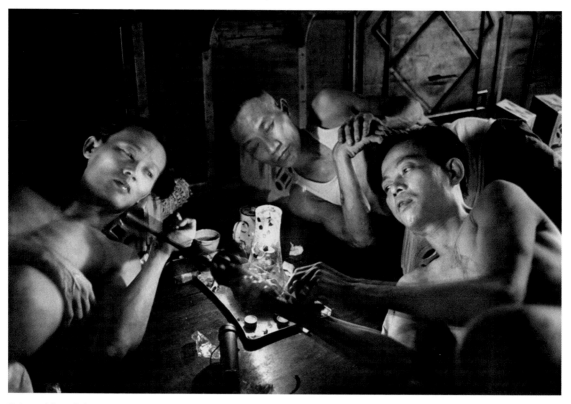

Opium addicts, Saigon, 1949

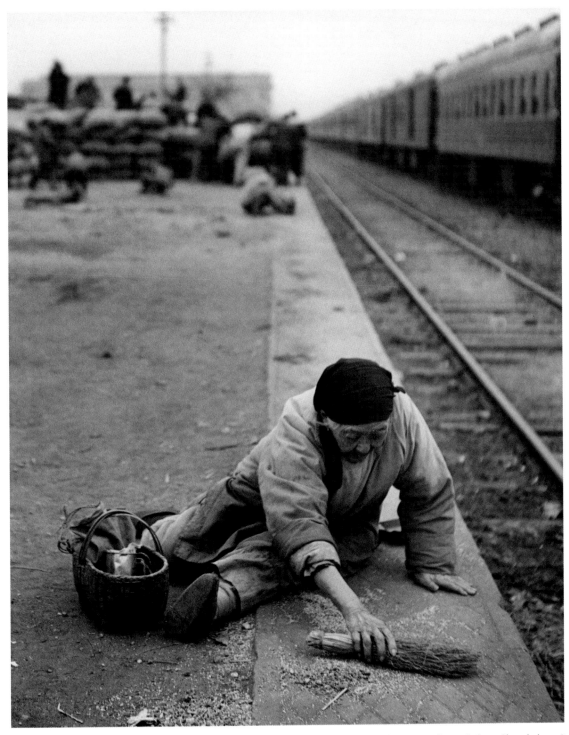

A hungry refugee sweeping up spilled rice on a railway platform, Shanghai, 1948

Margaret **Bourke-White** 1904–71

The First

"Photography is a very subtle thing. You must let the camera take you by the hand, as it were, and lead you into your subject." Margaret Bourke-White led the rest of us by the hand on many occasions. In 1929 she did the lead story for the first issue of *Fortune,* and the next year was the first Western photographer allowed into the U.S.S.R. In 1936 she collaborated with future husband Erskine Caldwell on a book documenting the rural poor of the South. Later that year she became one of the four original LIFE photographers, and had the cover shot for the inaugural issue. She was America's first accredited woman photographer in WWII, and the first authorized to fly on a combat mission. She was one of the first to depict the death camps, and later became the last person to interview Gandhi, six hours before he was slain. Her hundreds of thousands of photographs are about adventure, sensitivity, composition and courage.

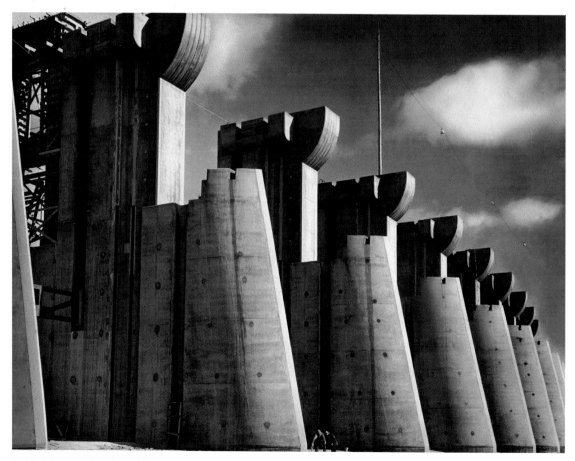

Fort Peck Dam, on the Missouri River, Montana, 1936

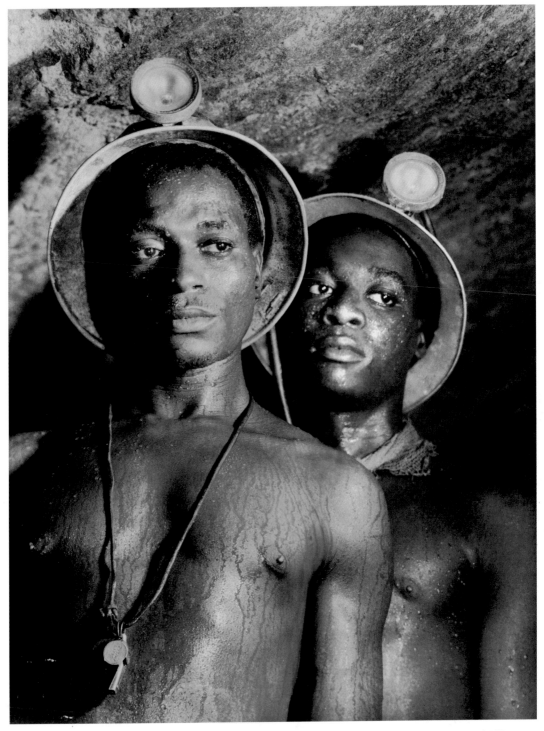

Gold miners, Johannesburg, South Africa, 1950

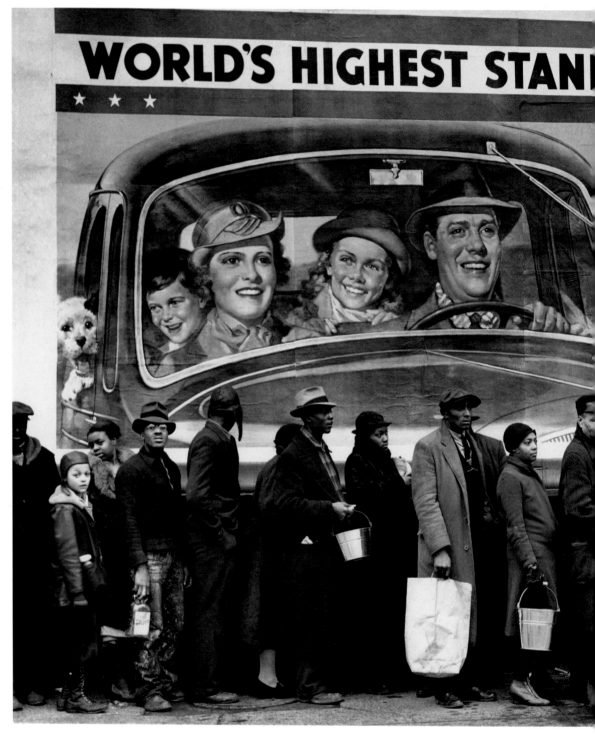

Breadline during the Louisville flood, 1937

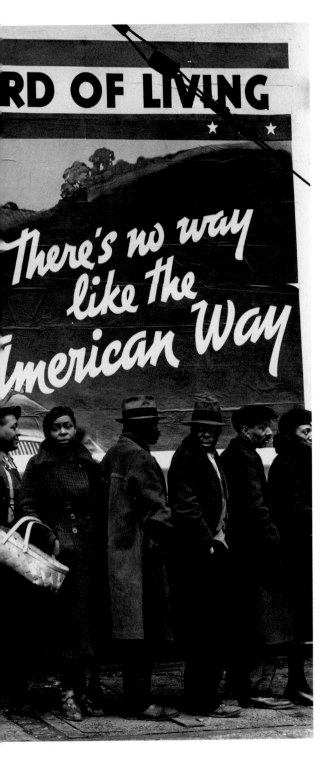

In the same way that Bing Crosby's recording of "Brother, Can You Spare a Dime?" brilliantly captured the plight of an America wrapped in the dread grasp of the Great Depression, so, too, did Margaret Bourke-White's 1937 photograph of a breadline, wearily assembled in front of an image that might as well have been sent from another world.

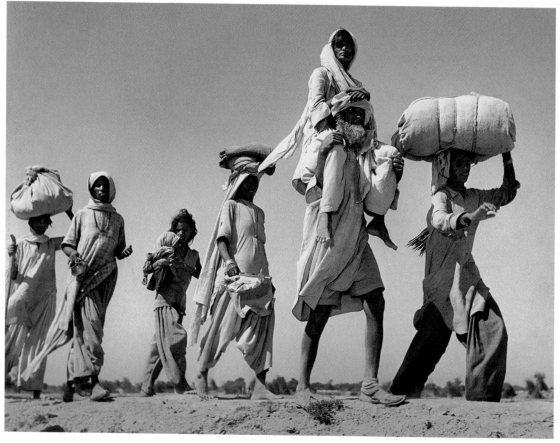

Sikhs migrating after the partition of India, 1947

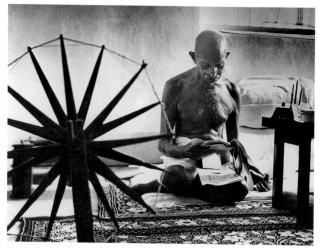

Mahatma Gandhi, India, 1946

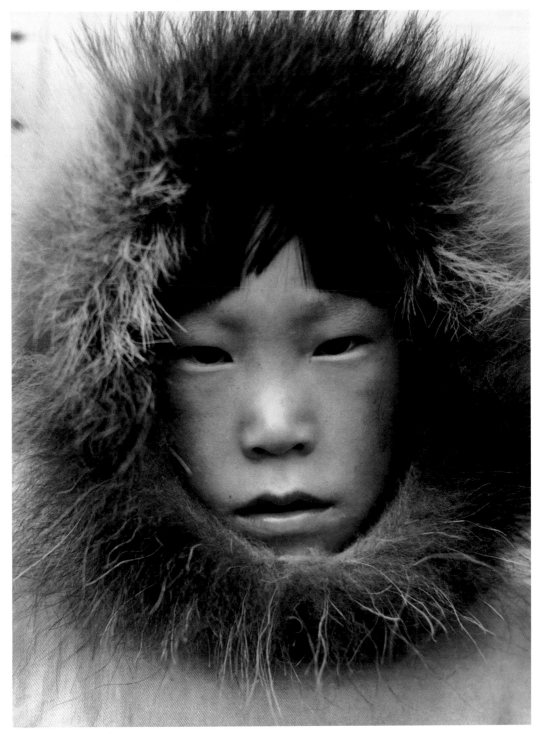

Eskimo child, Tuktoyaktuk, Canada, 1937

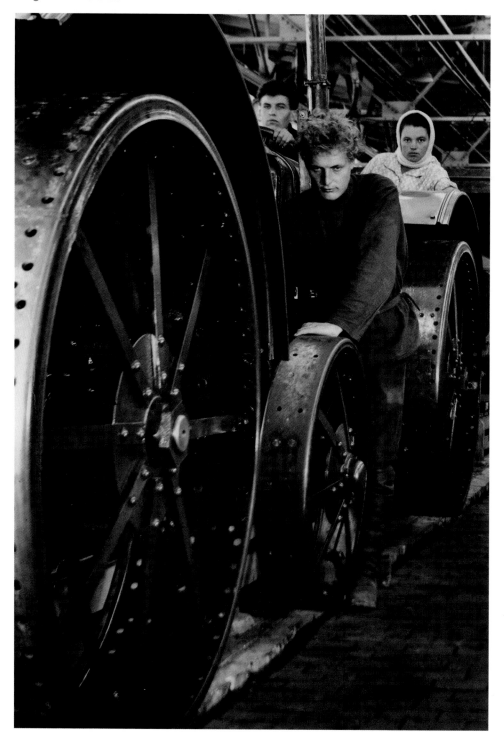

Tractor factory, U.S.S.R., 1930

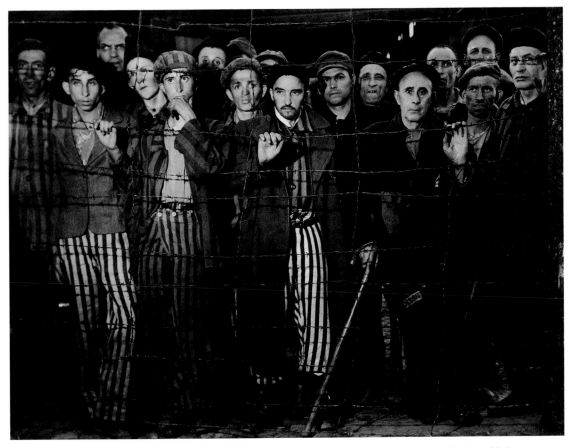

Buchenwald, Germany, 1945

The distance Bourke-White traveled from the industrial photography at left to the shattering human document above is immeasurable. "I saw and photographed the piles of naked, lifeless bodies, the human skeletons in furnaces, the living skeletons who would die the next day . . . Using the camera was almost a relief. It interposed a slight barrier between myself and the horror in front of me."

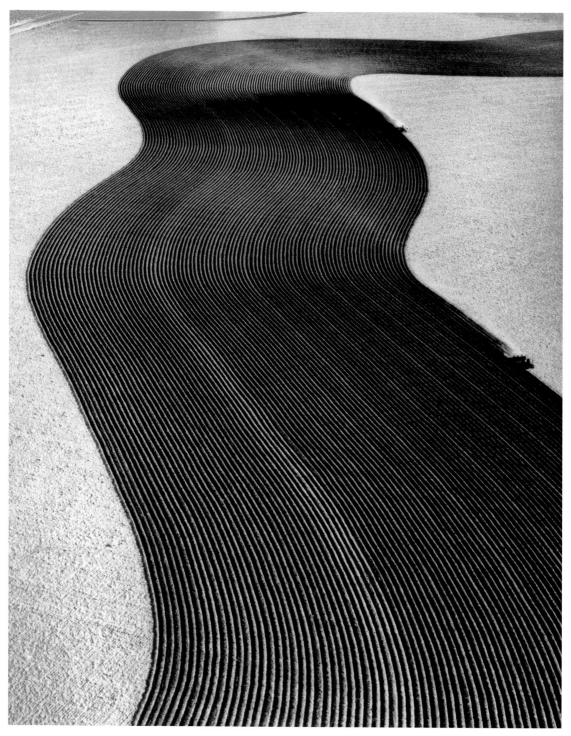

Two tractors plowing, Colorado, 1954

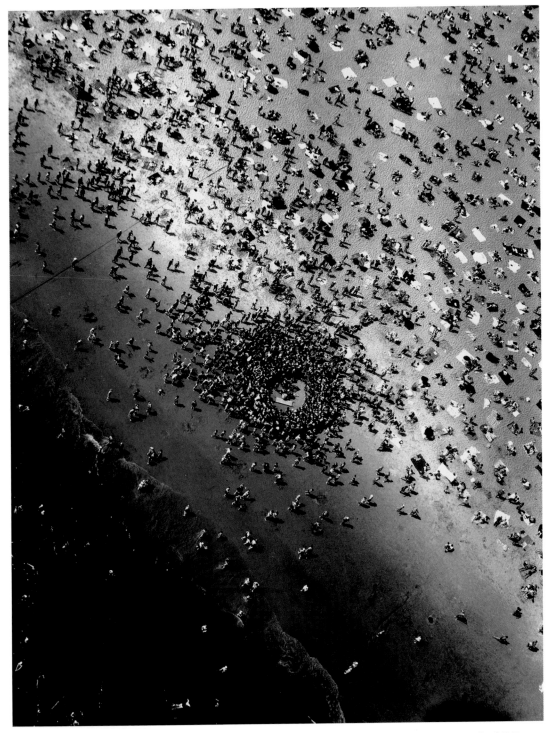

Mary Eschner's near-drowning, Coney Island, N.Y., 1952

Horace **Bristol** 1908–97

Storyteller

Because he came from newspaper people, he always considered himself a photojournalist, rather than a photographer. Indeed, in the '30s, when he was associated with the f/64 group, which included Ansel Adams and Edward Weston, the latter said Bristol's approach was that of an artisan rather than an artist. Bristol agreed; he wasn't interested in stately tripod work—he wanted to tell a story. After seeing Dorothea Lange's pictures of migrant workers, Bristol, who was on staff at LIFE during 1937 to 1938, pushed the topic at the magazine. Finding no interest, he persuaded John Steinbeck to work with him as a captionist for a book on the migrants' plight. After two months, Steinbeck begged off, saying there surely was a book to be made, but he saw it as a novel; Bristol later said that Steinbeck never mentioned his part in the birth of *The Grapes of Wrath*. Bristol went on to make an important patriotic contribution with his robust images of sailors during World War II.

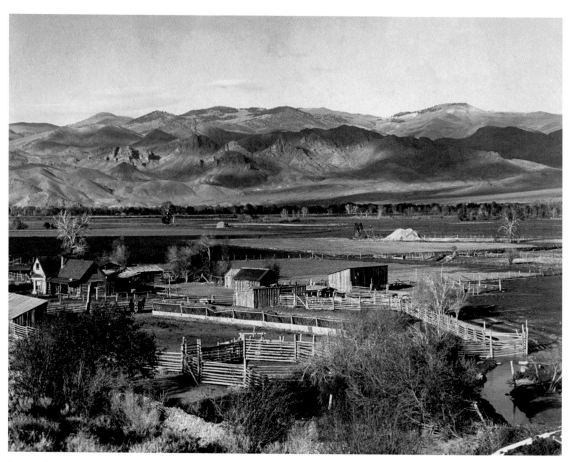

Farm on the Salmon River, Idaho, 1939

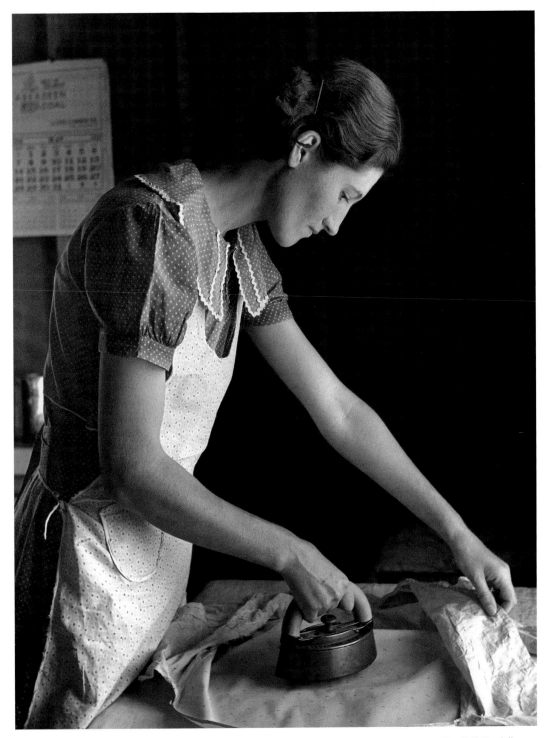

Mrs. F. M. Kendall, 1939

The inspiration for Ma Joad in the film *The Grapes of Wrath*, California, 1938

Looking for work, 1939

Torpedomen, 1945

Fisherman's daughter, Nong Khai, Thailand, 1954

James **Burke** 1915–64

Martin Igler

Back to His Roots

LIFE's photographers hail from a wide variety of countries, but Burke is the only one born in China. He attended college in America, married a newspaper editor from Richmond, then returned to China to write a book about his missionary father. During World War II he served in that country under Gen. Claire Chennault, and after the war decided to stay there as a freelance writer. He did a piece for LIFE in 1948 on a Chinese warlord, and "suddenly realized that my pictures described this warlord so much better than my words that I decided to go much deeper into photography." Three years later, he was on staff. In 1964, Burke was shooting an essay on the Himalayas, and while trying to secure a better angle of approach, he lost his footing and fell to his death.

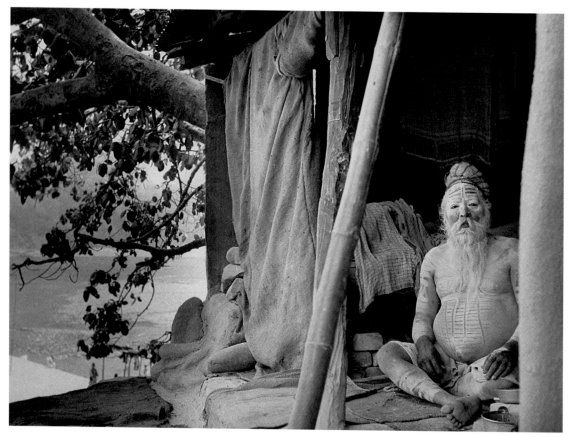

Hindu holy man in his home, 1951

Billy Graham convert, 1957

Larry **Burrows** 1926–71

The Compassionate Photographer

He was born in London, not to money but rather a hardworking railway employee, and as Larry's Britishness never waned nor did his industry. Early on, as he was learning his craft, he thought nothing of repeating an entire day's work to get the job done right. And time spent in the museums of Europe served him well, honing his own artist's eye—and a masterly appreciation for color—for his life's work, the battlefield. From Suez to Lebanon, Cyprus to the Congo, he became versed in the cruelties of war. Then, in 1962, began nine years (his last on earth) in a beautiful land filled with an awful violence: Vietnam. These images are nothing short of timeless. "One Ride with Yankee Papa 13" has been called perhaps "the greatest photo-essay ever made." After Burrows's death, LIFE Managing Editor Ralph Graves stated, "I do not think it is demeaning to any other photographer in the world for me to say that Larry Burrows was the single bravest and most dedicated war photographer I know of."

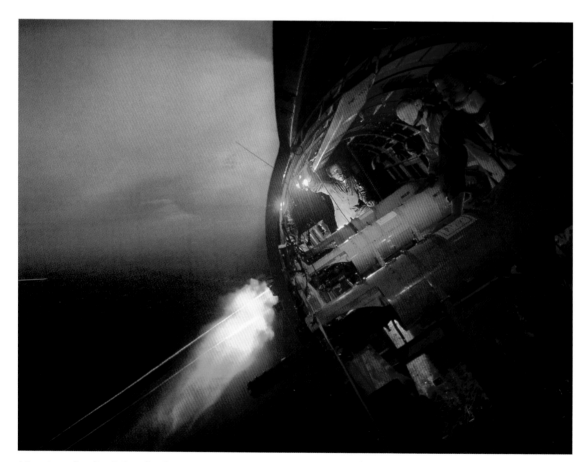

AC–47 tracer fire pinpointing a jungle target, Vietnam, 1966

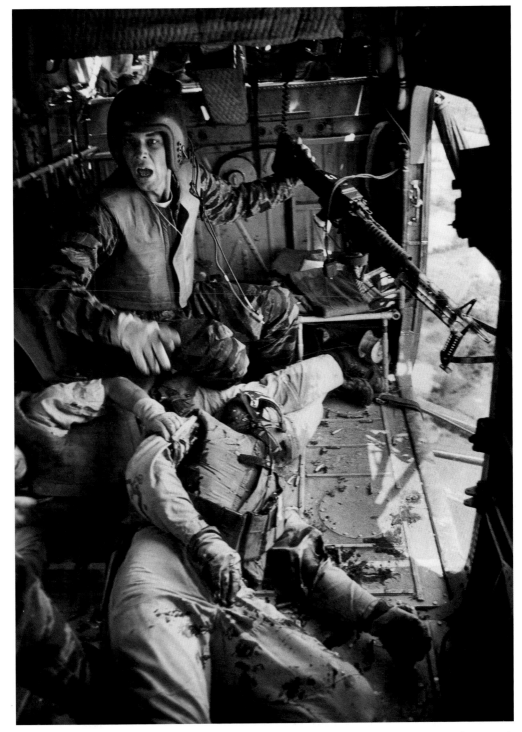

On *Yankee Papa 13*, Vietnam, 1965

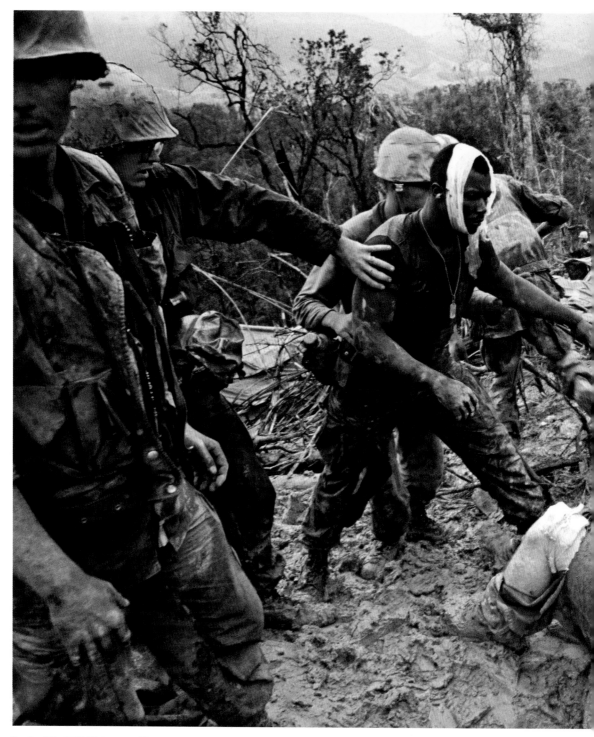

South of the DMZ, Vietnam, 1966

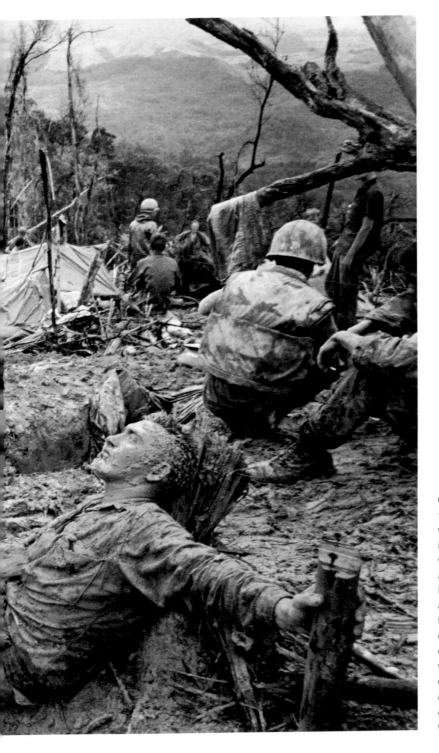

Casualties ran heavy on October 5, 1966, when a company of Marines was caught in an ambush on Mutter's Ridge. In this photograph, which has come to be called *Reaching Out,* Gy. Sgt. Jeremiah Purdie has just arrived at this first-aid station, and despite the shock from his own wounds seems more concerned with a fellow stricken comrade. Burrows went about his work with an eye for what he considered his duty, rather than any self-preservation. "I can't afford the luxury of thinking about what could happen to me."

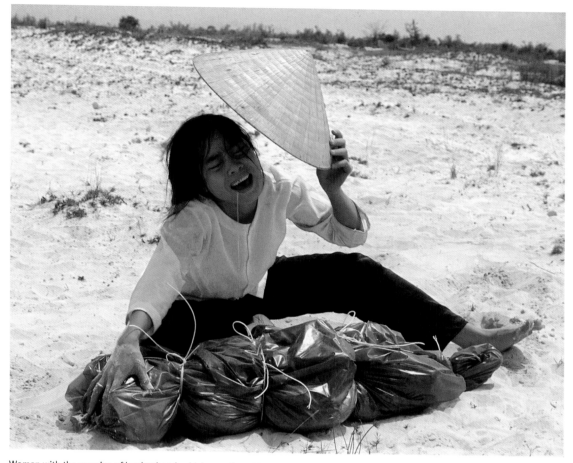

Woman with the remains of her husband, which were found in a mass grave, Hue, Vietnam, 1969

This image of a North Vietnamese atrocity has been used by some as a counterpoint to the My Lai massacre. In any case, it remains a powerful human document. The boy at right was paralyzed by shrapnel and shipped to America for surgery. He spent three years there with a foster family before being sent back to Vietnam. By then, he could speak only English and could walk only with crutches; he had become an enigma to his family, a liability. To Larry Burrows, "Lau's is not the greatest tragedy in Vietnam. But as one looks at pictures of this courageous little chap, one has to wonder whether the ultimate agony of this war is not seen in his eyes." What happened to Lau is yet unknown.

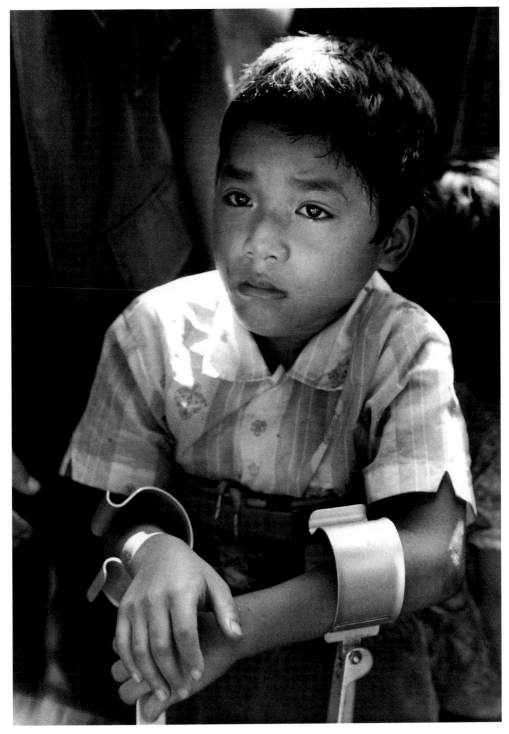

Paraplegic Lau Nguyen, 10, Vietnam, 1970

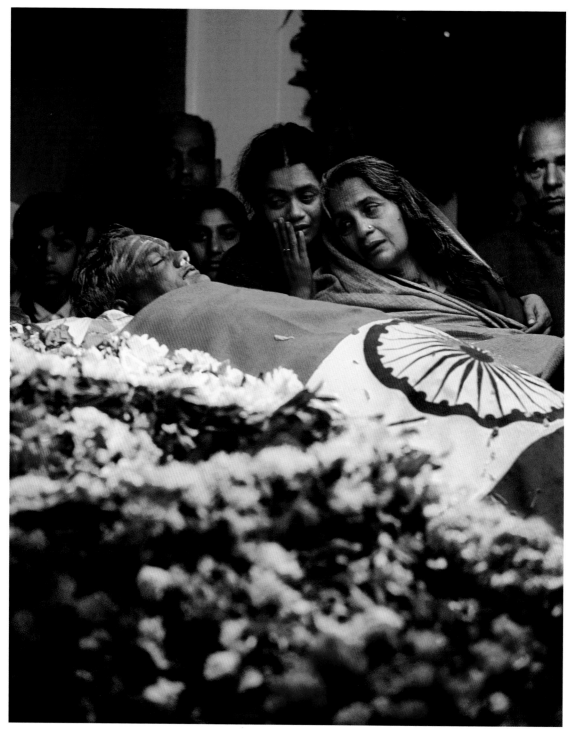

Lal Bahadur Shastri's funeral, New Delhi, 1966

Cyclone survivor, East Pakistan, 1970

Larry Burrows

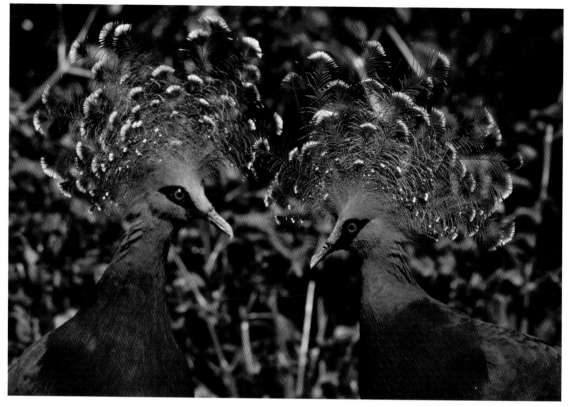

Crested Goura pigeons in Nondugl Aviary, New Guinea, 1966

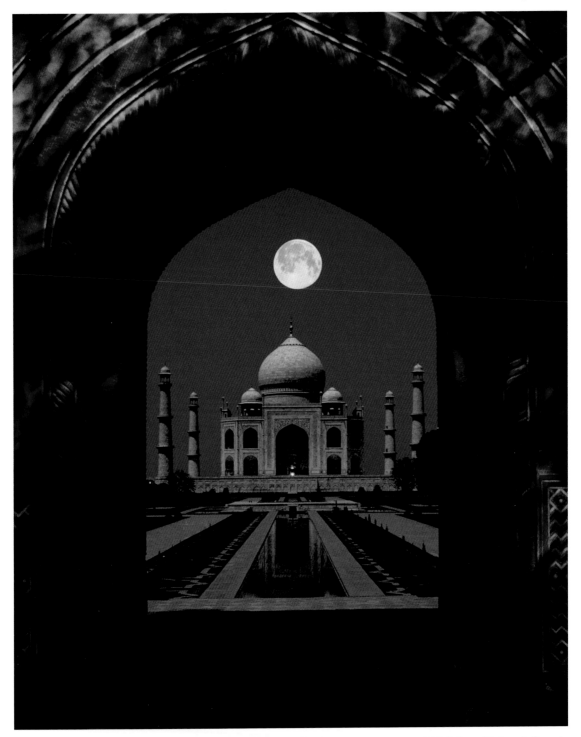

Taj Mahal, outside Agra, India, 1967

Cornell **Capa** 1918–2008

Objectivity Above All

As an 18-year-old native of Budapest, Kornel Friedmann (he would later follow his older brother, Robert, and change his name) learned what he needed to know about the power of a camera from Robert's Spanish Civil War images. "The times I grew up in became part of my conscience and my photography. I was not an artistic photographer and never became one," he maintained. "I haven't taken a landscape picture which was not part of a story. If I saw a peasant working in a field—which was very difficult for him to do—then I took the picture of a peasant with a field. But I didn't take a field without the peasant." On his approach to shooting, he once said, "The camera is an extension of yourself . . . Your story treatment may be subjective, but it is important to remain objective as to truth." Cornell, for all his many accomplishments, will be remembered always as "le petit Capa."

Alec Guinness, England, 1952

Adlai Stevenson at his Illinois farm, 1952

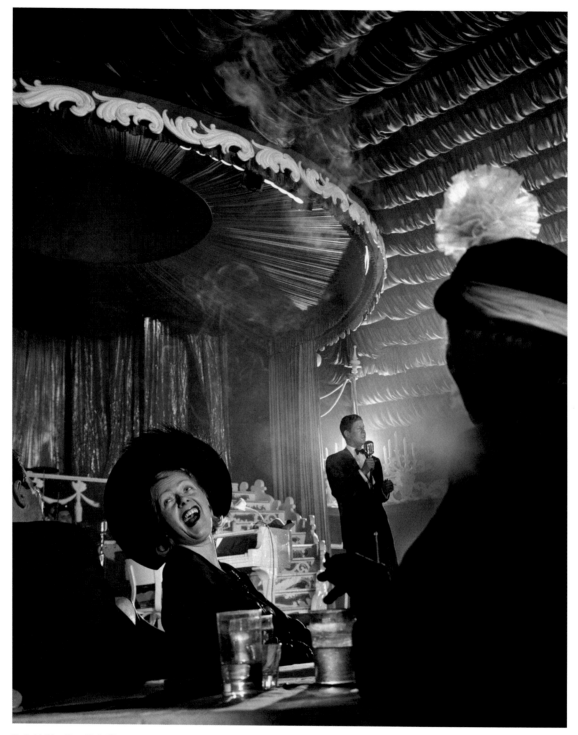

Rudy Vallée, New York City, 1949

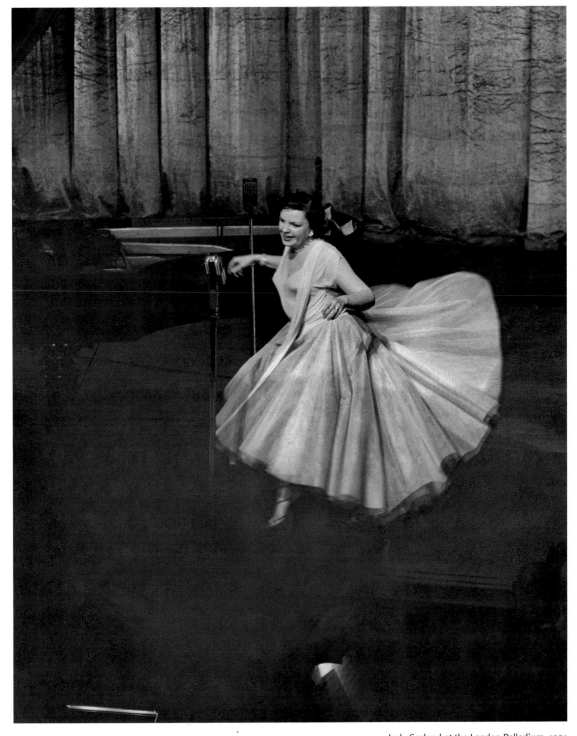

Judy Garland at the London Palladium, 1951

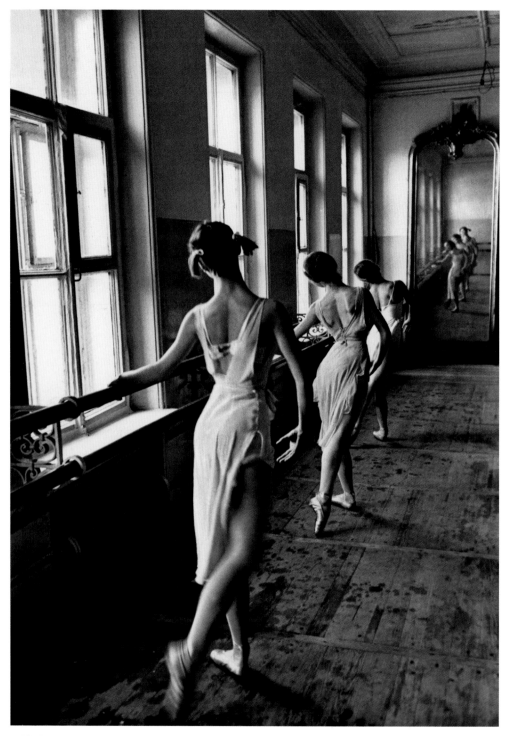

Bolshoi Ballet School, Moscow, 1958

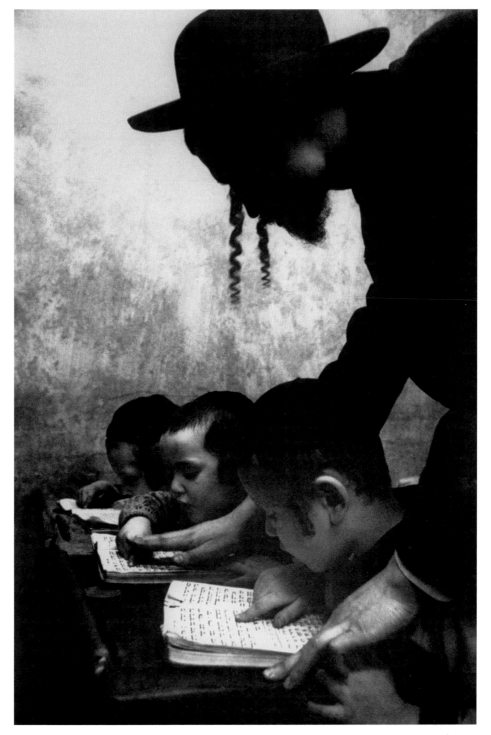

Lessons in a Hasidic classroom, Brooklyn, 1955

Boris Pasternak at his villa near Moscow, 1958

John F. Kennedy, 1962

Robert Capa 1913–54

A Master of Life and Death

He was the preeminent war photographer of his time and one of its most magnetic figures. It is entirely apt that this Hungarian émigré, Endre Friedmann, conspired in the '30s to create the dashing persona of Robert Capa, and then expanded on it until Robert Capa was bigger than life—at the Spanish Civil War, in China covering the fight against Japan, with U.S. troops in North Africa and Italy, and on a terrible Normandy beach on D-Day. All this from a man who hated war: "A war photographer's most fervent wish is for unemployment." But there is always one more war. In 1954 he was in Japan with a Magnum exhibition (he was one of the agency's founders) when LIFE had need of a photographer in Indochina. Robert Capa, of course, volunteered, but he would there step on a land mine and be killed. Said his brother, Cornell: "He died on a not-important road, in a not-important action. It had to be fate for him to do that." He died with his camera in his hands.

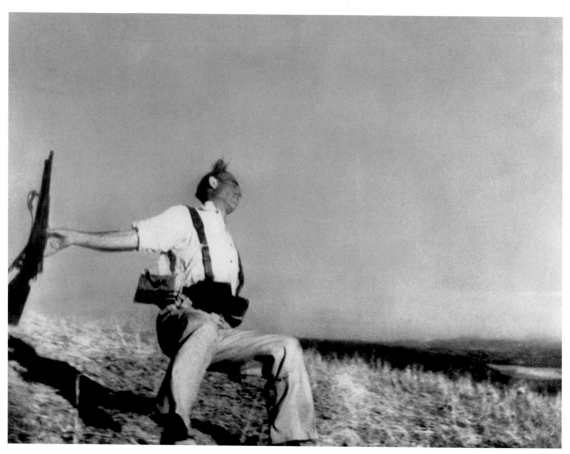

Death of a Loyalist soldier, Spain, 1936

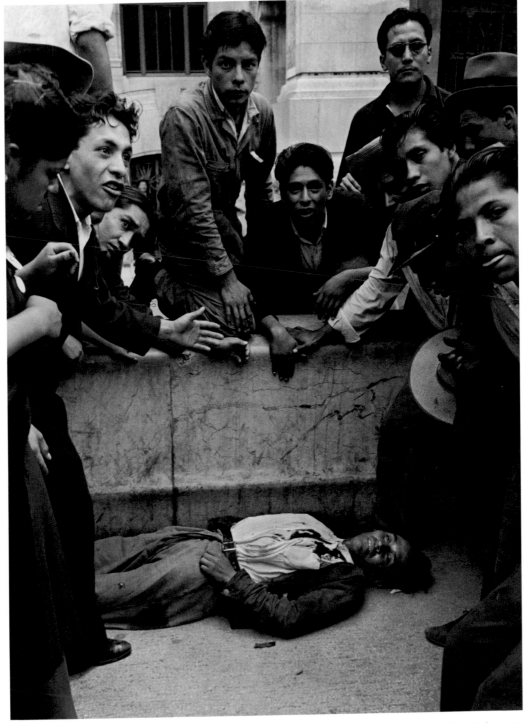

First dead in election riots, Mexico, 1940

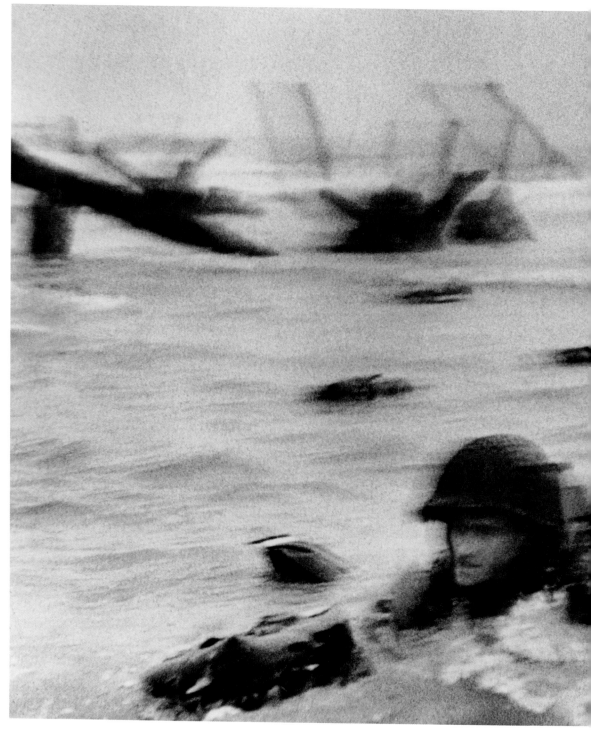

D-Day, Omaha Beach, Normandy, 1944

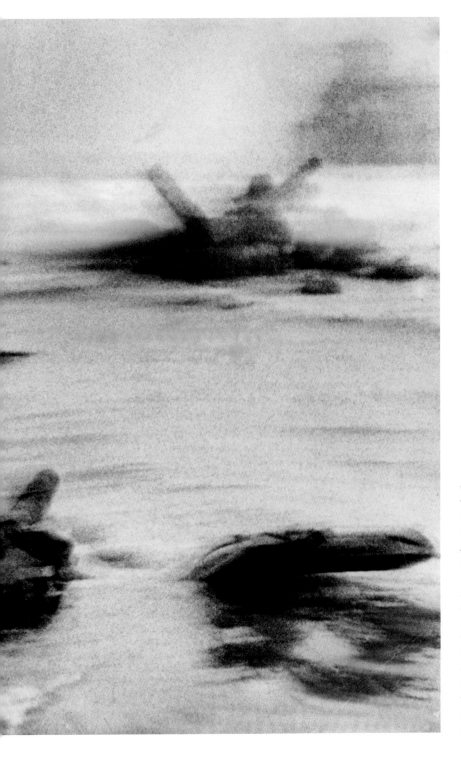

Capa was with the first wave of Allied soldiers to hit Omaha Beach on D-Day. He shot four rolls of film. A photo assistant, however, ruined all but 11 images. Fortunately, the handful that survived were more than enough to limn the massive assault. Capa shared the fears and fatigue of the men he accompanied. During one campaign, he just kept repeating to himself, "I want to walk in the California sunshine and wear white shoes and white trousers."

Ernest Hemingway in a London clinic, 1944

Gary Cooper, Sun Valley, Idaho, 1941

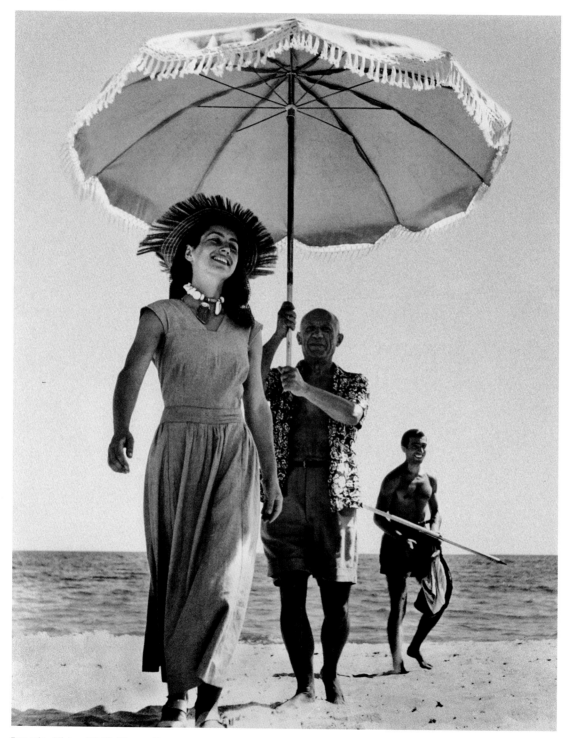

Françoise Gilot and Pablo Picasso, France, 1948

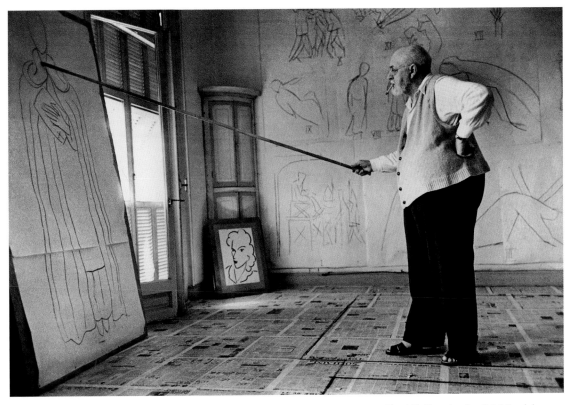

Henri Matisse drawing Saint Dominic, 1949

Two of the world's greatest painters. The sight of
Picasso letting down his hair—so to speak—is a
stunning departure from the artist's usual forbidding
presence. No modern artist was more intense, more
formidable, than Picasso. Here, he shades his lover
Françoise Gilot from the glare of the Riviera sun, as his
nephew savors the incomparable scenario. Years later,
Gilot said that the picture of the clowning moment
had been possible because Capa was a friend.

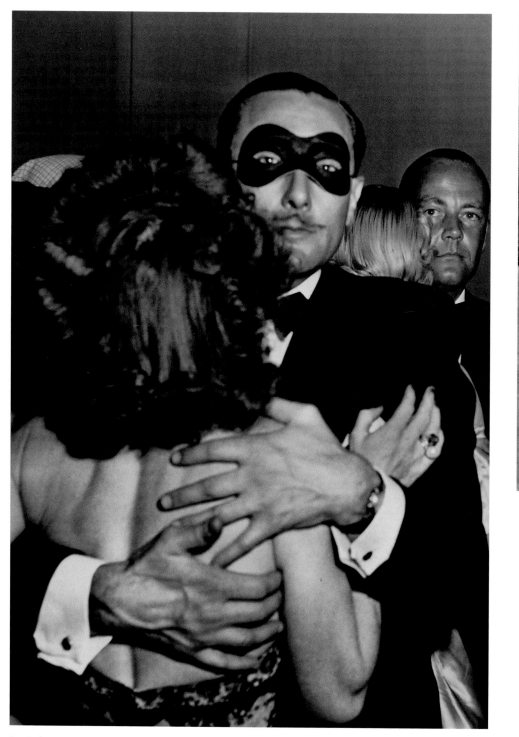

Carnival party, Zurs, Austria, 1950

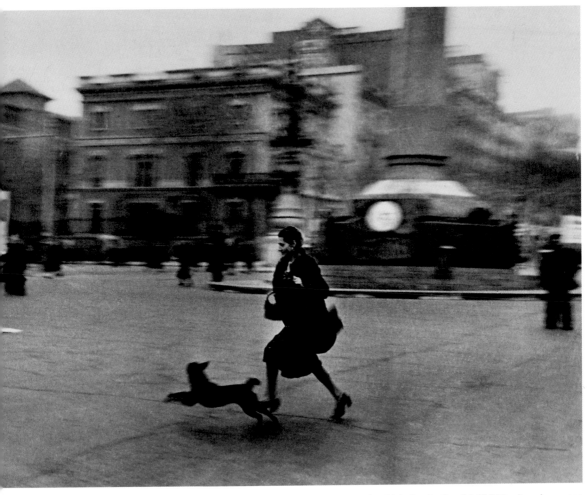

Air raid during the Spanish Civil War, Barcelona, 1939

Edward **Clark** 1911–2000

Epstein

Doing It His Way

Most of LIFE's photographers had a knack for capturing the essence of people, for laying claim to their most characteristic moments. Ed Clark had this ability in spades. Perhaps it was his own sense of self. He hailed from Nashville, and after LIFE offered him a contract, he was summoned to New York City. Clark demurred: "I'll work for you in Tennessee and go wherever you want me to go. I have two small boys. I don't want to bring them up in Manhattan." Picture Editor Wilson Hicks riposted, "We don't have a single employee in the whole state of Tennessee, and we're not going to start now." But after seeing Clark's work on ensuing assignments, Hicks folded: "O.K., Ed, you win. You can live in Nashville." Good decision. Over the years, Clark produced scores of memorable images for LIFE. His favorite? The young painter in Montmartre. "I didn't know where France was, let alone Paris. It was so beautiful that I just started photographing."

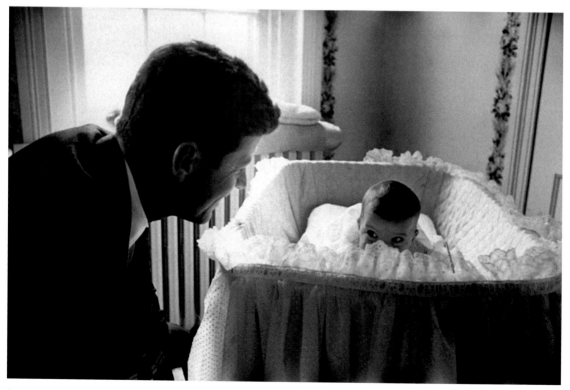

Senator John F. Kennedy and daughter Caroline, 1958

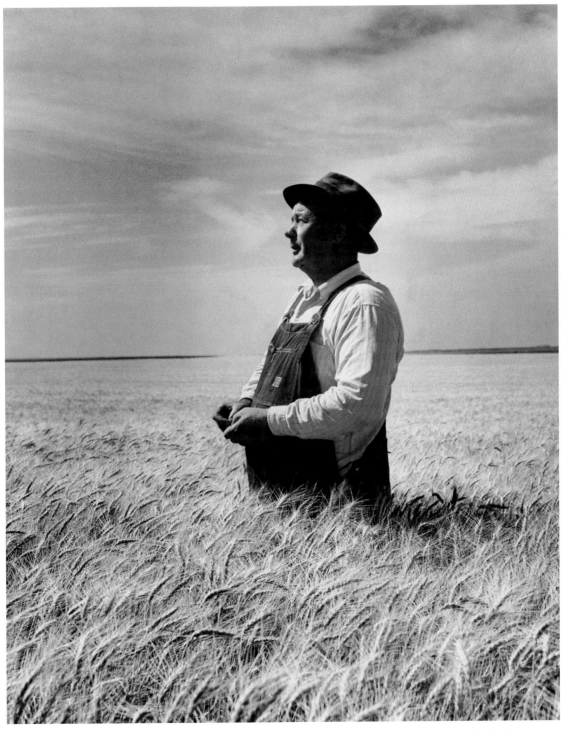

A farmer in his wheat field, Nebraska, 1946

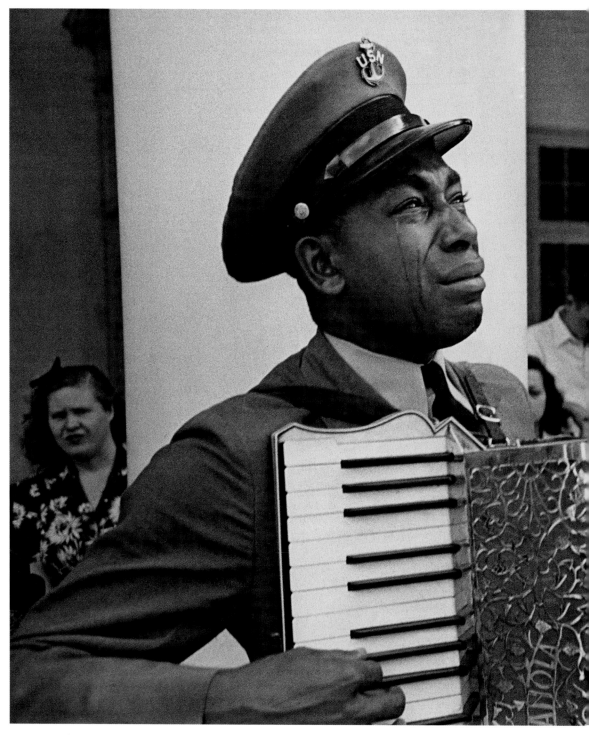

Navy CPO Graham Jackson, 1945

Clark had driven all night for LIFE—"Get to Warm Springs, Georgia, any way you can!"—to be able to get a shot of FDR's funeral cortege. Said Clark: "There must have been 135 photographers there from everywhere. The Secret Service lined us all up behind a barrier in front of a small house they called the Little White House so we could photograph the caisson as it came by with Roosevelt's casket on it . . . I heard this accordion start to play behind me and I turned around . . . I thought to myself, 'My God, what a picture.' I was the only one who saw it."

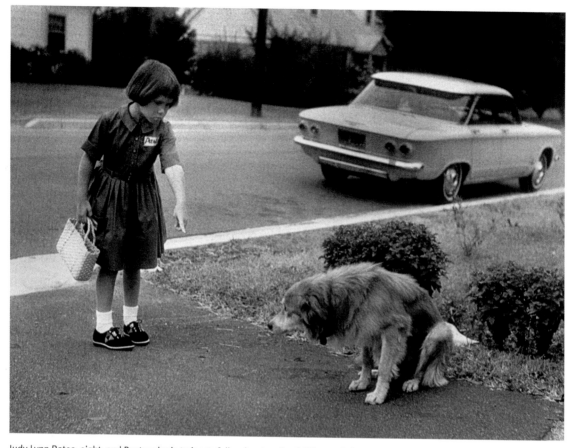

Judy Lynn Bates, eight, and Rusty, who is trying to follow her to school, Winston-Salem, N.C., 1962

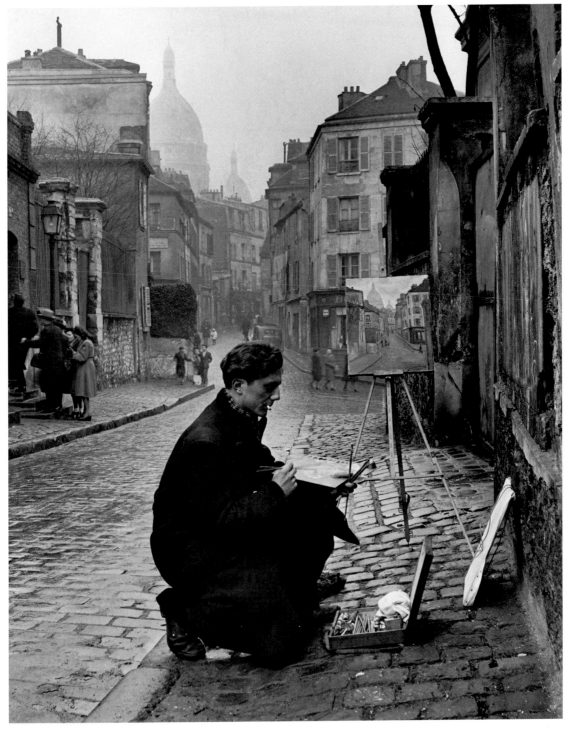

Painting Sacré-Coeur from the ancient Rue Norvins in Montmartre, Paris, 1946

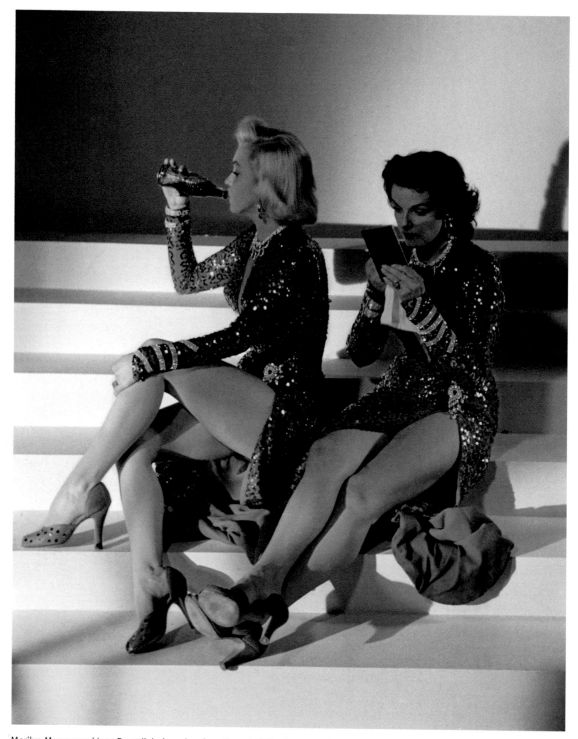

Marilyn Monroe and Jane Russell during a break on the set of *Gentlemen Prefer Blondes*, 1953

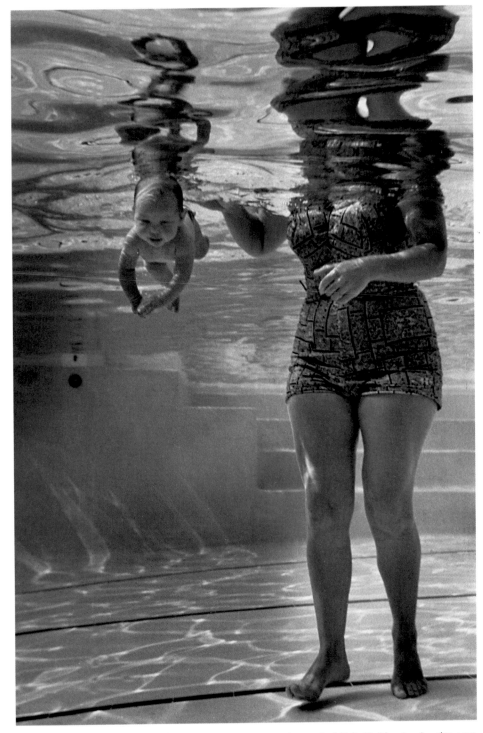

World's youngest swimmer, nine-week-old Julie Sheldon, Los Angeles, 1954

Ralph **Crane** 1913–88

Nat Greenblatt

Vigor and Variety

He was born in a small German town, the son and grandson of physicians. It was expected, of course, that he, too, would become a doctor, but instead he was drawn to a very interesting hobby of his father's: photography. In the end, one of Dad's patients got the 18-year-old "Rudi" a gig carrying equipment for the old Wide World Photo organization. The die was cast. Crane moved to the U.S. in 1941 and started out with the agency Black Star (the source for many LIFE photographers). Much of the work he did for Black Star ended up in LIFE, which he finally joined as a staffer in '51. A meticulous worker, he could handle any kind of story, always burbling with vitality and the hearty chortle that earned him the sobriquet Whooping Crane.

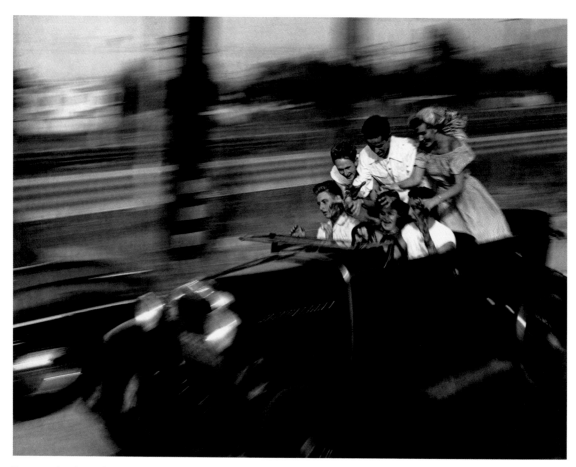

Teenagers in a hot rod, Los Angeles, 1949

Reenactment of an escape from a children's home, 1947

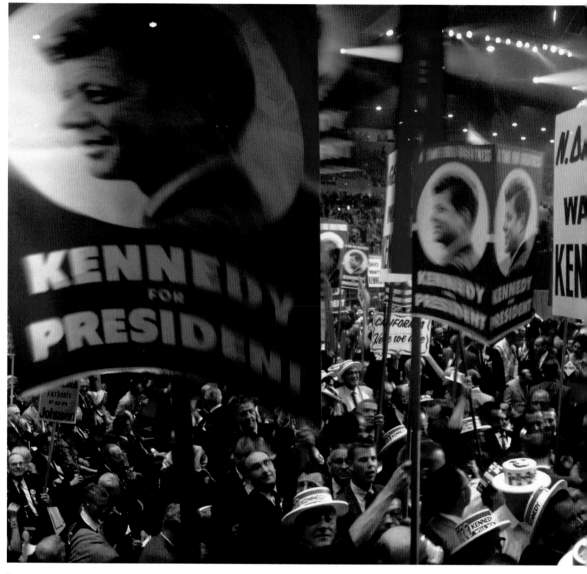

Democratic Convention, Los Angeles, 1960

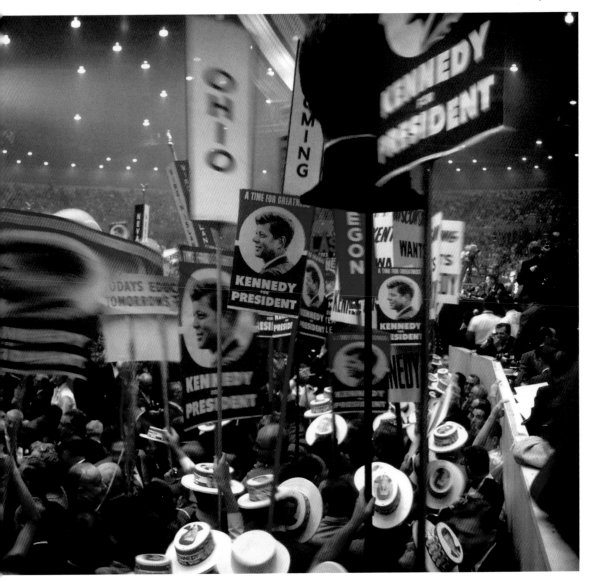

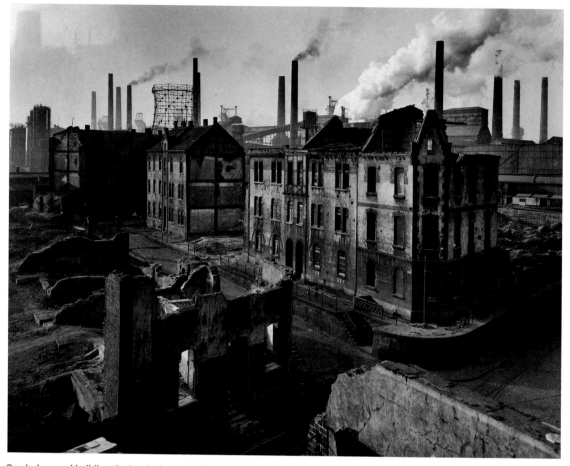

Bomb-damaged buildings in the shadow of the Thyssen steel mill, Duisburg, West Germany, 1953

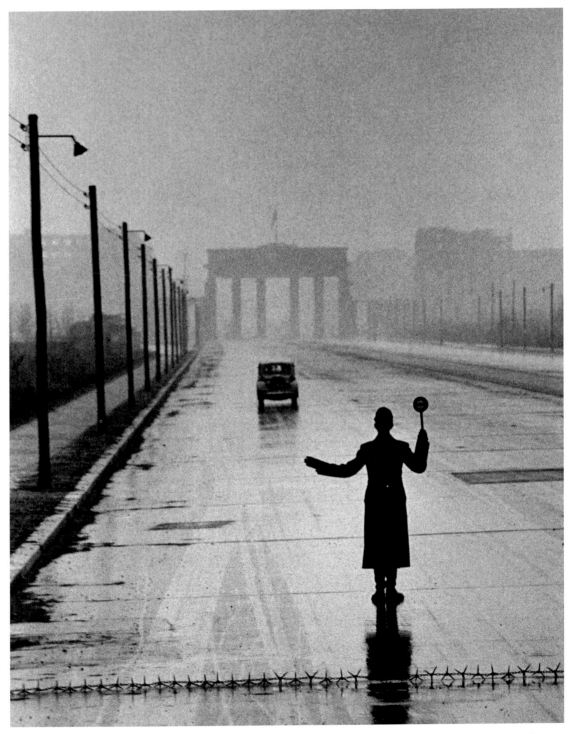

East Berlin automobile entering West Berlin, 1953

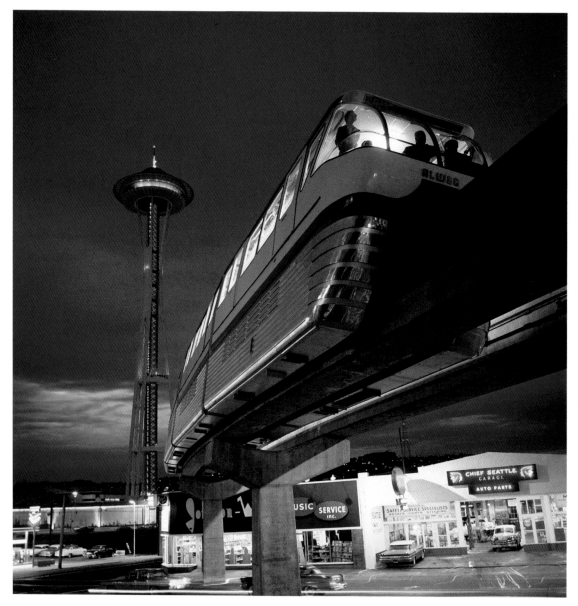

Monorail at Century 21, with Space Needle in the background, Seattle World's Fair, 1962

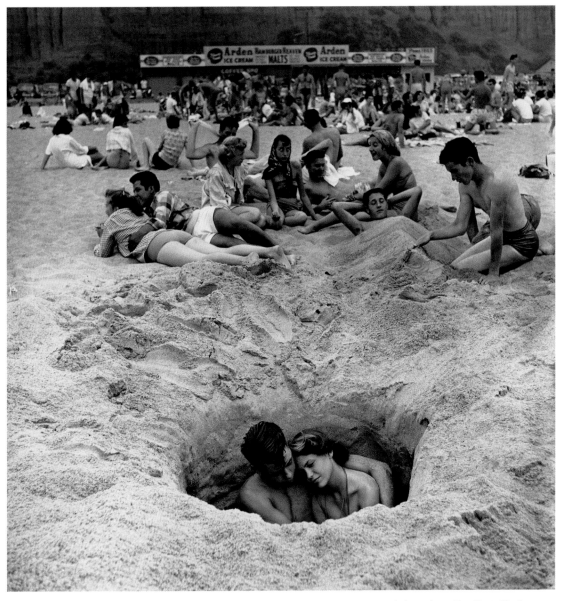

Independence Day, Santa Monica, 1950

Ralph **Crane**

In northwestern Mexico is carved the
Barranca de Cobre, or Canyon of
Copper. Although not quite as long as
the Grand Canyon, it may be somewhat
deeper than the U.S. gorge. In 1950 an
expedition from the Los Angeles County
Museum went into the canyon to
explore its bird life, and Ralph Crane
was along for most of the 58-day trek.

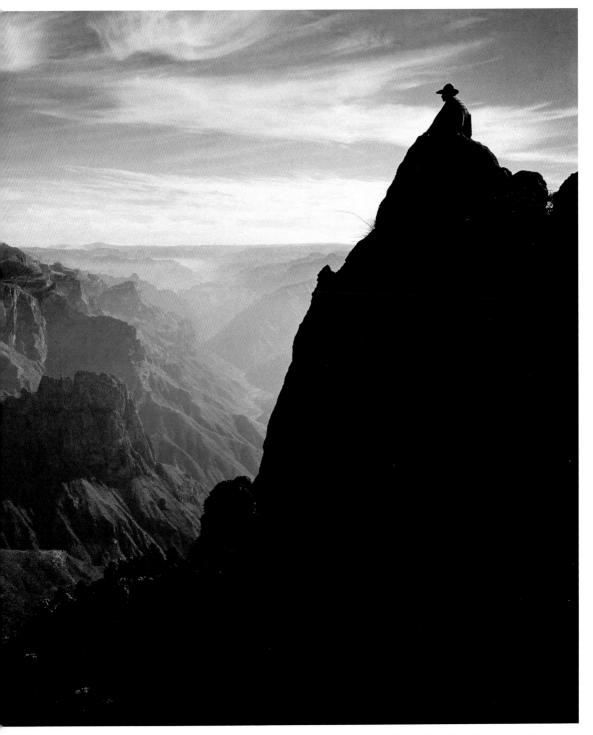

Mexican mule driver on the west rim of Barranca de Cobre, Sierra Madre Mountains, Mexico, 1950

Myron **Davis** 1919–

Face to Face with War

At age 11 he asked his mother how photographs were made. As it turned out, she had done some developing, so she explained the process. Then: "I went to the drugstore, got the chemicals . . . put a blanket over the bathroom window, made a little red light out of some red cellophane, got some old pots and pans, and ran a roll through. I was bit from there on." His first World War II assignment for LIFE landed him on a beach in New Guinea. There was a mutilated body on a stretcher. "I was so shocked I turned away and said, 'I cannot photograph this.' Then I thought, 'No, this is war. I've got to try to deal with this.'" He eventually formed a strategy: "I'd learned the smart thing, even journalistically in a way, was to get what you could and get back safely with your film." Davis modestly—and wrongly—insisted that he "never really captured the essence of war because most of the time when the bullets were going by, I was trying to squeeze my whole body into that little tin helmet."

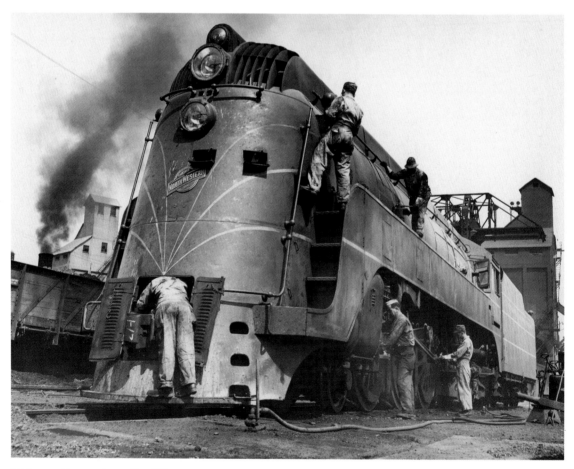

Soldiers working on a locomotive, Chicago, 1945

Larry Jim Holm, 12, with Dunk, Oskaloosa, Iowa, 1945

Dead Australian serviceman on an Allied beachhead, Lae, Papua New Guinea, 1943

U.S. troop train, 1943

Loomis **Dean** 1917–2005

Joie de Vivre

His father was an artist, and Loomis went to art school, "but it just proved I couldn't draw." He soon discovered his passion for photography, but before he went to work for LIFE in 1947, he sold Bibles during the Depression, put in four years as an assistant press agent for the Ringling Bros. circus, and served in the Pacific Theater. According to Dean, "LIFE almost single-handedly changed the image of the news photographer from a slovenly, tobacco-chewing slob under constant pressure . . . to the pseudo-sophisticated type in neckties who were allowed to use initiative and imagination . . . We knotted our ties and set off to con people into all sorts of things they frequently didn't want to do . . . in the final analysis, it was all the most fun in the world."

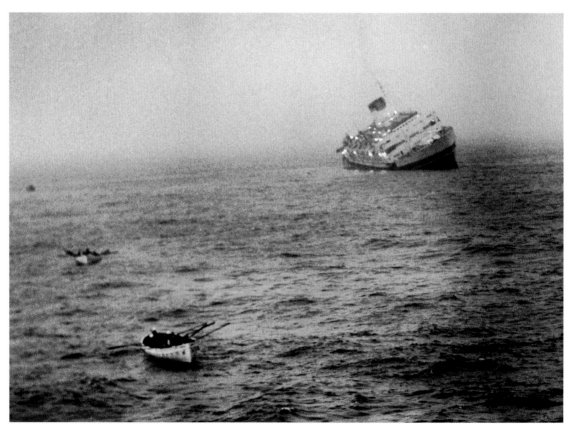

Italian liner *Andrea Doria* sinking in the Atlantic, 1956

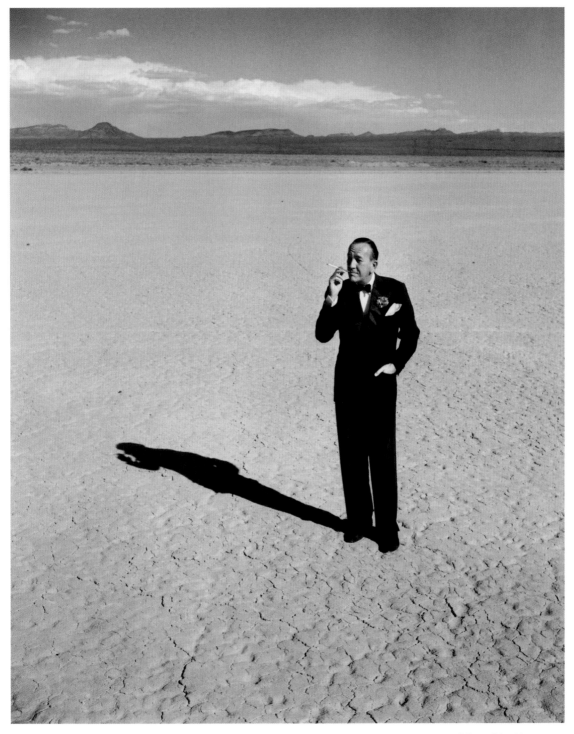

Noël Coward, Las Vegas, 1955

Debutantes Mary and Debbie Love, St. Louis, 1946

Jack Palance, 1952

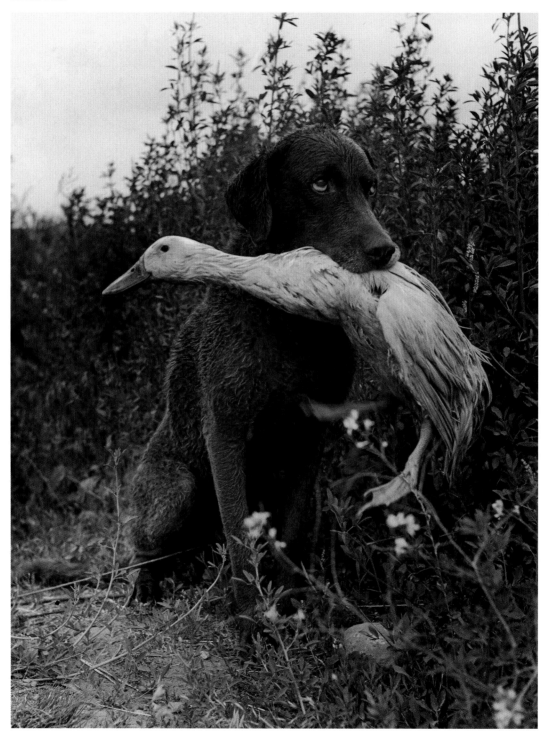

Donald, who habitually convinces dogs to retrieve him from water, rescued this time by Trigger, Yakima, Wash., 1949

Balthus, Château de Chassy, France, 1956

Off a trampoline, Santa Monica, 1948

Lucille Ball, Hollywood, 1952

John **Dominis** 1921–

Big Cats, Big Stars, Big Dinners

After an Air Force tour in Japan, Dominis wanted to remain in that country and work. Freelance work was illegal there in 1946, but his photographer colleagues helped him stay and get his start. He would return many times to Asia to cover wars. Back home, he shot sports (he had played end for USC in the 1944 Rose Bowl), politics, celebrities, even food. He spent three months trailing Sinatra to witness him in his element, among swank and boozy stars. That experience of tracking a subject among its own kind helped the stalwart Dominis on his famous "The Great Cats of Africa." The series won him an award even as he was still in the bush—and even though he orchestrated his famous baboon-leopard encounter (the feline was a rental dropped in among the simians). Dominis had never suggested otherwise. "Frankly, it was set up," he said. "In those days we were not against setting up some pictures that were impossible to get any other way."

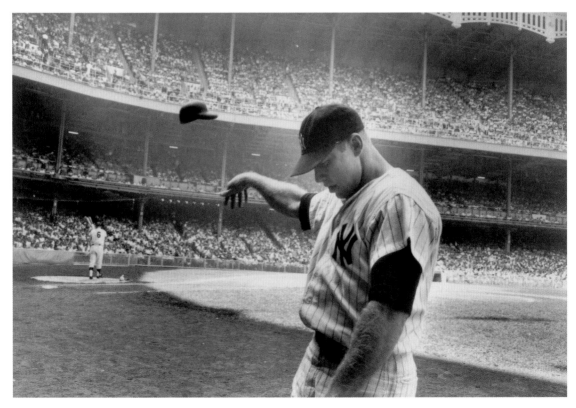

Mickey Mantle, Yankee Stadium, 1965

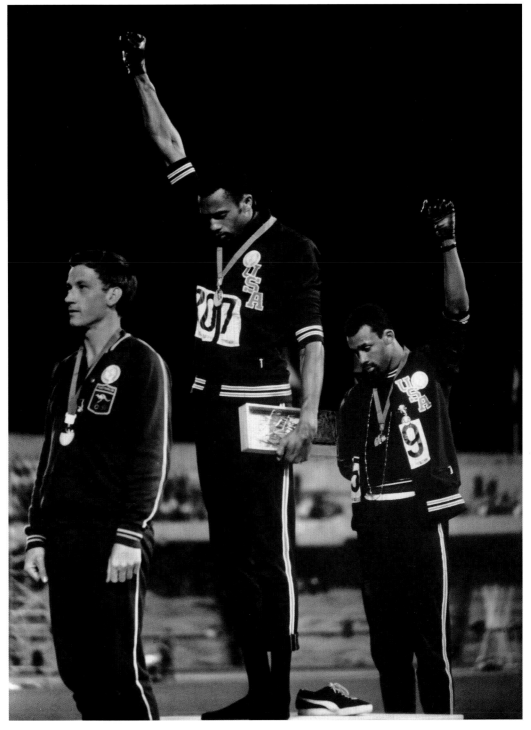

Peter Norman, Tommie Smith and John Carlos, Mexico City Olympics, 1968

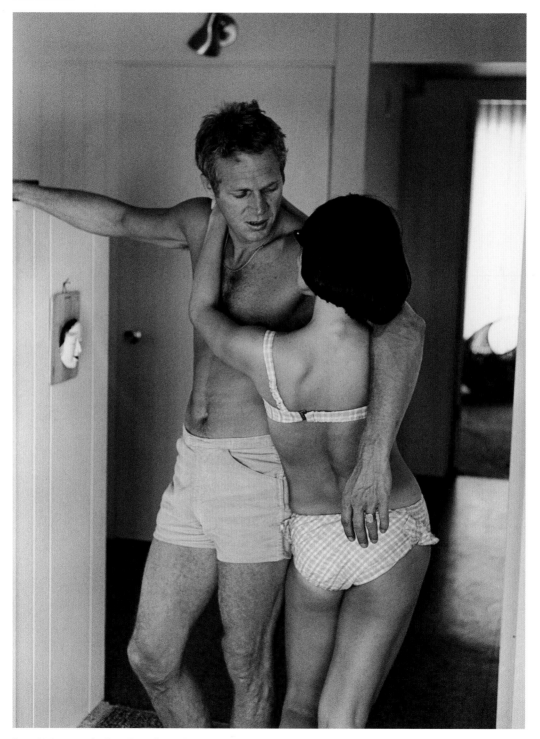

Steve McQueen and wife Neile, Hollywood, 1963

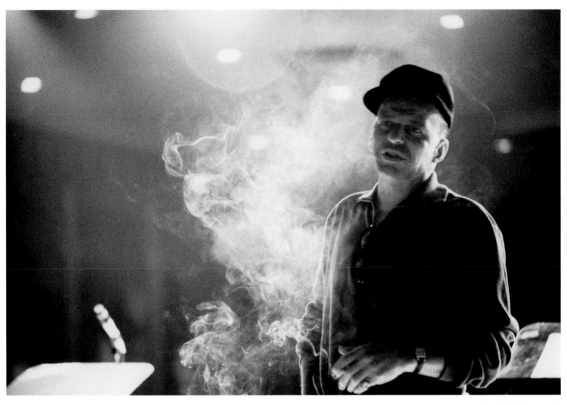

Frank Sinatra, 1965

On the occasion of Sinatra's 50th birthday, Dominis went to Florida, where he was performing. Dominis ended up spending three months with him, resulting in an unrivaled set of images of the entertainer. Left: "Steve McQueen was really a nice guy, but he's another of the ones who didn't really want to have even one picture taken, even though he'd agreed to the story . . . I had done quite a lot of sports-car racing when I lived in Hong Kong, so for fun I rented a Jaguar. I knew he had a Jaguar, and I thought it would help a little bit . . . He drove my car and I drove his. I started shooting a few pictures. I didn't hang around him a long time, maybe three weeks, and finally he relaxed."

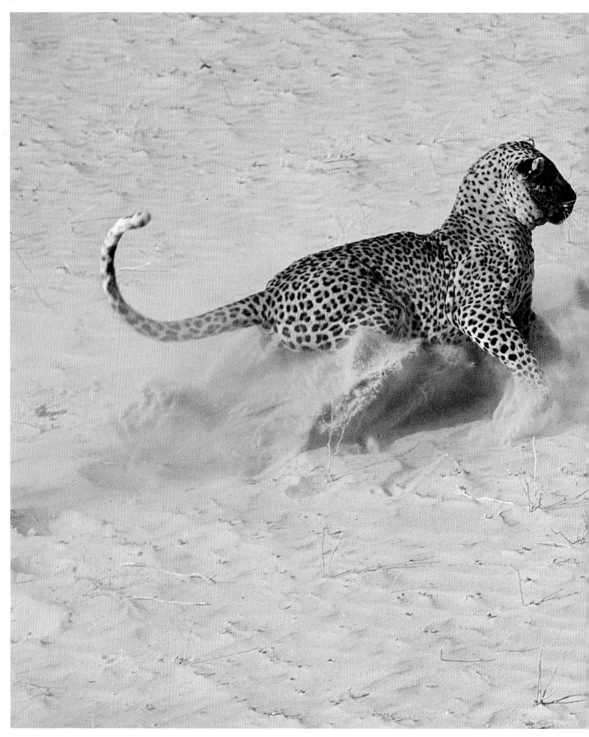

Botswana, Africa, 1966

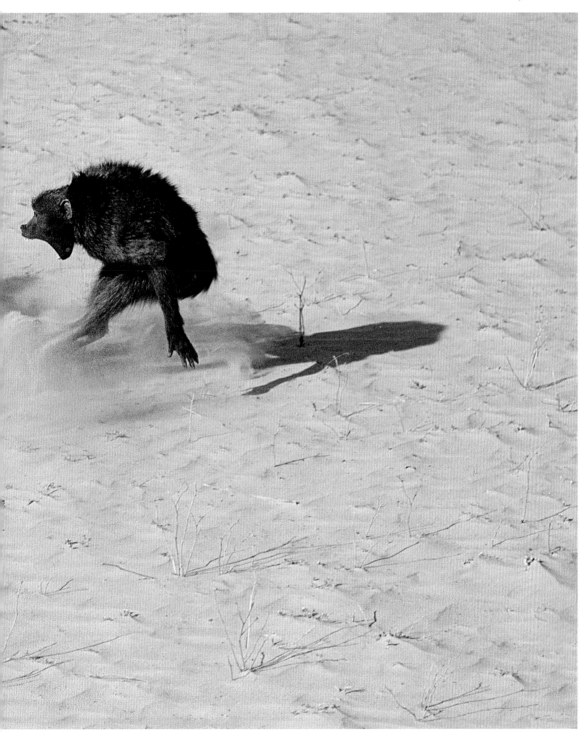

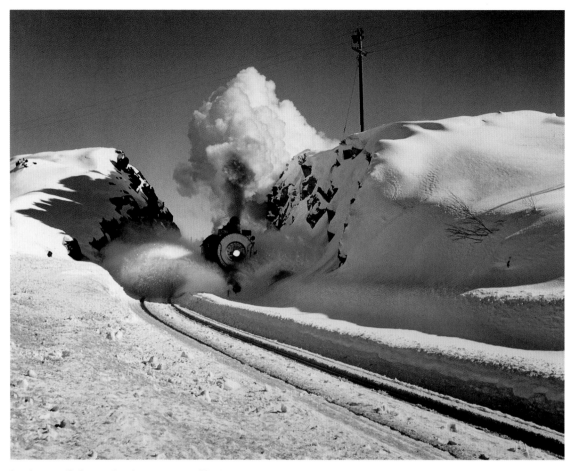

Southern Pacific locomotive clearing snow, California, 1949

Texas, 1962

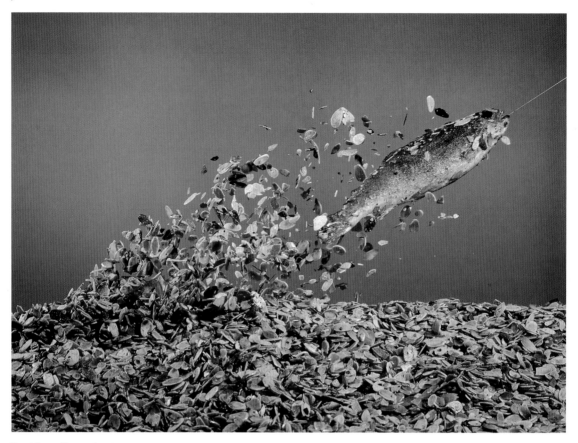

Trout Amandine, 1964

The photo at right exudes a sense of ease, but the picture above is a different matter. It is from LIFE's Great Dinners series, which Dominis worked on with editor Eleanor Graves. "We didn't want our pictures to look like ones in all the food and women's magazines," says Dominis. "I got these slivered almonds, and put this trout in there with a fishing line on it . . . The trout was soft from being cooked and it just fell apart . . . Finally, I cooked the trout on one side to make it the proper color, and then I put the line in and put it in the freezer. When it was stiff and firm, we put it in the almonds and my assistant pulled it out."

Priest, Detroit, 1955

Paul **Dorsey** c.1902–

Tough Guy

A former Los Angeles policeman, he joined LIFE in 1936 as the first photographer signed after the original four had been secured. Dorsey initially made his mark at LIFE with his work in China and Japan. He was on assignment there in 1939 when a Japanese officer spit in his face. Dorsey was unable to retaliate, but his time would come. As a Marine Corps photographer attached to Edward Steichen's unit, Dorsey was on hand for operations in such sites as Saipan and Guam. Along the way, he said, he personally dispatched seven Japanese—and "made darn sure they were dead."

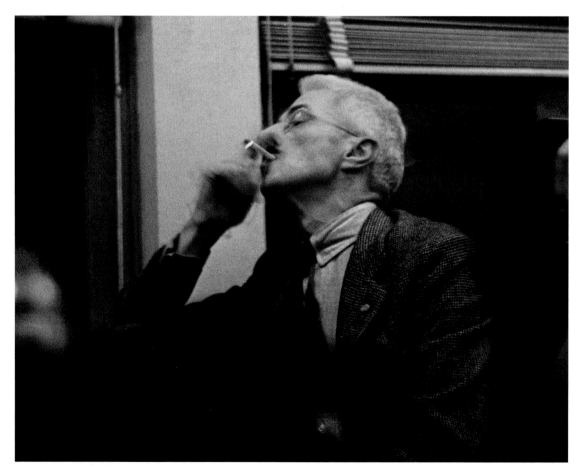

Dashiell Hammett. Hollywood, 1937

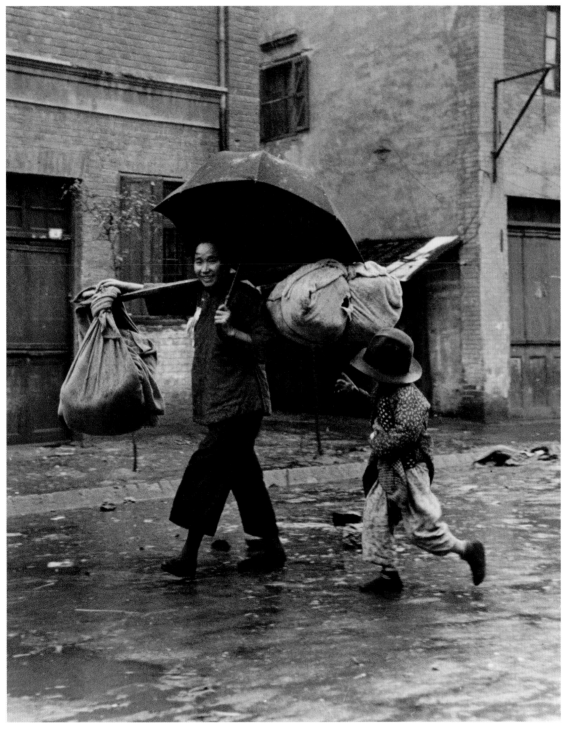

Refugees in Hankow, China, 1938

David Douglas **Duncan** 1916–

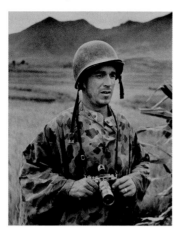

Master of War

As an 18-year-old at the University of Arizona, Duncan raced with his 39-cent Bakelite camera to a hotel fire and took a photo of a man desperately rescuing a suitcase from the blaze. The next day he read that the man was John Dillinger. The episode became for Duncan "the most significant single move of my life," and helped create one of the century's foremost photojournalists. His oeuvre covers a great range of subjects, but it is his war photography and his monumental study of Pablo Picasso that ensure his reputation. Duncan joined the Marines in World War II; he was on the USS *Missouri* to record the Japanese surrender. He became the signature photographer of the Korean War, and produced a stunning book on Vietnam called *I Protest*. "I wanted to show the way men live and die when they know death is among them."

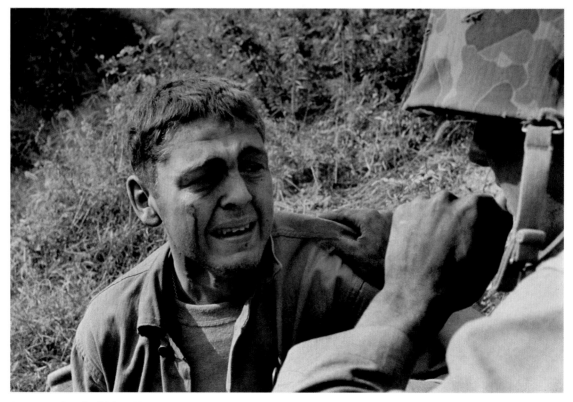

A young Marine after his jeep hit a mine, Korea, 1950

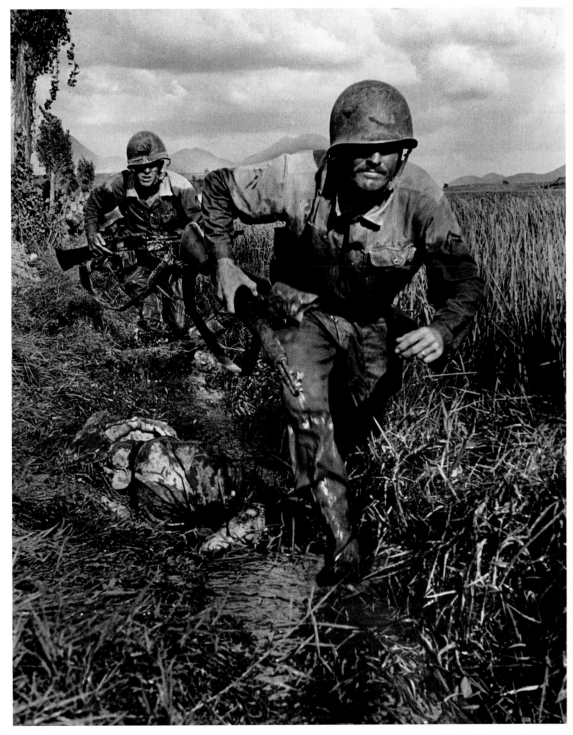

Marines advance past an enemy corpse, Naktong River area, Korea, 1950

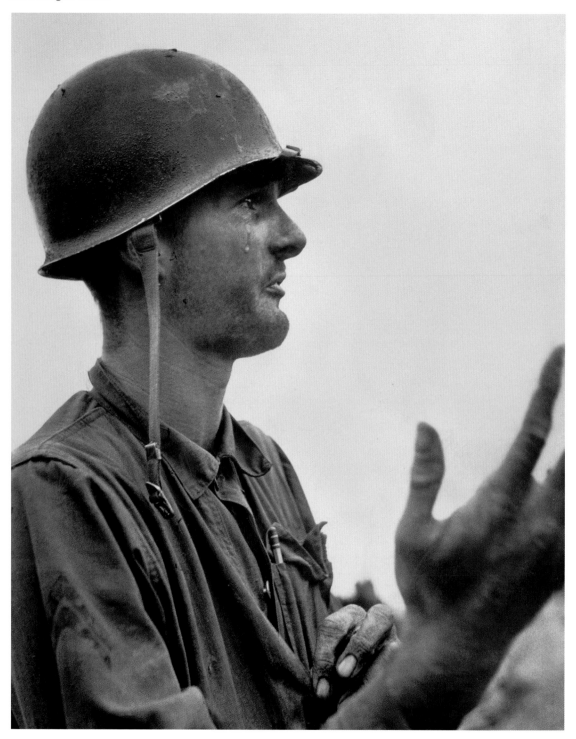

Corporal Leonard Hayworth, Korea, 1950

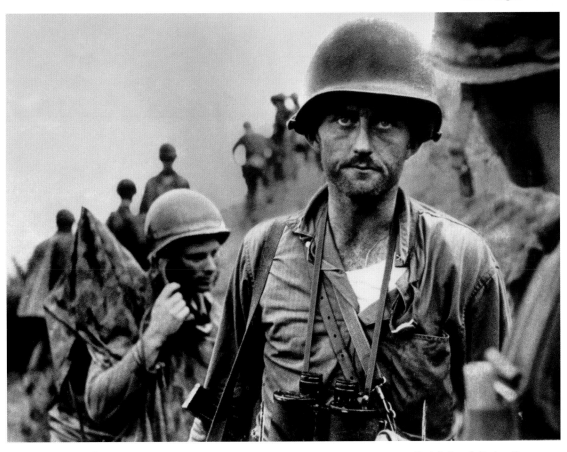

Captain Francis Fenton, Korea, 1950

Above, in Korea in 1950, Marine Captain Fenton ponders his fate and the fate of his men during an enemy counterattack. He has just been told that his company has lost radio contact and is nearly out of ammunition. At left, Corporal Hayworth, who serves under Fenton, shows his utter frustration as he has crawled back from his position only to learn that the ammo is gone. Coda: At the last moment, supplies arrived and the men were able to hold their position.

David Douglas Duncan

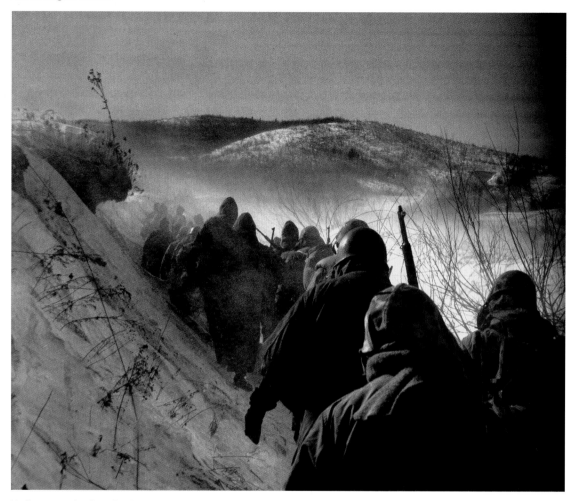

Marines retreating from the Changjin Reservoir along "Nightmare Alley," Korea, 1950

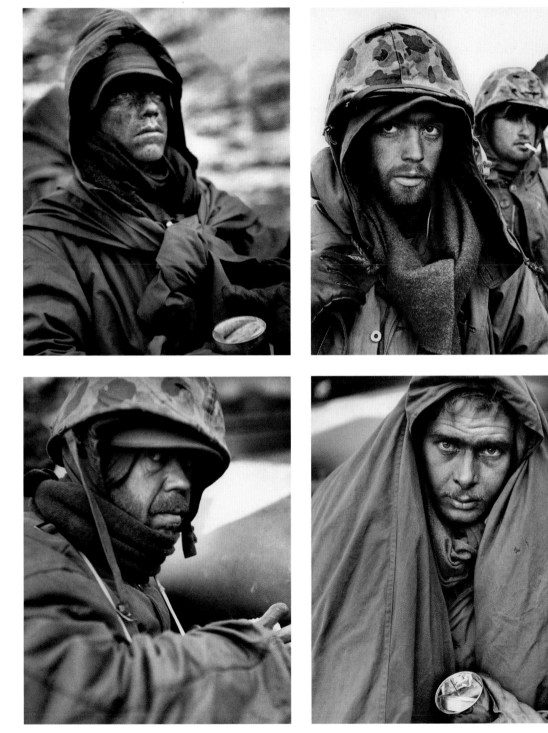

The retreat from the Changjin Reservoir, Korea, 1950

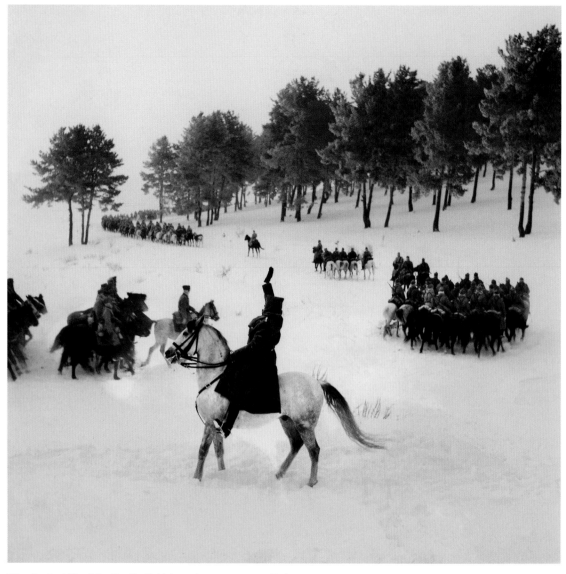

Brigadier Avni Mizrak leading the Turkish cavalry on maneuvers, Turkey, 1949

West German guard patrolling the border between East Germany and West Germany, 1952

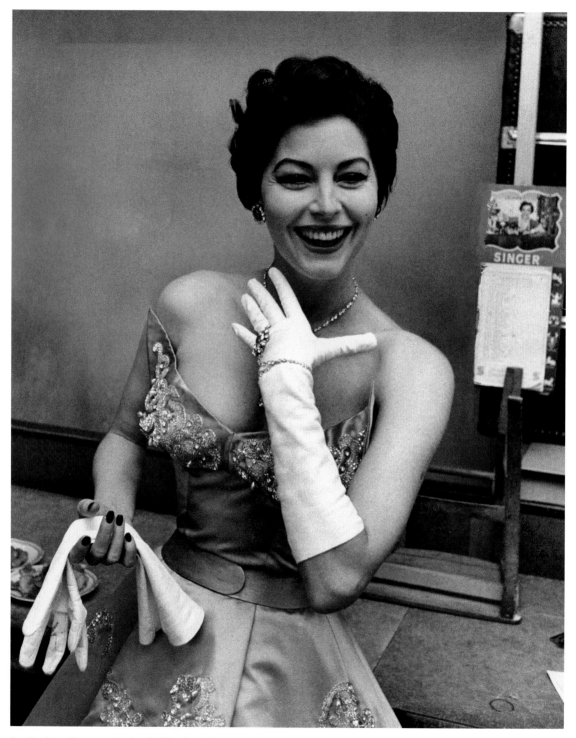

Ava Gardner, after appearing in a fashion show, Rome, 1954

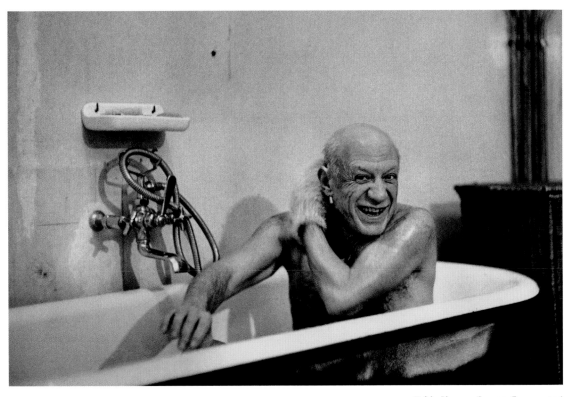

Pablo Picasso, Cannes, France, 1956

A 17-year friendship began in 1956 when Picasso invited Duncan to spend a couple of months at his Riviera villa. Not long after, Picasso asked Duncan if he wanted to meet some of his "friends," and led him into a room brimming with paintings. Over the course of their relationship, Duncan took more than 10,000 photographs of the towering artist, whom he called "a great Spanish gentleman. A guy I respected, I loved."

Alfred **Eisenstaedt** 1898–1995

Victor Keppler

Chronicler of the Century

It was a classic departure and a legendary beginning when the man who listlessly sold buttons and belts to the trade said goodbye to all that and embraced photography, and then defined what we now know as the photo essay. Henry Luce had sensed that this little fellow from Germany was precisely what his new magazine would require to lay the foundation for visual storytelling. With Eisie, the thing that was always there, within him, prompting and pointing the way, was the man's undying curiosity, which was tethered to his photographer's eye: "I see pictures all the time. I could stay for hours and watch a raindrop." Eisenstaedt never lost his childlike interest in things and people, in what made them what they were. He would put his subjects at ease, then get up close and take a few pictures—he didn't need roll after roll—then it was on to the next person, the next happening, tirelessly pursuing the heart of the matter that he saw so easily and wanted very much for us to see too.

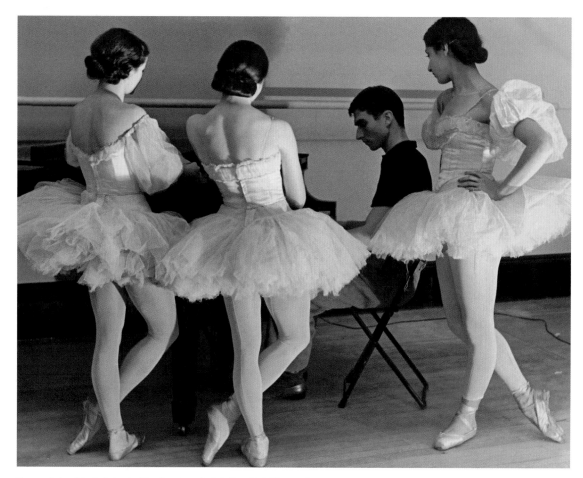

George Balanchine's School of the American Ballet, New York City, 1936

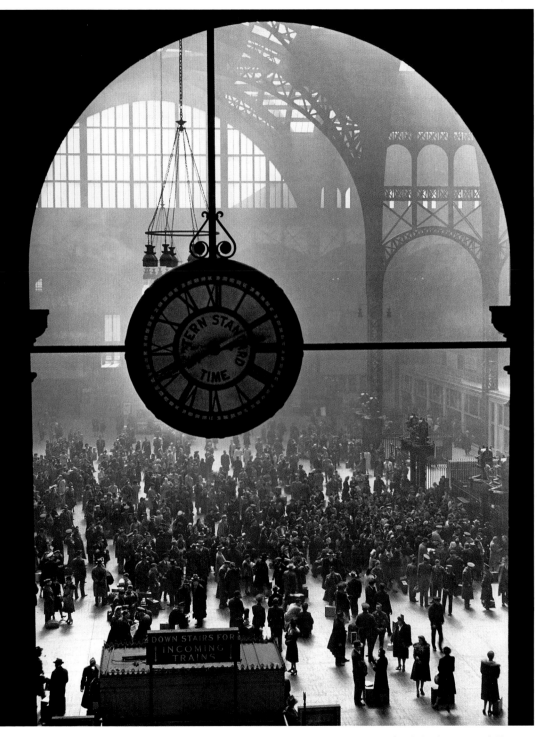

Pennsylvania Station, New York City, 1943

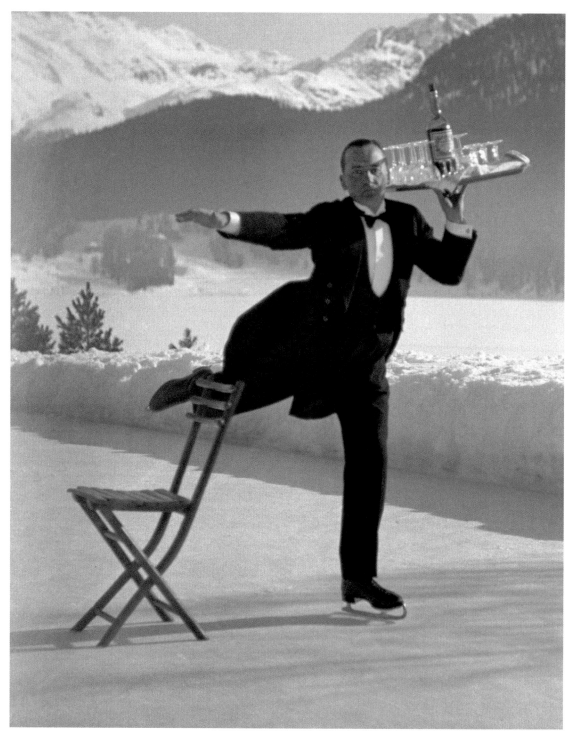

The Grand Hotel, Saint Moritz, Switzerland, 1932

La Scala, Milan, 1932

Saint Moritz, Switzerland, 1947

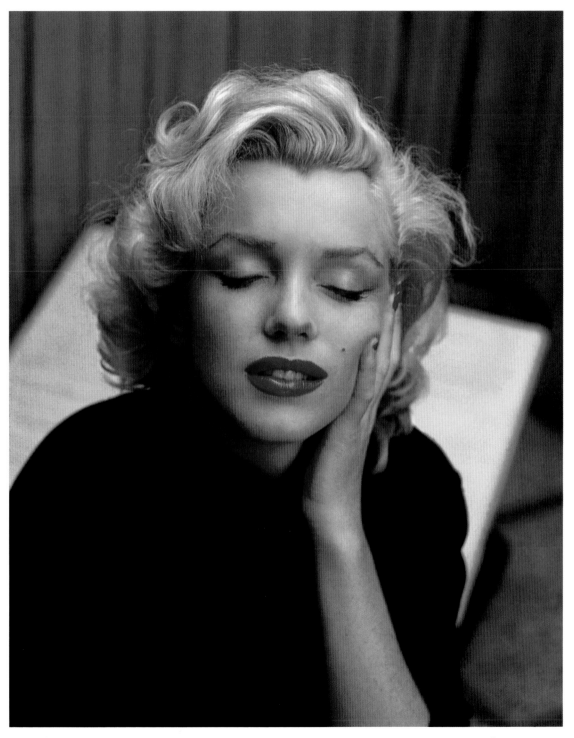

Marilyn Monroe, 1953

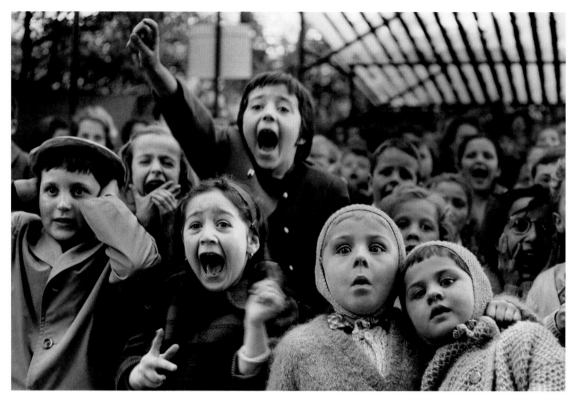

Puppet show, Tuileries, Paris, 1963

At right: The Picture. "There were thousands of people milling around, in side streets and everywhere. Everybody was kissing each other . . . And there was also a Navy man running, grabbing anybody, you know, kissing. I ran ahead of him because I had Leica cameras around my neck, focused from 10 feet to infinity. You only had to shoot . . . I didn't even know what was going on, until he grabbed something in white. And I stood there, and they kissed. And I snapped five times."

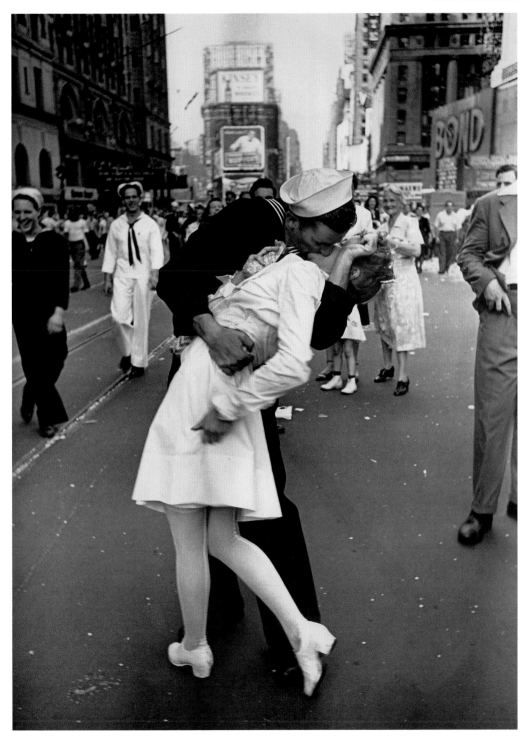

V-J Day, Times Square, New York City, 1945

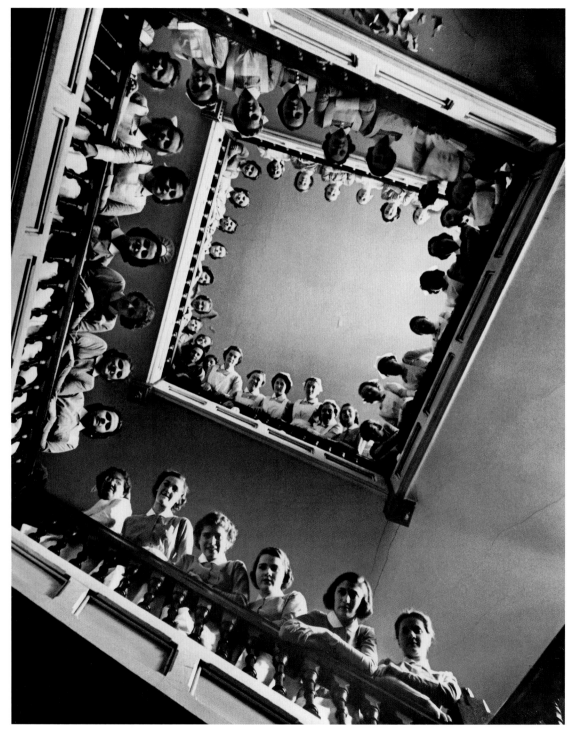

Nurses at Roosevelt Hospital, New York City, 1938

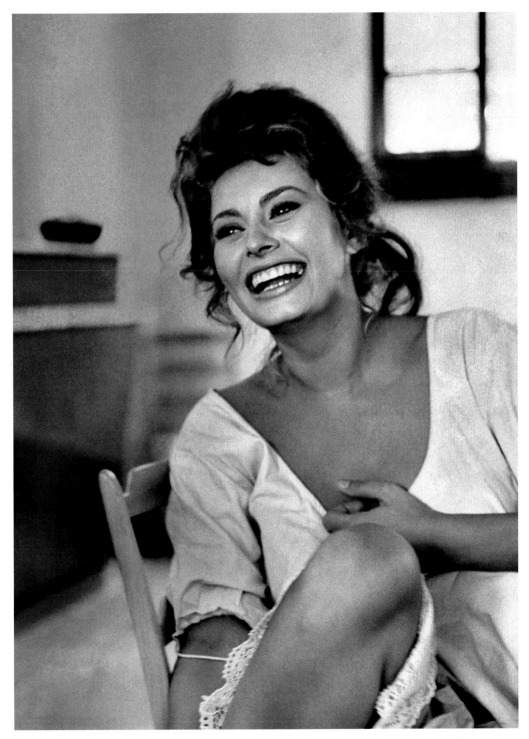

Sophia Loren, 1961

Eliot **Elisofon** 1911–73

Linn Wescott

Pushing the Envelope

He took up photography while working his way through Fordham, where he was premed but majored in philosophy. After graduating, he forged a successful business in commercial photography, which he gave up to join LIFE. Noting that the camera "says too much," the driven Elisofon sought "to try to take pictures that are impossible to take." He carried his camera into some serious danger zones during World War II. Once, leaving North Africa, his plane crashed and burned the trousers right off him. According to war correspondent Ernie Pyle, "Elisofon was afraid like the rest of us. Yet he made himself go right into the teeth of danger. I never knew a more intense worker." Elisofon's postwar subjects were quite varied, including everything from culinary still lifes to studies in the mountains of Africa. His friend Gypsy Rose Lee gave him a small piece of African art; he went on to bequeath 80,000 photos of Africa to the Smithsonian.

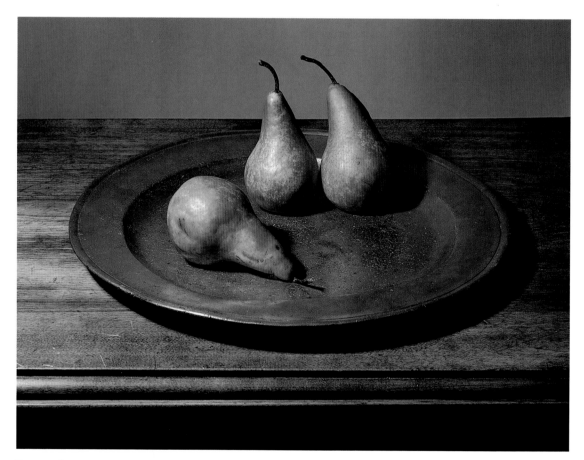

Pears, 1946

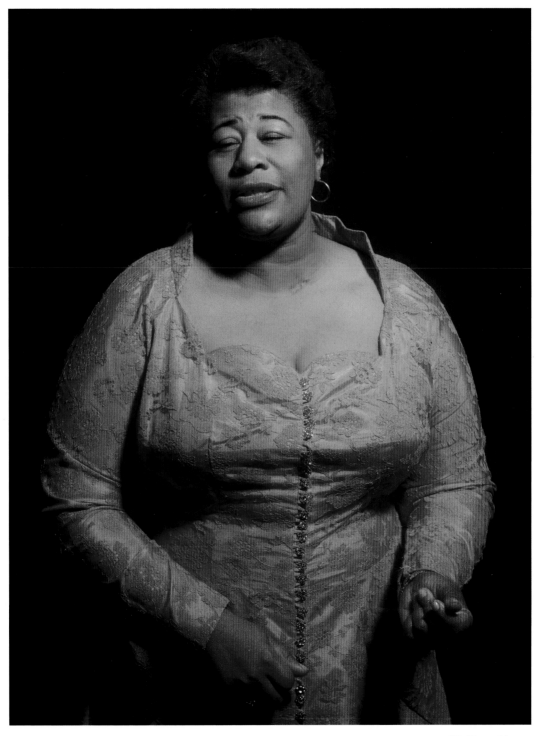

Ella Fitzgerald, 1955

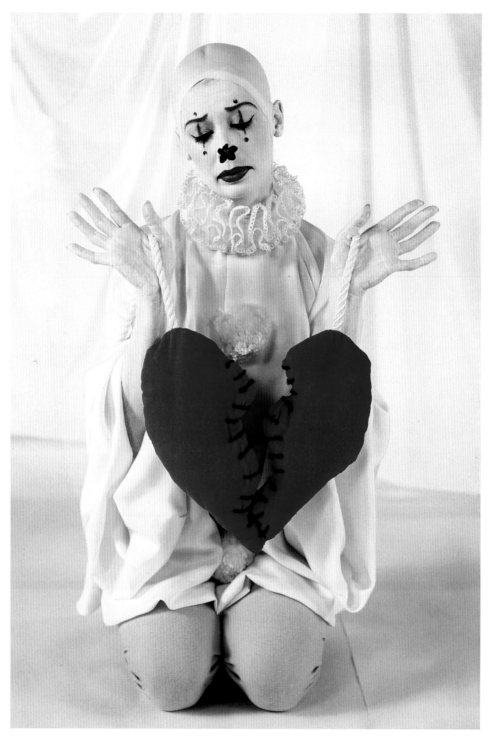

Gwen Verdon enacting her dream role of Harlequin, 1958

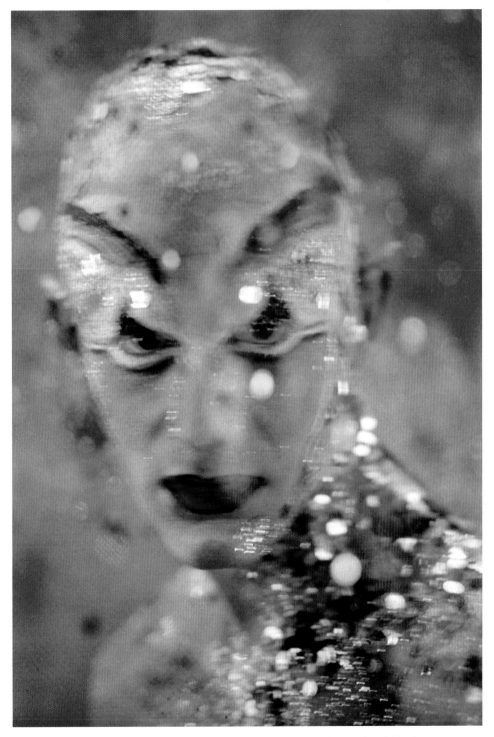

Roddy McDowall in his dream role, Ariel in *The Tempest*, 1957

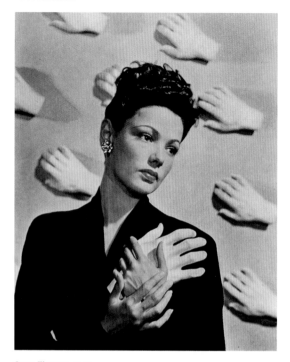

Gene Tierney, 1942

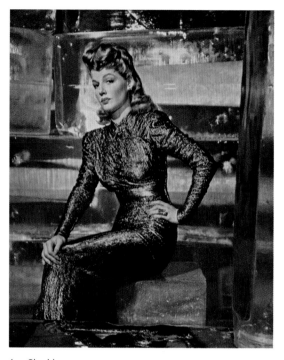

Ann Sheridan, 1942

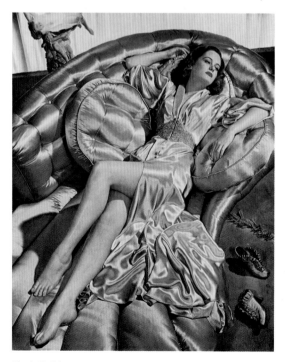

Alexis Smith, 1942

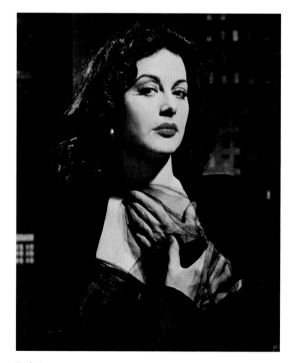

Hedy Lamarr, 1942

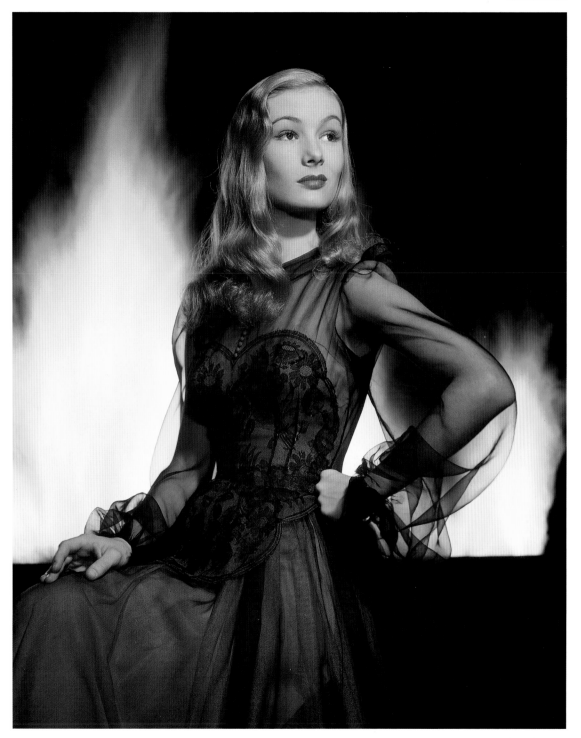

Veronica Lake, 1942

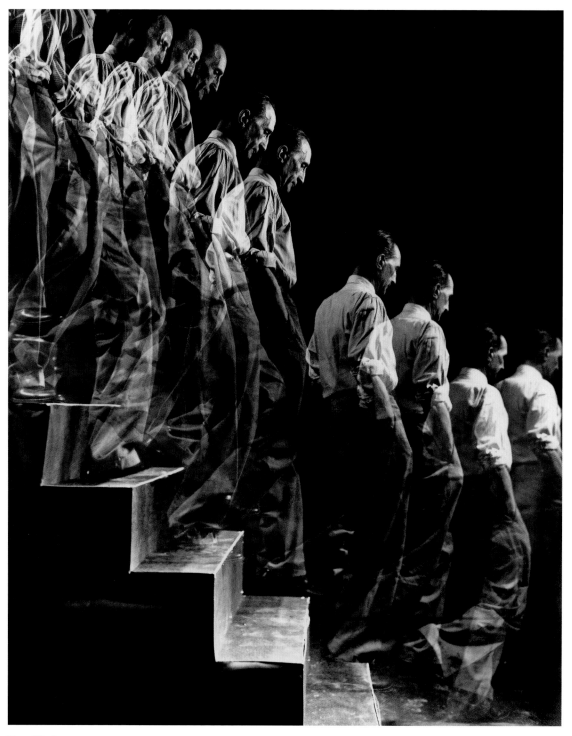

Marcel Duchamp, 1952

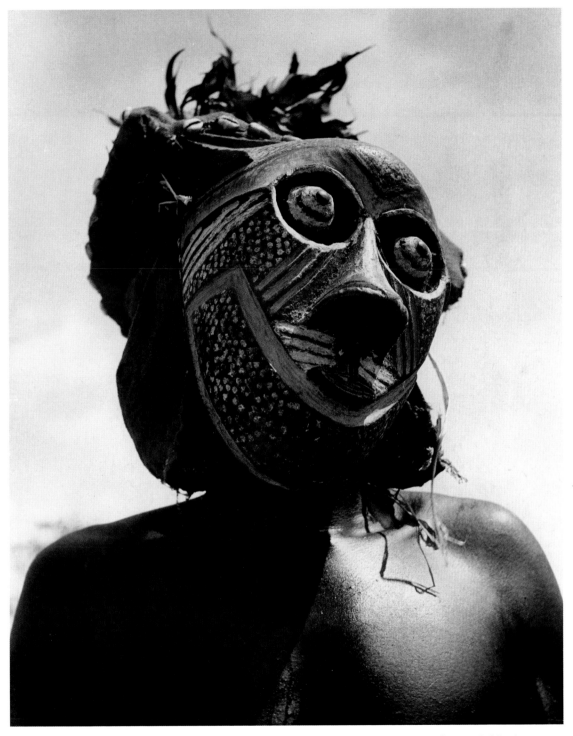

Tribesman, Belgian Congo, 1947

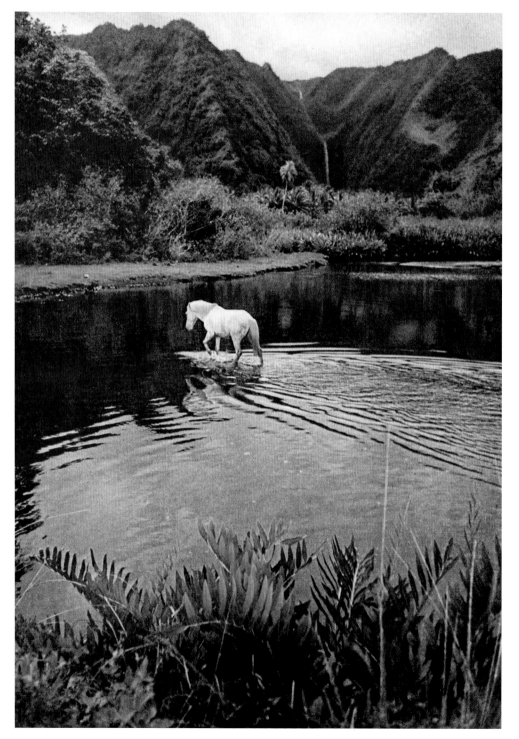

Tahiti's Papara region, South Seas, 1955

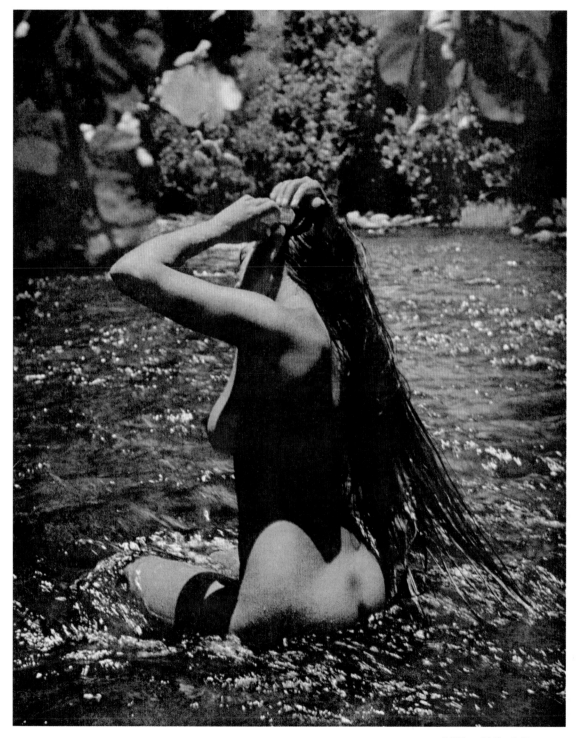

Tahitian girl, South Seas, 1955

Bill **Eppridge** 1938–

On the Inside Track

He was adept at celebrities, fresh- and saltwater fishing, the Arctic and many other subjects. He was nearly killed in the Dominican Republic in 1965 after LBJ sent in Army troops to protect American interests. And for an intensely dramatic LIFE series on young junkies, which served as the basis for the film *Panic in Needle Park,* Eppridge and a writer brought to light a world that few people could have imagined. But despite all this, it is one picture he will likely be remembered for. In 1968, Eppridge was in the Los Angeles hotel where Bobby Kennedy was shot and killed by Sirhan Sirhan. Everyone's attention was on the assailant. "There in front of me was the Senator on the floor being held by the busboy. There was nobody else around, and I made my first frame, and I forgot to focus the camera. The second frame was a little more in focus . . . then just for a second, while everything was open, the busboy looked up, and he had this look in his eye. I made that picture, and then suddenly the whole situation closed in again. And it became bedlam."

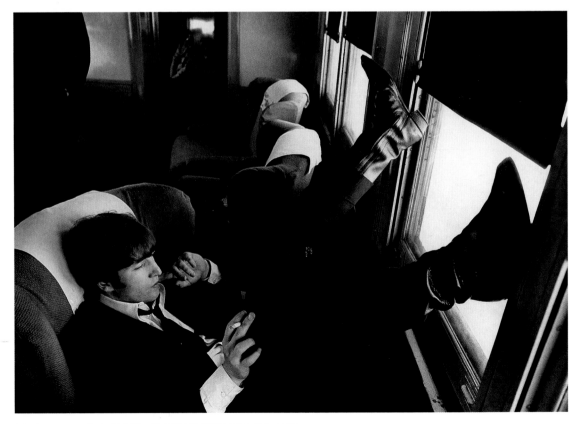

John Lennon on a train from New York City to Washington, D.C., 1964

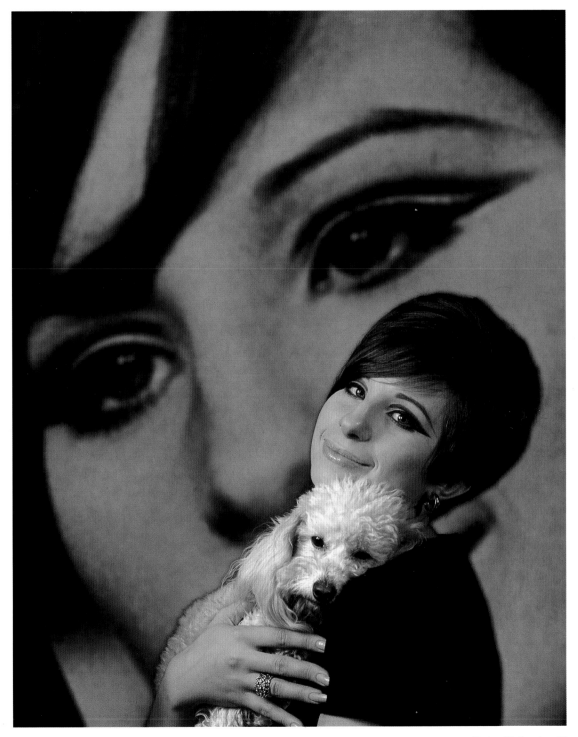

Barbra Streisand, 1966

An overdose: "You've got to fight it, Billy!" New York City, 1965

For this story, Eppridge spent two months living with a pair of junkies. In order to persuade the couple to let him and a writer completely invade their world, he told them it was their chance to make a contribution to society. The couple thought it over and finally replied, "O.K. This gives us a chance to do something good." Eppridge became so ingrained in the sordid, desperate life of the heroin addict that, at one point, narcotics detectives, convinced that he had stolen his cameras and LIFE credentials, were about to haul him off to jail. The article's writer came by and finally straightened things out.

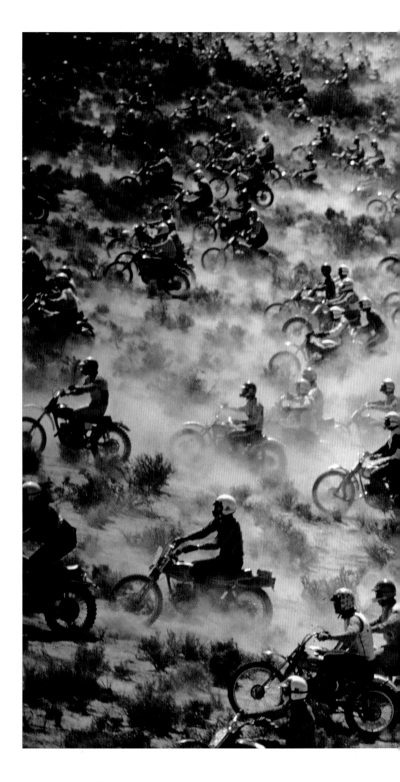

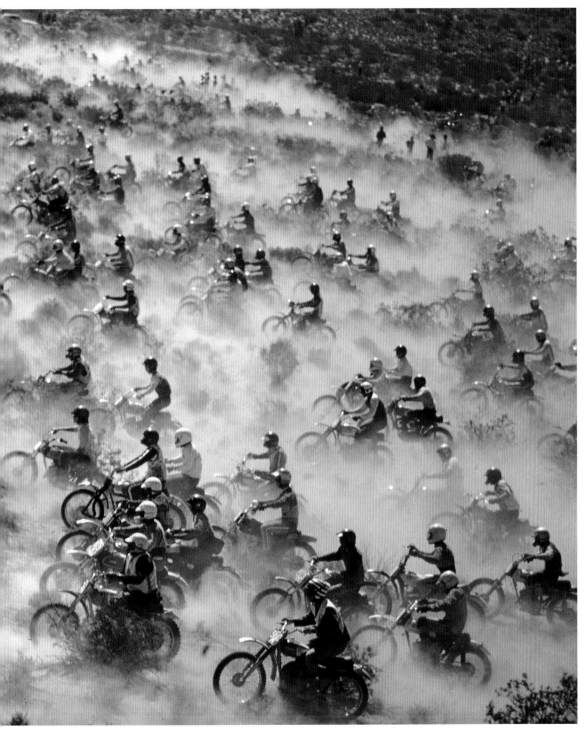

Racing cross-country, Mojave Desert, California, 1971

Presidential candidate Robert Kennedy and Freckles, Oregon, 1968

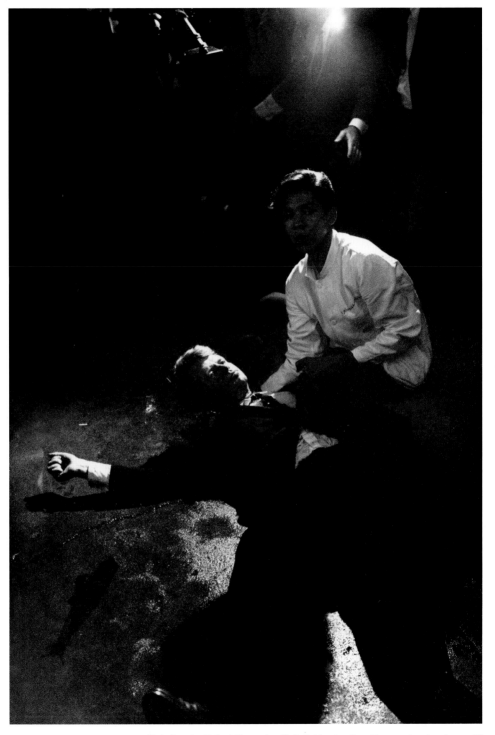

Slain Senator Robert Kennedy with hotel busboy Juan Romero, Los Angeles, 1968

J.R. **Eyerman** 1906–85

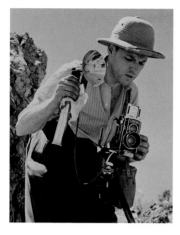

Engineering Meets Photography

As a boy he had already shot thousands of pictures with his father in Yellowstone and Glacier national parks. Then, at age 15, he entered the University of Washington, where he studied engineering. He eventually returned to photography and joined LIFE in 1942, which kept him busy during the war recording combat action in locales from the Mediterranean to the Pacific. At one point, Eyerman accidentally discovered the code name for the invasion of Japan ("Olympic"), but he kept his mouth shut and his lens open. He was one of the first to reach Hiroshima after the A-bomb hit. With the war over, Eyerman drew on his technical background to develop several impressive innovations in photography, including an electric-eye mechanism that tripped the shutters of nine cameras to make pictures of an atomic blast; a camera that could function 3,600 feet below the ocean's surface; robot cameras that took pictures 107 miles up in an early U.S. research rocket; and color film that was speeded up to make possible detailed photos of the aurora borealis.

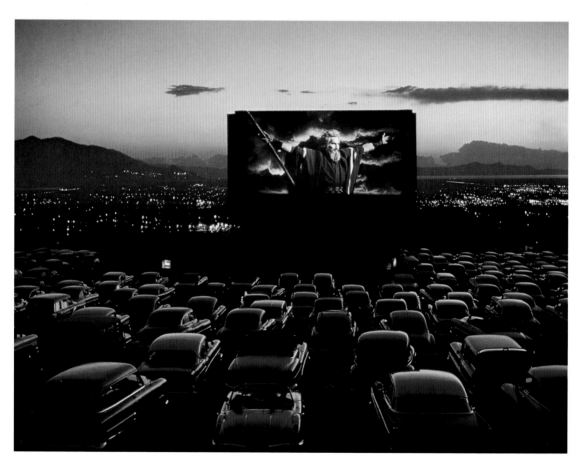

Drive-in movie theater, Salt Lake City, 1958

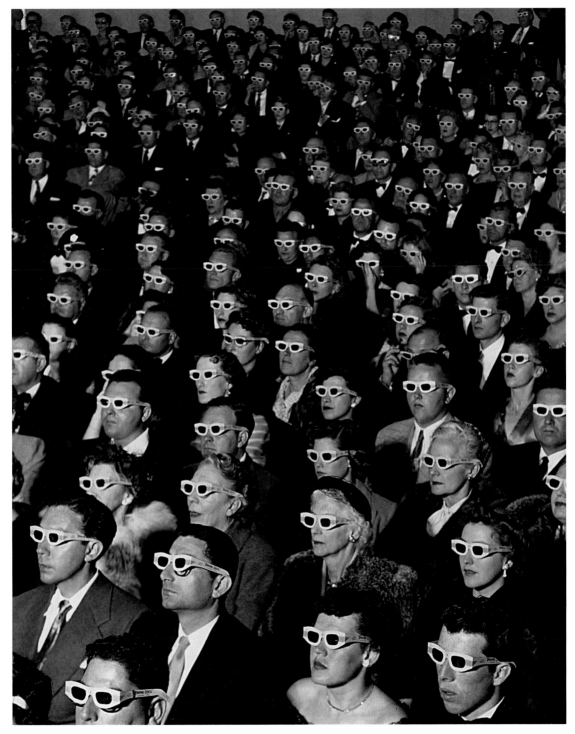

Watching *Bwana Devil* in 3-D at the Paramount Theater, Hollywood, 1952

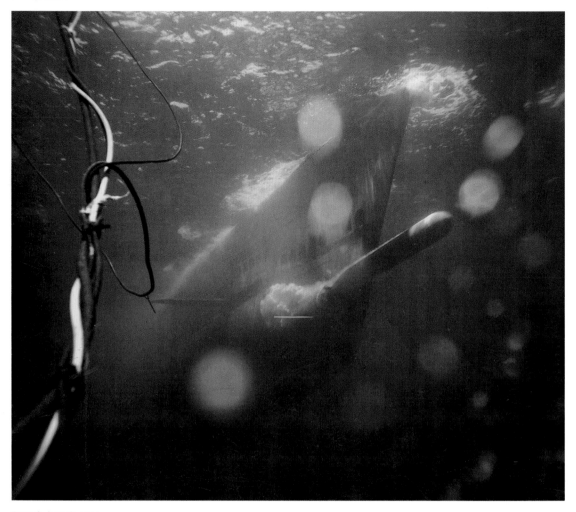

Torpedo launch, 1951

For some LIFE photographers, the camera was merely
a way to get a picture; for others, it was an aspect of
the medium that could be altered, expanded, improved.
Eyerman was certainly one of the latter. For a photo essay
on the Navy's undersea operations, he designed his own
camera and equipment. For the nuclear-bomb test at
right, he rigged nine cameras to shoot simultaneously.

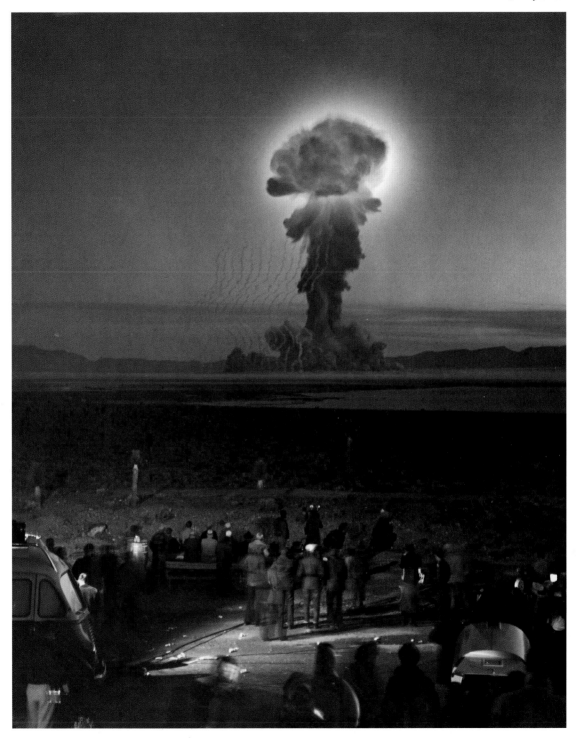

Civil defense officials watching an atomic-bomb test seven miles away, Yucca Flat, Nevada, 1953

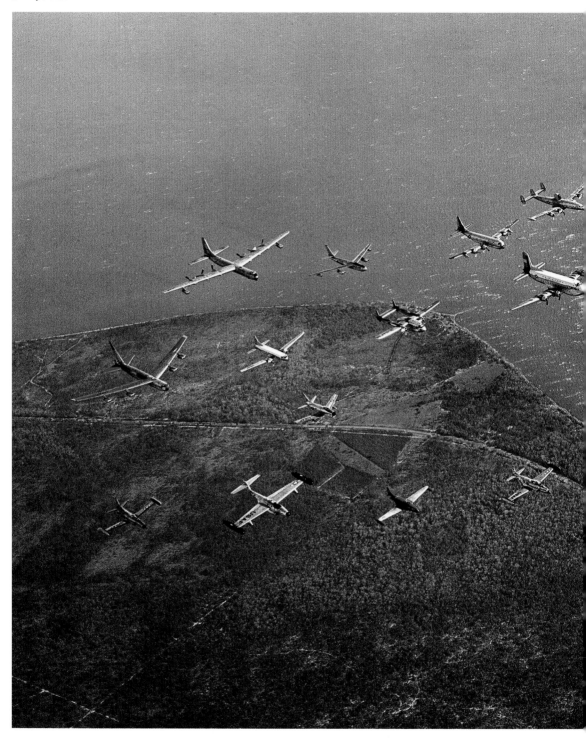

Nearly all U.S. Air Force models in a single formation, Florida, 1956

J.R. Eyerman

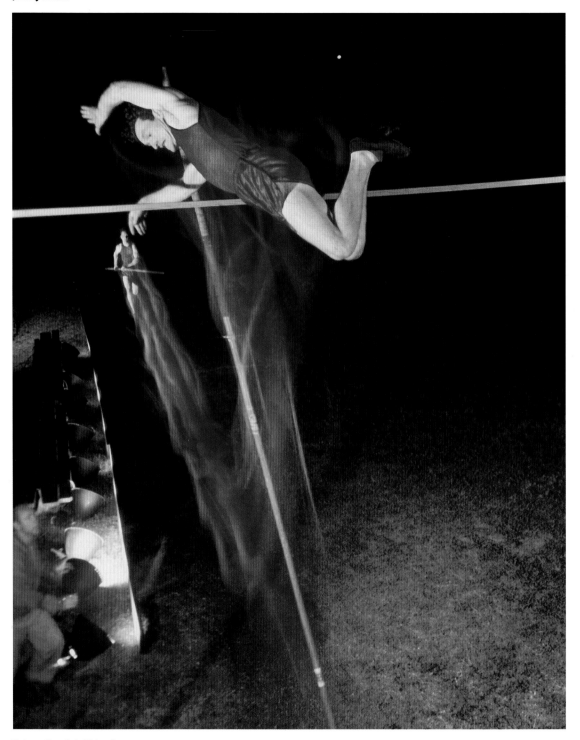

Pole-vaulter Bob Richards, 1951

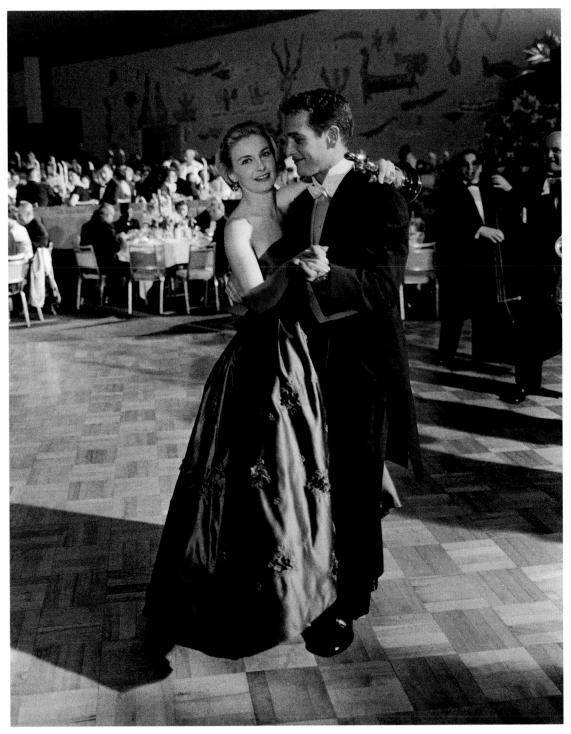

Joanne Woodward, after winning the Oscar for Best Actress, with husband Paul Newman, Los Angeles, 1958

N.R. **Farbman** 1907–88

Wedded to LIFE

He arrived on the shores of the United States from Poland at the age of four, and began working as a freelance photographer while studying electrical engineering at the University of Santa Clara. During his 15 years as a LIFE staffer, "Nat" was considered one of its most versatile practitioners. After he married the former fashion model Pat English in 1940, she learned enough about taking pictures from her husband that she got shooting assignments of her own, and thus they became an early husband-and-wife photographic team for the magazine.

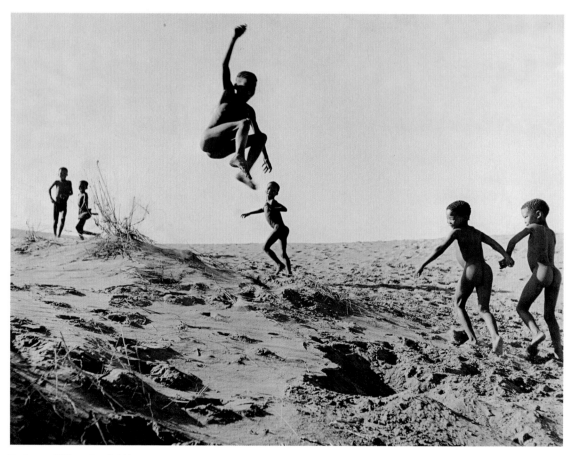

Bushman children, South Africa, 1947

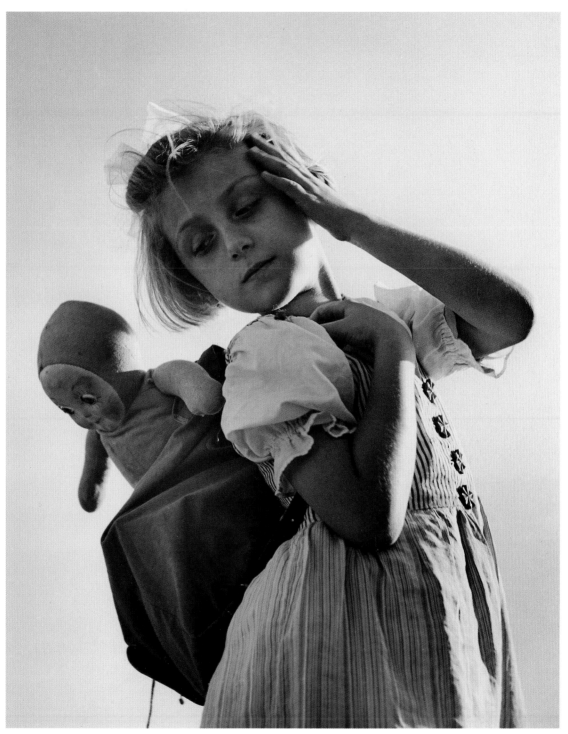

Vienna, 1946

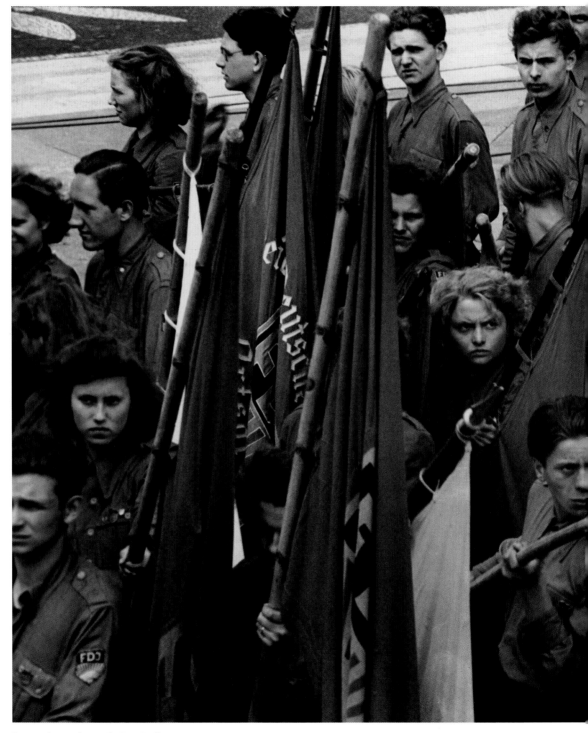

Communist youth parade, East Berlin, 1950

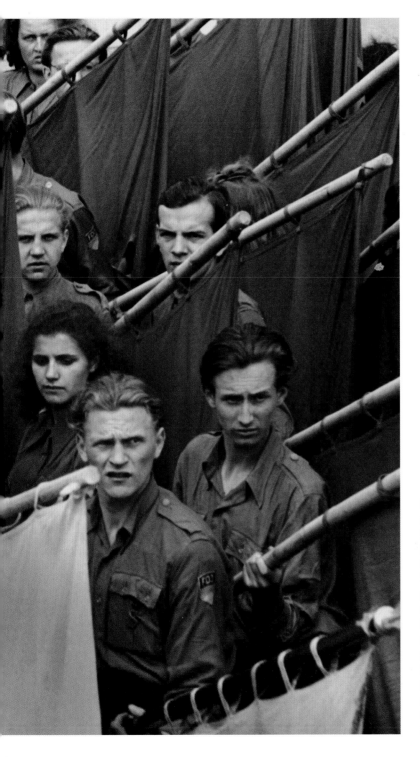

This is five years after the Nazis were finally beaten, but the image immediately calls to mind the public rallies of the Third Reich—with one crucial difference: The faces of these East German youths betray the weariness that will constrain their homeland for years to come. Though they were purportedly communists, many of those who gathered (or were gathered) for this large demonstration used the opportunity to slip into the West. This new war, the cold war, had decades still to go.

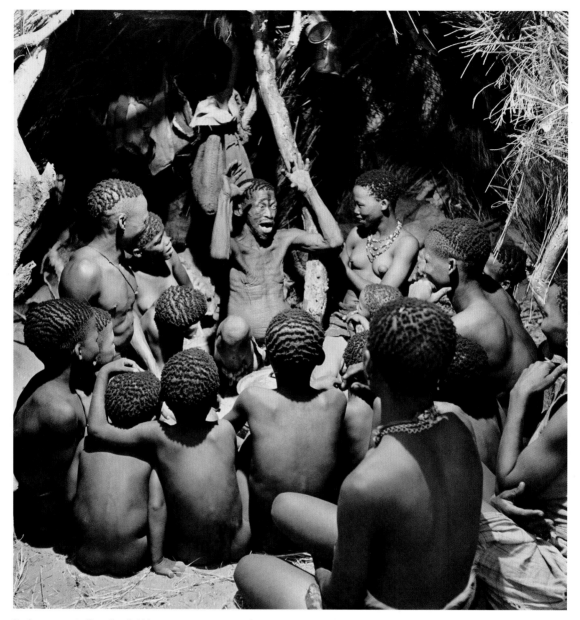

Bushman story-telling, South Africa, 1947

Bolton, England, 1947

Andreas **Feininger** 1906–99

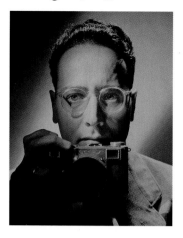

The Camera First and Foremost

LIFE's photographers were known for their images of people, but Feininger was a profound exception. His concerns were basically with things, perhaps a continuum from his early career as an architect (he worked for a year with Le Corbusier). "Realism and superrealism are what I am after. This world is full of things the eye doesn't see. The camera can see more, and often 10 times better." Not at all a people-person, Feininger wanted to carry on with his work without any interference. In that chilly single-mindedness he reminds one of Picasso. Yet it wasn't "photography" he was after, but a photograph: "I want to get shots of the things I'm interested in. I use it as a means to an end." In any case, he combined masterly technique with a discerning eye to produce work that is harmonious and incisive.

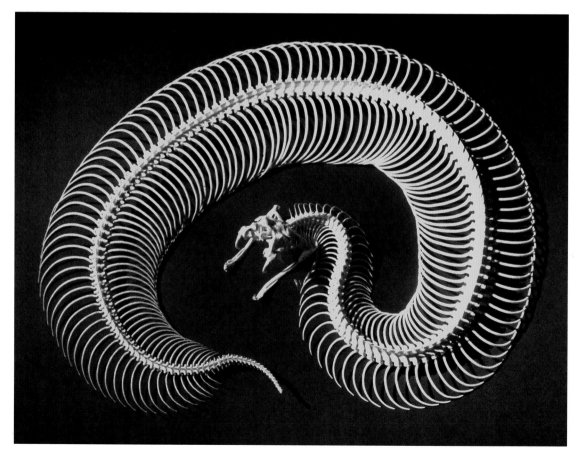

Skeleton of a four-foot-long gaboon viper, 1952

Dennis Stock, New York City, 1951

Feininger took this picture "because I felt putting these two achievements together gives you a fantastic look at the achievements of man. Man has built this enormous city and this enormous ship . . . there are tiny people lining the bridge of the ship. They are clear but very small. To think that people no bigger than these have constructed and built that enormous ship. That is almost unbelievable."

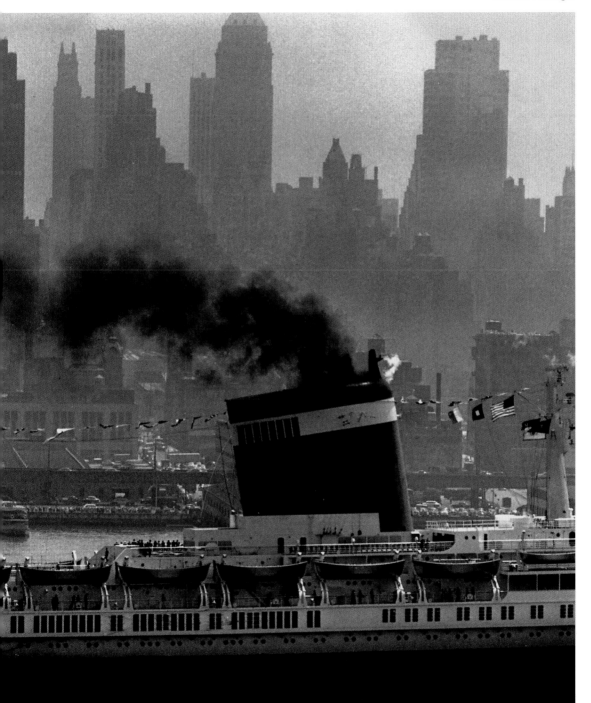

SS *United States*, New York City, 1952

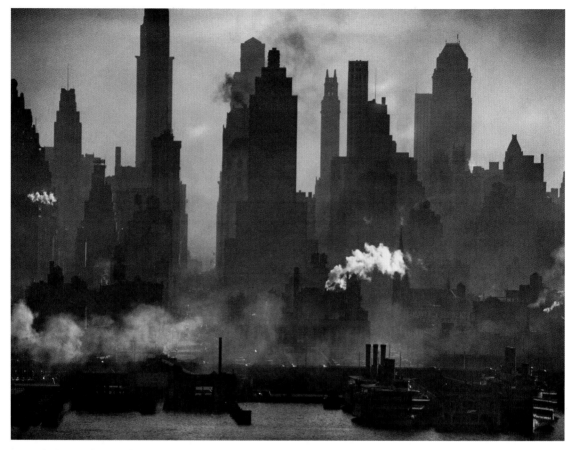

New York City seen from Weehawken, N.J., 1942

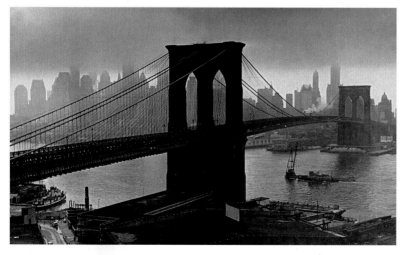

Brooklyn Bridge, New York City, 1946

Route 66, Arizona, 1953

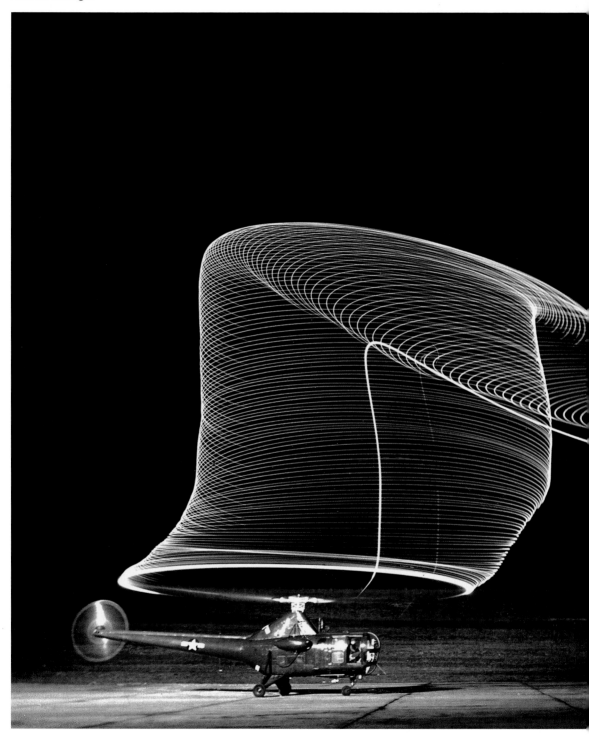

Helicopter taking off, 1949

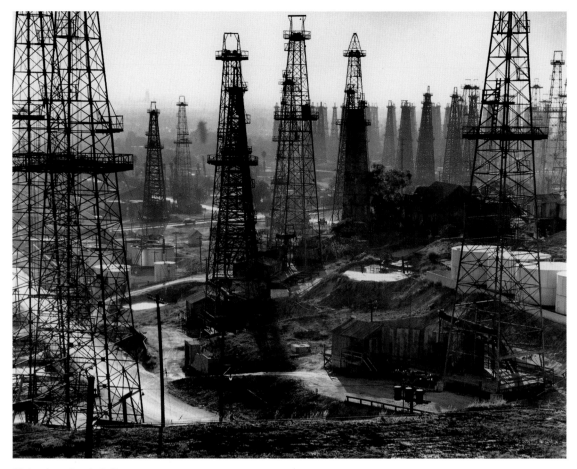

Oil rigs, Long Beach, Calif., 1948

As John Loengard notes in *LIFE Photographers: What They Saw,* these oil derricks are ugly but also somehow grand and dramatic. Feininger said he "did that deliberately because that way, people remember what oil stands for, what this pursuit of oil does to the environment. I had to go pretty far back to find the perspective that puts all these derricks close together. That is how I got this feeling of their importance and their dynamic and their horror. They have totally ruined the whole landscape as far as you can see . . . It is dead, totally dead."

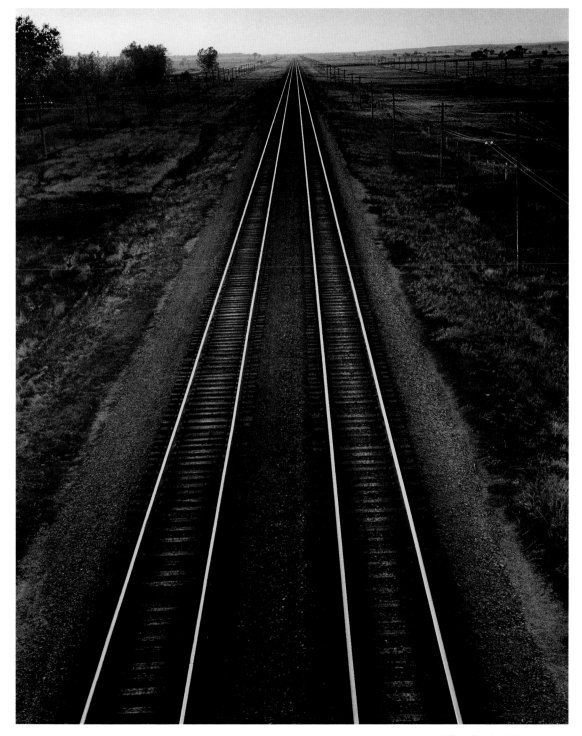

Railroad tracks, Nebraska, 1952

Al Fenn 1912–95

Genetic Predisposition

In 1931, as a gift on his first visit to Europe, he was given a Leica. By the time he returned to the States, his "heart now belonged to photography." During Fenn's 15 years at LIFE, his subjects were diverse, from baby birds to brawny boxers. Fenn's father was a physics professor and his mother an actress. "It seems quite logical," he concluded, "that I should be a photographer, which is apparently the genetic result of the mixture of science and art."

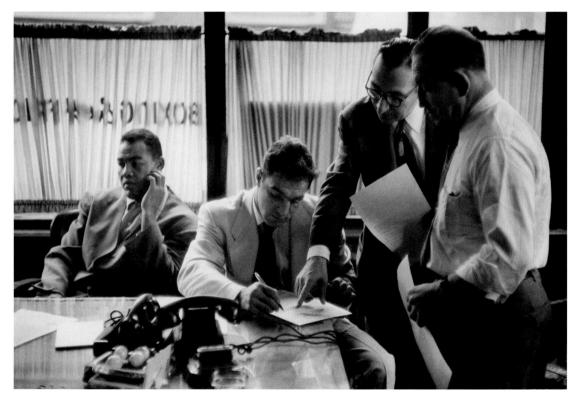

Rocky Marciano signing a contract for a fight as Joe Louis, seated, looks the other way, 1951

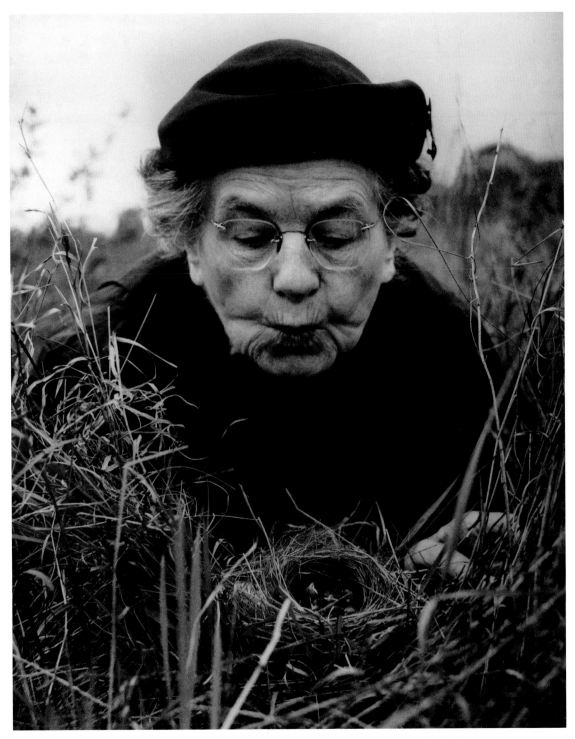

Mrs. Margaret Morse Nice with baby field sparrows, Chicago, 1956

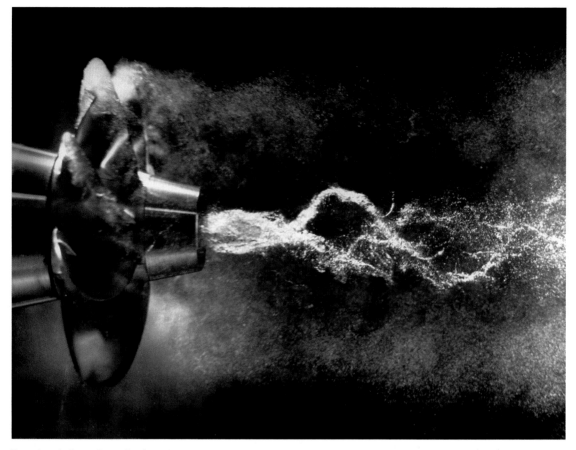

Torpedo turbulence, Pennsylvania, 1952

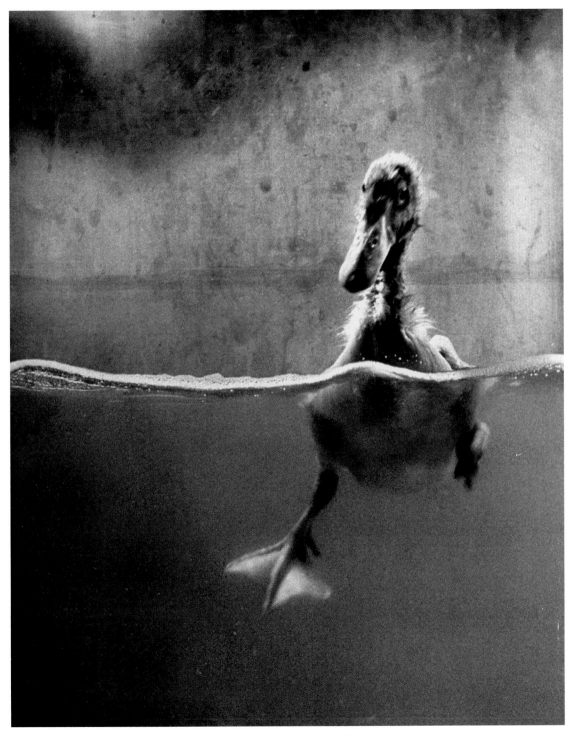

Experiment with duck in feather-drenching liquid, 1951

John Florea 1916–2000

Comedy and Tragedy

As with a few other LIFE photographers, Florea's subject matter ranged from fluffier than meringue to dark as death. He was in a darkroom on December 7, 1941, developing pix of buxom actress Jane Russell, when he heard about Pearl Harbor. He decided then and there to take his career in a different direction, which led to the dreadful combat at Tarawa, Rabaul and the Battle of the Bulge, then to the liberation of POW and concentration camps. Florea, the son of Romanian immigrants, was upset with LIFE's meager coverage of the camps: "I felt that LIFE was ignoring it at times . . . evidently they were afraid that it would horrify their readers." A stormy relationship with Picture Editor Wilson Hicks finally ended with Florea and the magazine parting ways in 1949. He went on to become a very successful director and producer of popular TV shows. Even so, Florea once predicted, "the only thing I'll be remembered for is what I had done for LIFE magazine."

Columnist Sidney Skolsky and Bob Hope, Hollywood, 1943

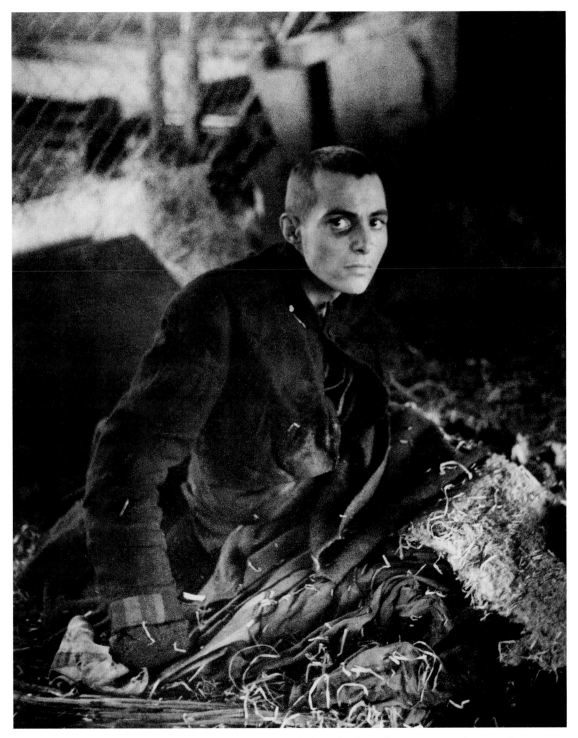

Prisoner in the barracks of a Nordhausen concentration camp, Germany, 1945

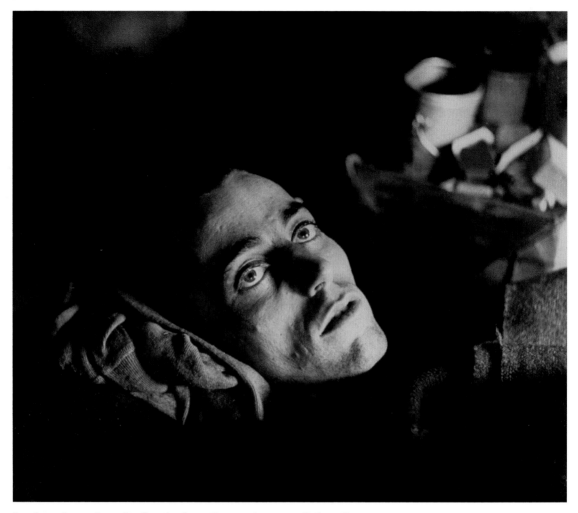

American prisoner of war after liberation from a German prison camp, Limburg, Germany, 1945

"In the town of Limburg we discovered an Allied prison camp . . .
They asked me for food that I didn't have. I did have a roll of Life Savers
with me . . . and I said to these fellows all in a row, 'Fellows, this is all
I've got.' So I gave each one of these kids a Life Saver out of my roll.
Finally, I started to run out and I started breaking them in half and
giving each one of them a half. Then I asked a couple of them if they
could get up. One kid could not. He weighed something like 70 pounds,
and I'll never forget his name. His name was Demler, Joe Demler."

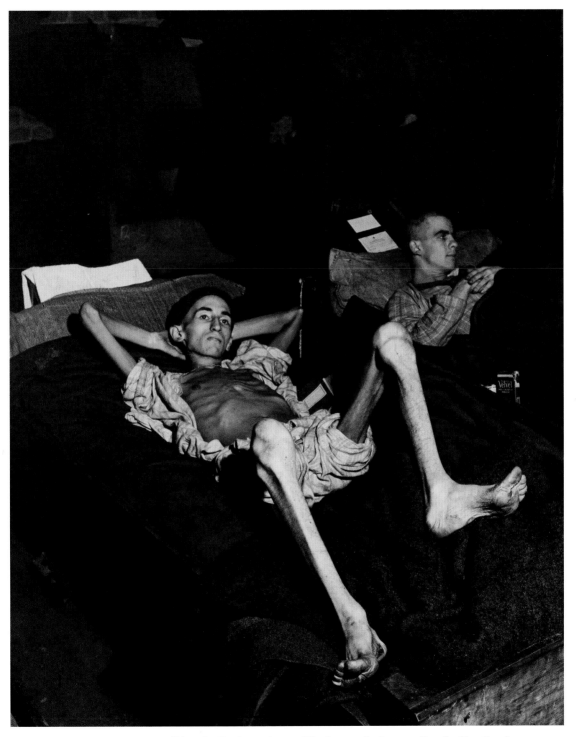

Private Joe Demler, a prisoner of the Germans for three months, after liberation, Germany, 1945

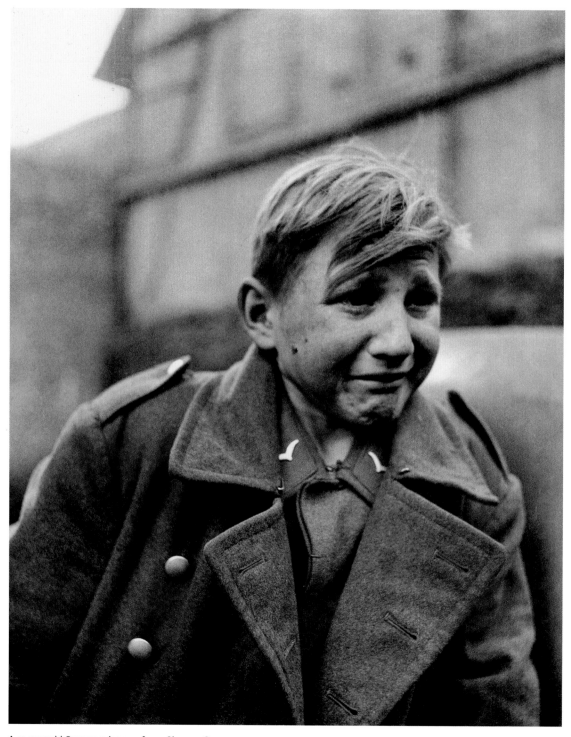

A 15-year-old German prisoner of war, Giessen, Germany, 1945

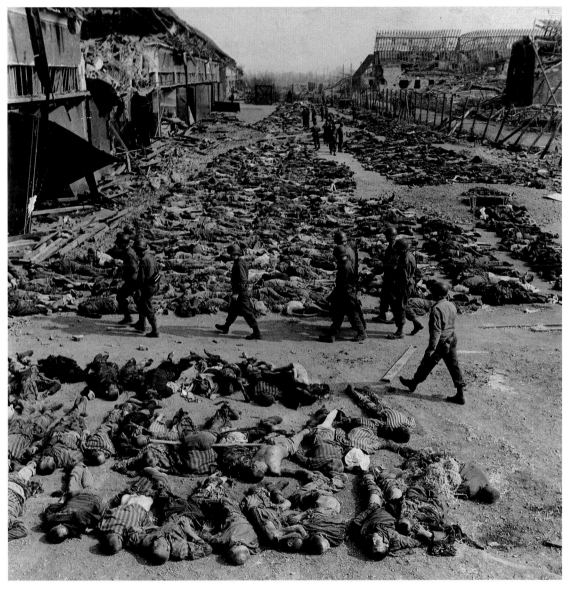

The bodies of 3,000 of the Nazis' slave laborers in preparation for burial, Nordhausen, Germany, 1945

Herbert **Gehr** 1910–83

Not to Be Denied

Back in the day, the magazine used to include on the Contents page an item called LIFE's Pictures, which carried a small portrait of a photographer featured in the issue, with a few words about how he or she worked on the story within. For Herbert Gehr, a few quotes from these items are instructive: "Brown-eyed and serious, he likes any kind of story on which he can work alone without rubbing elbows with dozens of other photographers." "Friends call him temperamental, basing their assumption largely on the fact that he was heard to mutter violently when the U.S. fleet refused to change its position to enable him to get a better pattern shot of its searchlight display." Asked how Gehr was able to get 70 sculptors to sit in perfect rows, one replied, "We were all terrified of photographer Gehr." Such commentary makes it easier to understand what was meant, in 1946, when LIFE's Pictures referred to him as a "Rembrandtesque perfectionist."

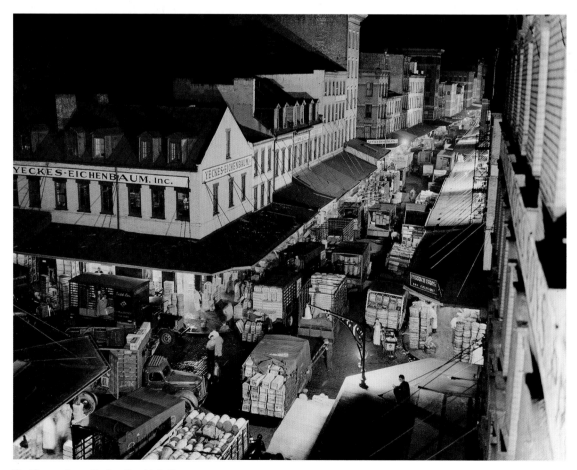

Washington Street Market, New York City, 1942

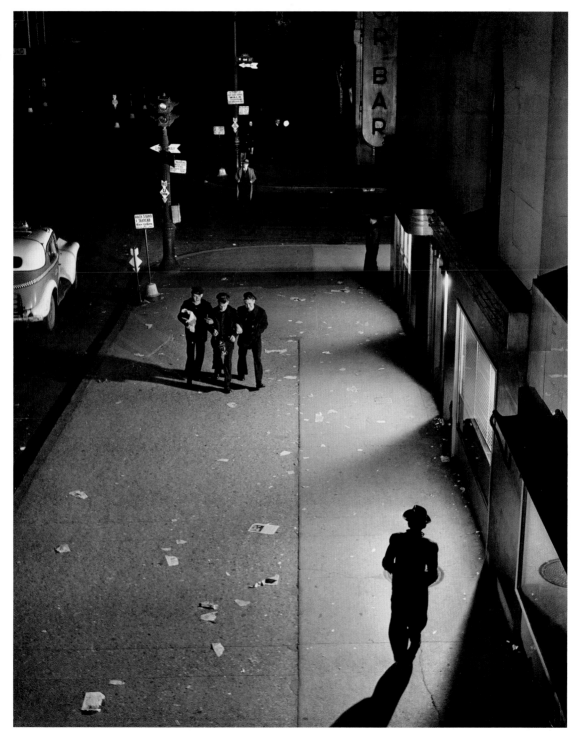

Sailors looking for fun in a curfew-closed Times Square, New York City, 1945

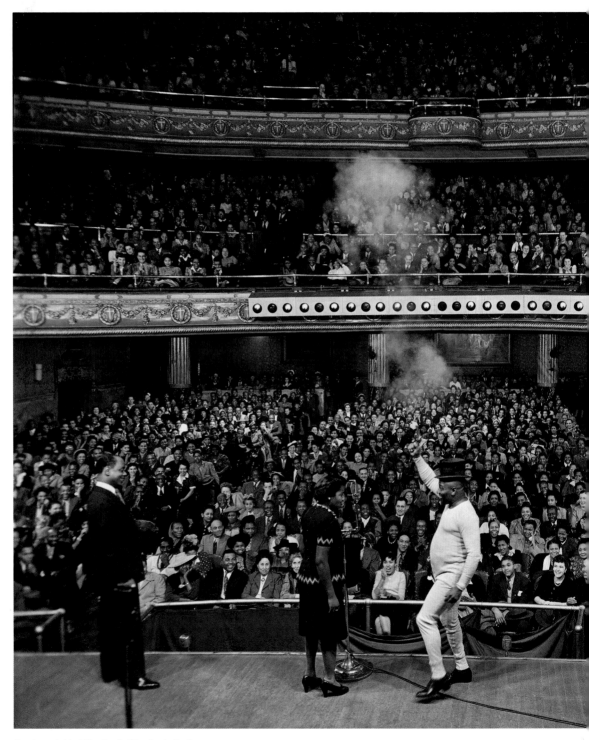

Amateur night at the Apollo Theater in Harlem, 1944

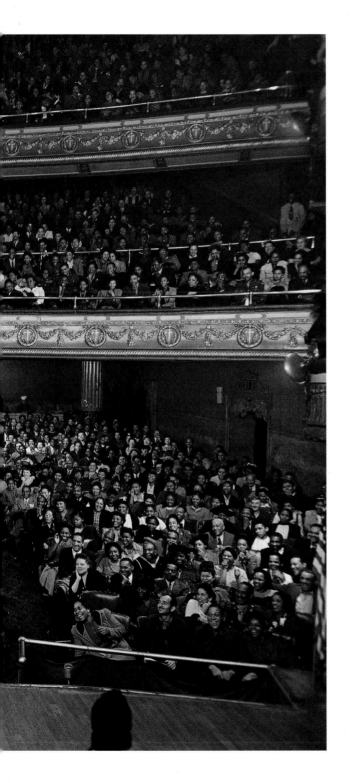

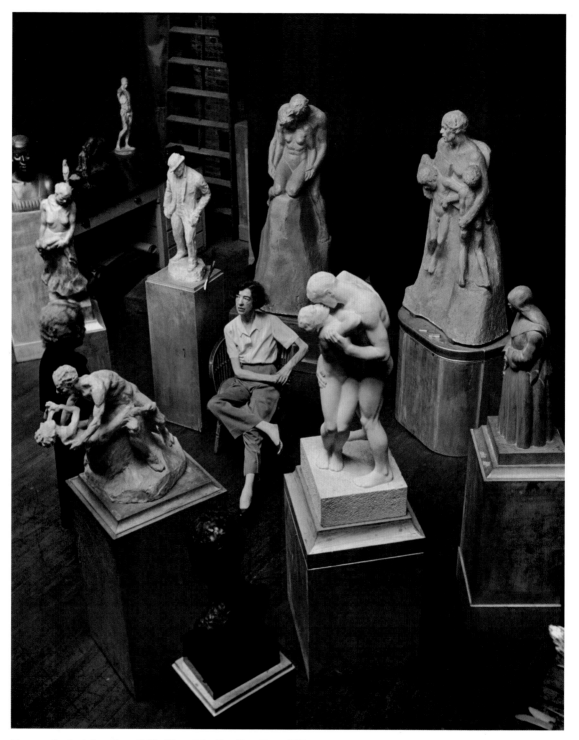

Museum director Juliana Force (left) with sculptor Mrs. Harry Payne Whitney, 1937

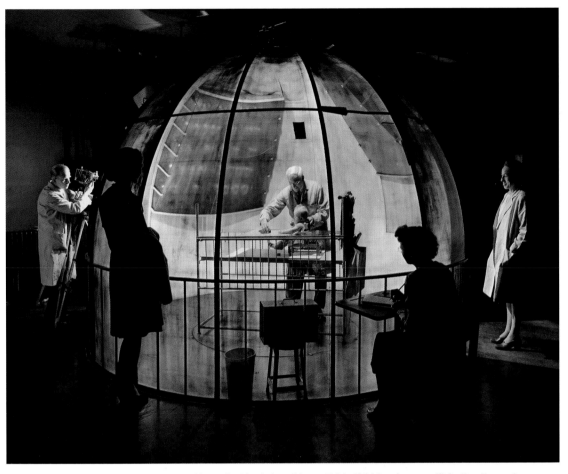

Dr. Arnold Gesell with a baby subject at Yale's Child Development Clinic, New Haven, Conn., 1947

As the baby boom era began, a study of the cognitive development of children was an ideal theme for LIFE. And as a master of the hard-to-shoot, Gehr was a perfect choice for photographer. The piece included some provocative pictures taken literally from the kids' angle.

Fritz **Goro** 1901–86

At the Forefront of Science

Called by the eminent evolutionary biologist Stephen Jay Gould "the most influential photographer that science journalism (and science in general) has ever known," this German émigré originally studied sculpture at the Bauhaus Art School before turning his full attention to what had been a longtime hobby. Over the course of his distinguished career, he was involved in numerous firsts, including still pictures of blood circulation in animals and photos of the first plutonium ever produced. Goro approached his subjects with endless patience, and his work documented significant scientific breakthroughs as the diligent photographer sought to "translate" them for the average person.

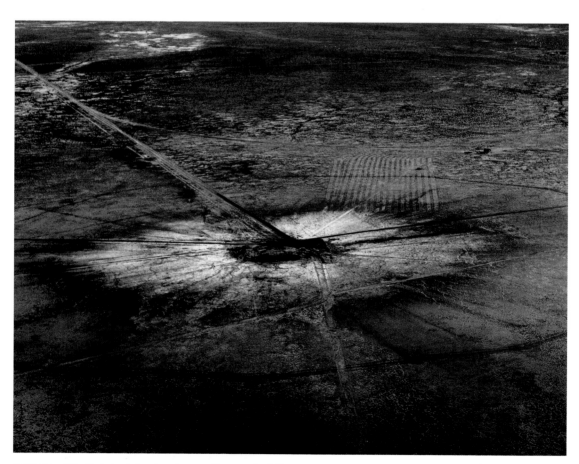

Aerial view of the first atomic-bomb crater, near Alamogordo, N.M., 1945

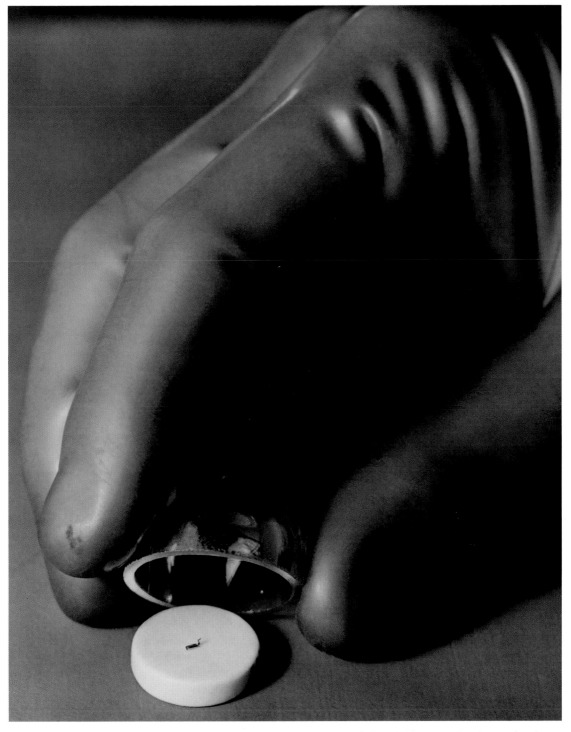

A speck of the world's first plutonium on a tiny platinum shovel, 1946

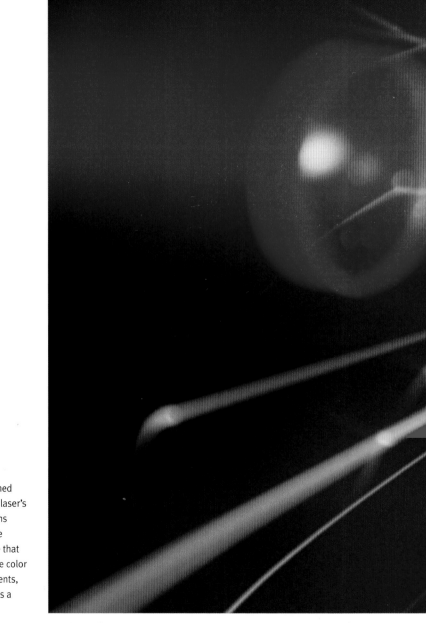

The problems in subduing laser
light for a still photograph seemed
insuperable in 1963. After all, a laser's
flash is measured in thousandths
of a second, so even with a time
exposure it seemed improbable that
it could register on any available color
film. After hundreds of experiments,
Goro tried using a razor blade as a
triggering device, and voilà!

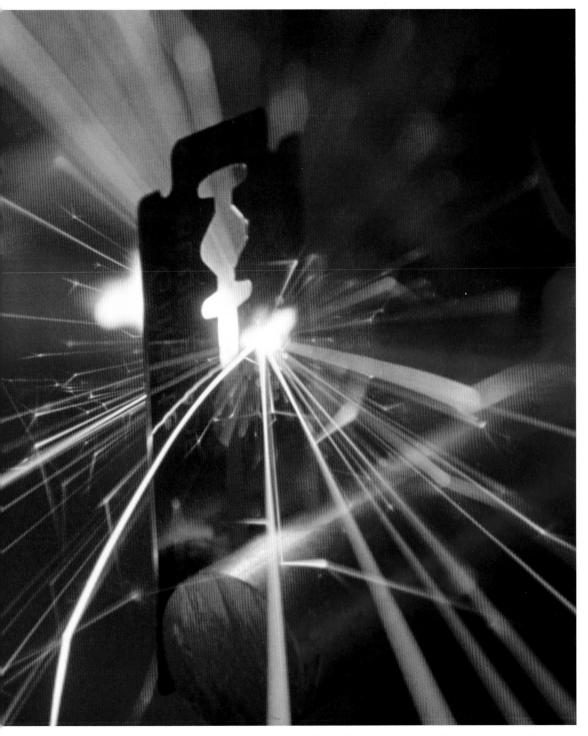

Red laser light blasting a pinpoint hole through a razor blade, 1963

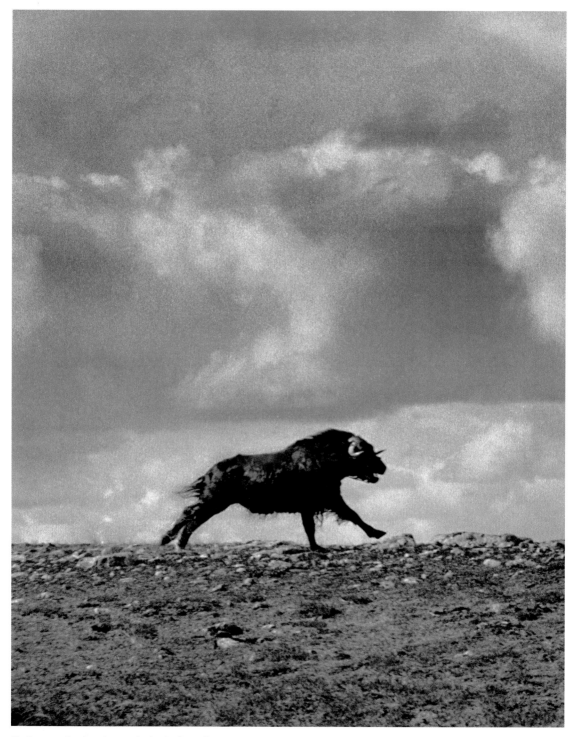

Musk ox running from hunters in the Arctic tundra, 1954

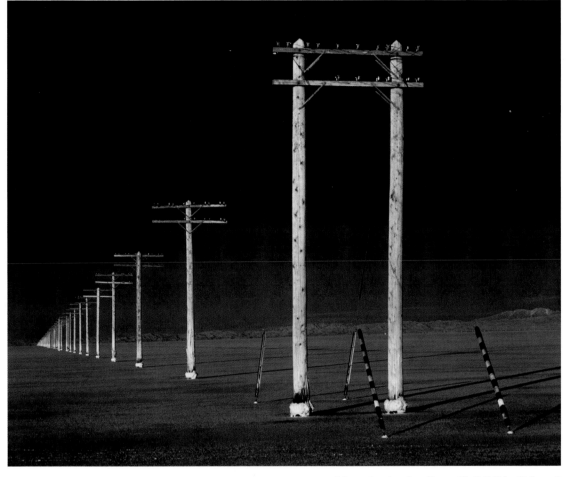

Telegraph poles along Bonneville Salt Flats, Utah, 1948

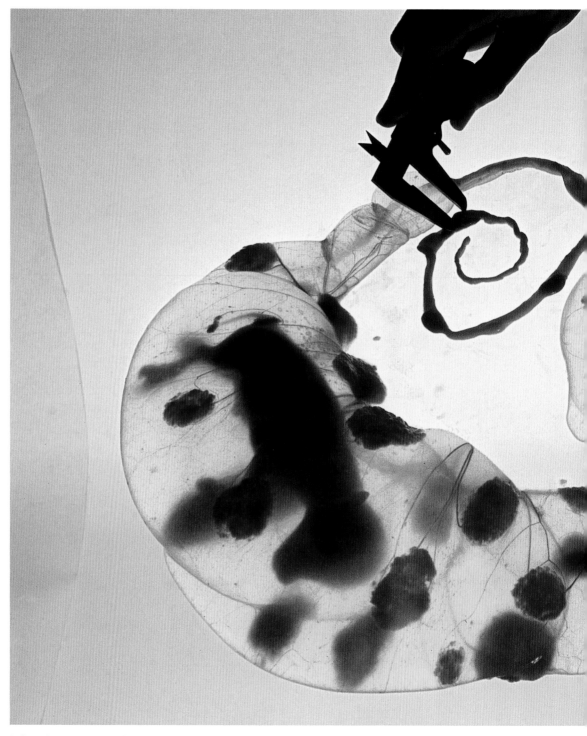

Embryonic experiment, Washington State University, 1965

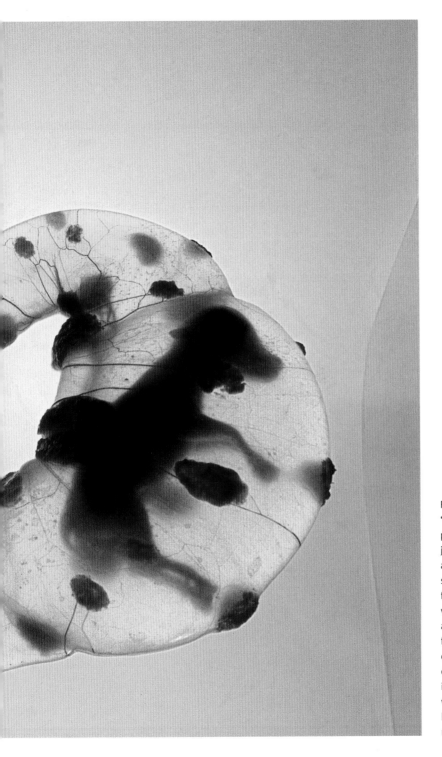

For a 1965 LIFE series on the "frontiers of medicine," Goro photographed this amniotic sac just after it was removed from a cow's uterus. The two evident shapes are 90-day-old calf fetuses, well-formed and still very much alive. The six lumps along the shriveled end contain fetuses that died soon after conception. This was part of an experiment on why a given fetus in a womb thrives, while another wastes away. Note: The various brown spots on the uterine wall make up the cow's placenta.

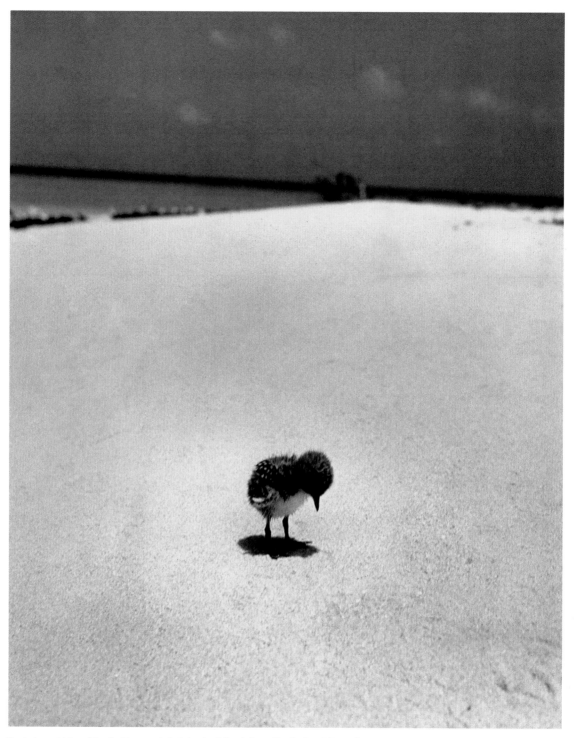

Sooty tern chick waiting for its parents to bring back food, Great Barrier Reef, Australia, 1950

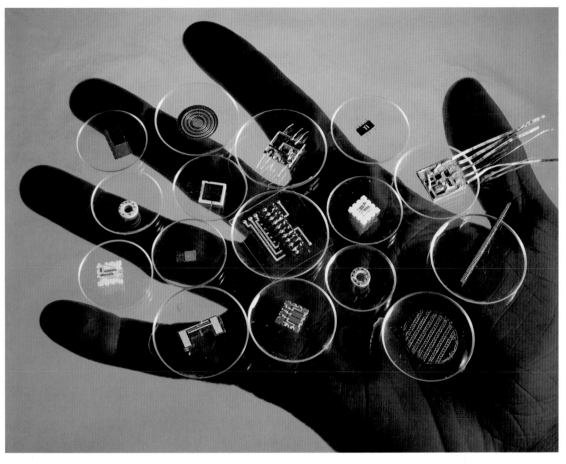

Microelectronic parts, including computer components, 1961

Allan **Grant** 1919–2008

The Lighter Side

If Norman Rockwell had used a camera instead of a paintbrush, his artistry might have looked something like Allan Grant's. Grant specialized in capturing the lighthearted side of American life, and his work often appeared in LIFE's Speaking of Pictures section, a repository for humorous or otherwise striking images. If his rep was as the man responsible for the laughs, he also made pictures that were anything but funny: a bewildered Marina Oswald shortly after her husband had shot President Kennedy, a grim Marilyn Monroe just before she died. Grant had aspired to be an aeronautical engineer—he loved photographing aircraft—but never regretted his choices, nor where he wound up. "Staff photographers, freelancers and everyone who owned a camera," he said, "were all hoping to get published in LIFE. It was like getting one week of fame instead of the 15 minutes Andy Warhol talked about."

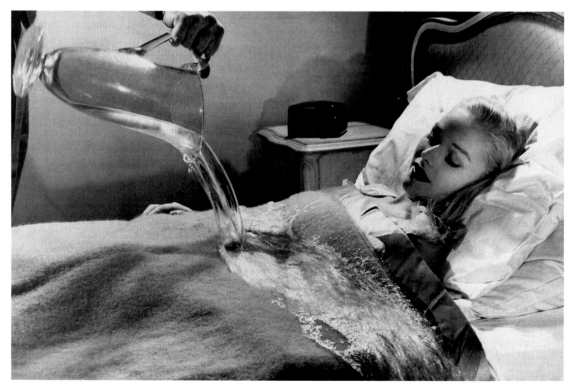

Electric-blanket demonstration, 1946

Shirley MacLaine and daughter Sachi Parker, 1959

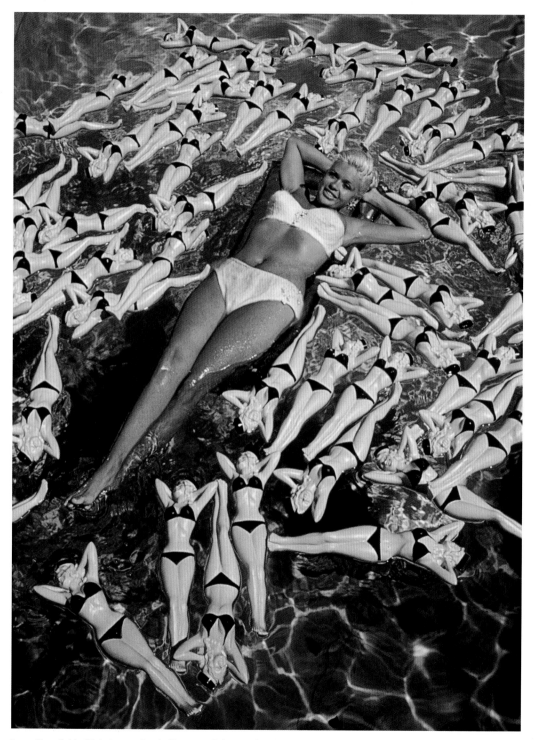

Jayne Mansfield with hot-water-bottle likenesses in her pool, Hollywood, 1957

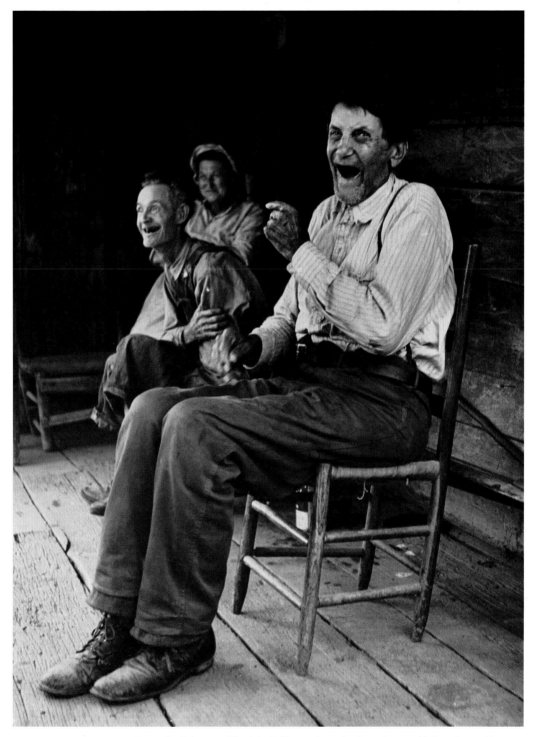

Former Confederate soldier John Salling, estimated to be 106 years old, Scott County, Va., 1953

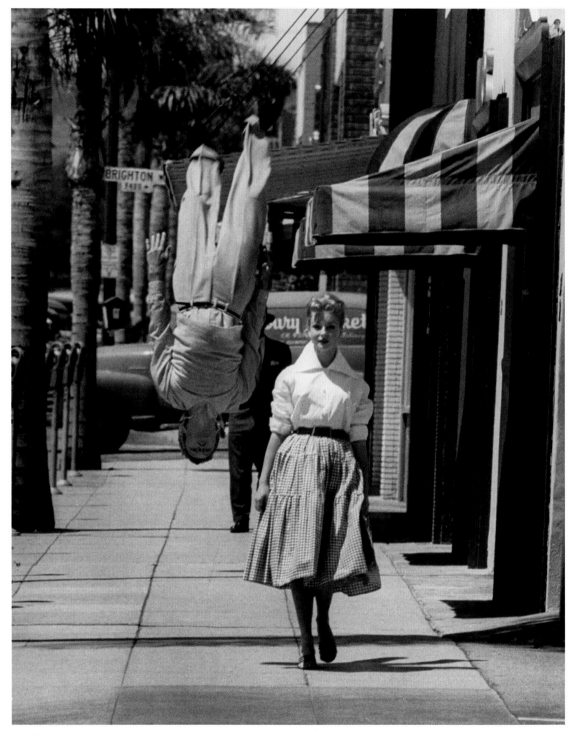

Russ Tamblyn doing a flip, with starlet Venetia Stevenson, Hollywood, 1955

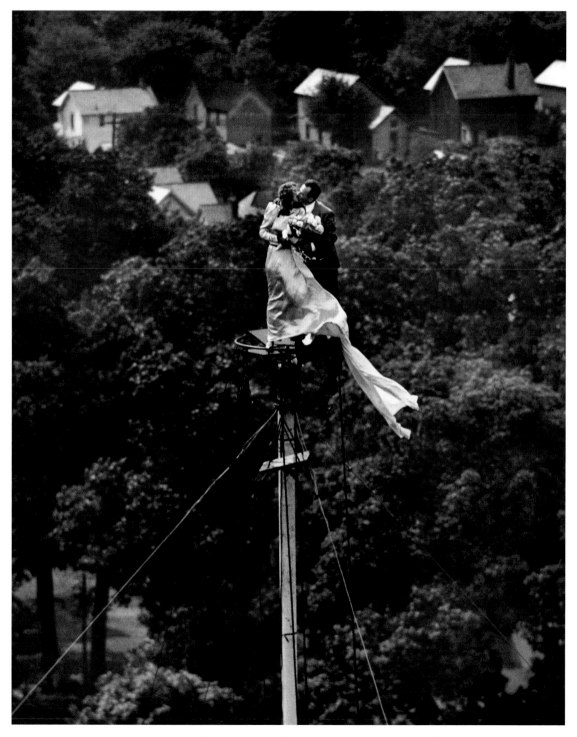

Yolanda and Marshall Jacobs, after being married atop a flagpole, Coshocton, Ohio, 1946

Milton **Greene** 1922–85

Edward Hardin

In Quest of Beauty

His job, as he saw it, was to be "a photographer of beautiful women." Greene worked in the fashion industry before joining LIFE, and developed a reputation for theatrical photo shoots. His stylist once recalled: "The way Milton would work, he would bring in the props, turn on the music—it was Stravinsky for Marlene [Dietrich]—turn off the phones and bring out the sherry." Greene photographed nearly everyone who was glamorous or fabulous in the mid-20th century—including men from Cary Grant to Norman Mailer—but he is best remembered for his extensive work with Marilyn Monroe. The two became such good friends that for a period she lived in Greene's Connecticut farmhouse with Milton and his wife. After Greene and Monroe both died, his photos of her took on a life of their own: Greene's son digitally restored them; the government of Poland secretly bought them, then publicly sold them off.

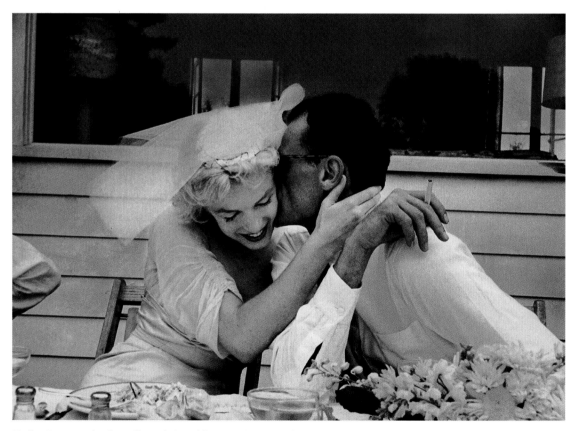

Marilyn Monroe and Arthur Miller at their wedding reception, Waccabuc, N.Y., 1956

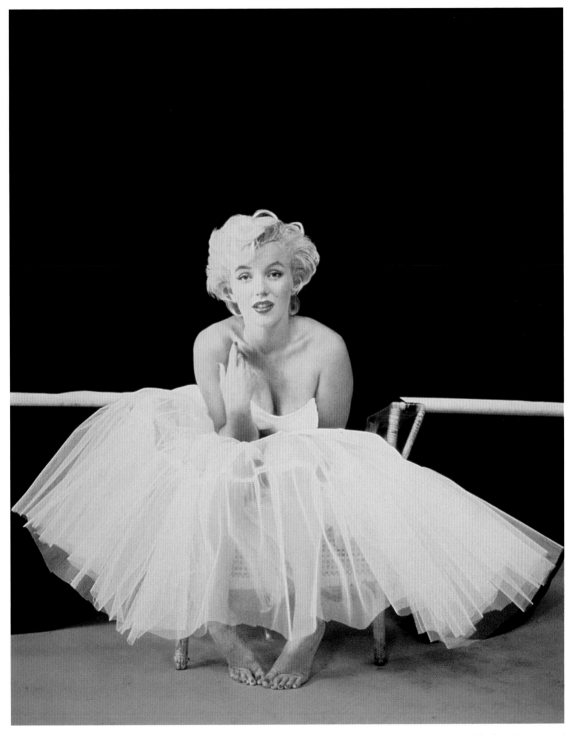

Marilyn Monroe, 1956

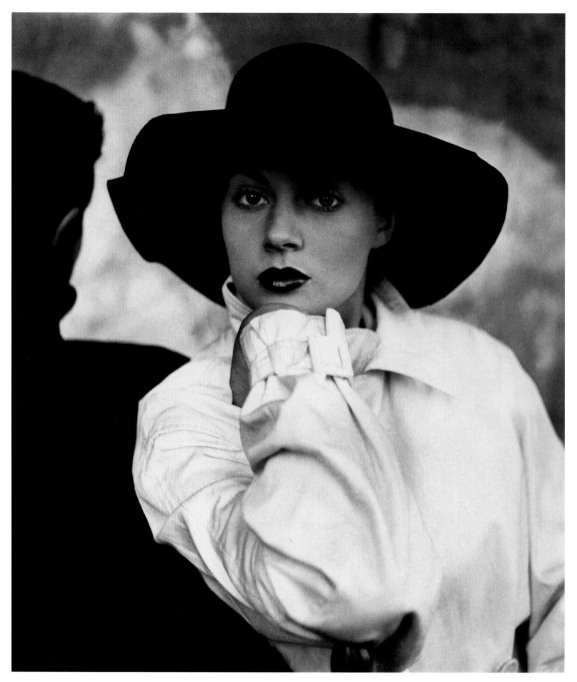

Anita Ekberg, Italy, 1951

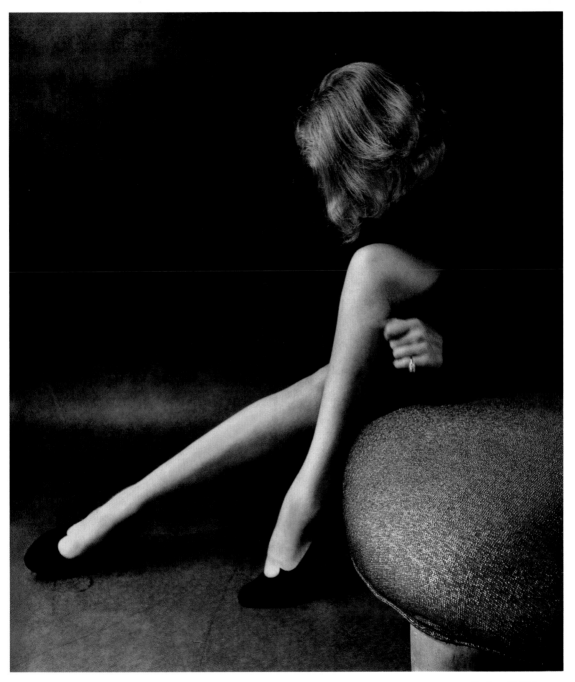

Marlene Dietrich, 1952

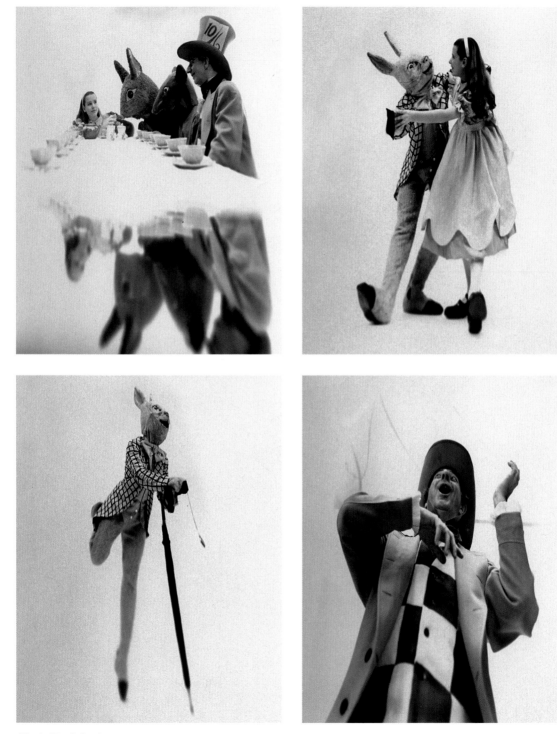

Alice in Wonderland, 1950

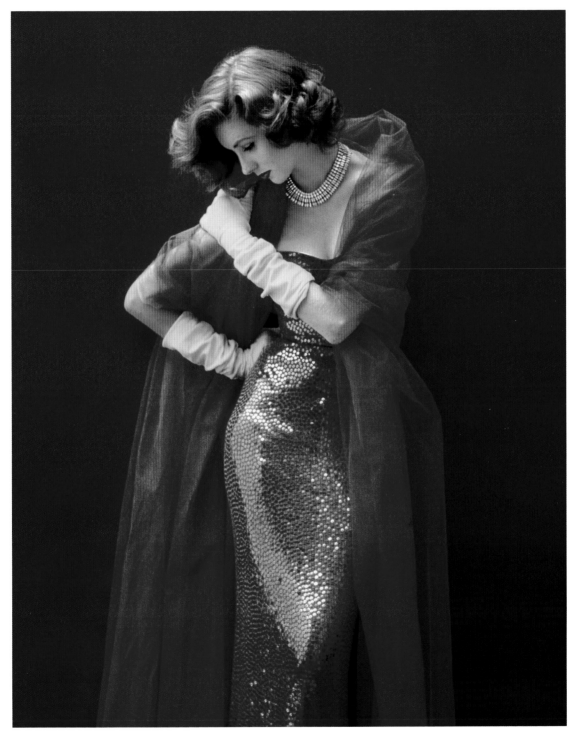

Suzy Parker modeling the siren look, 1952

Farrell **Grehan** 1926–2008

Town and Country

He was one of the few photographers with an equal appetite for the great outdoors and the inner city. His only requirement of his subjects was a sense of vigor. Thus did he produce a photo essay for LIFE on transcontinental railway travel and one on modern dance. In recent years he published exciting photographs of New York City. "More than the commercial bluster, New York is about its neighborhoods and the thrilling struggle of life."

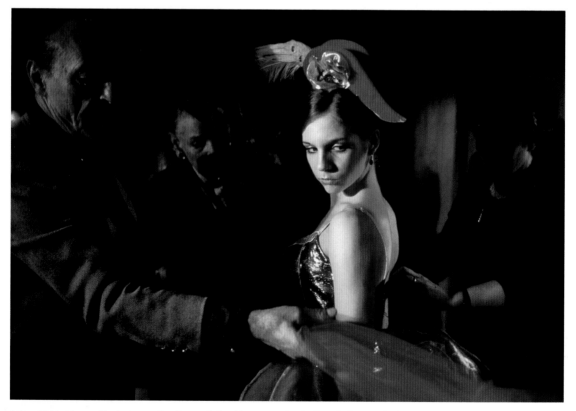

Gelsey Kirkland, 17, with choreographer George Balanchine, preparing for Stravinsky's *Firebird,* New York City, 1970

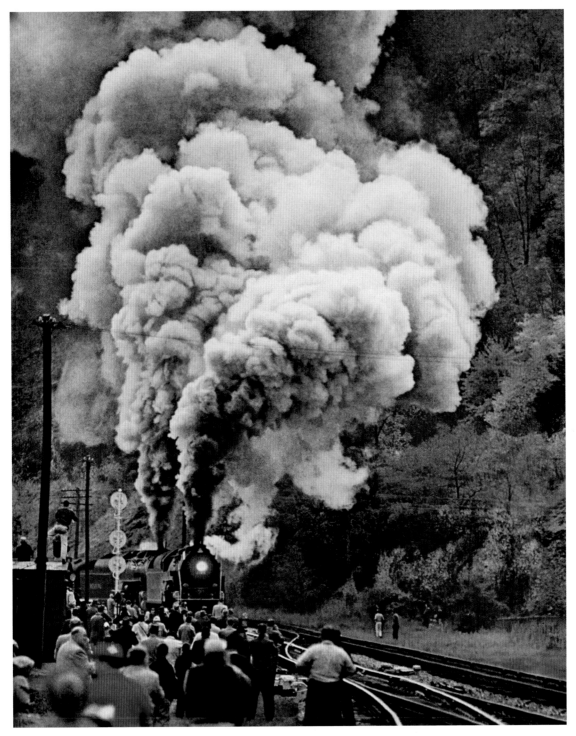

Special outing on the Reading line, 1961

Arthur **Griffin** 1903–2001

Bay Stater

One of New England's earliest photojournalists, Griffin worked at *The Boston Globe* before and after shooting for LIFE and *Time*. As a native of Massachusetts, he was proud to have taken the first color photograph of the great Red Sox slugger Ted Williams, in 1939, and he was also known for his landscape photography of the region.

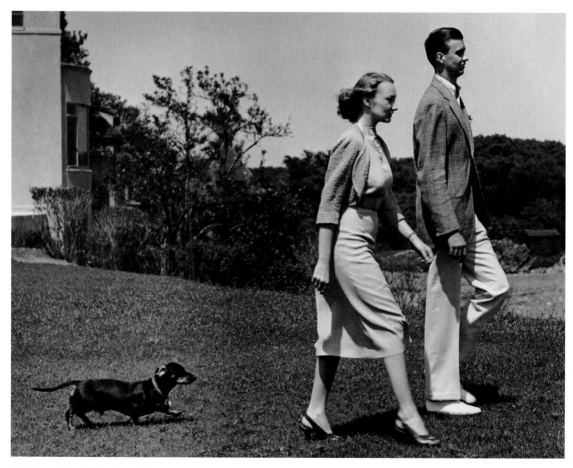

John Roosevelt and fiancée, with her pet dachshund Percy, Nahant, Mass., 1938

Jurist Felix Frankfurter, 1940

Henry **Groskinsky** 1934–

A Proper Schooling

The photographers in this book followed a variety of paths to reach the heights they attained, but certain trends are on exhibit. Henry Groskinsky is a worthy exemplar of the noble tradition of beginning as a LIFE assistant. Larry Burrows began by drying prints, Cornell Capa and Mark Kauffman started out in the lab, and Carlo Bavagnoli worked as an assistant to Dmitri Kessel in Italy. Said Groskinsky of LIFE, "There's no school like it in the world." For nearly a decade, at championship fights and political conventions, he was there ahead of time, setting giant strobe lights to illuminate the vast arenas. On the road he learned by developing test film in motel bathrooms. These apprentice labors imbued Groskinsky with a formidable array of technical skills, so that in the end he became a master of both the intimate and the grand.

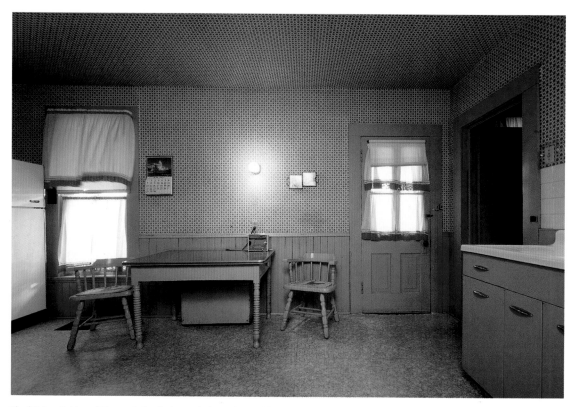

The kitchen in Harry S Truman's family home, Independence, Mo., 1984

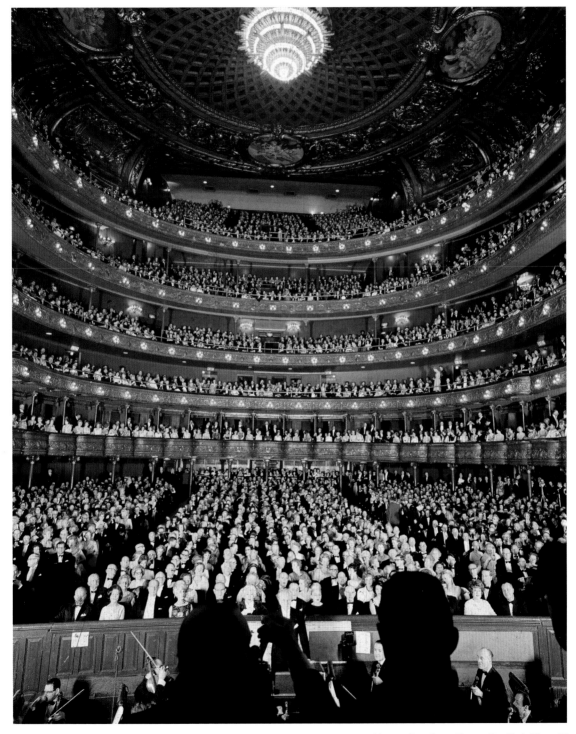

Metropolitan Opera House, New York City, 1966

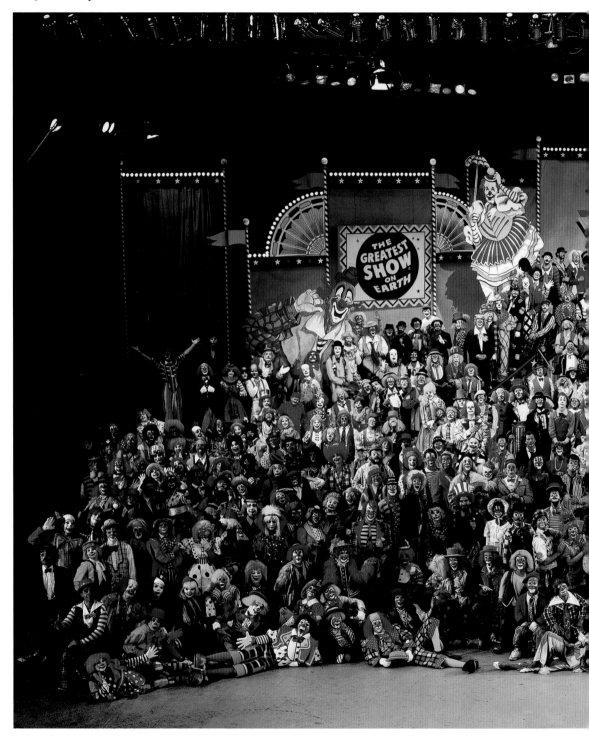

Reunion of the Ringling Bros. and Barnum & Bailey Clown College, Venice, Fla., 1987

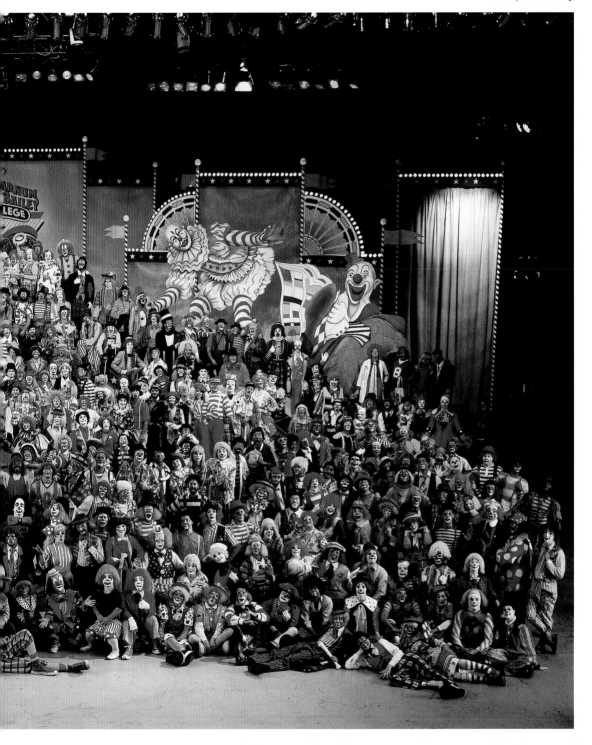

Henry Groskinsky

Temperature-revealing liquid crystal showing decreased blood circulation in smokers, 1968

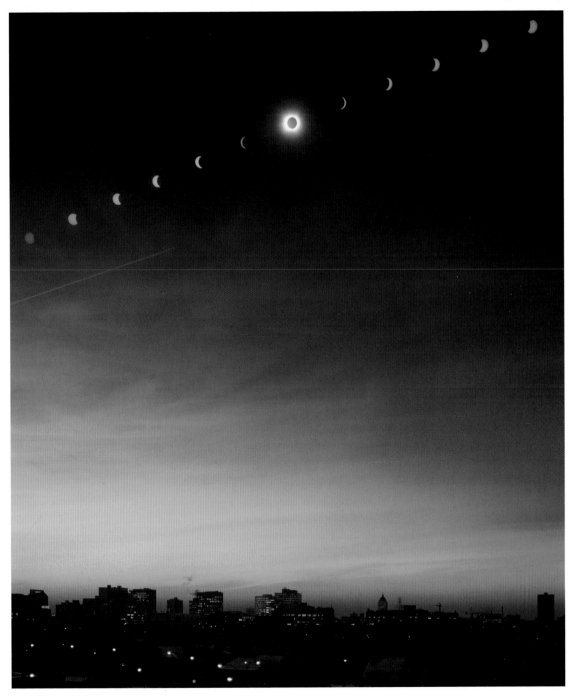

Total eclipse of the sun, Winnipeg, Canada, 1979

Philippe **Halsman** 1906–79

Yale Joel

Cover Story

He may never have been on LIFE's staff, but he will always be considered one of the magazine's most important photographers. That would be true even if one based the assessment only on cover shots. Halsman's 101 outpaces any competition. Indeed, after shooting No. 100 (Johnny Carson), the Latvian-born lensman said, "This is the high point of my career. It has taken me 27 years to achieve this record, and I like to think of it as the equal of, maybe the superior of, Babe Ruth's." One of the premier portraitists of the century (three of his images appeared on postage stamps), he produced work that traveled comfortably from zany to disarming to exquisite. How did he manage to deal with such a range of celebrities? "As a photographer, you try to use the tools of the trade. If it is a painter you are photographing, you use a brush or an easel for a prop. For a sculptor, a chisel. For Mae West, you use a big bed."

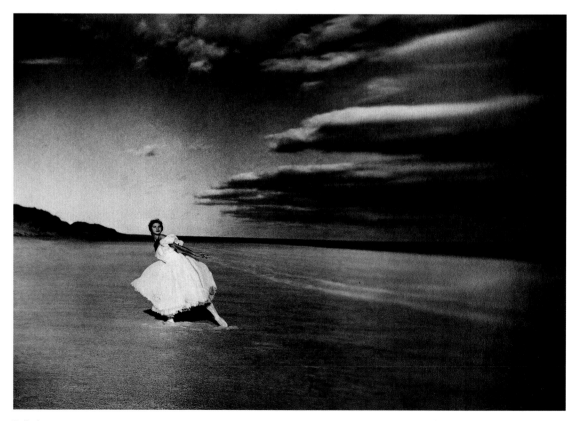

Ballerina, 1947

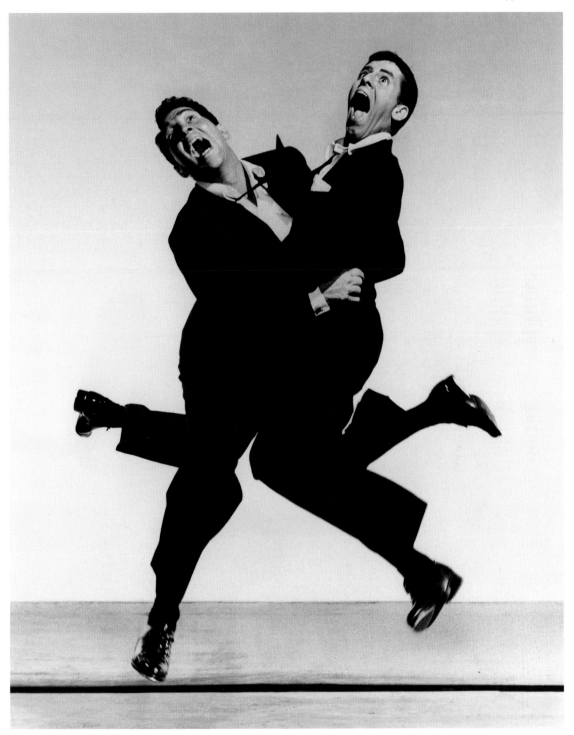

Dean Martin and Jerry Lewis, 1951

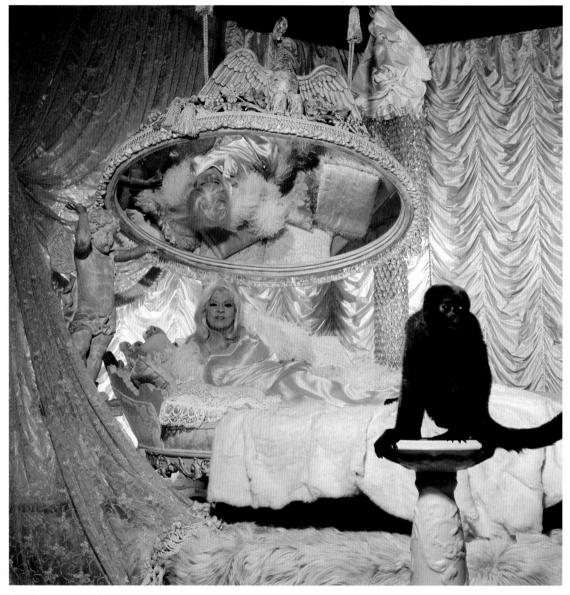

Mae West and her pet monkey, Tricky, 1969

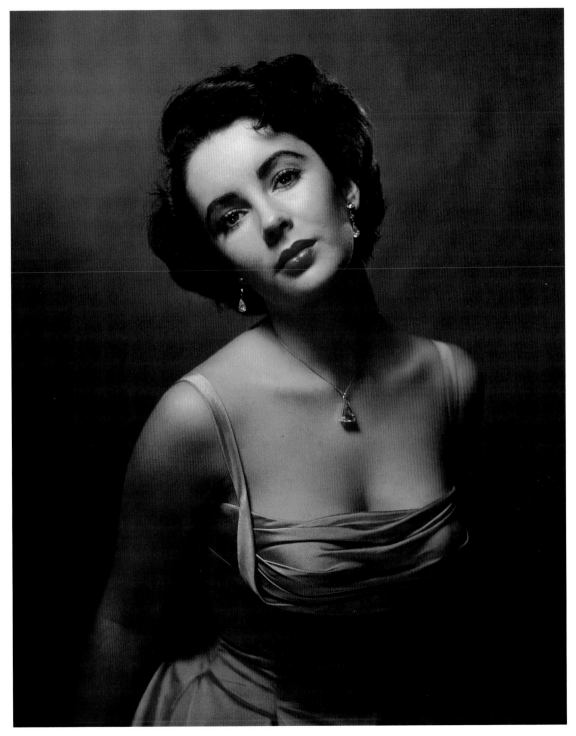

Elizabeth Taylor, 1948

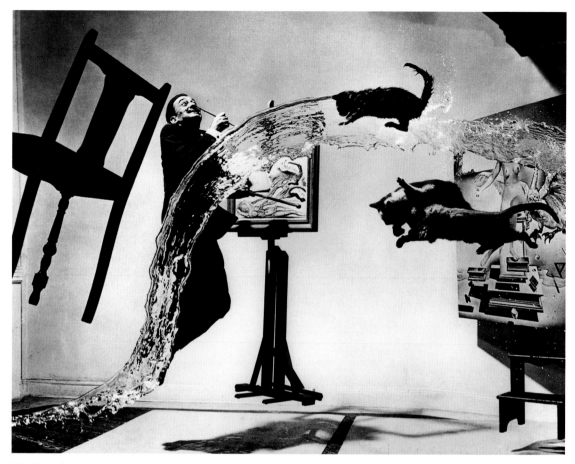

Salvador Dalí, 1948

Halsman met the surrealist Salvador Dalí in 1941, kicking off three
decades of collaboration. *Dali Atomicus,* above, is the most famous result.
"Of the beautiful women I have photographed, I recall Marilyn Monroe
most vividly," said Halsman. "Her great talent was an ability to convey her
'availability.' I remember there were three men in the room . . . Each of us
had the thought that if the others would only leave the room that something
would happen between Marilyn and himself." To get the cover photo at
right, Halsman needed her to jump 200 times. Before she left she told him
to call if another take was necessary—"even if it is four in the morning."

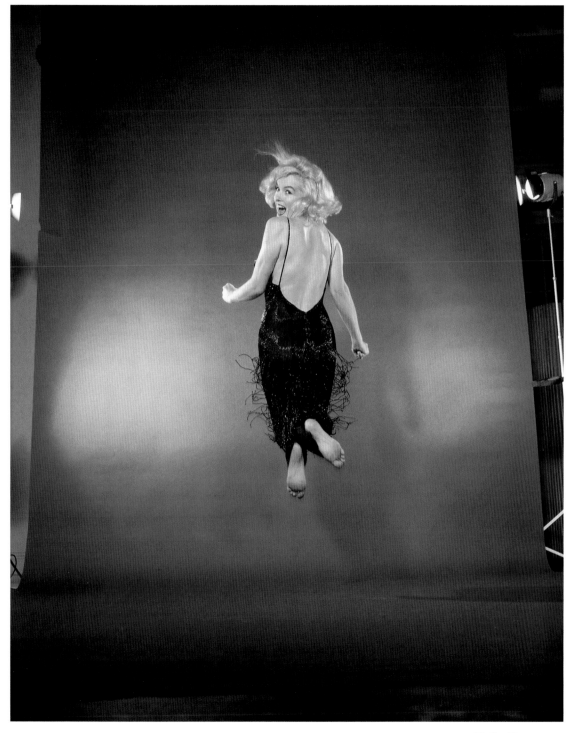

Marilyn Monroe, 1959

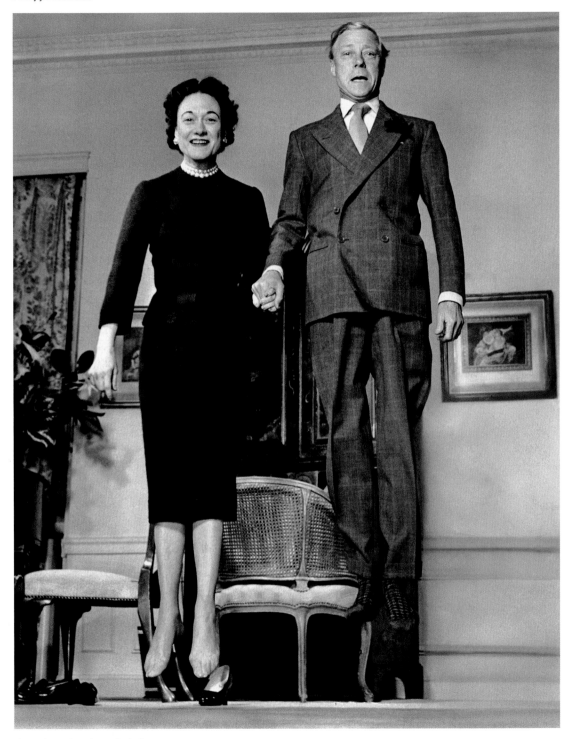

The Duke and Duchess of Windsor, 1956

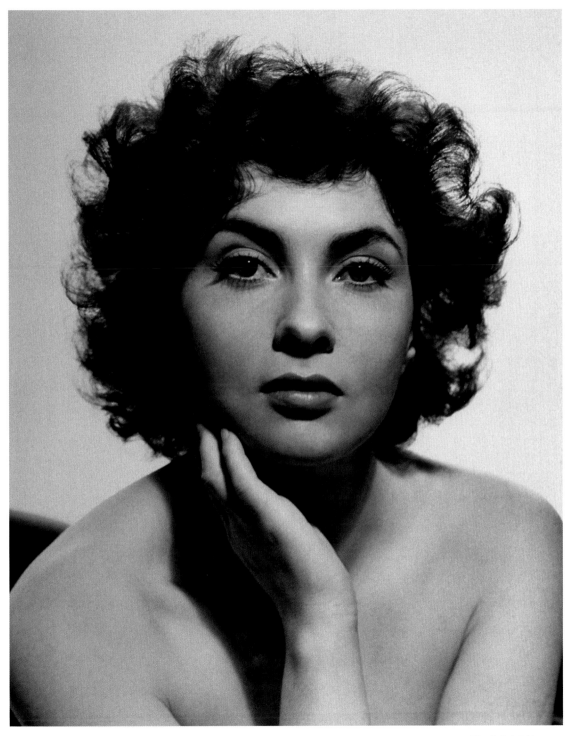

Gina Lollobrigida, 1951

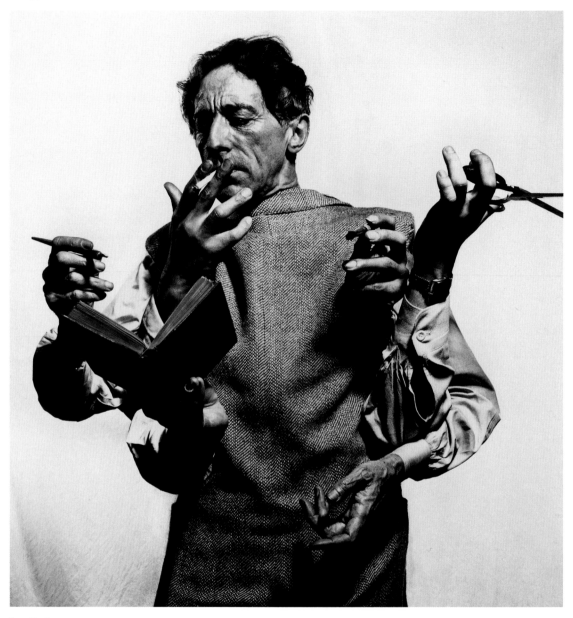

Jean Cocteau, 1949

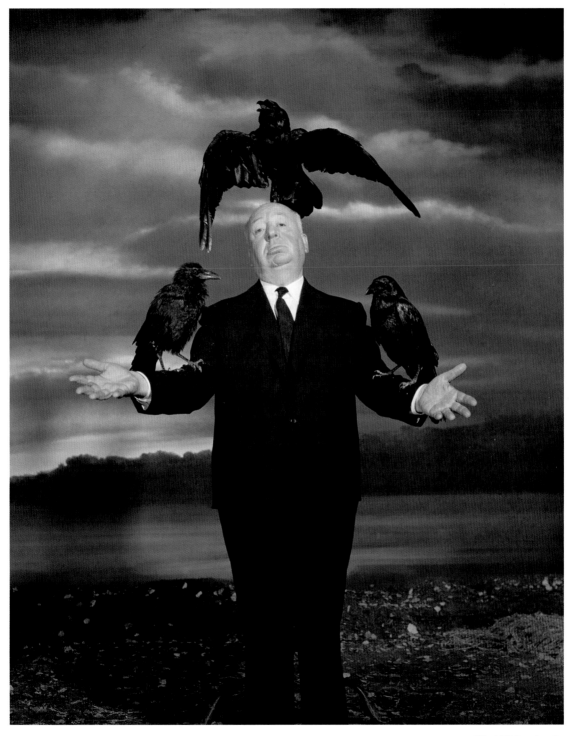

Alfred Hitchcock, 1963

Marie **Hansen** c.1918–69

Shooter, Not Shootee

LIFE's third female staff photographer, Hansen covered the White House, politics and Hollywood. MGM producer Joe Pasternak was so taken with her that he wanted to make a movie about that exotic creature: the woman photojournalist. Pasternak persuaded Hansen to take a screen test in which she smooched with film star Walter Pidgeon. However, she turned down a showbiz contract because she felt more comfortable on the other side of the lens.

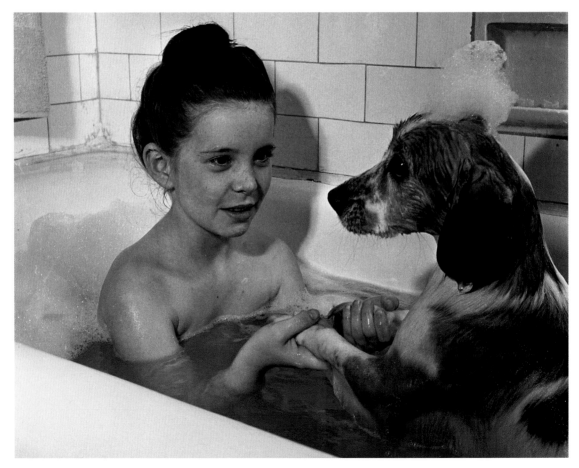

Margaret O'Brien and her spaniel, Maggie, 1944

Coney Island Amusement Park, New York, 1944

Marie Hansen

Lady Nancy Astor flanked by two employees, 1946

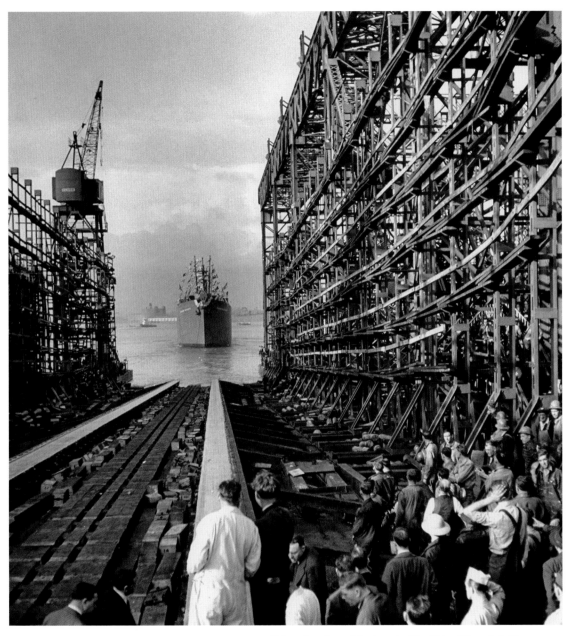

Shipyard workers at the launch of the *Richard Bassett*, Baltimore, 1942

Rex **Hardy** 1915–2004

Alexander King

A Question of Temperament

"When I got out of Stanford," said Hardy, "I wanted some adventure. I had run across Peter Stackpole, and I wanted to be like him. A chap I had gone to school with was going to open an office for LIFE, the new magazine, and hired me to cover Hollywood at $30 a week." And that was that. In 1936, Hardy became the magazine's first shooter to have Tinseltown as his beat, and he recorded delicious portraits of Harpo Marx, Astaire and Rogers, and others. He departed LIFE in 1939, partly owing to disagreements with Picture Editor Wilson Hicks—but there was more to it: Hardy tried freelancing for a while, but it just didn't work out. Finally, he said candidly, "the Navy came along, and that was the end of it for me. I lacked the talent that the rest of these people had, as well as the temperament . . . I guess I lacked the ego of the performer." He did, however, have the courage to become an important test pilot.

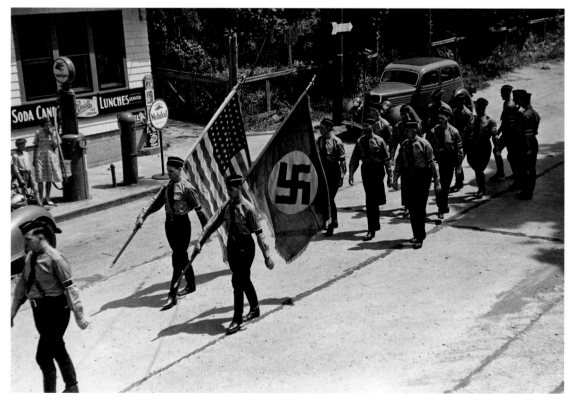

American Nazi Party members, Yaphank, N.Y., 1937

Bette Davis (left) playing musical chairs during the Tailwagger Party, California, 1938

Bernard **Hoffman** 1913–79

Whimsy and Carnage

Carl Sandburg once described him as "Camera historian . . . man of philosophy and whim." The two met at a shoot at the poet's house. Sandburg let his 15 goats inside so the creatures wouldn't freeze, then entertained one and all with his guitar. "They listened politely," Hoffman said of the goats. His official company biography reads: "When I began to work for Time Inc., Dad was so mortified by what I had done, that he promptly moved to a different neighborhood . . . and became a card sharp." He is best remembered for his stark pictures of Japan just after the atomic blasts.

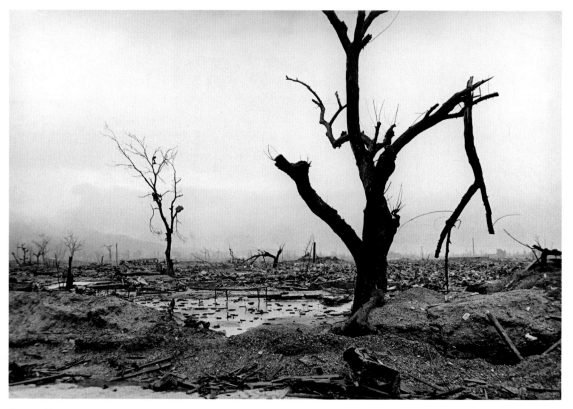

Flattened buildings, Hiroshima, 1945

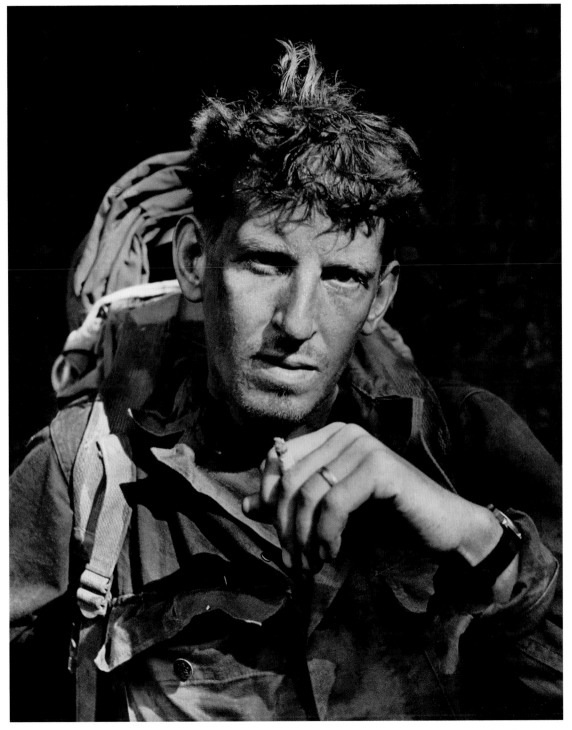

One of Merrill's Marauders, Burma, 1945

Jefferson Street, Franklin, Ind., 1940

A typical rural Saturday night back then was
a lot more bustling than it is today. For an
hour or two, any small town in America
might be jammed with double-parked cars,
with their well-dressed riders strolling or just
standing about, listening to the high school
band, talking politics or busily shopping.
Hoffman was sent to record this American
phenomenon for history and chose Franklin,
Ind., with its population of 6,200.

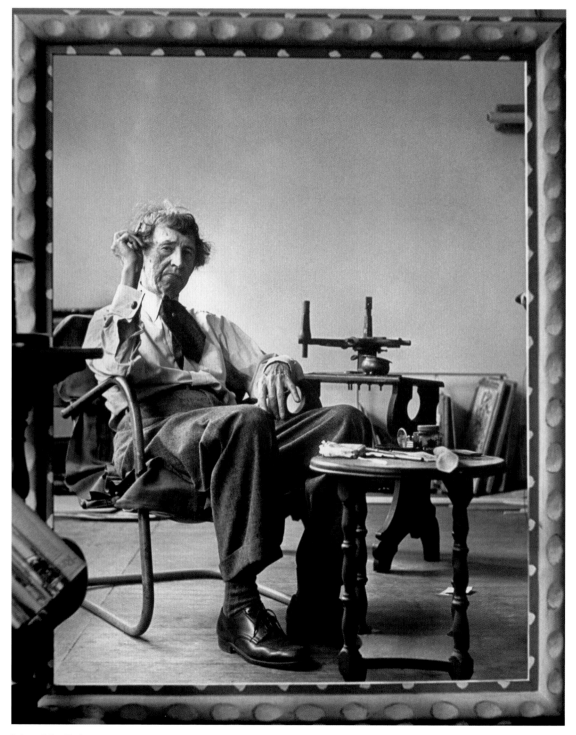

Painter John Marin, 1950

Children trying to catch toys released by a new kind of kite, 1949

Martha **Holmes** 1923–2006

On Their Side

Martha Holmes was one of those photographers who strove mightily to make her subjects look good. She would find their best side, shadow their thinning hair or even touch up the picture afterwards. "If they know you're on their side—and I am—that helps," Holmes once said. Among LIFE's female staff photographers, she is often overlooked, while such as Bourke-White and Leen leap quickly to mind. This is certainly due in part to her considerable modesty. Ever the Southern lady, when she began her career at the Louisville *Courier-Journal* she always wore "a frilly little dress" on Sundays. One weekend, a fire broke out, and working that story got her to switch to culottes. She eventually donned slacks, but in any outfit, Holmes remained her unique, warm, courtly self.

Danny Kaye, June Havoc, Humphrey Bogart and Lauren Bacall at the House Un-American Committee hearings, Washington, D.C., 1947

Senator John L. McClellan ready for a filibuster, Washington, D.C., 1949

Undergrads exchanging hellos, 1947-style

Billy Eckstine with admirers, New York City, 1949

Humorist James Thurber, nearly blind, drawing at home, 1950

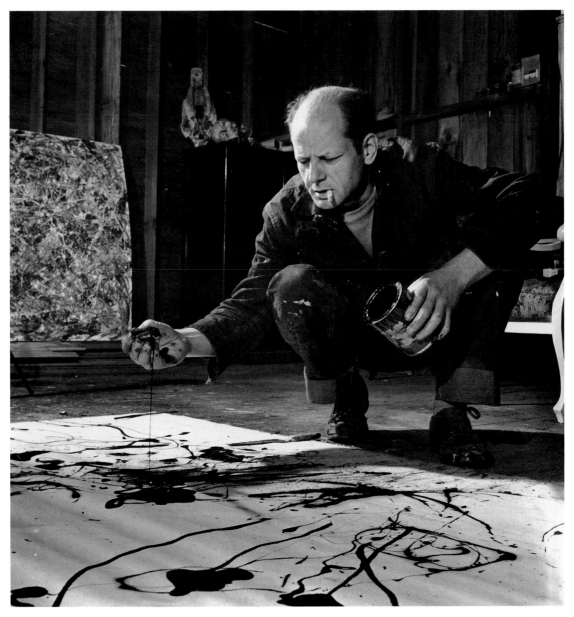

Jackson Pollock in his studio, 1949

James **Jarché** 1891–1965

London Lensman

Born in his father's London photo studio, Jarché seemed destined for the trade—even though an apprenticeship with a successful Bond Street photographer lasted only one day. Having survived that initial misstep, Jarché became one of Britain's first press photographers to make a name for himself back when it involved taking cameras where they had never been: to the tippy-tops of buildings or down the deepest mine shaft, to sporting events, political meetings or even trials. "At a dramatic moment," he said, "my bowler hat—in which a small camera was concealed—would lift and click, the tell-tale sound covered by a well-timed cough." With enough adventures to fill a book, Jarché wrote one. *People I Have Shot* became a British best-seller.

The Prince of Wales and Wallis Simpson, England, 1936

U.S. Ambassador Joseph P. Kennedy and his wife, Rose, leaving a banquet at Buckingham Palace, 1938

Yale Joel 1919–2006

The Setup Man

After spending World War II in Italy as an Army combat photographer, he returned to the U.S., and in 1947 joined the staff at LIFE, where he spent the next quarter century working out of LIFE's Washington, D.C., Paris, Boston and New York City news bureaus. He was known for his versatility, often traipsing along the East Coast capturing Americana. His forte was the tricky shot that required esoteric equipment or choreographed setups.

Admiral Hyman Rickover in the nuclear reactor shell at the Shippingport power facility, Pennsylvania, 1957

French comedian Jacques Tati, New York City, 1958

Ervand Kogbetliantz and his three-dimensional chessboard, 1952

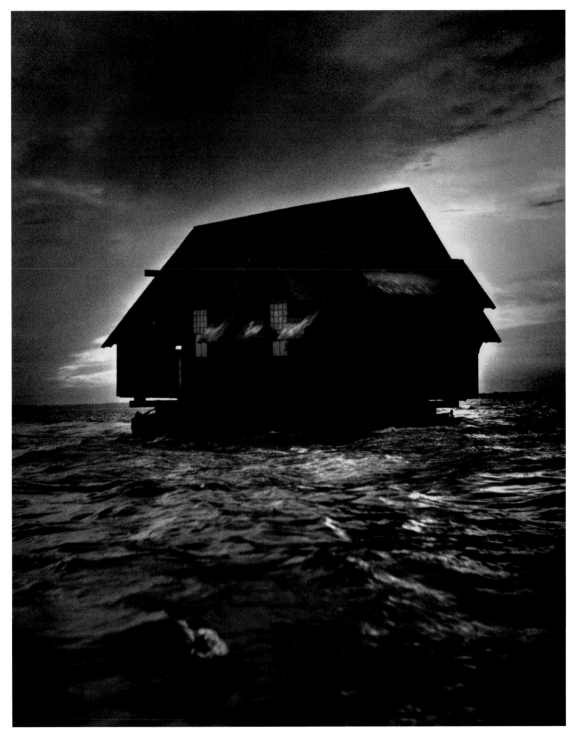

A house being relocated by water from Kennebunkport to Goose Rocks Beach, Maine, 1951

A two-way mirror in the lobby of a Broadway movie house, New York City, 1946

Teenage party, Briarcliff, N.Y., 1956

Jimmy Childs, nine, giving a piano recital at the home of his piano teacher, Manchester, Iowa, 1962

Mark **Kauffman** 1921–94

Teen Wonder

Of all the possible images of Eleanor Roosevelt that inundated LIFE's editors in 1939, they chose one for the cover by a 16-year-old high school student named Mark Kauffman, and thus began a decades-long relationship with the magazine. Once out of school, he worked as a technician in LIFE's Los Angeles photo lab. When the bureau's established photographers left to cover World War II, they effectively bequeathed Kauffman his pick of Hollywood assignments. After 10 months, he signed on with the Marines as a combat photographer before returning as a staffer in 1945. Because Kauffman devised ways to bring sports photography closer to the reader—through technical innovations and skilled use of panning—Henry Luce tapped him to help start *Sports Illustrated* in 1954 and selected one of his baseball photos for the publication's first cover.

Independence Day, Accra, Ghana, 1957

Samuel Goldwyn's daily two-to-five-mile walk, Los Angeles, 1942

Mark Kauffman

Waking up Mom, Seattle, 1955

Wilma Rudolph winning the 100-meter dash, Rome Olympics, 1960

Bebe and her daughter, Chicago, 1946

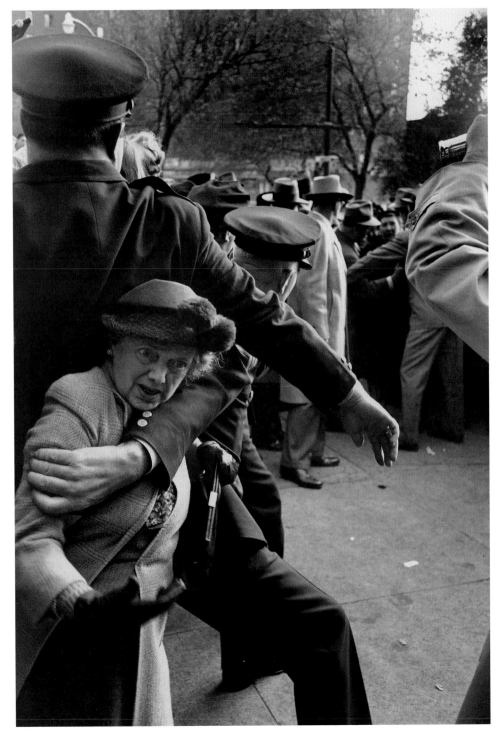

Woman being held back at the appearance of Mamie Eisenhower, Providence, 1952

Robert W. **Kelley** 1920–91

No Assignment Too Daunting

In a previous book on LIFE photographers, Stanley Rayfield describes Kelley as "first and foremost a current news cameraman" who was "in his element in the thick of a fast-breaking news story." Which means, of course, that Kelley frequently placed himself in harm's way and found that his involvement went beyond his assignment. For example, in 1956 he delivered relief supplies to stranded flood victims in Mexico, then got an overhead shot. That same year he broke a leg in Tennessee as he leapt from a car to escape a mob of segregationists. A decade later he injured his shoulder in a fall in Vietnam. For Kelley, it was all in the line of work.

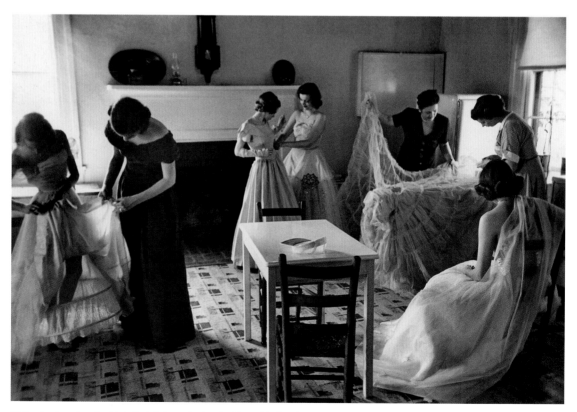

High-schoolers donning historical costume for hotel visitors, Murfreesboro, Tenn., 1951

Kenneth Merriman and his stilts, Cannon County, Tennessee, 1952

Robert W. **Kelley**

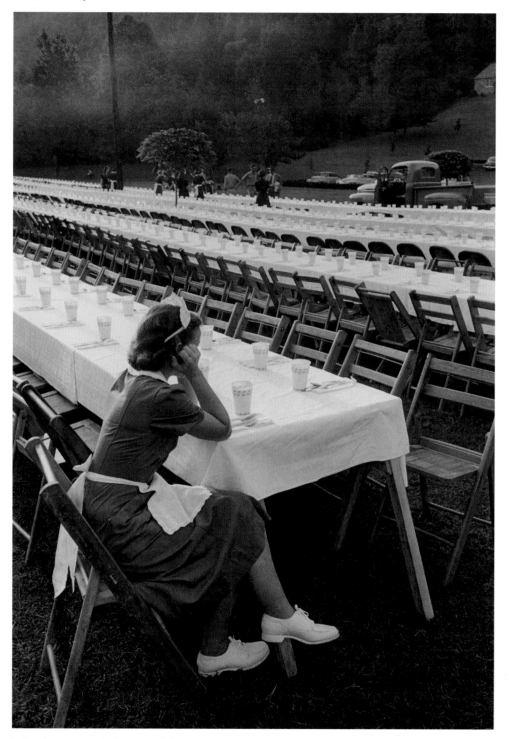

Before the governors' barbecue, Gatlinburg, Tenn., 1951

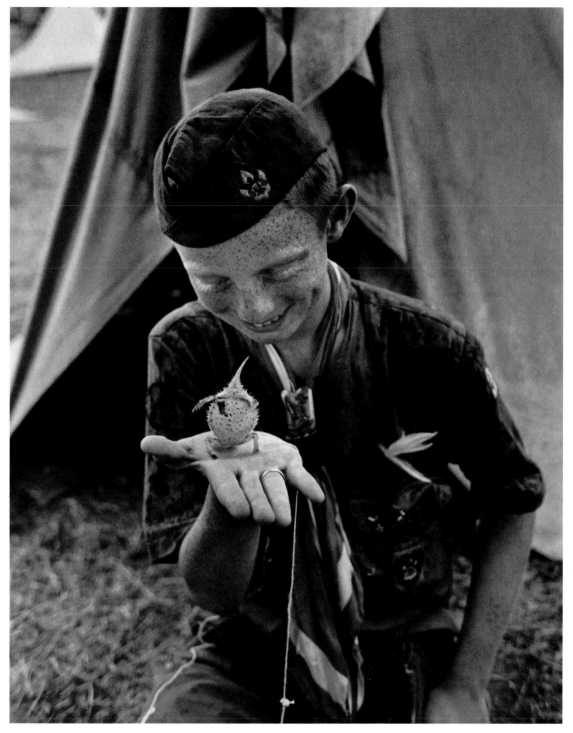

Billy Peterson, who has traded two pieces of deer horn for a horned toad, Valley Forge, Pa., 1950

Dmitri **Kessel** 1902–95

Ben Schnall

Man of the World

It has been said of Kessel, "He is an international human being," a telling reference to a man who lived well and long, in many places and with many interests. He grew up in comfort, on his father's sugar-beet plantation in the Ukraine; as a boy he had a Brownie camera that he had gotten by trading a set of watercolor paints and brushes. But this tidy, idyllic life was swept away during the Bolshevik Revolution. Dmitri was drafted into the army at age 16, and that service doubtless informed his later photography of World War II. After escaping the Russian Revolution, he arrived in America in 1923 and began to concentrate on photography. His home base later became Paris, but he was a man who was at home only rarely. The world held too many attractions for this endlessly curious fellow, who was capable of shooting hard-hitting, eruptive news photos but also gorgeous architectural photography, notably of churches and cathedrals, along with stimulating photos of great artworks.

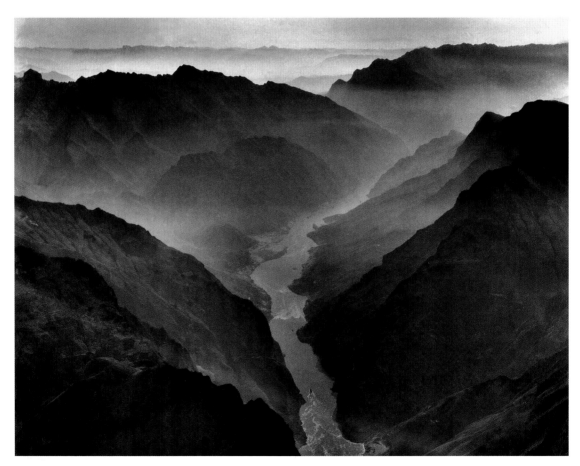

Yangtze River gorge, Szechwan, China, 1946

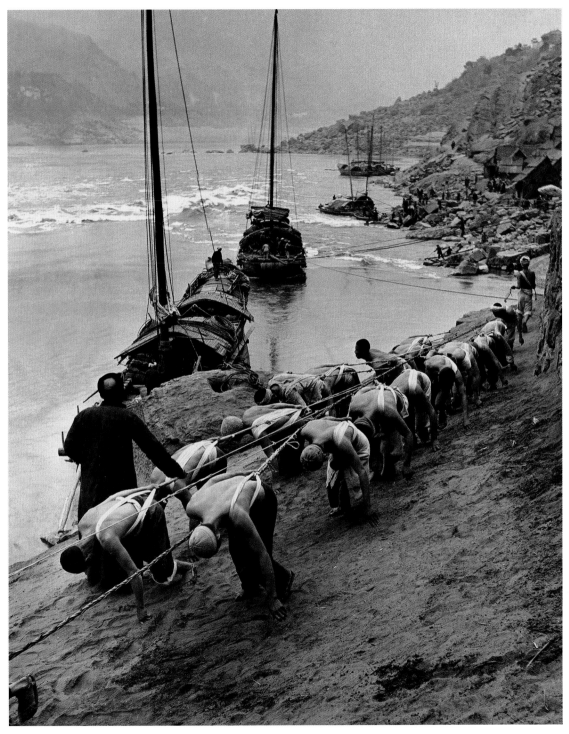

Trackers towing a junk up the Yangtze River, China, 1946

Brownstone awaiting a wrecking ball, New York City, 1959

Maria Padiska, whose mother was killed by the Germans in the Distoma Massacre, Greece, 1944

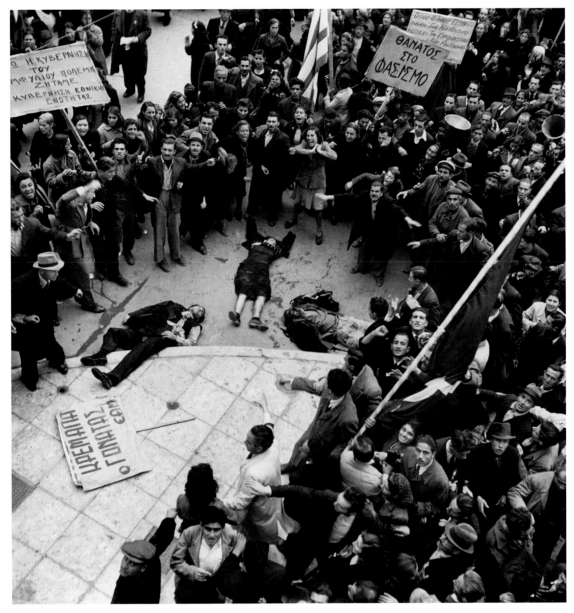

Three of 23 killed when police opened fire at a National Liberation Front demonstration, Athens, 1944

Dmitri Kessel

Kessel was long noted for his work in color. He began exploring the medium in 1937, and over the years became an expert color-printing technician. According to Kessel, his early years in photography yielded two vital lessons: "The first was the importance of self-criticism, the second how to print." Here, the superb fidelity of color harmonizes with a sureness of texture to produce an exhilarating image.

Piazza Navona, Rome, 1962

French President Vincent Auriol shooting pheasants, Château de Rambouillet, France, 1950

Mohammad Reza, Shah of Iran, after his coronation, with Prince Reza and Empress Farah, Tehran, 1967

Wallace **Kirkland** 1891–1979

On the Move

Most of the photographers herein started early with the camera, if only as a hobby. "Kirk," however, followed many pursuits and was nearly 40 before he found his proper calling. He quickly became an outstanding nature photographer, which was perhaps a reflection of his having been born and raised on a coconut plantation in Jamaica. He possessed such a sense of wanderlust that he carried a slate on which he wrote his name, the town he was in, the hotel and, if there was space, the date, then hung it at the foot of the bed. Thus could he effect a swift and accurate orientation each morning.

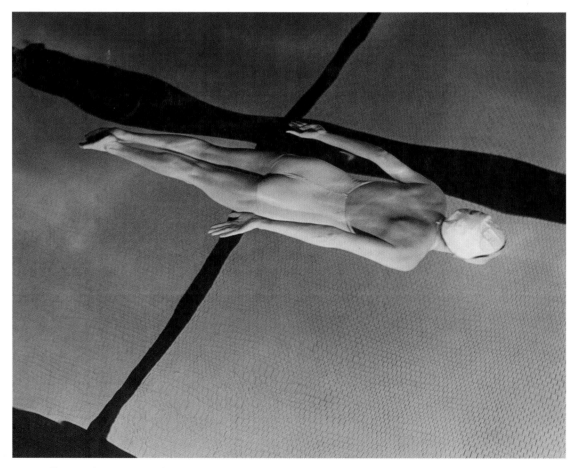

Jeanne Wilson, Purdue University, Indiana, 1946

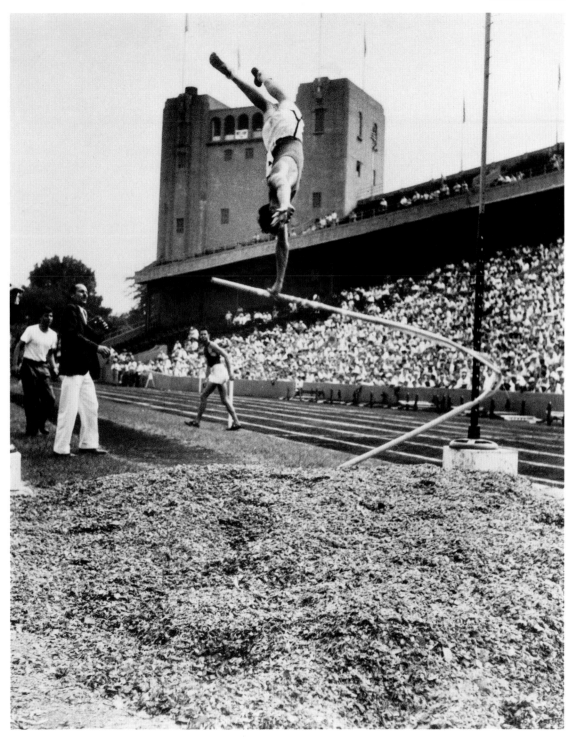

Harry Cooper's pole snapping during Olympic tryouts, Evanston, Ill., 1948

Yorkshire hogs at a Curtiss Candy Company farm, near Cary, Ill., 1951

Pregnant Mrs. Jane Dill, after being told the chemical wafer on her tongue indicates the baby is a girl, Northbrook, Ill., 1954

Henrici's, Chicago's oldest restaurant, 1952

Otter diving for a frog, 1953

George **Lacks** 1910–1960

Bill O'Meara

Out of China

Lacks spent much of his career in Shanghai, which made sense because he had lived there for years before he joined LIFE and had even been an official photographer for the Chinese government. During a stint in LIFE's Los Angeles bureau, he photographed a young lawyer in Whittier who was considered a political comer, as well as a story on the city's "Divorce Mill." The rate of 80 breakups a day was then considered staggering. Once, to illustrate the fast clip of the court, Lacks took a portrait of 24 participants and the brief testimony they gave to end their short, sad marriages.

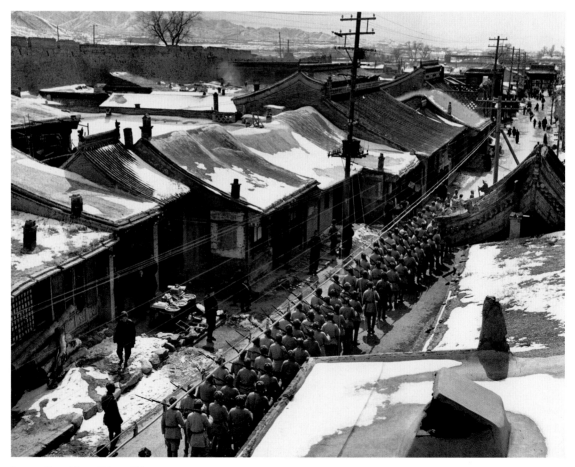

Communist soldiers, Kalgan, China, 1946

Attorney Richard Nixon resuming his career after being discharged, Whittier, Calif., 1947

Bob Landry 1913–c.1960

One for the Boys

He was on a cruiser in the Pacific when the Japanese attacked Pearl Harbor, and from then on Bob Landry was in one important place after another during that long war. Like Capa, he went in with the first wave at D-Day, but *all* of Landry's film was lost, and his shoes, to boot. Despite braving combat scenes, it was a peacetime picture he took before all that, in the summer of 1941, that he will be remembered for. There are countless versions of the story, but regardless of where it was shot or where that negligee came from, what it boils down to is that he took that photo of Rita Hayworth—one of the sexiest, most beguiling pieces of film of all time, one that didn't need to be on the cover to win the hearts and (well, maybe) minds of American soldiers at home and abroad. One civilian above others was amply impressed; Orson Welles eyed Rita in LIFE and resolved to marry the starlet.

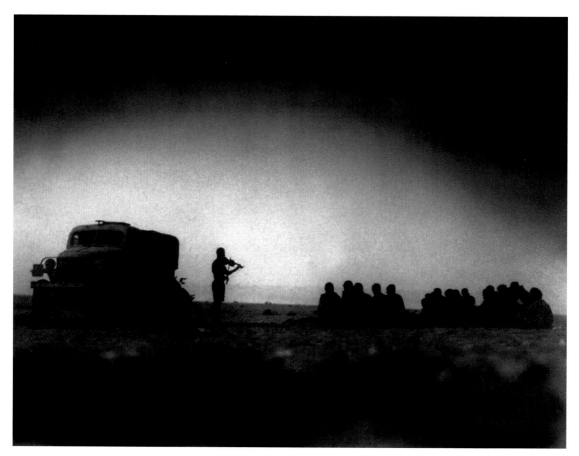

Chaplain playing violin with singing British 8th Army staff the night before an attack, El Alamein, Egypt, 1942

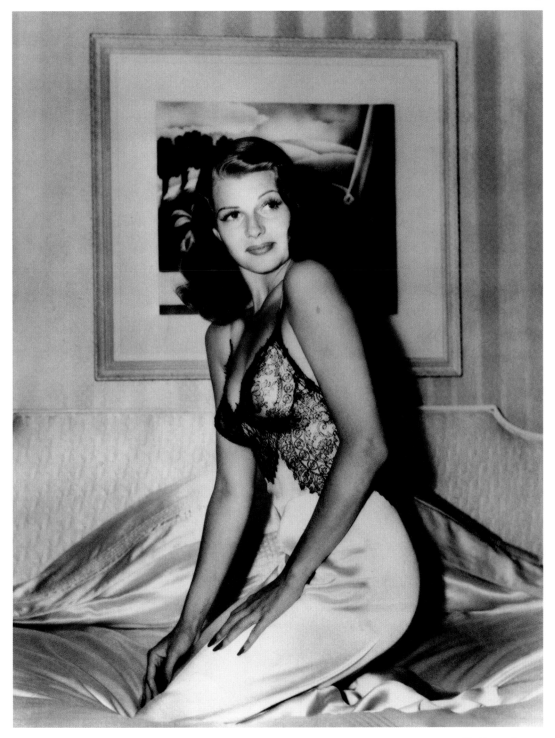

Rita Hayworth, 1941

French patriots and a German collaborator, Rennes, France, 1945

French woman, after discovering her husband's body, St. Marcouf, Normandy, 1944

Bob Landry

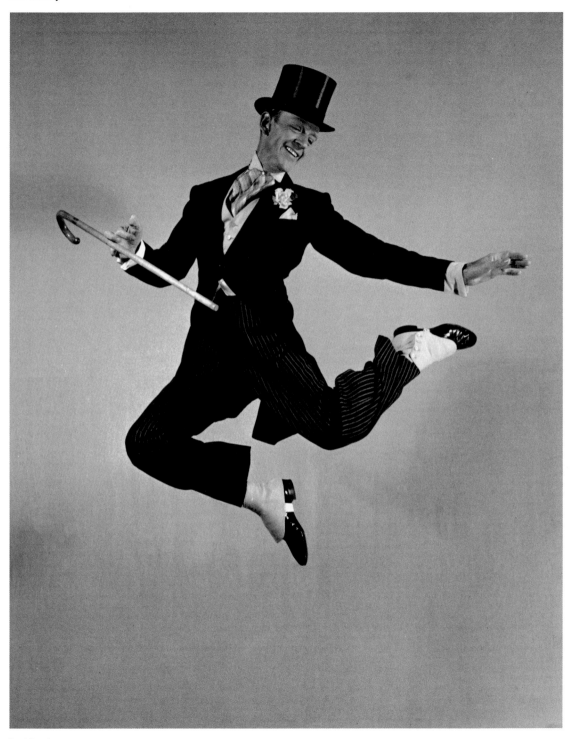

Fred Astaire, 1945

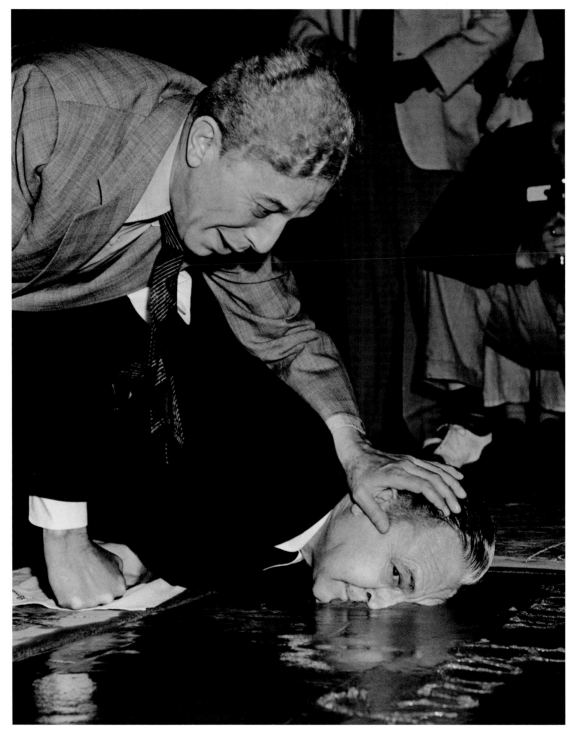

John Barrymore's profile being immortalized by Grauman's Chinese Theater owner Sid Grauman, Hollywood, 1940

Walter B. **Lane** 1913–96

Alice Heidel

At Home at Sea

During World War II, his local draft board gave Lane a three-month reprieve to take a freighter to Iceland for a LIFE assignment on American soldiers based there. Then it was off to the Navy for almost four years. He returned to cover Washington, D.C., and recalled how President Harry Truman, posing with a gift crate of strawberries, asked Lane if he liked them, and then tossed one into Lane's mouth: "He peels one and popped it. The other photographers just stood there. Darn it—not one of them took a picture."

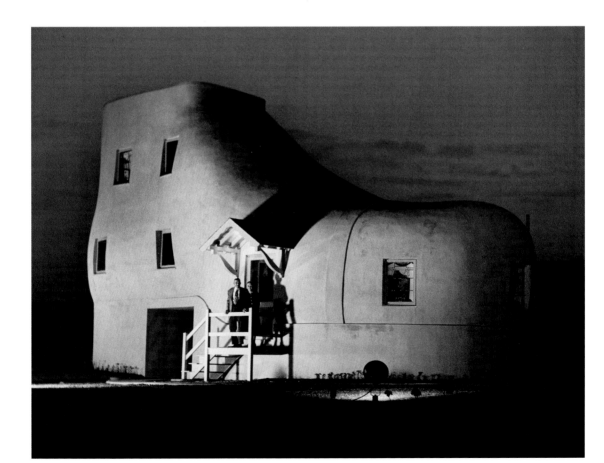

Mahlon N. Haines's house, York, Pa., 1949

Government building, Washington, D.C., 1946

Lisa **Larsen** 1925–59

Glamour Girl

A recipient of many awards, including Magazine Photographer of the Year, which she received just one year before she died of cancer at age 34, Larsen used her Leica to render sympathetic portraits notable for their warmth. She survived a rigorous trip to the Himalayas and was the first American photographer to enter Outer Mongolia after a government-enforced 10-year ban. Beyond the down-and-dirty assignments, the German-born Larsen was known as the "glamour girl" of press photography for her way of endearing herself to people, particularly those in the news. The otherwise gruff Soviet Premier Nikita Khrushchev gifted her with a bouquet of peonies, and North Vietnamese President Ho Chi Minh said, "If I were a young man, I'd be in love with you."

Senator John F. Kennedy and Jacqueline at their wedding reception, Newport, R.I., 1953

Ho Chi Minh during his official visit to Poland, 1957

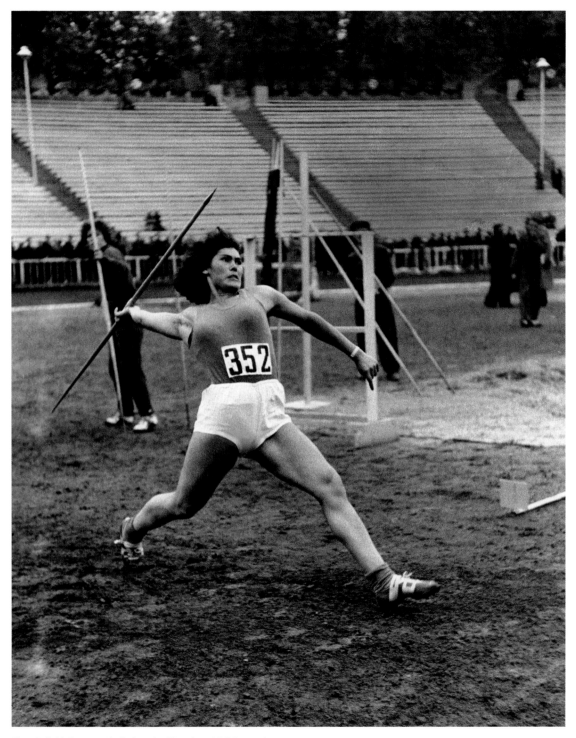

Virva Rolleid, four months before the Olympics, U.S.S.R., 1956

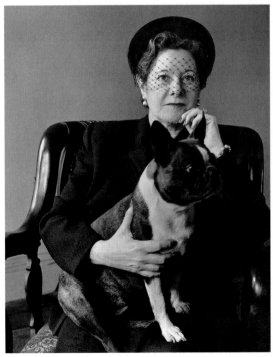

Members of a grand jury, Brooklyn, 1951

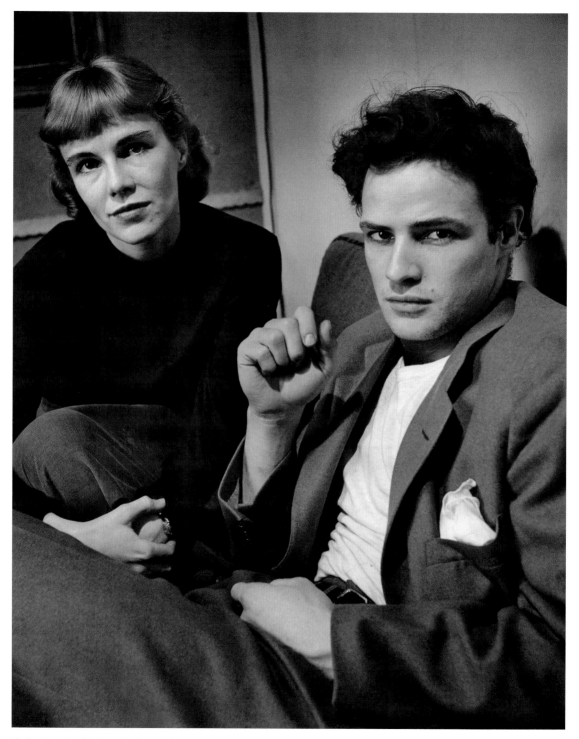

Marlon Brando with sister Jocelyn, 1948

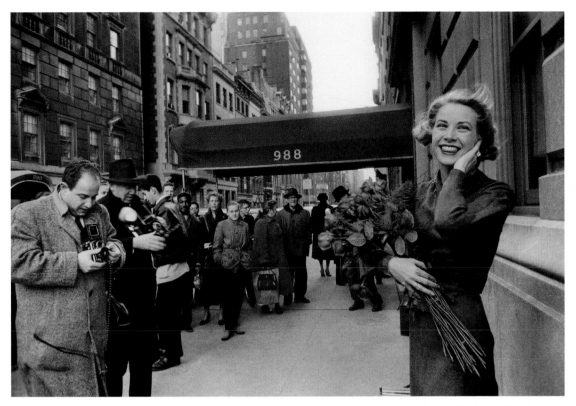

Grace Kelly shopping in New York City, 1956

Nina **Leen** c.1914–95

Dog Whisperer

As a European and an experienced photographer of animals, Leen had a sensibility that prompted her to study Americans the way a biologist would an exotic species. "It was typical for Americans not to see what [the American look] was," she said. "To them it was usual—Isn't everybody like that? For me, America *wasn't* usual." Her many subjects ranged from the latest fashions to Ozark clans, even as she continued to study animals, including snakes and bats. "I wanted to show bats in pictures because words would just fly off into the air," she said. "People wouldn't believe it and could not imagine them." After seeing pictures of an orphaned puppy on a road next to her slain mother, Leen adopted the spaniel-like mutt. She called her Lucky, and nurtured her to health and fame. An inspiration to stage-mother dog owners everywhere, Leen featured Lucky in LIFE, on TV, in a movie and in the book *Lucky, the Famous Foundling*.

Spear-nosed bats, 1966

Whippet chosen Best in Show at the Westminster Kennel Club Dog Show, New York City, 1964

Nina Leen

From *The American Man*, 1946

Four generations of an Ozark family, with ancestors' portraits, Bellevue, Mo., 1946

Florida, 1950

In May 1950, LIFE decided it was time to let the world
know what the shoreline fashions would be that summer,
at least stateside. "American women . . . long ago rejected
France's famous beachwear innovation, the scanty two-
piece Bikini bathing suit. The two-piece suit . . . is running
a poor second this summer to the one-piece suit." Judging
by Leen's shot above, looks like the odds were about
three to one. At right, seven years earlier, Leen combined
her fashion instincts with her lifelong interest in wildlife.

Wartime coif called Winged Victory, New York City, 1943

Teenager, Webster Groves, Mo., 1944

Charles Hoffman's family waiting for his train, Darien, Conn., 1949

Neil **Leifer** 1942–

The Sweet Scientist

"I've done four or five pictures that people will remember"—this from the man who has shot over 200 covers for *Time, Sports Illustrated* and *People,* more than any other photographer. He got his start on New York City's Lower East Side at the Henry Street Settlement's photo workshop, and through the years contributed memorable portraits of such as Fidel Castro, Pope John Paul II, Frank Sinatra and Charles Manson. But Leifer's claim to fame must be regarded as his sports work, among the finest in the past half century, with special attention accruing to his boxing images. In recent years, he has turned his focus almost entirely to filmmaking, with great critical success.

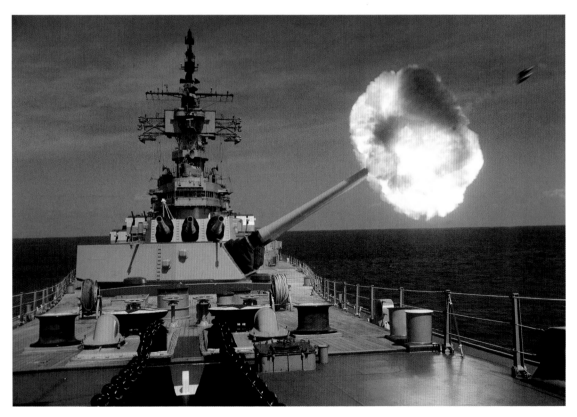

USS *New Jersey,* Gulf of Tonkin, east of North Vietnam, 1968

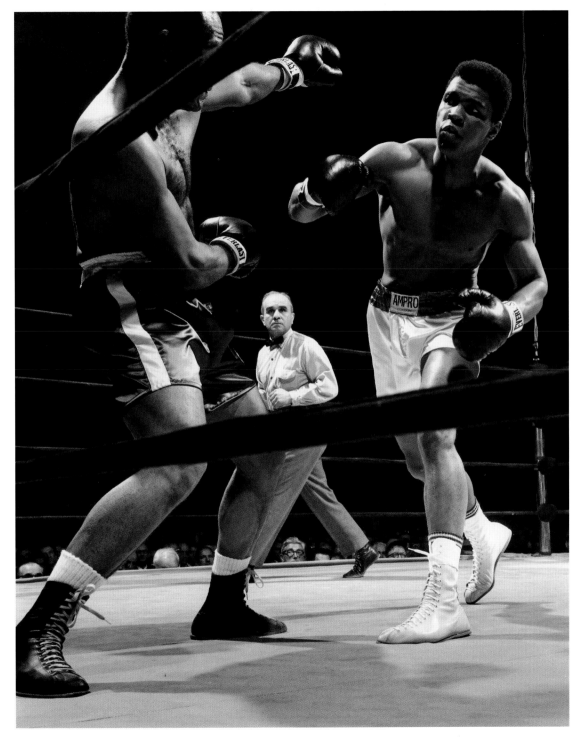

Zora Folley vs. Muhammad Ali, New York City, 1967

Anthony **Linck** 1919–2004

One Plucky Photographer

In order to get a unique perspective on his subjects, he would do anything, including piloting small planes to get the distinctive shot. One night in 1972, Linck circled his craft for four hours around Kennedy Space Center, calculating he wouldn't run out of gas before the delayed *Apollo 17* finally lifted off. It all worked out though, and through his plane's customized window he captured an image of the last men to go to the moon. Shortly after World War II, he also flew in the face of danger when he documented young war victims in Warsaw, children who had been maimed by land mines. After he gave a one-legged kid on a homemade crutch some candy as thanks for letting him take his picture, Soviet police arrested Linck. They tried to make him confess to being a spy, but an American official rescued him.

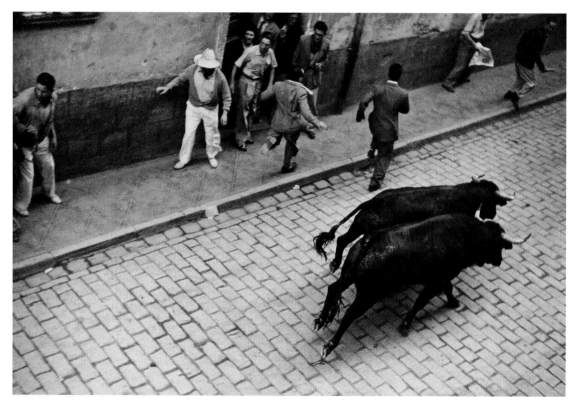

Running of the bulls, Pamplona, Spain, 1997

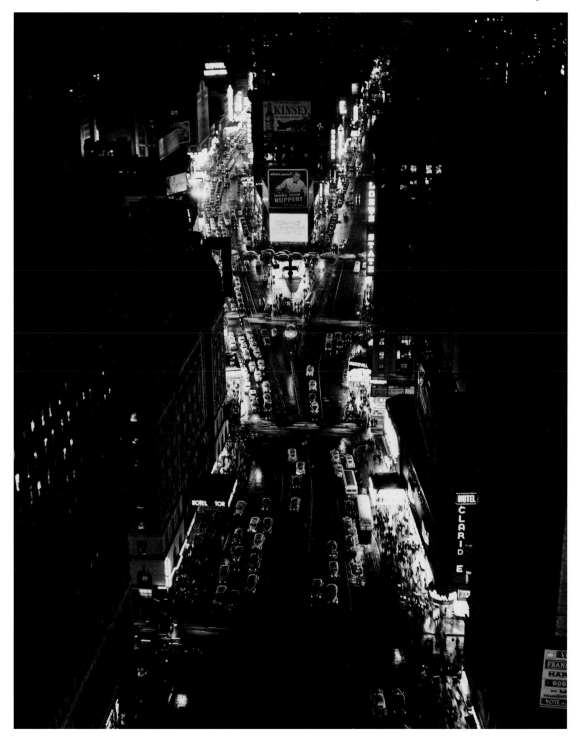

Times Square, New York City, 1944

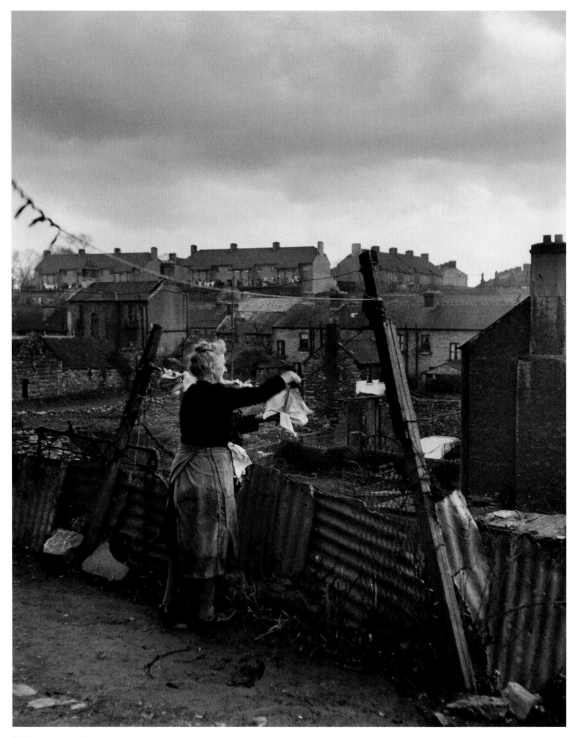

Dublin slum, 1948

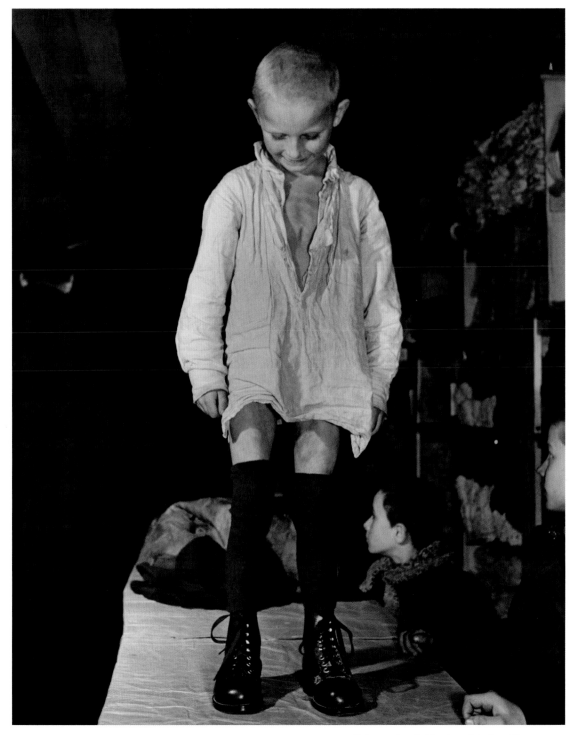

Trying on donated boots and clothes, Warsaw, 1947

John **Loengard** 1934–

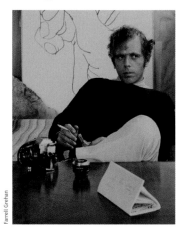

Farrell Grehan

The Natural Look

Loengard was a promising Harvard *Crimson* photographer when LIFE asked him to shoot a picture of a freighter grounded off Cape Cod in 1956. The photo never ran, but the assignment kicked off Loengard's long association with LIFE. He freelanced for a while, then, in 1961, when the editors wanted to infuse an aging staff with new blood, they hired him. Getting natural expressions from the faces of the famous was his forte, though his toughness impressed the soldiers in Vietnam. "One thing that amazed the . . . veterans was his disdain, if not outright contempt, for the nightly dangers which abounded," one reporter said. "Another was his appetite for a cuisine which to any newcomer was not only inedible but unthinkable. The menu, when other food was scarce, sometimes consisted of dog, lizard and even rats." Loengard went on to become LIFE's seventh picture editor. He also helped create the stunningly successful *People,* and served as its first picture editor.

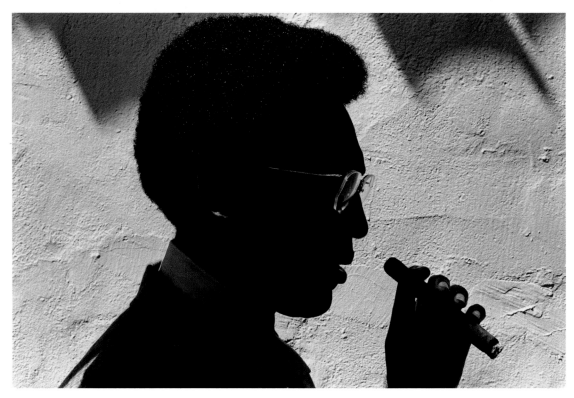

Bill Cosby, Beverly Hills, 1969

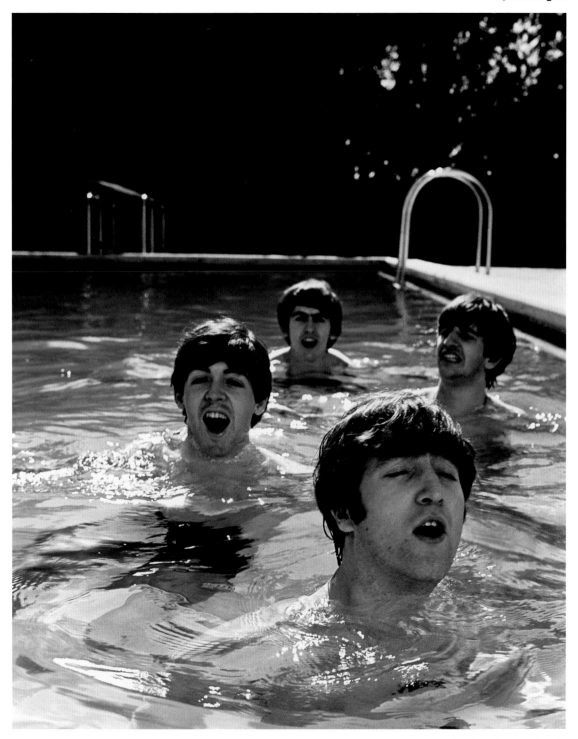

The Beatles, Miami Beach, 1964

Ranch foreman Whistle Mills, Arizona, 1970

Georgia O'Keeffe on her roof, Ghost Ranch, New Mexico, 1967

Shaker fence, Sabbathday Lake, Maine, 1967

Henry Moore's *Sheep Piece*, Much Hadham, England, 1983

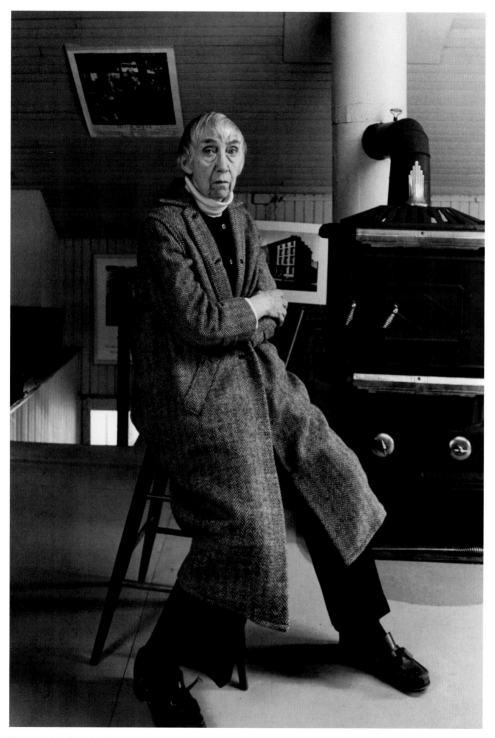

Photographer Berenice Abbott, Maine, 1981

Photographer Brassai, Paris, 1981

Hands and faces are his favorite
subjects. "If I'm very close in on the
face, expression doesn't exist,"
Loengard once said. "The face
becomes a landscape of the lakes of
the eyes and the hills of the nose."

Furniture-maker George Nakashima, New Hope, Pa., 1970

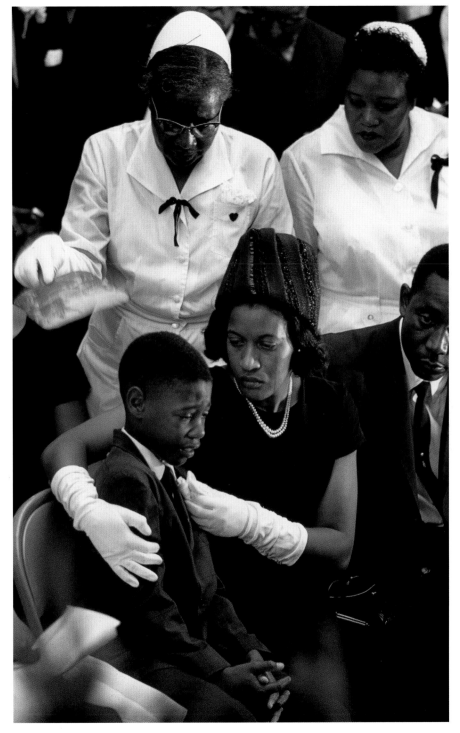

Myrlie Evers and son Darryl Kenyatta, at Medgar Evers's funeral, Jackson, Miss., 1963

Michael **Mauney** 1937–

Last of His Kind

The last photographer to join the LIFE staff before the
weekly magazine closed in 1972 was Michael Mauney,
a veteran newspaper photographer from North Carolina.
Mauney was relieved to be away from the hard-news
pressure of bagging the defining moment of an event:
"I just always shied away from putting myself in a position
of having to get that moment," he once recalled. "I'd
be around on the back side shooting something else or
something." Instead, he gravitated toward capturing
people's reactions to the big scene. LIFE's folding ended
what he considered his apprenticeship. "I wish they'd gone
on another couple of years," he said. "I think I would've
developed a lot more as a photographer."

A couple during sex education class, Cedarburg, Wis., 1969

Former Hanoi prisoner Lt. Col. Norris M. Overly with his family, Wright-Patterson Air Force Base, Ohio, 1968

Thomas **McAvoy** 1905–66

John Sadovy

The Candid Camera

LIFE debuted in 1936 with four staff photographers—Margaret Bourke-White, Alfred Eisenstaedt, Peter Stackpole and Thomas McAvoy—all now regarded as masters. A newspaper veteran before joining the magazine, McAvoy specialized in candid news shots. He was nearly alone in his approach, as the uncontrived portrait was then revolutionary. McAvoy was the complete pictorial chronicler of Franklin D. Roosevelt; one series of natural shots so unnerved the President that the White House barred further unposed pictures. McAvoy took the first photo of the Senate in session, prompting a rule banning candid Senate shots. The conventions of journalism that restrain photographers today did not hold McAvoy back. He once hired a limousine and improvised a pass to sneak into a high-security cold-war diplomatic reception. He would employ all kinds of trickery—disguises, teeny cameras snapped discreetly—to get an honest picture.

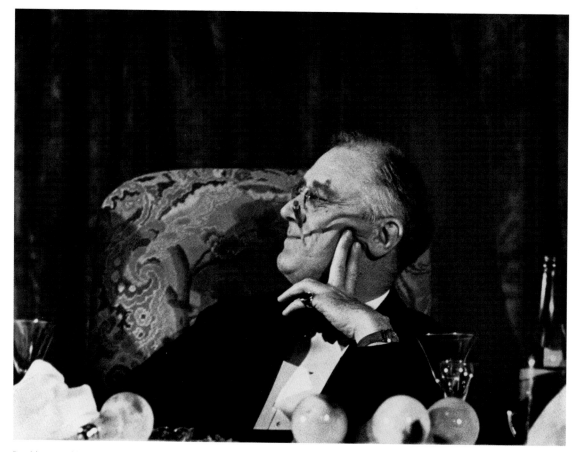

President Franklin D. Roosevelt during speeches at the Jackson Day dinner, Washington, D.C., 1938

Marian Anderson's Easter concert at the Lincoln Memorial, 1939

The opening of Congress, Washington, D.C., 1940

Blind doctor Albert-André Nast using his ear instead of a stethoscope, Chelles, France, 1953

Konrad Lorenz studying the behavior of goslings, Westphalia, Germany, 1955

FDR's desk as he left it before his death, Washington, D.C., 1945

Leonard **McCombe** 1923–

A Sense of Moment

Born off the coast of England on the Isle of Man, McCombe, as with many other photographers, originally meant to be a painter, but a sarcastic instructor suggested he go get a camera. Good advice: McCombe was a pro by age 16, and at 21 became the youngest Fellow in the 91-year history of the Royal Photographic Society. His gripping war pictures caught the attention of LIFE, and in 1945, at age 22, he began working for the magazine. McCombe became known for his "candid" work and an uncanny knack for seizing the moment in which people are at their most revelatory. Said the photographer: "I want my work to be thought-provoking rather than entertaining." He clearly succeeded at prompting us to think, but it was always with a measure of grace that made his work a pleasure to behold.

Kim Novak on the New York–bound *20th Century Limited*, 1956

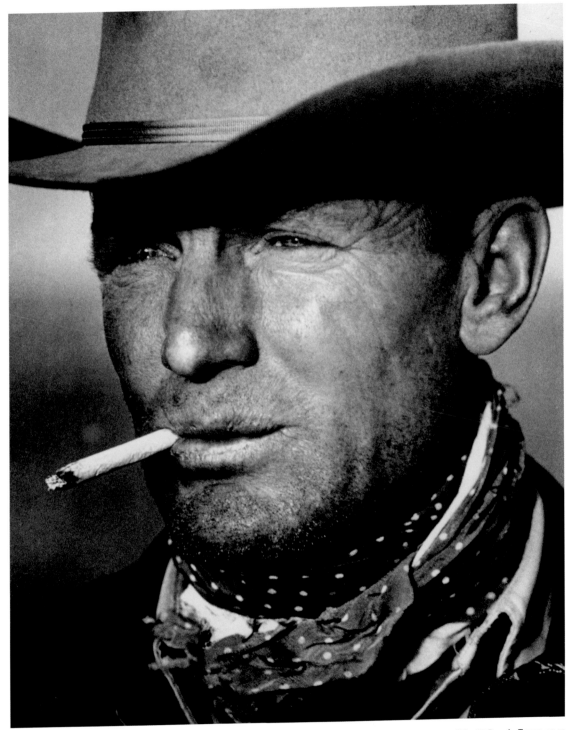

Clarence Hailey Long, foreman of the JA Ranch, Texas, 1949

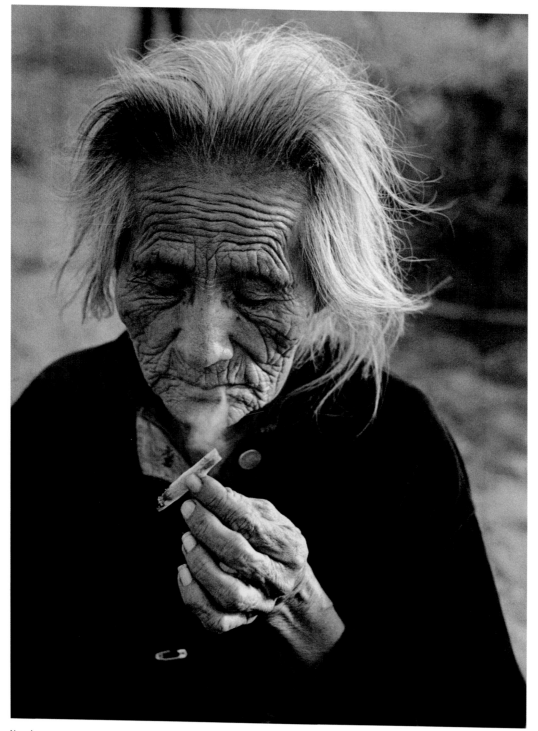

Navajo woman, 1953

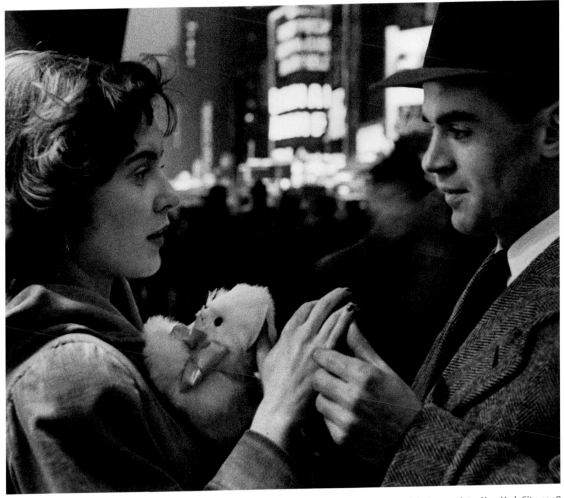

Career Girl Gwyned Filling and Carl Nichols on a date, New York City, 1948

LIFE made the photo essay an important contribution to journalism, and, some would argue, to art. Barbara Baker Burrows is a longtime photo editor at LIFE: "When you're finished with a photo essay, you should pretty much know what the story is about without having read anything. A terrific example would be Leonard McCombe's *Career Girl*. People had never before seen a story like that, one that featured pictures of ordinary people living out their lives."

Train rape victim with fellow passengers, Berlin, 1945

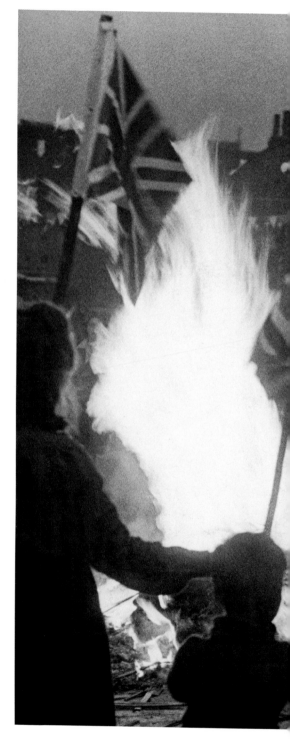

McCombe's World War II work attracted serious attention from LIFE's editors, who made several attempts to secure his services. One day after the war, a LIFE envoy invited him to have a "malted" in an American PX. "I hadn't the faintest idea what a malted was," McCombe recalled, "but I had never tasted anything so delicious. So I decided that, with the salary LIFE was offering me, and malteds in every drugstore, America was the place for me."

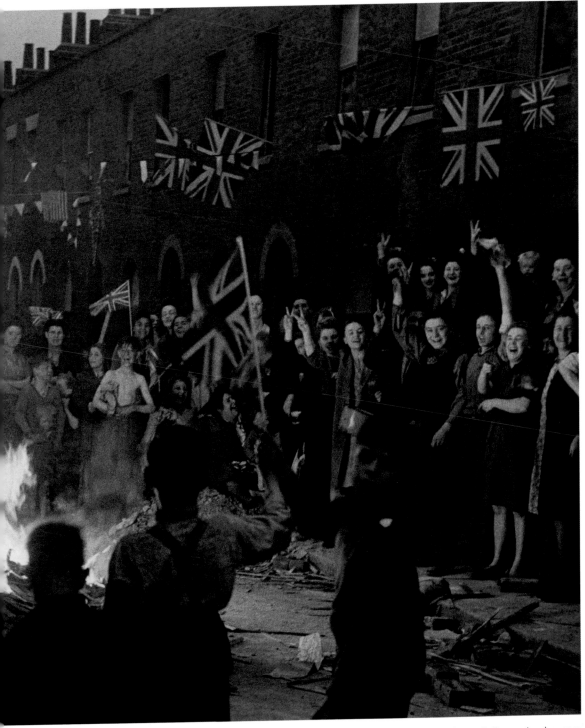

Britons celebrating the end of the war in Europe, London, 1945

Leonard McCombe

Kindergartner crippled at birth by the drug thalidomide, United Kingdom, 1968

Johnnie Ray singing "Cry," Los Angeles, 1952

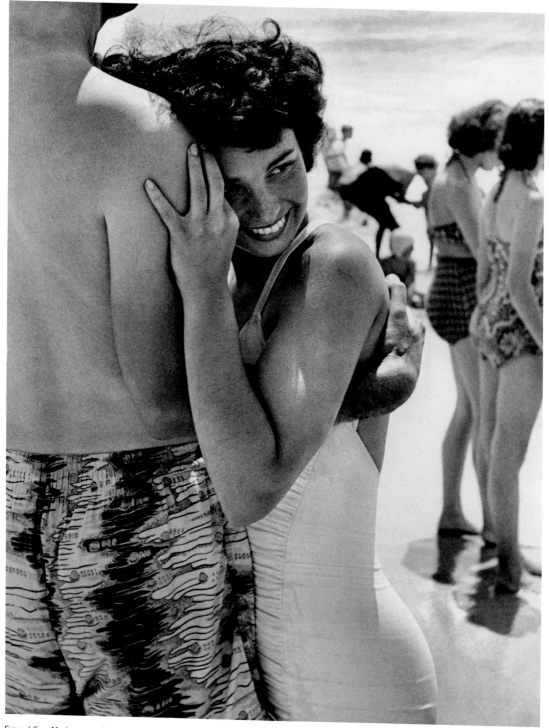

From I *See My Love,* a photographic-fiction romance, 1951

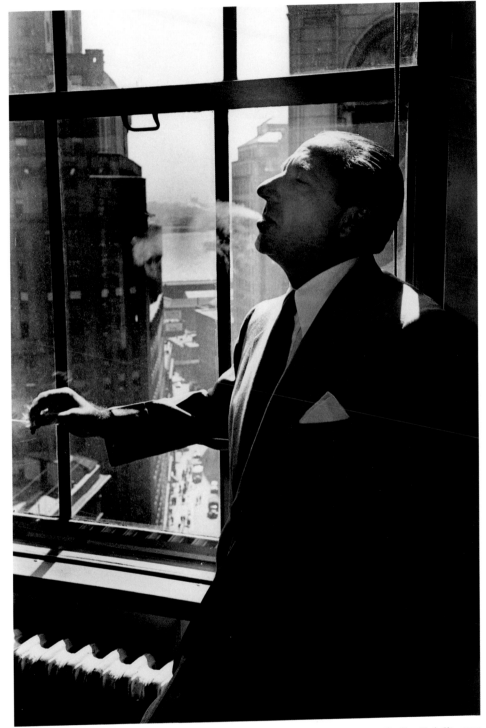

Mobster Frank Costello, New York City, 1949

Joe **McNally** 1952–

Anne Cahill

Mr. Versatility

The plan had all along called for him to be a journalist, but as a writer. Then a required course in photography at Syracuse took him down a different path; working with a camera showed McNally "what I was cut out to do." His start as a copy boy at New York's *Daily News* placed him in the company of some first-rate shooters. Subsequently, the wonder boy was employed at one interesting job after another, all the while learning, until he developed into the can-do photographer who, at the top of his profession, noted: "The qualities that I think get underestimated quite often are durability and tenacity and a willingness to just keep at it. Time spent behind the camera is just phenomenally important." *American Photo* put it best when they said in 1994 that McNally was "perhaps the most versatile photojournalist working today." That same year, LIFE made him its first staff photographer in two decades. He has continued to work nonstop, most notably for *National Geographic,* always on the lookout for the next new thing.

Leonard Bernstein at home, Fairfield, Conn., 1988

Firefighters Richard Gleason, Patrick Gleason and retired firefighter Peter Gleason, near Ground Zero, New York City, 2001

Michelle Pfeiffer, 1995

Steve Martin, 1992

Gail Devers, 1996

Poppo, a Japanese performance artist, East Village, New York City, 1985

In a LIFE piece on the cost of war that was shot by McNally in
Afghanistan and, here, in Rwanda, chilling panoramic images were
the order of the day. In this sanctuary in Ntarama, skulls and
skeletons were on view as a memorial to the 2,000 who died there.

Ntarama sanctuary, 1997

Vernon **Merritt** 1940–2000

Vernon Merritt III

The Strong, Quiet Type

"He was the epitome of a Southern gentleman," said Bill Eppridge. This apparently included having the courage to stand up to the less gentle of his brethren. As just one example, when integration was ordered in Tuskegee, in his home state of Alabama, black students were bused to another town. Merritt got on one of the buses, and "when we got there, Sheriff Jim Clark came onboard. I had a couple of Nikons around my neck, and he snatched them off and whacked me with a cattle prod. I was shocked a few times and hit a couple of times and then thrown out on the street. I wound up in jail."
In Vietnam, he was shot by a sniper and paralyzed for months. Co Rentmeester was in Vietnam with him: "He was soft-spoken, but he was also a major daredevil. He was somewhat of a risk taker, which in the world of journalism and photography makes you successful."

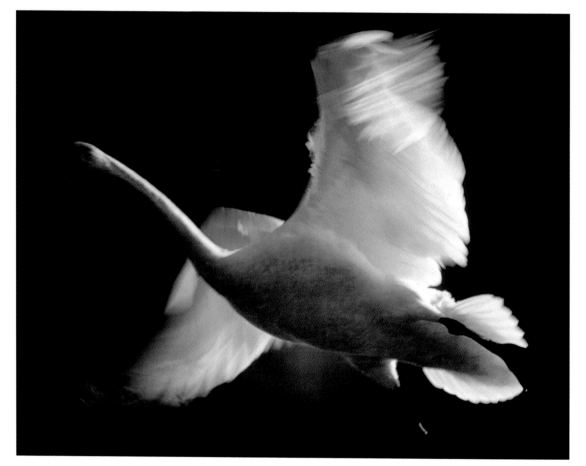

Trumpeter swan, 1970

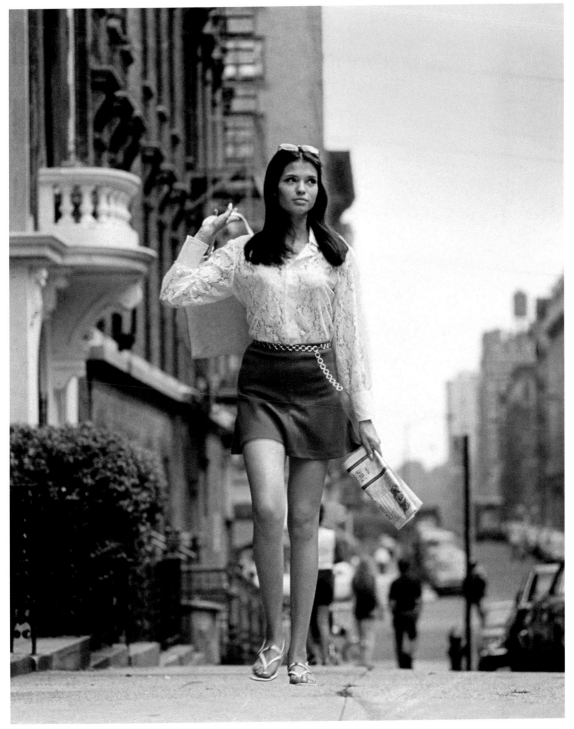

"The New York Look," 1969

Hansel **Mieth** 1909–98

That Darn Monkey

Two German teenage lovers rambled across Europe in the 1920s—sleeping under bridges and scratching out a living taking pictures of fellow bohemians as well as struggling laborers. But as Hitler rose to power, Hansel Mieth and Otto Hagel fled to America and carried on their work in California, documenting working conditions on farms and fishing boats. She landed a job at the Works Progress Administration, then at LIFE, and he became a famous photographer in his own right. According to Mieth, they married to appease LIFE editors in a hasty dual-wedding ceremony in which Robert Capa also got hitched—strictly for American citizenship. After Mieth extensively photographed a rhesus monkey study, she was furious that LIFE editors ran only one picture: a sullen, runaway rhesus she had pursued into the water. Although it became her most iconic image, she resented it: "I call him the monkey on my back."

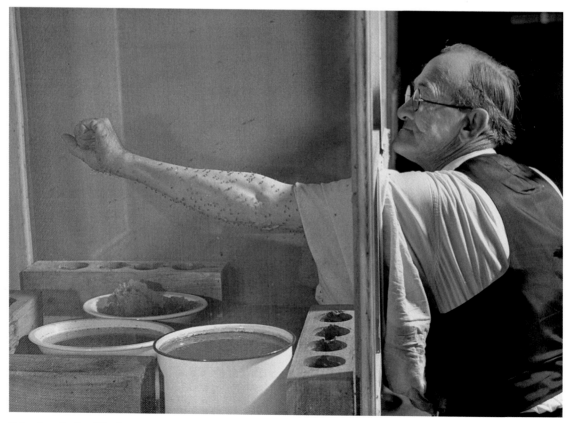

Yellow fever testing, Miami, 1940

Rhesus monkey, Santiago Island off Puerto Rico, 1939

The photographer's sister, Emma, Fellbach, Germany, 1950

Wartime prejudices faced by the German-born Mieth and her husband helped them empathize with the plight of Japanese Americans. LIFE assigned the duo to photograph the internment camp at right, but then declined to run the story. For the article "We Return to Fellbach" they explored the postwar emotions in their hometown 20 years after they had left. A few weeks before the story ran, Mieth's sister (above) died of heart disease.

Japanese American internees saluting the flag in –18° weather at a relocation center, Heart Mountain, Wyo., 1943

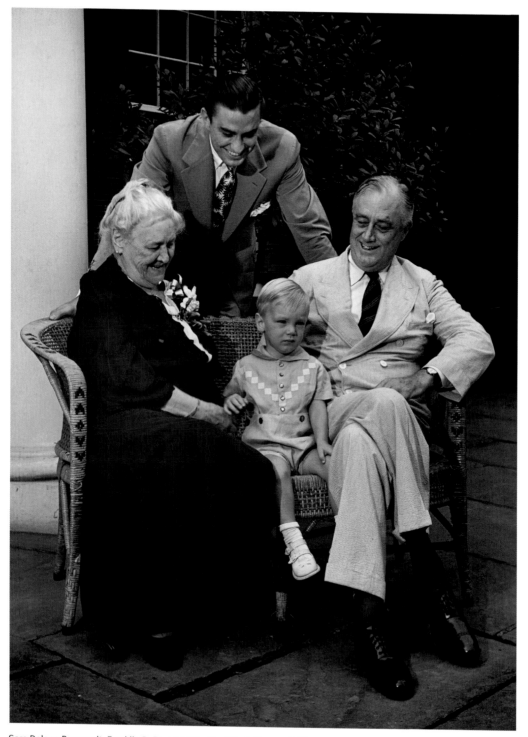

Sara Delano Roosevelt, Franklin D. Roosevelt Jr., Franklin D. Roosevelt III and President Franklin D. Roosevelt, 1940

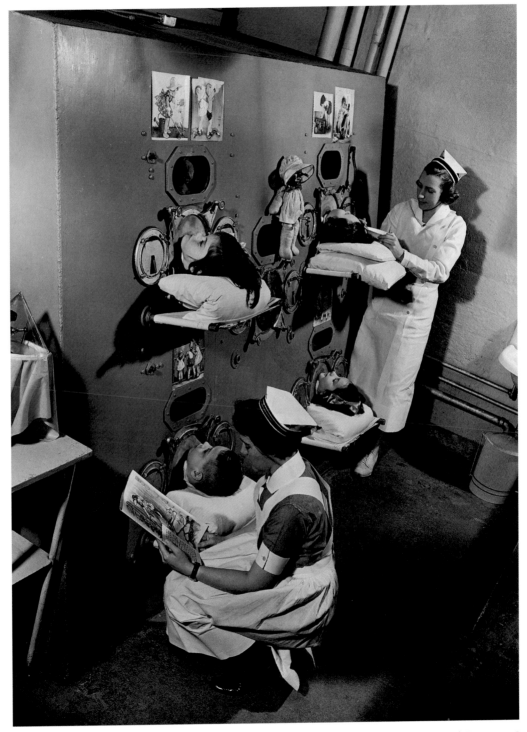

Iron-lung treatment for polio, Children's Hospital, Boston, 1938

Gjon Mili 1904–84

The Instant

For a photographer who was far removed from the realm of bland portraiture, it is amusing to recall that he had a sampler in his New York City studio that proclaimed, ALL THE WORLD'S A CAMERA. LOOK PLEASANT, PLEASE. Gjon Mili was born in Albania and raised in Romania, before emigrating to America to study electrical engineering at M.I.T. After working at Westinghouse on photographic applications of lighting techniques, he met in 1937 with M.I.T.'s Harold Edgerton, who had developed the stroboscopic light. Mili experimented with the process, then did a shoot for LIFE of tennis star Bobby Riggs in action, setting off a long relationship with the magazine. The pictures, taken in 1/100,000th of a second, also marked the beginning of a decade of strobe work: "Time could truly be made to stand still. Texture could be retained despite sudden violent movement." Mili went on to take all manner of photographs, marked always by a command of the medium infused with craftsmanship and economy.

Frog jumping into an aquarium, 1941

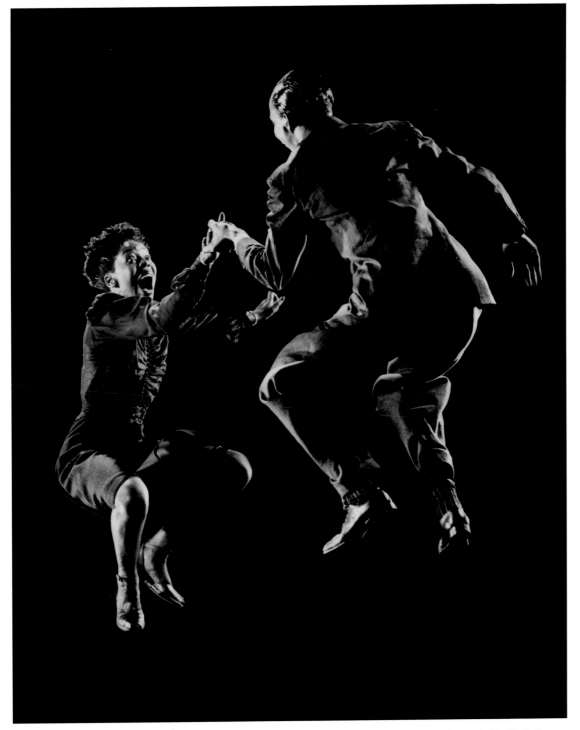

Willa Mae Ricker and Leon James demonstrating the lindy, 1943

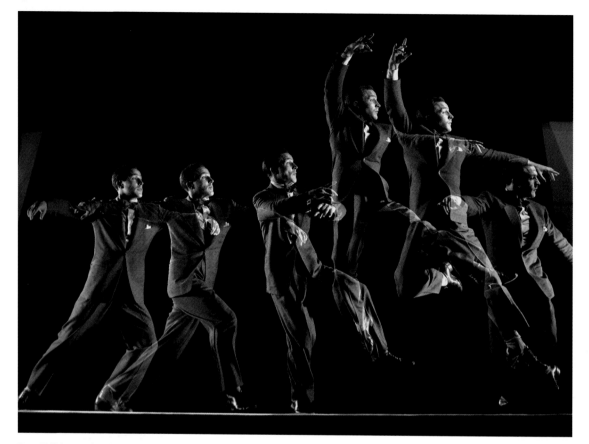

Gene Kelly's grand jeté, 1944

As an amateur oboe player, Mili had a real appreciation
for the performing arts, and over the years he made
many lovely photographs of dancers, musicians and
actors. He also made a number of fine short films, with
such subjects as Dave Brubeck, Lester Young, Pablo
Casals and Pablo Picasso. Mili's photograph of Picasso
sketching with a penlight is among his most famous.

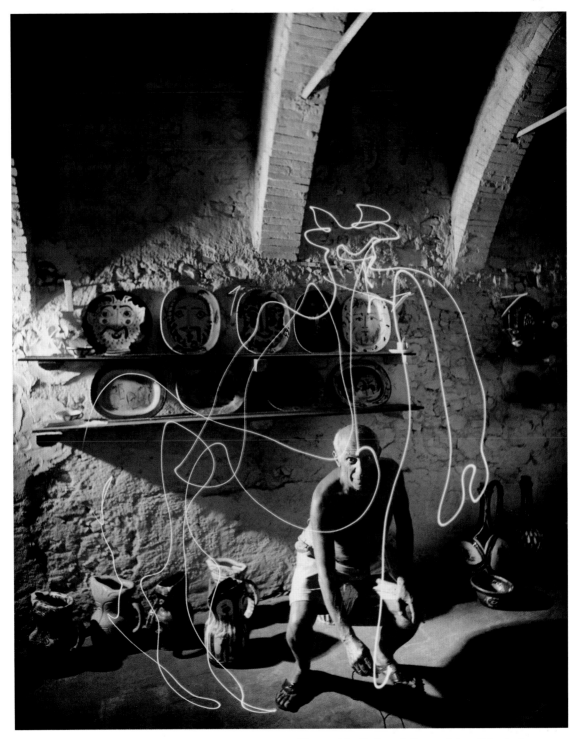

Picasso at the Madoura Pottery workshop, Vallauris, France, 1949

Nora Kaye performing a pas de bourrée, New York City, 1947

"My generation came at a time when photography was advancing by leaps and bounds, creating the impulse to experiment and to seek new approaches." The time finally came, though, when the device that had made him a star was no longer enough: "After a decade I became fed up with the strobe because I had done most everything once and I didn't want to repeat myself." Mili would not completely abandon the strobe, but he worked more and more without it, and with very gratifying results.

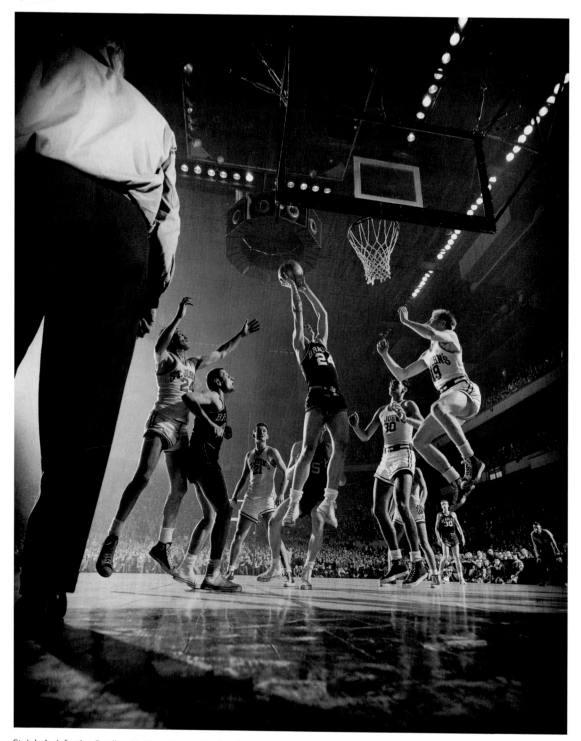

St. John's defeating Bradley, Madison Square Garden, New York City, 1951

Ted Williams, 1941

Playwright Sean O'Casey at home, Great Britain, 1964

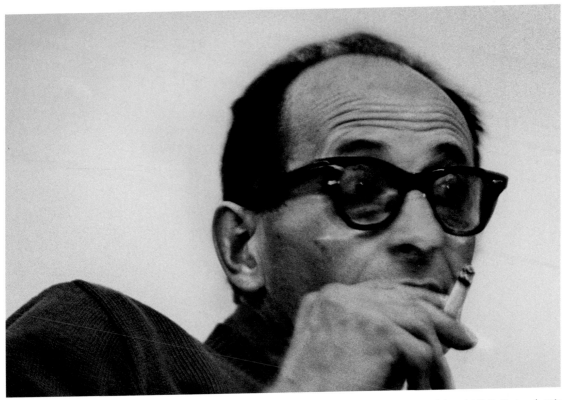

Nazi war criminal Adolf Eichmann in his cell at Djalameh Jail, Haifa, Israel, 1961

Francis **Miller** 1905–73

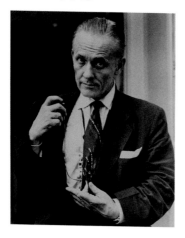

Secret Shooter

James Bond could not have concealed a camera with more finesse. Miller hid them in cigarette cases, camouflaged them with neckties and carved out the pages of a copy of *The Best-Known Novels of George Eliot* to encase his lens. His agility with a surreptitious camera was so well-known, a colleague once blew his cover by yelling to him, "Hey, Miller, where you got the camera hid this time?"

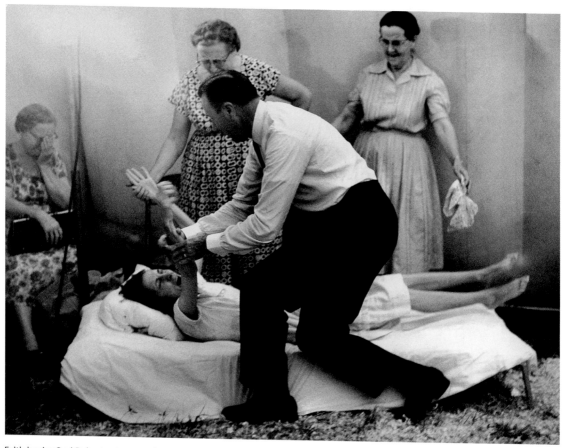

Faith healer Oral Roberts at a crusade meeting, Texas, 1962

Cocktail party, Chicago, 1957

Francis Miller

Adopted German brothers, St. Louis, 1958

Watching the World Series, Chicago, 1952

Demonstrating the Aqua Bobber, near Detroit, 1961

Tapirs, Brookfield Zoo, Chicago, 1954

Ralph Morse 1918–

The Right Stuff

After high school, he got a job with a photographer, sweeping floors, delivering pictures, that sort of thing. A few years later, in 1939, he was shooting for LIFE. By the end of WWII, having already covered Doolittle's raid on Tokyo, the initial landing at Guadalcanal and the liberation of Paris, he was the only civilian photographer present when the Germans surrendered to Eisenhower. Seriously loquacious and a perpetual motion machine, Morse designed equipment if it didn't exist and was a master of techniques such as multiple exposures. His ability to adapt the camera for one new challenge after another was what he was all about. In 1958 he began a 15-year period of covering the space program. His immersion in that pioneering field, and his talent for conveying the experiences therein, resulted in some of America's most revelatory, and intimate, photojournalism. As former Managing Editor George Hunt said, "If LIFE could afford only one photographer, it would have to be Ralph Morse."

Start, middle and finish of the 60-yard dash at the Millrose Games, New York City, 1956

Jackie Robinson rounding third base during a World Series game against the Yankees, 1955

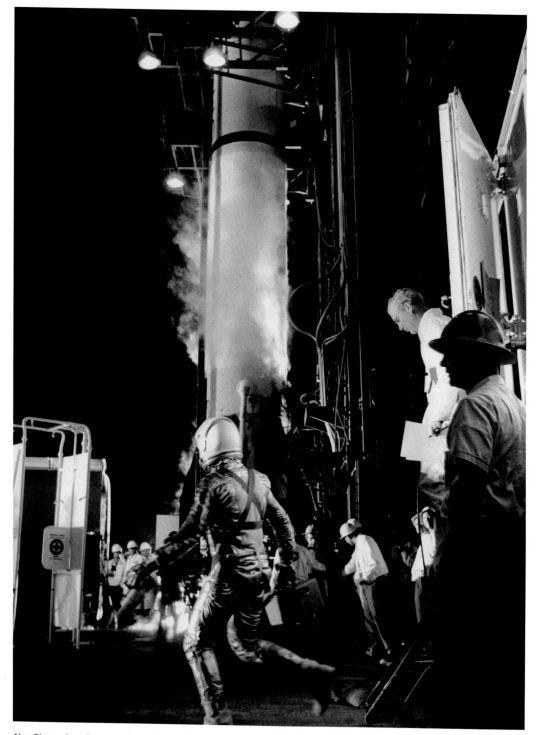

Alan Shepard on the way to becoming the first American in space, Florida, 1961

Project Mercury astronauts' wives, left to right from top: Schirra, Shepard, Glenn, Carpenter, Slayton, Cooper and Grissom, 1959

Astronaut Scott Carpenter and his family, 1962

Apollo 11 lifting off, Cape Canaveral, Fla., 1969

He was such a constant in their activities
that the Mercury Seven team dubbed Morse
the Eighth Astronaut. Those were, of course,
the days when these adventurers stood
on America's highest pedestal. Of LIFE's
coverage, Morse said, "You've got to
remember, we made heroes of the astronauts
the day they were picked . . . We took
seven men who were all good test pilots and
terrific guys, but we were making heroes out
of men who hadn't done anything yet."

Severed head of a Japanese soldier, Guadalcanal, 1943

Light-beam contour map used by the Air Force to design flight helmets, 1954

Army surgeons completing a plaster cast on mortar-wounded medic George Lott, U.S. Army hospital, England, 1945

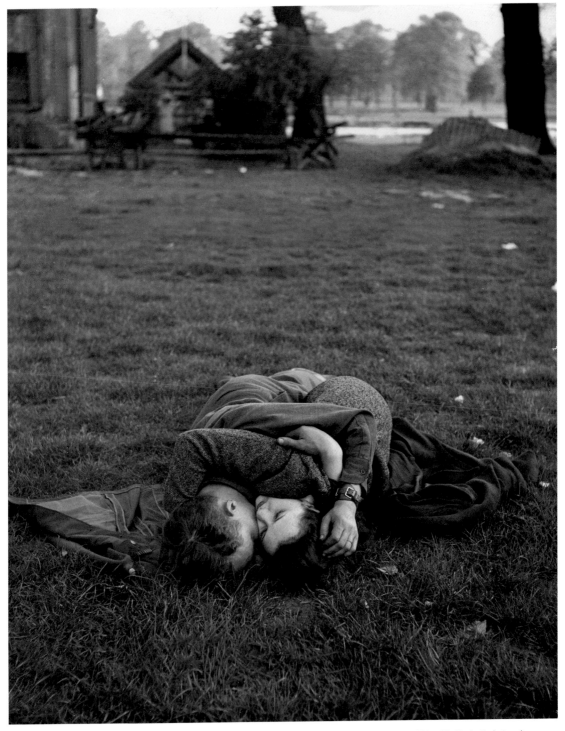

American soldier with his English girlfriend in Hyde Park, London, 1944

Carl **Mydans** 1907–2004

Being There

Having started out as a newspaper reporter, Mydans switched over to the camera and at the height of the Depression worked for the Farm Security Administration, documenting the travails of migrant farm families. After signing on with LIFE, he and his wife, Shelley, became the magazine's first roaming photographer-reporter team. In 1941 they were sent to China to cover Japanese bombing sorties there; late in the year they were trapped in Manila when the Japanese overran the Philippines, and they were held captive for nearly two years before being repatriated in a POW exchange. When the prison camp was about to be liberated, Douglas MacArthur sent Mydans in with the first tanks. Of course, Mydans's picture of MacArthur "returning" to the Philippines is one of history's most celebrated photographic images. Mydans was known also for his intriguing portraits of such as Pound and Faulkner. In the words of David Hume Kennerly, "Carl Mydans is a photographer's photographer and a human's human."

General Douglas MacArthur during American landings at Lingayen Gulf, Luzon, the Philippines, 1945

Senior delegate Mamoru Shigemitsu signing surrender documents on USS *Missouri*, Japan, 1945

USS *Vesole* and Russian freighter *Polzunov,* which is carrying nuclear missiles, during the Cuban Missile Crisis, 1962

Daiwa department store crumbling during an earthquake, Fukui, Japan, 1948

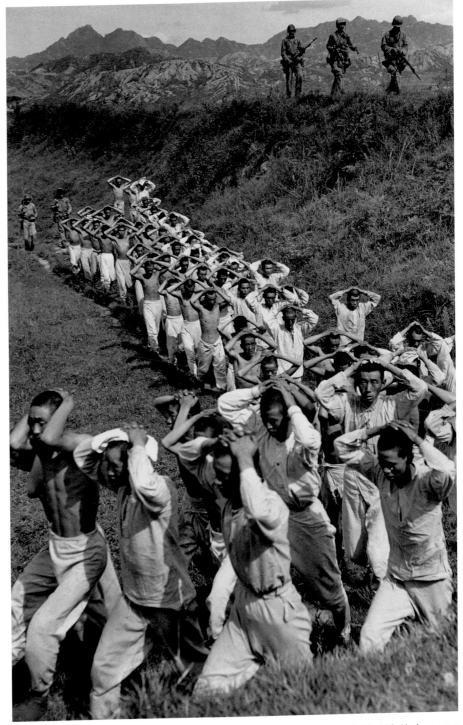

North Korean prisoners guarded by U.S. Marines, 1950

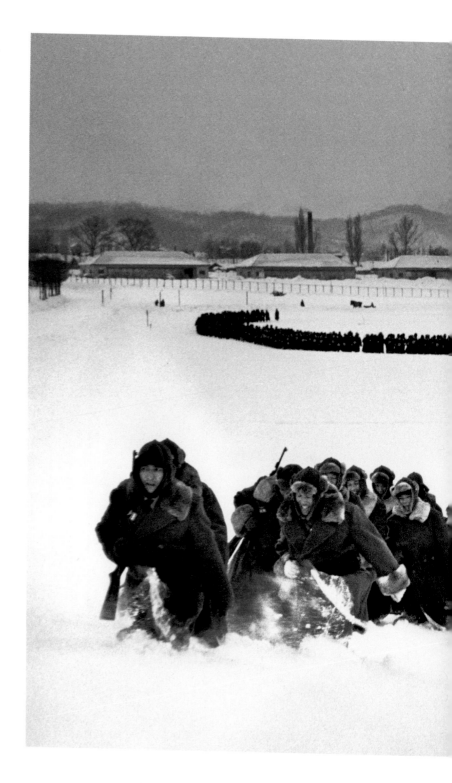

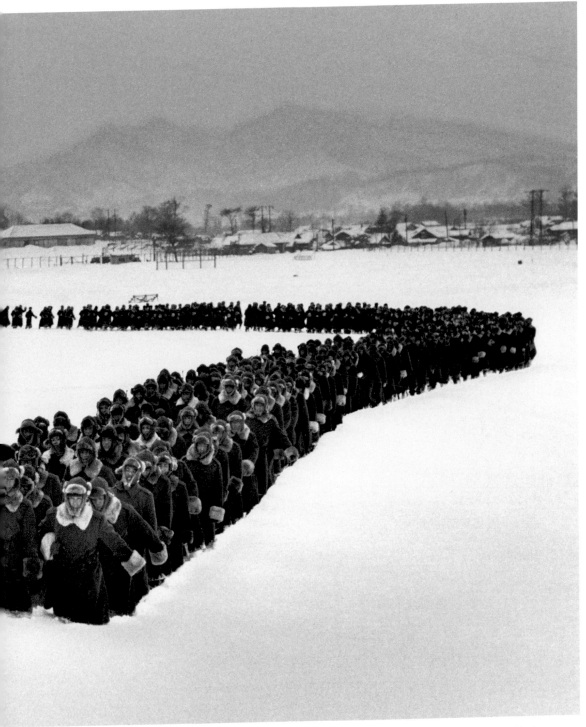

Japanese "Police Force," Hokkaido, Japan, 1951

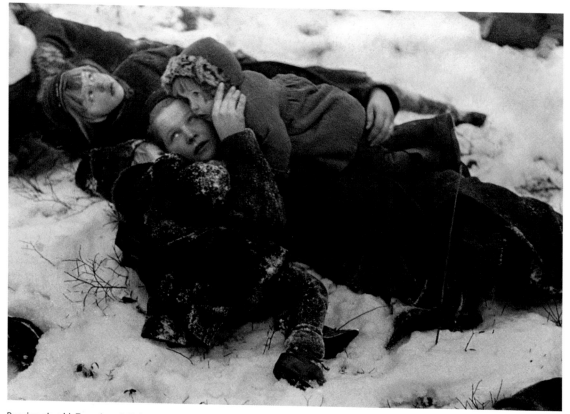

Russian air raid, Tammisaari, Finland, 1940

In the prison camp at Santo Tomas in the Philippines, said Shelley Mydans, "they didn't feed us, so we were very hungry, and we were sick sometimes." Rogers and Todd, at right, were among the three dozen men with whom Carl shared a room at the prison. Between them, the duo lost 131 pounds during their four years of internment.

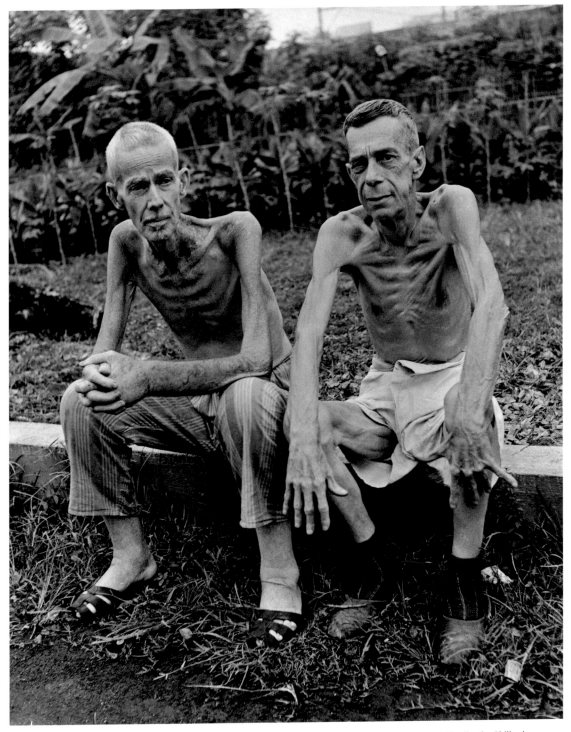

Civilians Lee Rogers and John C. Todd after liberation from a Japanese prison camp, Manila, the Philippines, 1945

Lennart **Nilsson** 1922–

Right from the Start

He began to explore the secrets of life when he was five years old, as an avid collector of flower and plant specimens. By the age of 12 he was taking pictures of them, and three years later his photographic series *Nature of the Farm* ran in a leading Swedish magazine. As an adult, he became quite well known for his landscape and portrait work. Then in 1951, Nilsson saw a row of tiny bottles in a lab, each containing a two-month-old fetus. "I had no idea the embryo was so mature so early. In that same second I knew I would concentrate on the early development of the human." When LIFE published a long cover story in 1965, "Drama of Life Before Birth," Nilsson burst into fame, and the piece, which the photographer said was a dozen years in the making, became one of LIFE's most celebrated articles. Over the years, says Nilsson, he has been asked countless times, When does life begin? His response: "Maybe the first moment of human life, it starts with a kiss."

Willy Falk and his wife, Margareta, who is seven months pregnant, Stockholm, 1966

Living 18-week-old fetus and placenta, Stockholm, 1965

Sperm pushing its way into an egg, Stockholm, 1990

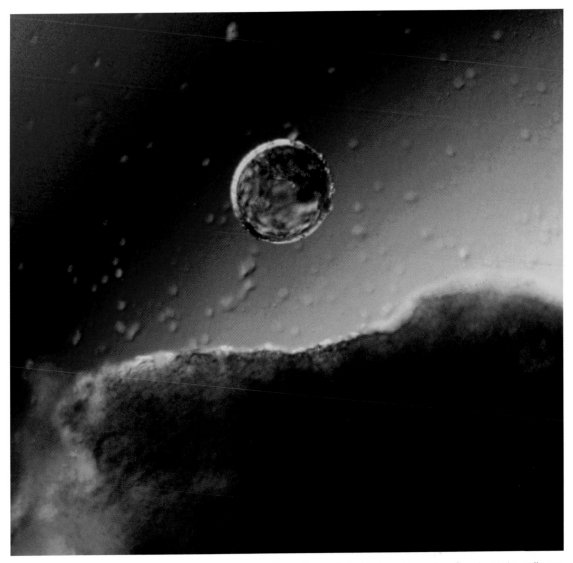

At four days, the primitive embryo, called a blastocyst, bouncing along the uterine wall, 1990

In the intervening years, many of Nilsson's provocative images appeared in LIFE. Then in 1990 came another major cover story, "The First Days of Creation." It was yet one more tour de force of microphotography—a journal of human development from the first second through the earliest hours and days.

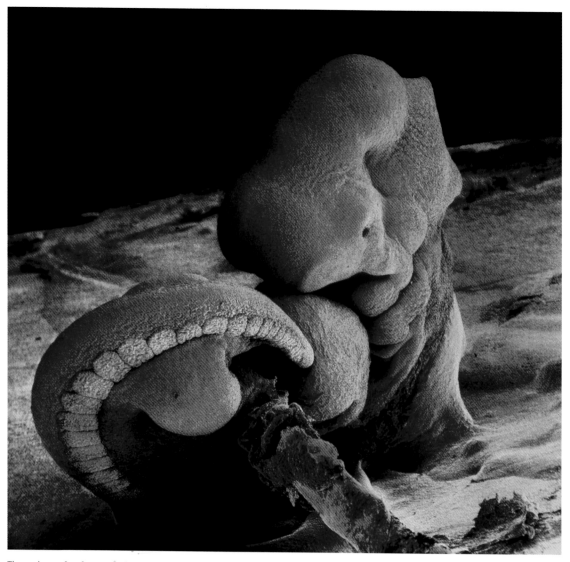

The embryo after four and a half weeks, with a tail that will soon disappear, 1990

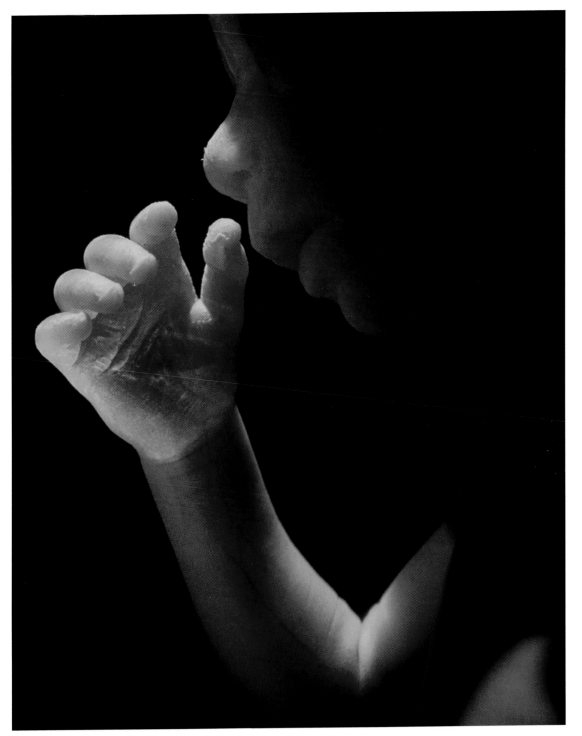

Human fetus at 17 weeks, 1990

John Olson 1947–

Grenades and Guitars

"From the age of 10, I wanted to be a photographer. My father was a farmer, and when he passed away, he was still mystified that you took this little box out and pushed a button and a week later, from the drugstore, these images came back." LIFE learned of the precocious Olson through photos he took for *Stars and Stripes* while serving two years in Vietnam, where he was wounded twice. He became the magazine's youngest staff photographer ever at age 21, and his youth was no doubt central to the success of a completely different sort of feature he shot for LIFE: on rock stars and their families. For the piece, he spent time at the home of Eric Clapton's grandmother, whose parrot kept repeating a particularly nasty phrase, too vulgar to print here. When he asked what the parrot was saying, Grandmum answered, "Gobble gobble." Clapton later explained it all to the baffled Olson. It seems that rockers Delaney and Bonnie had stayed there for a month, and taught the parrot the phrase, "but my grandmother won't admit it."

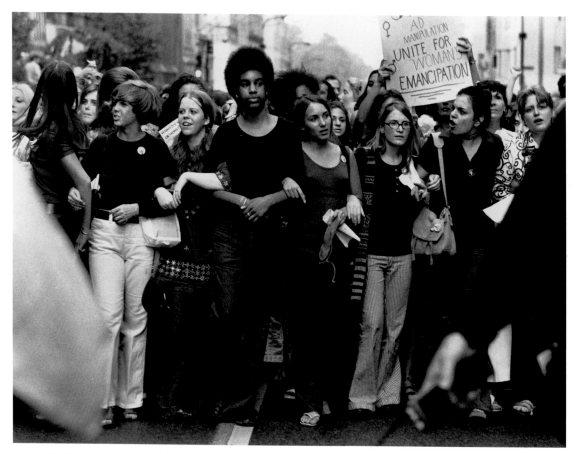

A parade for the 50th anniversary of the 19th Amendment, which gave women the right to vote, New York City, 1970

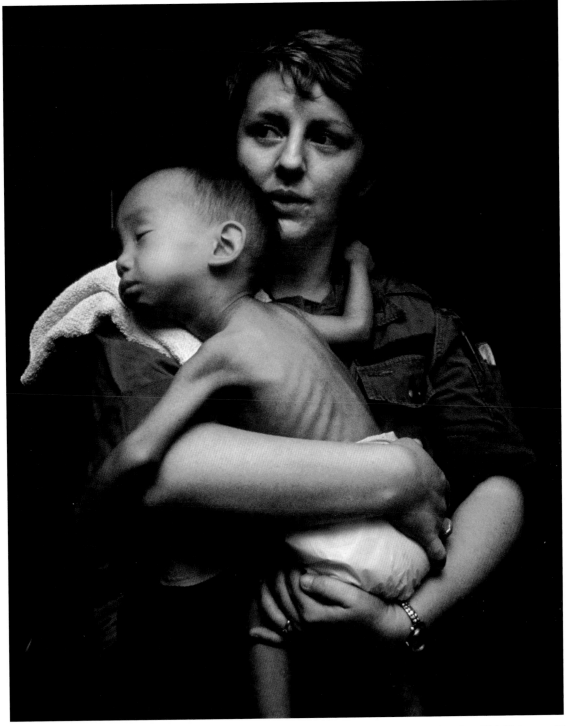

Army nurse Donna Hamilton, Long Binh, Vietnam, 1968

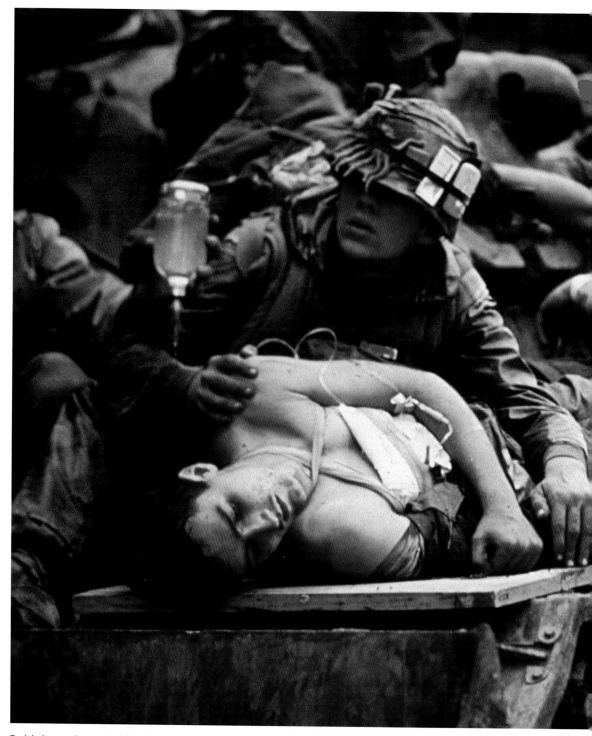

Tank being used as makeshift ambulance, near Hue, South Vietnam, 1968

John Olson

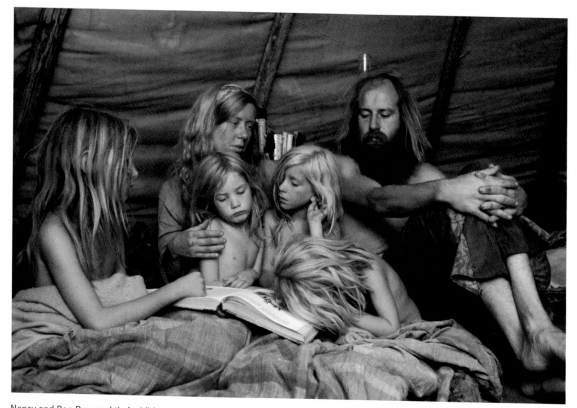

Nancy and Ron Bray and their children, at a hippie commune, Sunny Valley, Ore., 1969

As part of a 1969 LIFE story on hippie communes, Olson photographed this family as they prepared to bed down in their tepee. Dad was a former computer programmer, Mom had gone to Radcliffe. Before joining the commune a year earlier, their search for faith had led them to civil rights work and Quakerism.

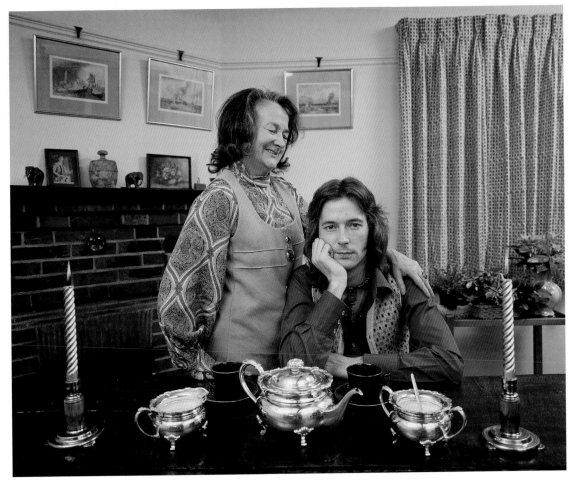

Eric Clapton and his grandmother in the house he bought her, Surrey, England, 1971

Gordon **Parks** 1912–2006

The Renaissance Man

Something mighty there is inside a man that takes him from being the youngest of 15 children raised in Kansas poverty, something that lets him clear the cruel hurdles implanted by a racist society, something that permits not merely survival but mastery of all that he embraced. A poet, and a pianist, a classical music composer, and one very at home with the blues, which permitted him to make the fine biopic called *Leadbelly,* a nice partner to his ceaselessly hip *Shaft,* and a journalist, a novelist, and a man with enough life that even three autobiographies cannot contain the whole, a painter of oils and watercolors, and a photographer of street gangs and Paris boulevards, of fashion extravaganzas and mean Rio streets, and, most of all, a man who will not yield to intimidation . . . It is not simply that he was the first black man to do all these things, but that any man was able do all these things, and do them well.

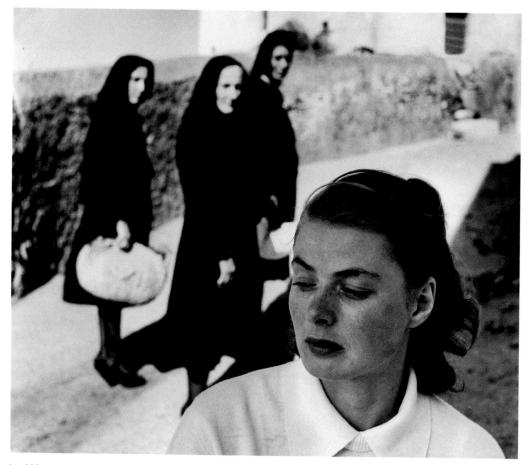

Ingrid Bergman on location for Roberto Rossellini's *Stromboli,* Italy, 1949

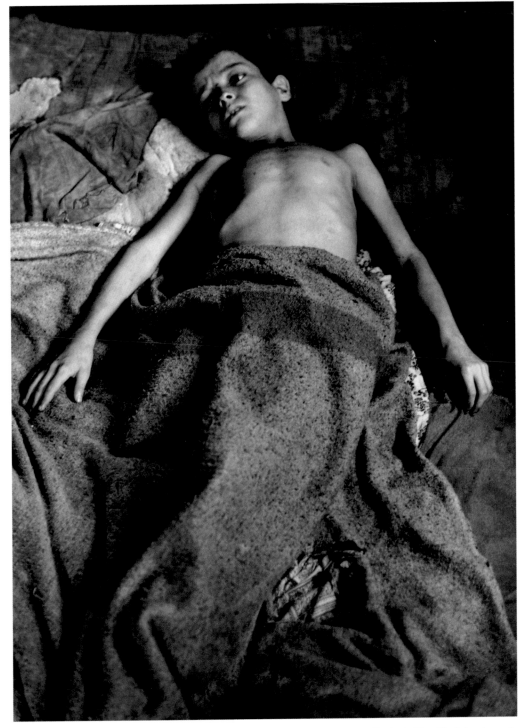

Flavio da Silva, Rio de Janeiro, 1961

Ella Watson, Washington, D.C., 1942

Ella Watson's grandchildren, 1942

Parks had moved his family to Washington, D.C., in 1942 after joining the
Farm Security Administration, and was stung by the racial schism that beset
the agency and the nation's capital in general. Ella Watson was a charwoman
there. After a long day riddled with bigotry, Parks began talking to her. "She
told me about how her father had been lynched. How her daughter died at
childbirth. How she was bringing up two kids on a salary fit for half a person."
Suddenly realizing how his camera could be a real weapon against injustice,
he produced "my first professional photograph," and his signature image.

Ethel Sharrieff, daughter of Elijah Muhammad, leader of the Nation of Islam, Chicago, 1963

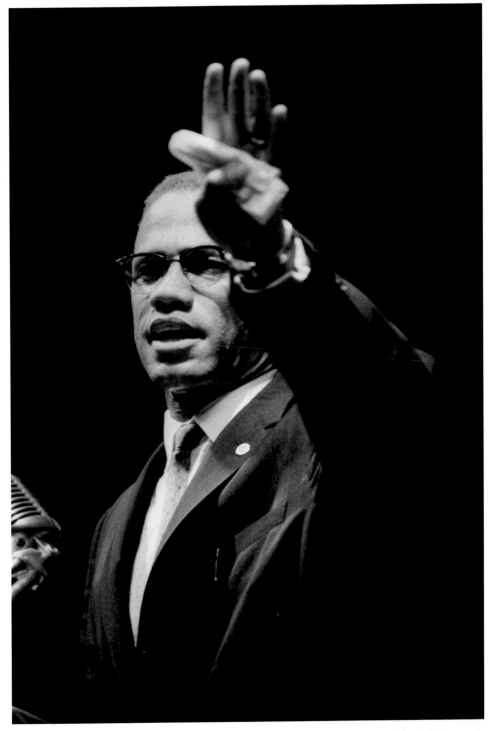

Malcolm X, Chicago, 1963

Harlem gang leader "Red" Jackson, 17, trapped in an abandoned building by a rival gang, 1948

Detectives forcing their way into a suspicious room, Chicago, 1957

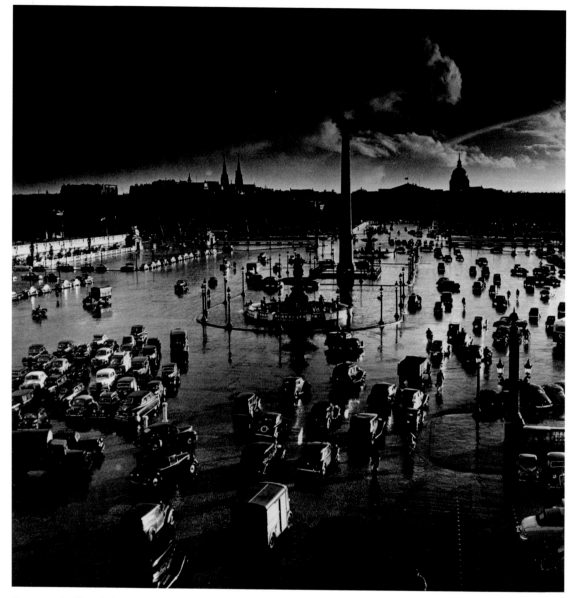

Storm over the Place de la Concorde, Paris, 1951

James Galanos afternoon dress and 15-layer chiffon hat, 1961

Charles **Phillips** 1932–2003

Starting at the Top

It is almost axiomatic that accomplished photographers begin their careers with rather elementary entry-level positions and then work their way up. Phillips, however, had a Leica in his hand the first time out. The six-foot-four towhead began taking pictures while serving in the Army during the Korean War. Upon receiving his discharge, he began work for LIFE. As a staff photographer, he covered protests against the war in Vietnam; he was gassed during the mayhem in the streets at the 1968 Democratic Convention in Chicago. After LIFE, Phillips shot extensively for the Smithsonian Institution and the Architectural Bureau of Indian Affairs.

Vietnam War demonstration outside the White House, Washington, D.C., 1969

Protesting U.S. involvement in the Vietnam War at the Democratic National Convention, Chicago, 1968

John **Phillips** 1914–96

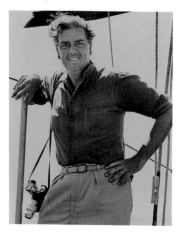

Stickler for a Story

Marshal Tito, then a Yugoslav resistance leader, was holed up in a cave in 1944 wearing a uniform made out of a horse blanket when Phillips arrived to do a portrait. He integrated himself into Tito's life so completely that he once followed the revolutionary to the bathroom. He was quite easy to work with—except when it came to his dog. One time Tito insisted,"'You watch my dog. He jumps.' He had Tigar belly flop in the water. He said, 'Maybe you better get another picture.' That was the only time he worried. He was so proud of Tigar's jumping." Once, to get pictures in Nazi-occupied Austria, Phillips rented a fancy car and put swastikas on the side. Phillips, who left LIFE five years after the war, said, "During the war, nobody could give us instructions because the movement orders were secret. You went along, dreaming up your stories on your own."

Soldiers dancing the Kolo while singing "Tito, Tito, Little Flower, Beloved by All the Youth," Yugoslavia, 1949

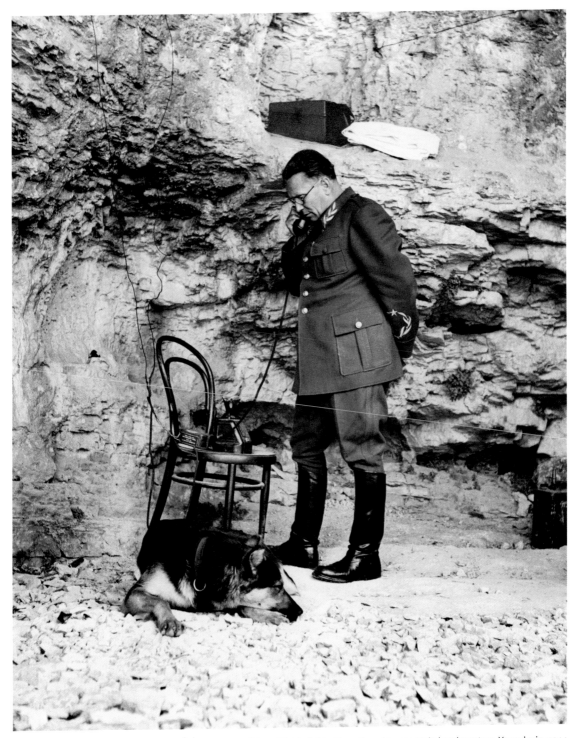

Marshal Tito, with Tigar, talking with his field officers from his mountain headquarters, Yugoslavia, 1944

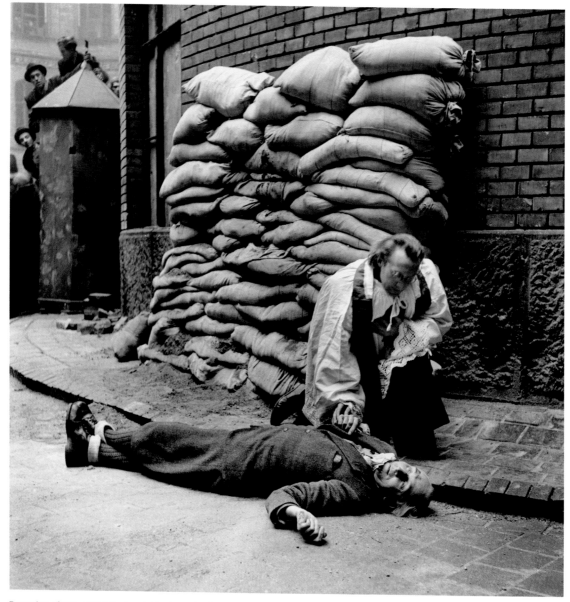

Execution of Prime Minister Laszlo Bardossy, Budapest, 1946

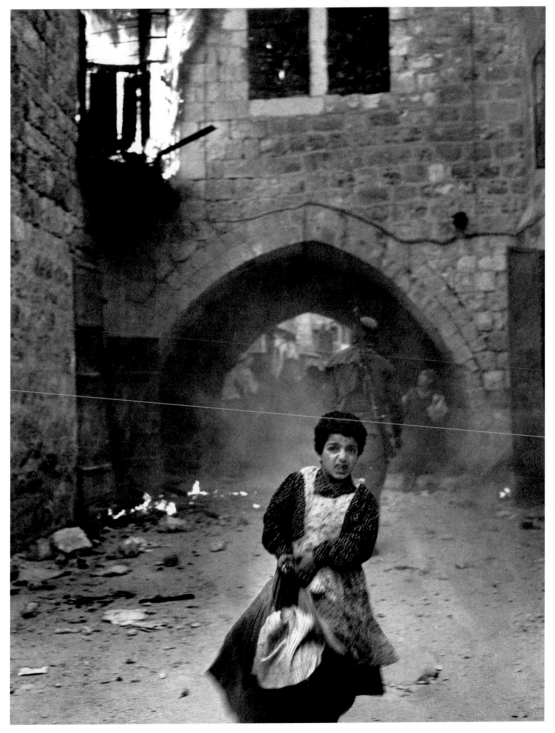

Rachel Levy, seven, during fighting in Jerusalem, 1948

Hart **Preston** 1910–2009

Pictures and Words

"Management said we were the best photographers in the world," he once said, "but actually I think they looked upon us as very highly skilled clowns." This Stanford grad, however, considered himself a "photo reporter," a sort of raconteur with a camera. "They were 'stories,'" he said. "They had a beginning and a middle and an end, as you would have with written journalism." He barely survived the malaria he caught in South Africa, and went on to run *Time*'s Rio de Janeiro news bureau, where he switched to the other side: writing.

The young Shah of Iran and American politician Wendell Willkie on an airplane, 1943

Benny Goodman, Chicago, 1940

Bill **Ray** 1936–

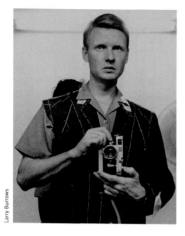

Larry Burrows

A Cornhusker with Zeal

"When a LIFE magazine photographer came to a small town in America, the headline might be 'Missouri Floods—100,000 Homeless; LIFE Photographer Eisenstaedt in Town,'" said Ray, who took up the camera to escape his tiny Nebraska hometown. He always wanted to be closer to the action. He turned down a job at *National Geographic* to be a freelancer in New York City covering people. When LIFE sent him to Vietnam, he would goad pilots to fly him lower. "Damn it, I didn't come here to photograph stars," he once yelled at a pilot, who grinned and took him down. When LIFE planned "One Day in the Life of America" in 1974, Ray was set to shoot pictures in a missile silo. "My mother died, and her funeral was on that day. So that was my assignment." He photographed her funeral for LIFE. Ray said his mom would have liked it that way.

Soldier Elvis Presley, surrounded by handlers, before sailing to Germany aboard the USS *General Randall,* Brooklyn, 1958

Co-ed dorm, Oberlin College, Ohio, 1970

Jane Fonda, 1971

Marilyn Monroe singing "Happy Birthday" to President John F. Kennedy, New York City, 1962

Konosuke Matsushita in the garden of his philosophical institute, Kyoto, Japan, 1964

Man playing a *sis*, Usicar, Turkey, 1970

Ray spent three and a half months in Japan in 1964 for a
LIFE special issue. "I did pictures of Konosuke Matsushita,
the Henry Ford of Japan. I had him walking through his
garden—a beautiful rock garden—and if I wanted him to go
back and do it again, he did it. I don't know if I asked him in
English or what. I guess I waved at him or something.
A lot of gardeners would come out and rake all the stones
just in the right place, and he'd walk again."

Co **Rentmeester** 1936–

Muscular Photography

As if it were yet another competition to be won, Rentmeester throws himself into every photographic job with the same gusto that he called on when he rowed for Holland in the 1960 Olympics. In 1965 he passed up the safety of the media enclave in Watts to record the raw street riots. In Vietnam, a sniper's bullet shattered his camera lens and tore into his left hand. After he mended, LIFE offered him a lengthy sabbatical, but Rentmeester insisted on going straight to a series of wildlife assignments; on the very first shoot, a 400-pound orangutan in Borneo tenderly took his mangled hand into her mouth. Rentmeester has also been responsible for a number of innovations in sports photography, so it comes as no surprise that he has six *Sports Illustrated* covers to his credit. His photographs have appeared in several books, and he wrote *Holland on Ice*, in which he enthuses about skating on his homeland's canals.

Mark Spitz training for the Munich Olympics, Germany, 1972

Jason Michael Waldmann Jr., who weighed 1.2 pounds at birth, The Children's Hospital of Philadelphia, 2000

Michael Jordan, 1984

Nadia Comaneci at the Montreal Olympics, 1976

A man salvaging his furniture as his house burns down during the Watts rioting, Los Angeles, 1965

Black September terrorist, holding Israeli Olympic athletes hostage, Munich, 1972

Rentmeester was handed the Watts assignment very
early in his LIFE career, even before going on staff.
It was daunting: "Looting was taking place right in
front of me, and I was shooting it and taking the
exposed film and putting it in my socks because I had
a tremendous apprehension that somehow I was going
to get into trouble here . . . I was confronted all the time
by African Americans who raged at me. I would thicken
my Dutch accent to show I was not an American."

Balinese farmer and his flock of ducks, Indonesia, 1966

Japanese macaque in a hot spring, Shiga Kogen, Japan, 1970

Arthur **Rickerby** 1921–72

What Goes Around…

He paid his way through Duke by covering sports for local papers. Rickerby spent World War II in Edward Steichen's crack Navy photography unit, chronicling the fall of Japan: battles, prison camps and the surrender aboard the USS *Missouri*. His portraits of politicians were hung in the Museum of Modern Art in New York City. For all that, he is probably best remembered for mastering the craft he started out with: sports photography.

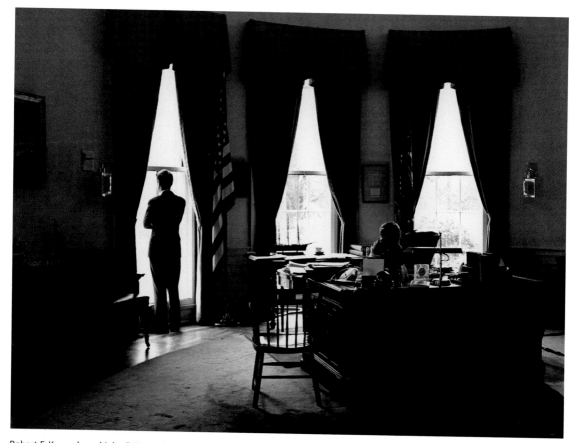

Robert F. Kennedy and John F. Kennedy in the Oval Office, Washington, D.C., 1962

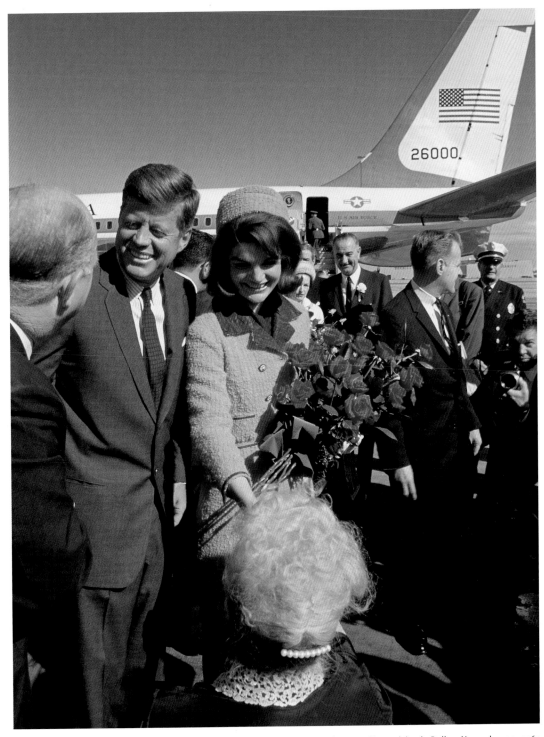

President John F. Kennedy and First Lady Jacqueline arriving in Dallas, November 22, 1963

Arthur Rickerby

NFL title game, Browns and Packers, Green Bay, Wis., 1965

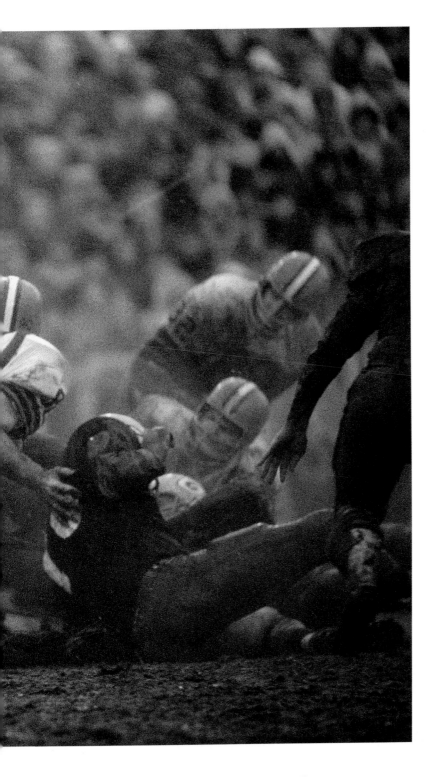

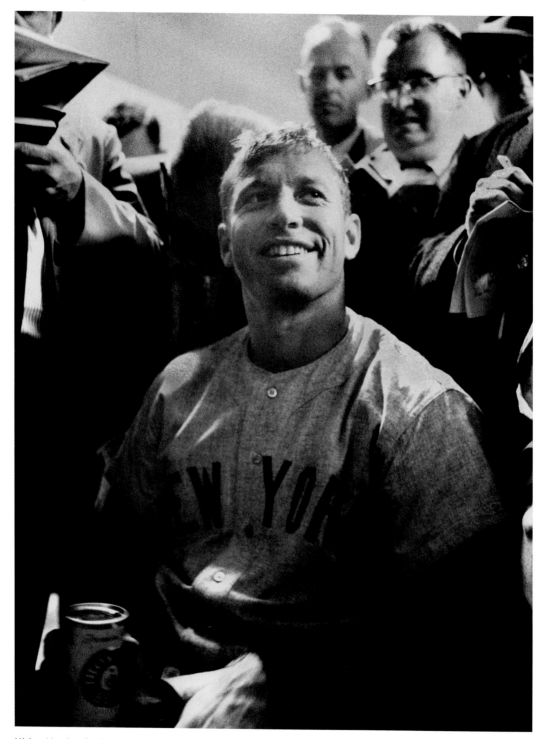

Mickey Mantle, after hitting two home runs in the World Series against the Pirates, Pittsburgh, 1960

Willie Mays returning to the Polo Grounds, New York City, 1962

George **Rodger** 1908–95

Goodbye to All That

A self-taught photographer, he was born in England, and it was his pictures of the London Blitz that brought him to the attention of LIFE's editors. He was on the magazine's staff from 1939 to '45 and traveled widely as a war correspondent—across the Sahara with the Free French and in such outposts as Eritrea, Iraq and Burma. Rodger was with the Allies on D-Day, then was the first photographer to enter the Bergen-Belsen concentration camp. He was trying to figure out how to photograph the dead and dying when "I suddenly thought, 'My God, what's happened to me? This is the end . . . all this absolute horror . . . [and me] thinking of nothing but lovely compositions.'" He had had enough of war, enough of violence. After becoming one of the founding fathers of the Magnum agency, this great adventurer spent many years taking pictures in Africa. Most notable was his brilliant work documenting the Nuba people of Sudan.

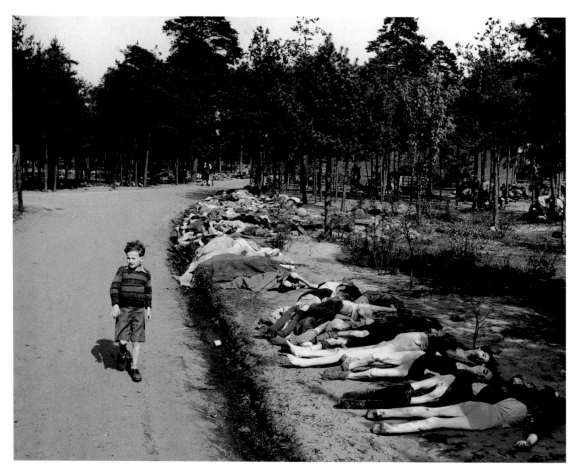

A German boy passing corpses near Bergen-Belsen concentration camp, Germany, 1945

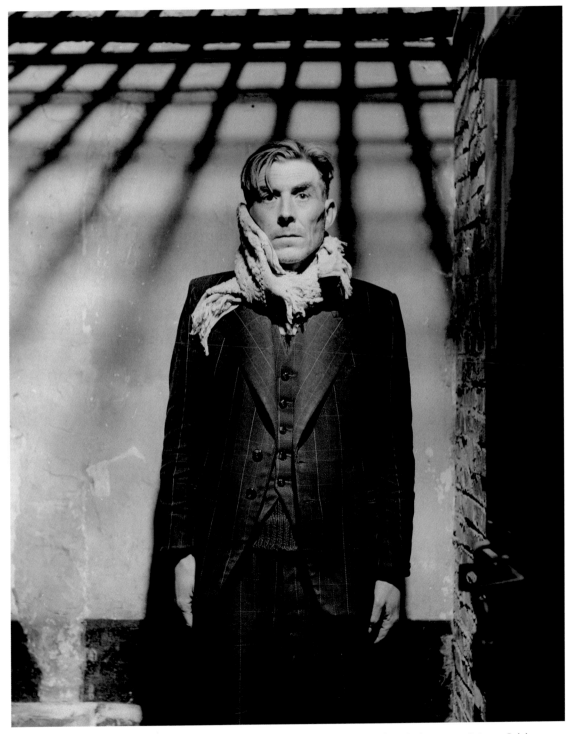

Former SS guard being held at the liberated Breendonk Nazi prison camp, Antwerp, Belgium, 1944

Michael **Rougier** 1925–

The War Within

According to LIFE lore, Rougier is the only unknown who walked into the office and was hired right then and there as a staff photographer. His feat had been to get pictures of a then–camera shy Eva Perón and smuggle the film out of Argentina. It turned out, however, that celebrities would seldom be his subject. As a war correspondent in Korea, he did not aim for action shots but instead focused on "the stresses and strains of a soldier's mind." He also showcased the plight of a Korean orphan in "The Little Boy Who Wouldn't Smile," a story that brought Rougier acclaim and the boy clothes, medicine and toys from readers. Once, while trailing a geological survey crew up a nameless Antarctic mountain, Rougier tumbled down its side and was badly hurt. The peak now bears the name Mount Rougier.

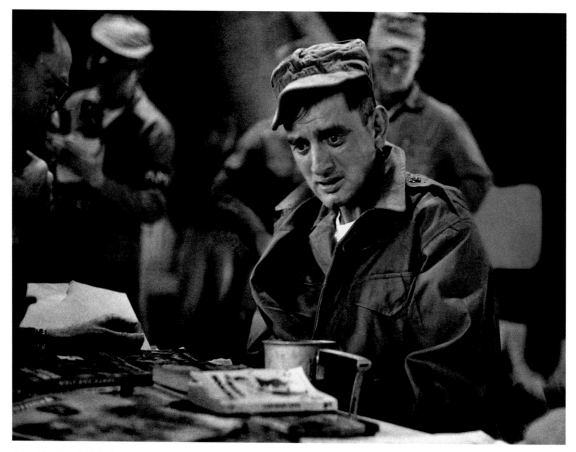

Army Pfc. John Ploch being processed during a prisoner exchange at Freedom Village, Panmunjom, Korea, 1953

Kang Koo Ri at an orphanage, after U.S. soldiers found him next to his dead mother, Korea, 1951

Hungarian freedom fighter during the revolution against the Soviet-backed government, Budapest, 1956

A 22-year-old Marine corporal struck by a Chinese mortar, the last American to die before the Korean War truce was signed, 1953

Before the wedding, Oakes, N.D., 1962

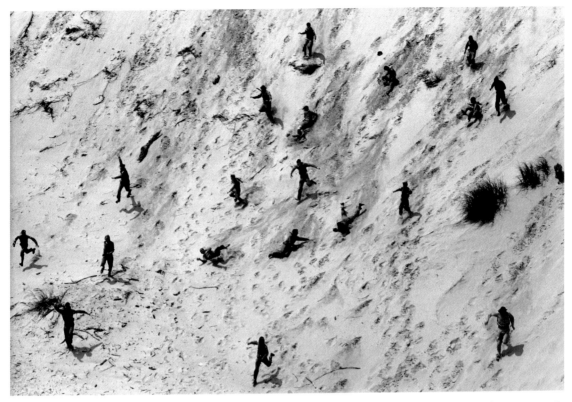

Boy Scouts from Chicago at the Indiana Dunes, 1960

Walter Sanders 1897–1985

The "Giant"

Untold numbers of fathers have bought their first camera to take a picture of their baby daughter. But Walter Sanders was probably the first one who did that and went on to become a LIFE photographer. After studying history and economics in his native Germany, Sanders became fascinated with the camera, and by the mid-1930s had forged a reputation throughout Europe for his storytelling photography. He had also developed a reputation among the Nazis as a man involved in "non-Aryan" activities, so in 1937 he came to the U.S., and he started shooting for LIFE that year. Sanders had a long career with the magazine, which was properly summed up by his colleague Carl Mydans: "In the age of the growth and explosion of photojournalism, Walt Sanders was a giant. He brought with him to the new magazine LIFE the skills he had developed as a young man in Germany and, in sharing them with all of us, played a major role in the making of LIFE magazine."

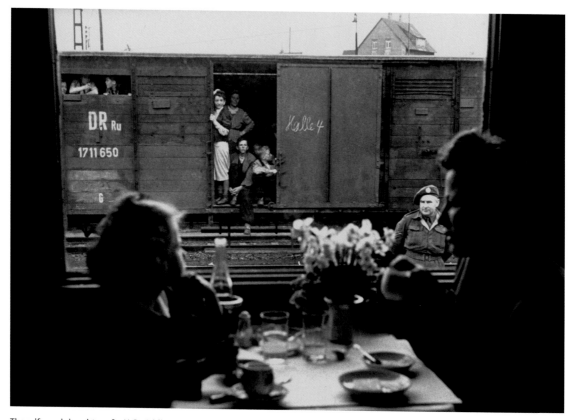

The wife and daughter of a U.S. soldier, opposite displaced Germans, Germany, 1946

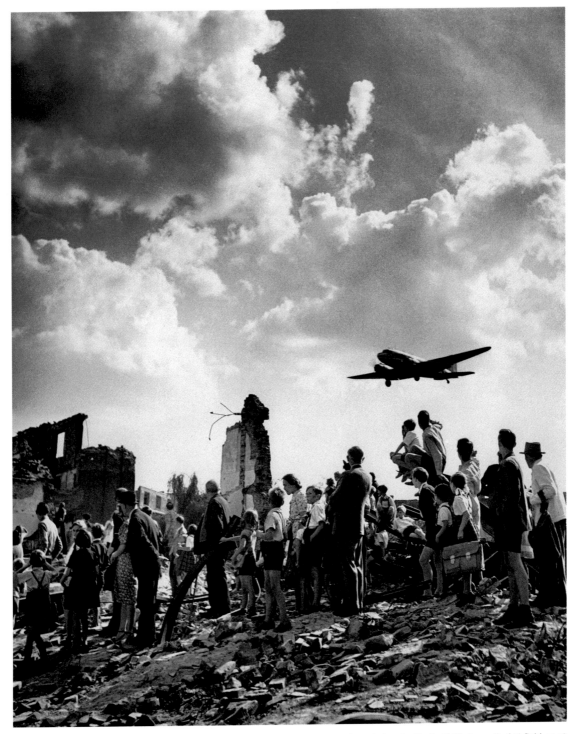

U.S. C-47 cargo plane during the Berlin Airlift, Tempelhof Airfield, 1948

Betty Grable modeling a shirt of her own design, Hollywood, 1943

Fraternity preparing for a spring blanket party at Kansas State Teacher's College, 1941

MGM head Louis B. Mayer (front row, center) with his stars, Hollywood, 1943

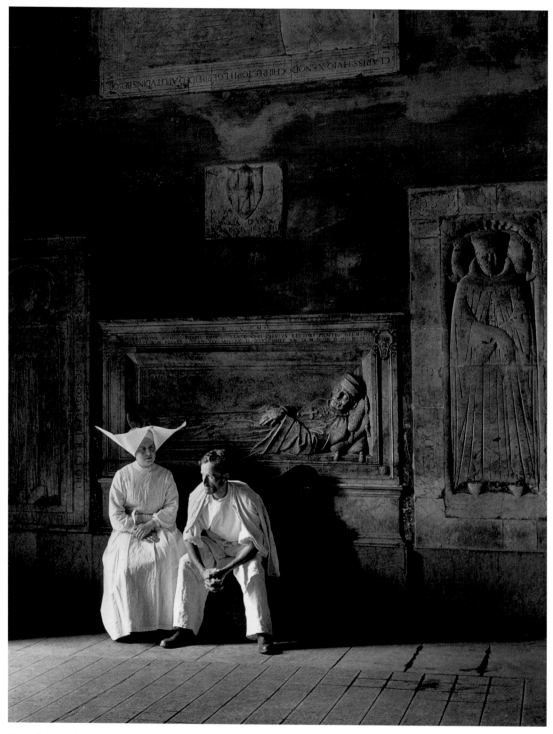

Siena, Italy, 1946

Manhattan, 1941

Eric **Schaal** 1905–94

At One with the Intelligentsia

Salvador Dalí worked side by side with Schaal. Once, instead of painting on canvas, Dalí staged a phantasmagoric scene and Schaal transformed it into a real-life photograph. The brainy Schaal was at ease among many of the profound thinkers and important artists of the mid-20th century. With figures ranging from Albert Einstein to Sinclair Lewis to Woody Guthrie, he was able to blend in so entirely that his subjects seemed to forget he was there.

Huge hands of Russian piano virtuoso Sergey Rachmaninoff, 1943

Bell Telephone engineer in a research room designed to eliminate 99 percent of all outside sound, 1947

David E. **Scherman** 1916–97

Time for a Change

Many LIFE photographers were at the front during World War II, but no one else could claim that one of his photos helped sink a German vessel. In April 1941, Scherman was heading for Cape Town on the Egyptian *Zamzam*, when it was shelled by a German raider. Scherman took a picture of the raider from a lifeboat, then hid the film. When the Germans discovered there had been Americans aboard, they transferred them to a ship. The Americans were repatriated, and the photo ran in LIFE. The British navy, which had been pursuing such a raider, had the picture posted aboard all ships. Eight months later, a British plane spotted the raider and sank her. In 1953, according to Scherman, LIFE's Managing Editor Ed Thompson said to him, "I want you to become an editor and claw your way to the top. You weren't a very good photographer anyhow." Scherman went on to be an editor at LIFE for two decades, the only staff photographer ever to achieve such a switch.

First African American troops ever to be sent to England, 1942

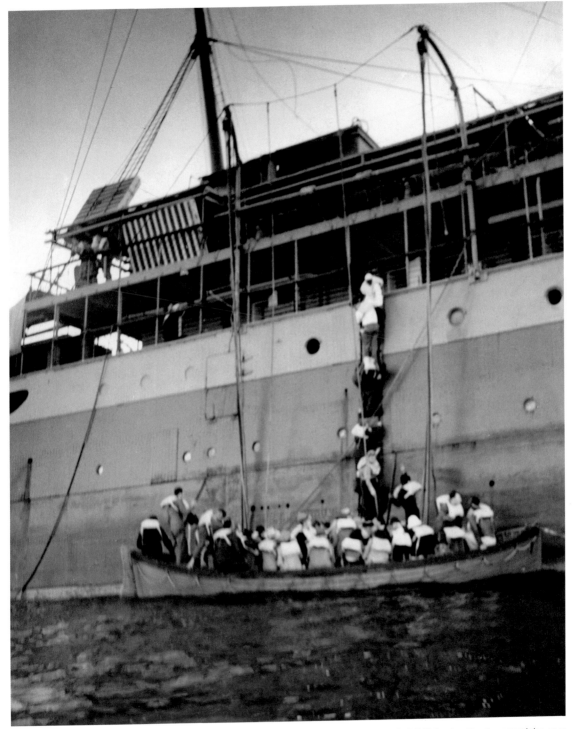

Trying to board an already full lifeboat as the *Zamzam* sinks, 1941

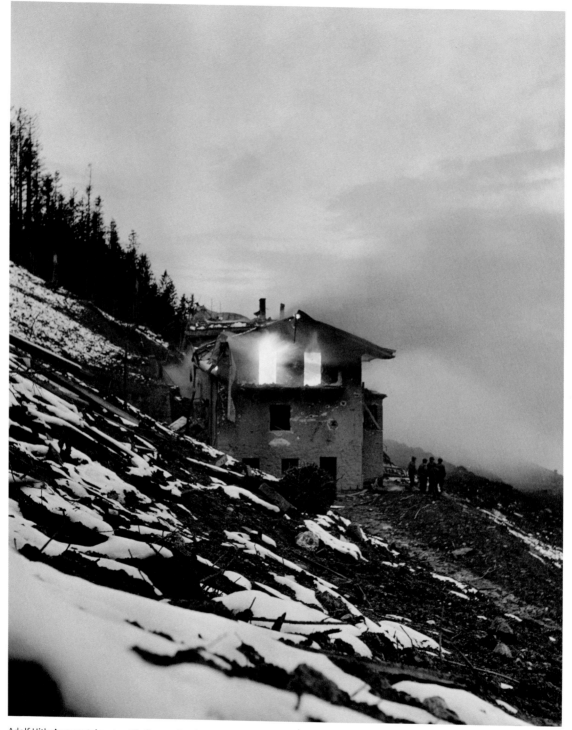

Adolf Hitler's mountain retreat in flames, Berchtesgaden, Germany, 1945

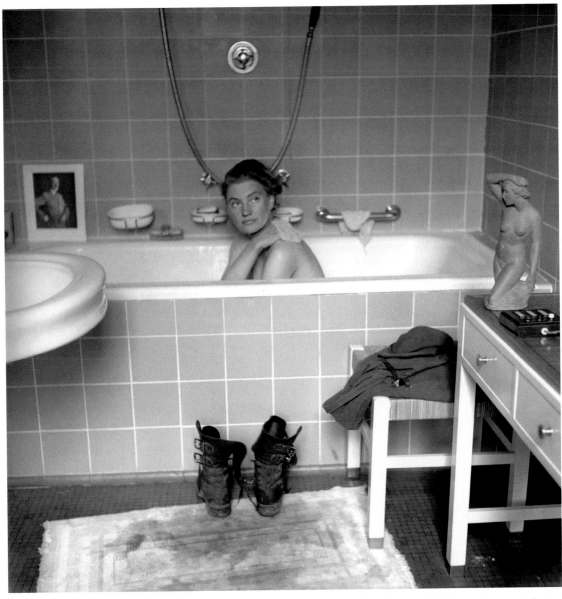

Photographer Lee Miller in Adolf Hitler's bathtub, Munich, 1945

Frank **Scherschel** 1907–81

Howard Sochurek

On-the-job Learning

At age 14, he ran errands for a photo agency in Chicago. "Instead of going to high school and college, I learned psychology convincing murderers and divorcées caught with the other man to pose for pictures." By 19 he managed *The Milwaukee Journal*'s photo department, and several years later he took in his orphaned little brother, Joe, who would also become a LIFE photographer. During World War II, Frank took pictures from bombers flying missions over Germany and islands of the Pacific. At the Normandy invasion, as one of the magazine's six accredited photographers, he again shot from the air. "We thought it was going to be murder but it wasn't," he said. "To show you how easy it was, I ate my bar of chocolate. In every other operational trip, I sweated so much the chocolate they gave us melted in my breast pocket." He later retired to his wife's Wisconsin hometown to open a camera store.

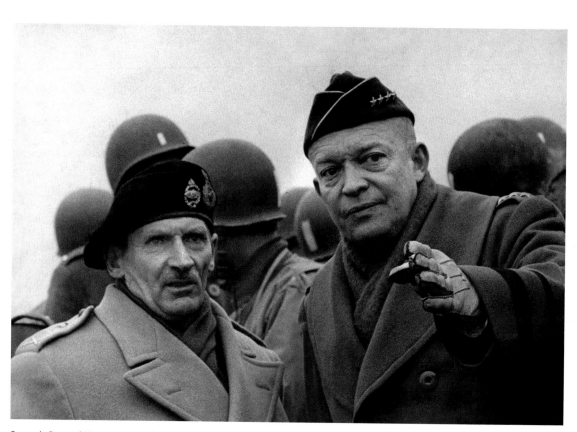

Generals Bernard Montgomery and Dwight Eisenhower reviewing Allied troops, England, 1944

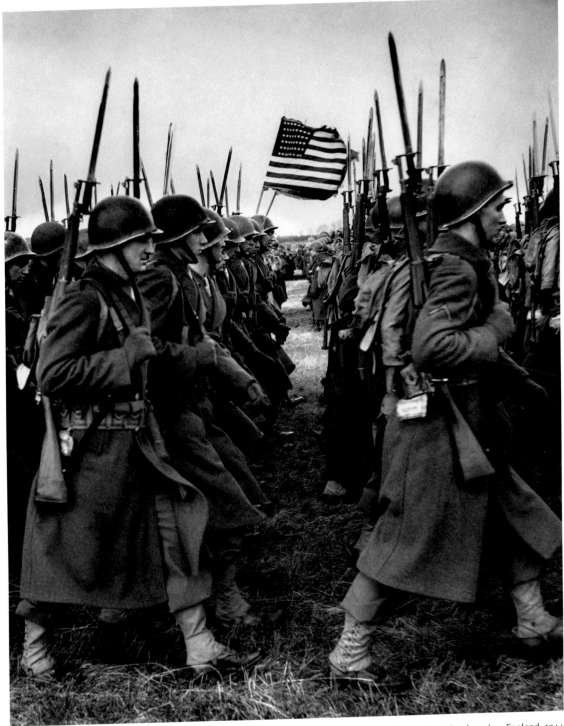

U.S. glider unit on parade at an airfield before the D-Day invasion, England, 1944

Peggy Guggenheim on her roof, the Grand Canal, Venice, 1953

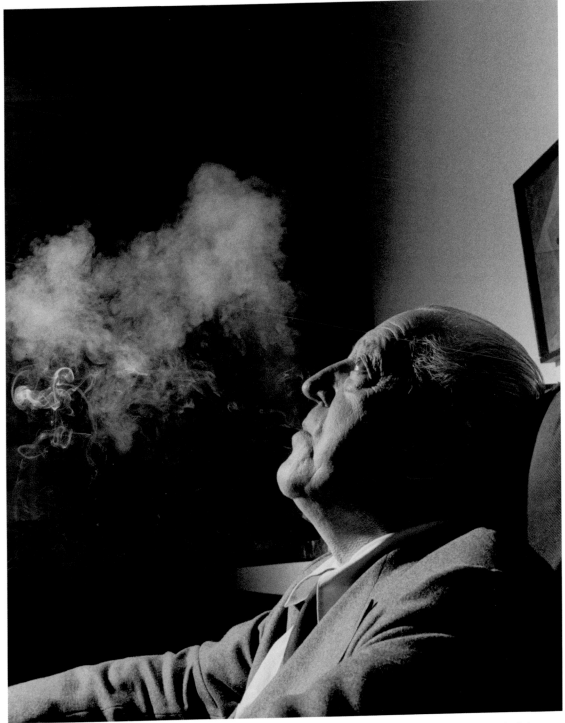

Architect Ludwig Mies van der Rohe, 1957

Spain, 1954

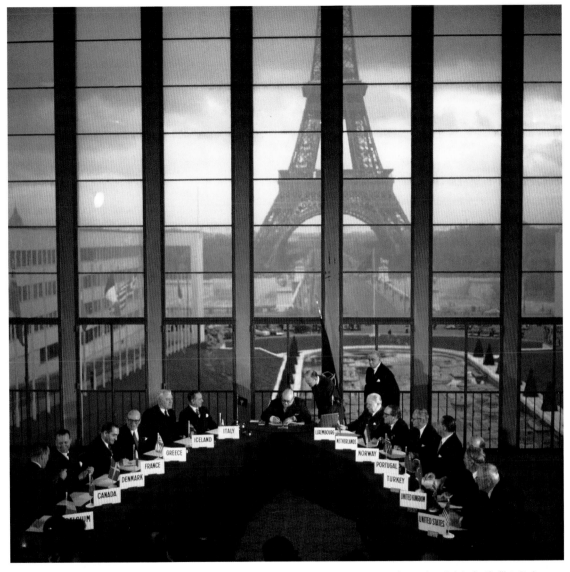

Representatives of 14 NATO nations signing a pact admitting West Germany as a 15th member, Palais de Chaillot, Paris, 1954

Joe **Scherschel** 1921–2004

The "Vice President"

With his parents both dead, at age 13 he moved in with his big brother, Frank, who was already an established photographer. Frank designated Joe as his "vice president," which entailed holding lights and doing some printing. Initially this turned Joe off to photography. "I figured he was trying to brush off some work on me, and there was no way he was going to do that," Joe remembered. "But later, when I did realize I had an interest, he ignored me." Nevertheless, Joe began to pick up Frank's extra jobs. Unlike Frank, a famous LIFE combat photographer who was thrust into peril on the battlefield, Joe mainly faced danger on the front lines of America's desegregation battles.

Students Steve Poston and Jessalyn Gray taunted by white supremacists, Texarkana, Tex., 1956

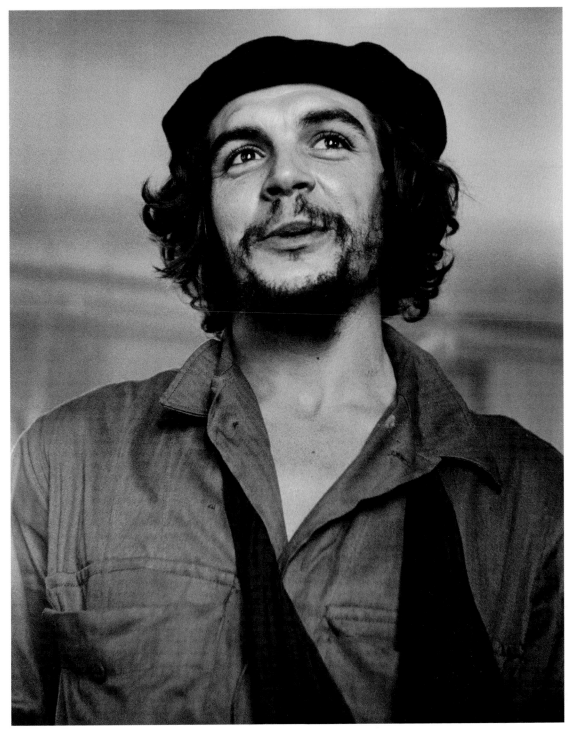

Ernesto "Che" Guevara with his arm in a sling, Havana, 1960

Jimmy, roller-skating in front of his farm, Ohio, 1952

North Korean soldier on the second day of cease-fire peace talks, Kaesong, North Korea, 1951

Paul **Schutzer** 1930–67

Fearless

As a youngster he considered becoming a painter or a lawyer, following his father and brothers, but at 22 he yielded to his childhood love of photography. He entered the professional ranks as an errand boy and shipping clerk for the Freelance Photographers Guild, and managed to secure a few assignments. Schutzer was only 26 when he joined the LIFE staff. He had a knack for taking pictures of powerful people—Eisenhower, Nixon, Kennedy—and yet he said, "It's the quiet things that happen around us every day that are the really important things. A good camera story need not be dramatic, but it must be entertaining and a personal adventure for the viewer." That's certainly so, but Schutzer never shied from dangerous subjects; in fact, one colleague said he had "almost too much courage." Schutzer was killed on the first day of the Six-Day War when the Israeli half-track in which he was riding was struck by a 57mm shell. He was 37.

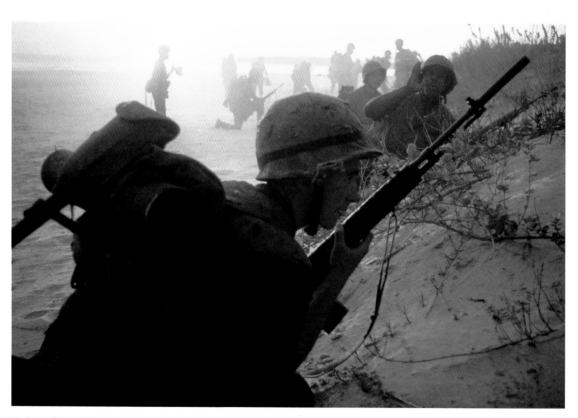

Marines of the 7th Regiment, under fire on the beach at Cape Batangan, Vietnam, 1965

Vietcong prisoner captured at Cape Batangan, Vietnam, 1965

Paul Schutzer

Freedom riders Julia Aaron and David Dennis on an interstate bus, escorted by Mississippi National Guardsmen, 1961

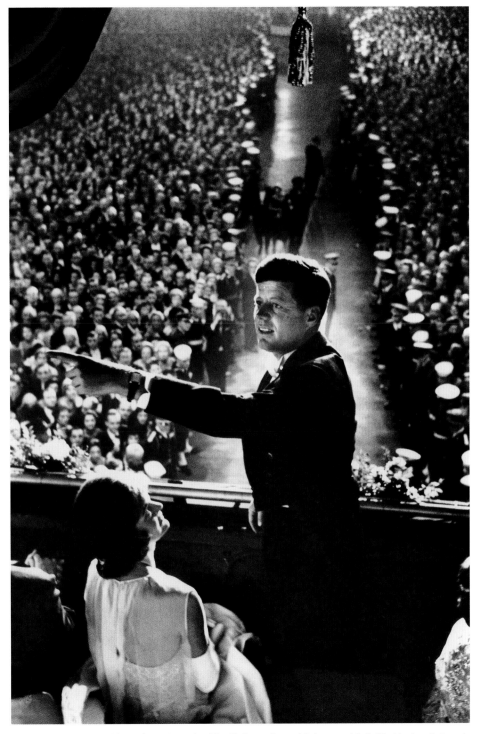

President John F. Kennedy with wife Jacqueline at his Inaugural Ball, Washington, D.C., 1961

Natalie Wood at the Cannes Film Festival, France, 1962

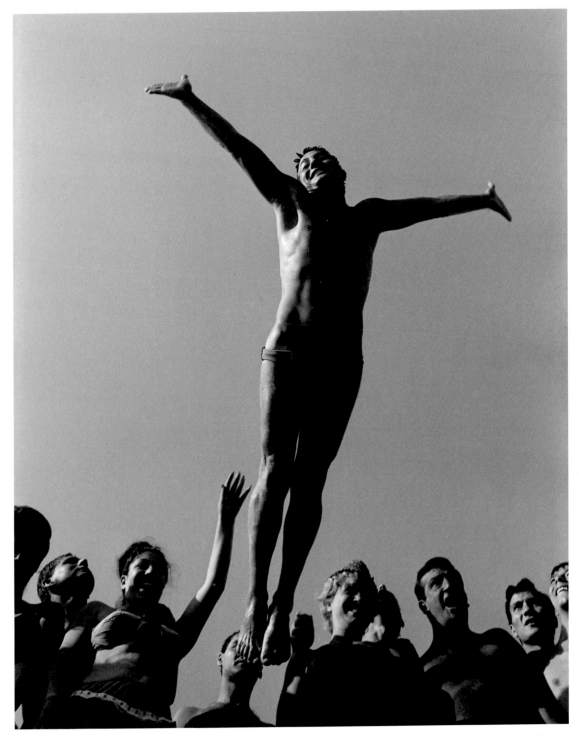

Showing off at a swimming pool, Italy, 1963

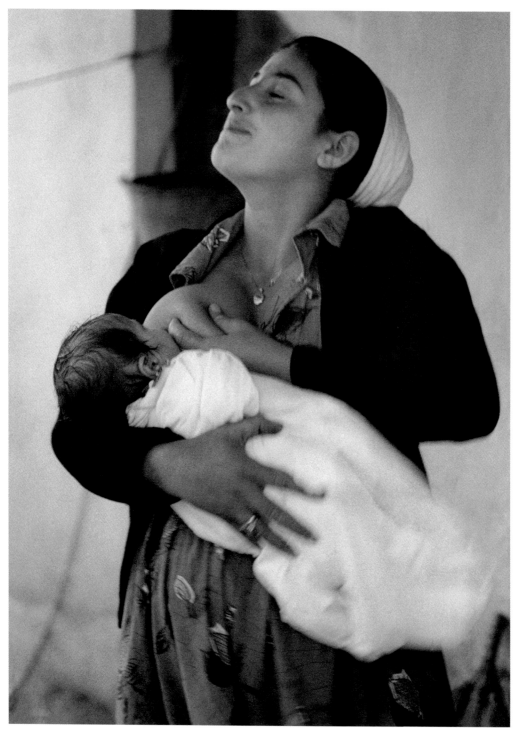

Mother and child, Israel, 1960

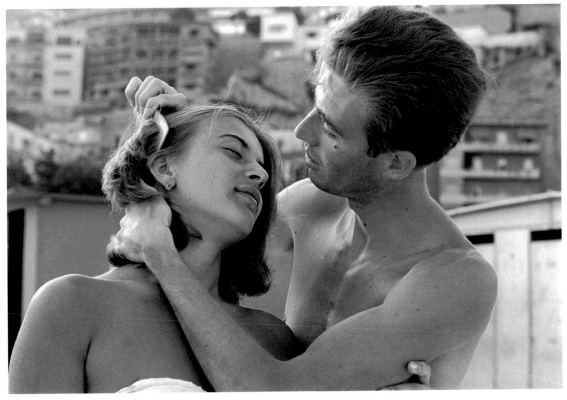

Couple, Italy, 1963

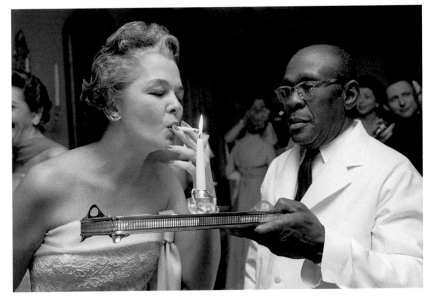

The Piedmont Ball, Atlanta, 1958

Mark **Shaw** 1922–69

Images of Camelot

Just as Abraham Lincoln thought Mathew Brady's photographs won him the presidency, so Jackie Kennedy thought Mark Shaw's pictures helped her husband win the 1960 election. "They really should be in the National Gallery!" she enthused. "I have them propped up in our Sitting Room now, and everyone who comes in says the one of me and John [Jr.] looks like a Caravaggio." Shaw took JFK's favorite picture of himself, an evocative snapshot set amidst dunes. Shaw was very much a part of Camelot, and his most famous still photography is associated with that period. Shaw later became an acclaimed cinematographer.

Senator John F. Kennedy, near Hyannis Port, Mass., 1959

Jacqueline Kennedy with daughter Caroline, Hyannis Port, 1959

Jacqueline Kennedy with son John Jr., Palm Beach, Fla., 1963

There were certainly other photographers present at the Kennedy White House, but no one else enjoyed the entrée provided to Shaw. He was also an outstanding fashion photographer—for *Harper's Bazaar, Mademoiselle* and many more—who had chronicled a number of European couture shows for LIFE. Given Jackie's storied fashion sense, it's not surprising that Shaw became the "family photographer."

John **Shearer** 1947–

The Magic Box

"I fell in love with photography at 11 . . . I was lucky that my father had a very good friend named Gordon Parks, who lived down the street." With mentoring from Parks, Shearer began taking pictures professionally as a teen. The photographic process was one that he took to readily, even instinctively: "Human gesture and expression are the essence of photography. It's not about lights or fast lenses and fast film. It's the ability to capture a moment in time. To capture the spirit of someone in that magic box is wonderful. It's what I fell in love with as a kid." Shearer was on staff from 1970 to '72, and one of his plum assignments was the first Muhammad Ali–Joe Frazier fight. He later translated the experience into a deft metaphor: "When the weekly LIFE stopped . . . it felt like I had been fighting for the heavyweight championship. I'd practiced, and I'd sparred, and I got ready, and I fought the big fight. And then there was no place to go. I had job offers, but it wasn't the same. There was nothing like it."

State trooper holds burnt cap of a hostage guard at Attica State Prison, New York, 1971

Muhammad Ali taunting Joe Frazier, Philadelphia, 1971

Sam **Shere** 1904–82

Death in the Air

A dozen or more photographers were in Lakehurst, N.J., on May 6, 1937, to document the landing of the German zeppelin *Hindenburg,* but it is Sam Shere's photograph of the airship bursting into flames that became an icon. At that time, the Russian-born Shere worked for Hearst. He was a war correspondent for LIFE during World War II, and later contributed shots of American life, particularly the crush of people in New York City.

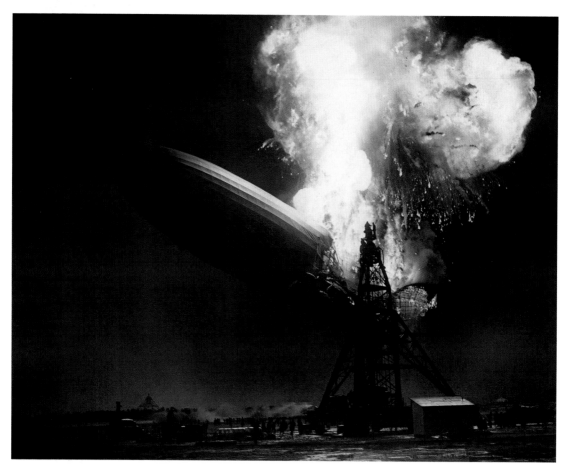

The *Hindenburg* exploding, Lakehurst, N.J., 1937

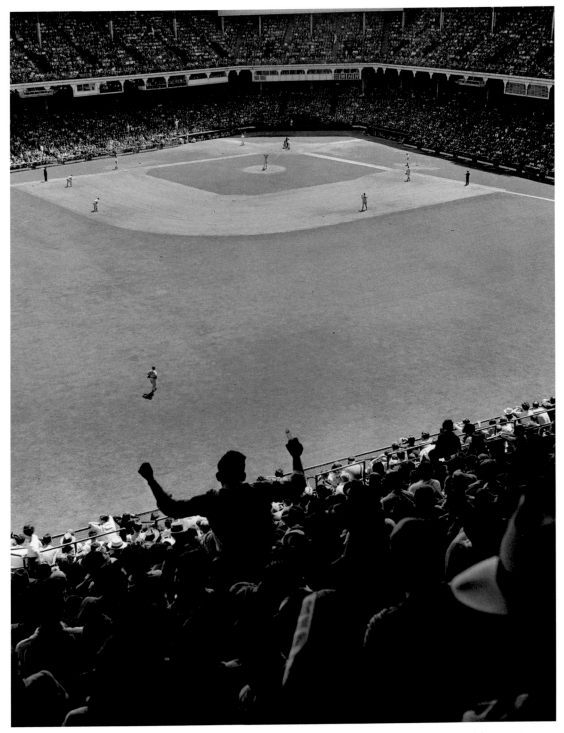

Ebbets Field, Brooklyn, 1946

William C. **Shrout** 1913–1986

Tough but Tender

War, injury and disease met their match in Bill Shrout. During WWII he was in the Pacific for some extremely intense battles, such as Guadalcanal, and finally was so battered that doctors ordered him out of the combat zone. Still, he begged for more. "I will risk my neck for LIFE in order to get the kind of pictures you are after," he wrote. "Malaria does not bother me . . . I will stay out there for the duration." Shrout got his wish, and returned to document the fighting. When he was back home in Alabama, away from the theaters of war, things were very different. Every night his family said prayers together, then were in bed by 8:30.

Mayor Fiorello La Guardia in his office, New York City, 1945

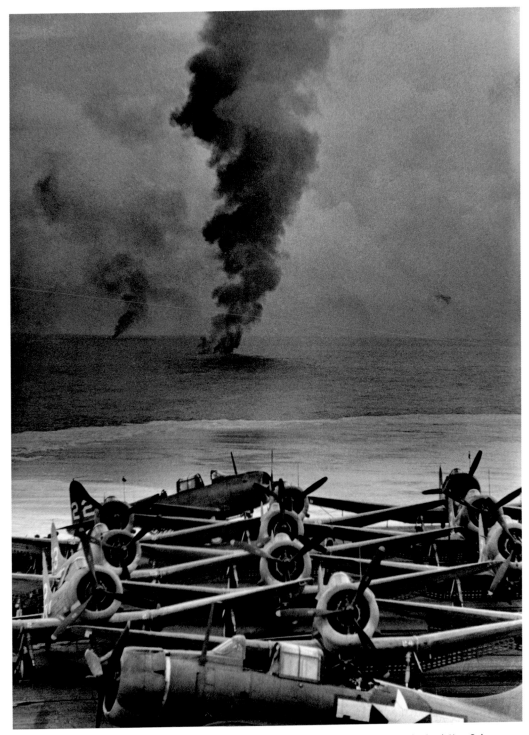

Deck of a U.S. aircraft carrier, with Japanese planes burning in the background, near the port of Rabaul, New Guinea, 1943

America First Committee rally, with speakers including Charles Lindbergh, Chicago Arena, April 1941

With his historic nonstop solo flight across the Atlantic in 1927, Charles Lindbergh instantly became one of America's greatest heroes. When his son, in one of the century's ugliest dramas, was kidnapped and killed in 1932, the entire country sought to comfort their stricken Lindy. By the middle of the 1930s, he was a national institution. So when he returned from several visits to Hitler's Germany and stated that intervention would be wrong, and also presented his considered opinion that the Luftwaffe was a mighty flying machine, many Americans listened closely. Then, five months after this photo was taken, Lindbergh forever tarnished his image when he said that the British government, FDR's administration and "the Jews" were spoiling for intervention in Europe. Even for Lucky Lindy, this kind of bigotry just wouldn't wash in the U.S.A.

George **Silk** 1916–2004

Kiwi Adventurer

"I left school to punch cows and I left them to take pictures," said the New Zealand–born Silk. He joined the Australian Army as a photographer in World War II. Rommel's troops in North Africa captured him, but he escaped. While in New Guinea (following the Kokoda Trail for 700 miles on foot), Silk shot a picture of a blinded soldier that the Aussies tried to suppress; LIFE, however, printed it. He finished the war as a LIFE photographer in the Pacific. Silk said he felt ashamed not to be fighting, "so I drove myself to show the folks at home, as best I could, how the soldiers lived and died." His empathy came across whether shooting fishermen or athletes. He became a noted sports photographer, despite considering some American sports ridiculous ("only *girls* played basketball in New Zealand"). A boatsman himself, he became the magazine's expert on sailing. And on cold weather: Silk visited the North Pole twice and once shot the America's Cup races atop a 90-foot mast.

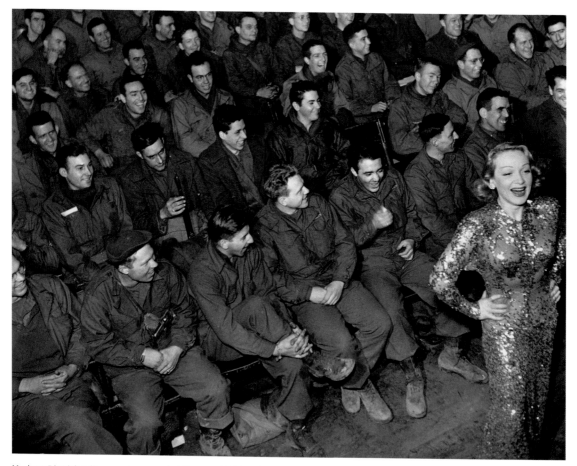

Marlene Dietrich telling servicemen what they are thinking, during the "mental telepathy" act of her USO show, Germany, 1945

Papuan native guiding a blinded Australian infantryman away from the Buna battlefront, Papua New Guinea, 1943

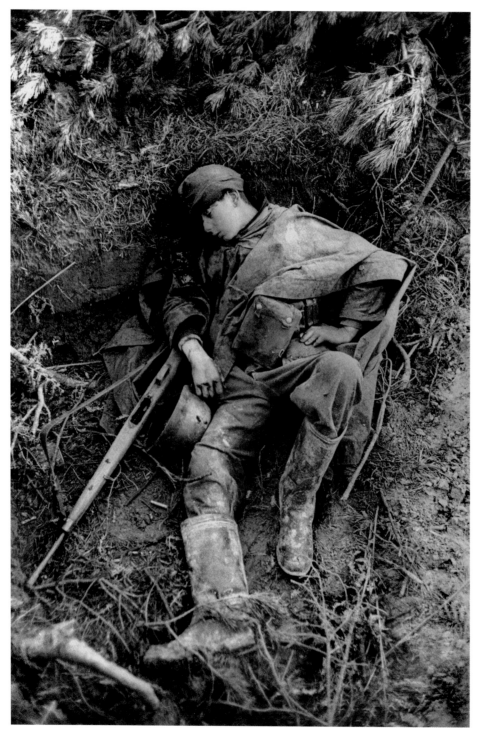

Dead German soldier, Holland, 1945

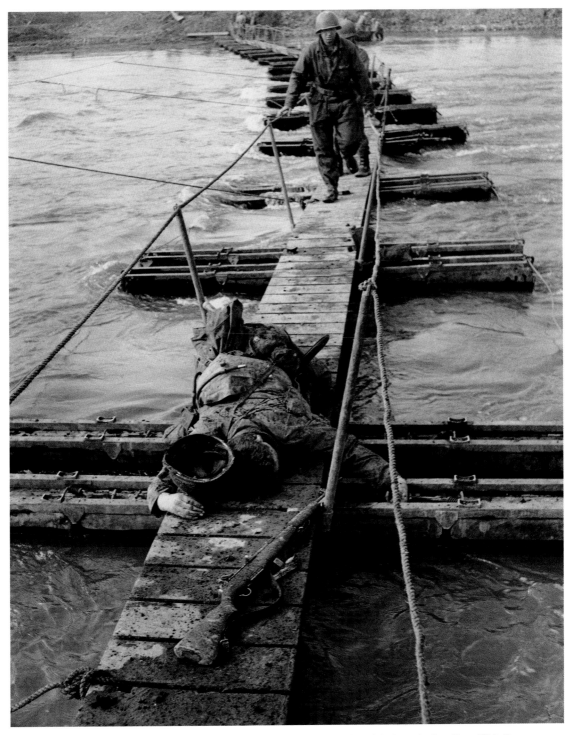

Two U.S. infantrymen, under intense fire, approaching a just-slain GI on the Roer River, Jülich, Germany, 1945

Dodgers General Manager Branch Rickey watching spring training with his grandson, Vero Beach, Fla., 1948

Students looking down on Forbes Field, where the Pirates are winning their first World Series in 35 years, Pittsburgh, 1960

Hurdlers at U.S. Olympic tryouts, Palo Alto, Calif., 1960

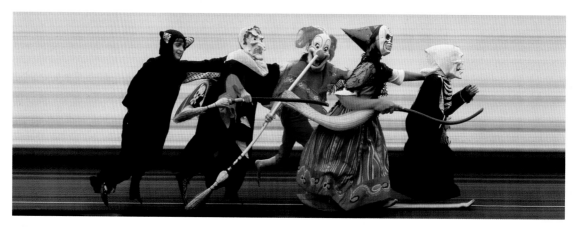

Halloween, Chappaqua, N.Y., 1960

Silk modified a "strip" camera for such as the track meet above. But its development took a different route. As Silk told *American Photographer,* he "took the camera home and had my kids run by it and then, under a blanket in the garage, I developed a piece of film this long (arms fully spread) and when I held it up and looked at the spooky image I said, 'That's Halloween!' [The holiday was coming up shortly.] So I got color film and got the kids . . . to put on their costumes and run by the camera."

Swedish high jumper Gunhild Larking, awaiting her turn to compete at the Melbourne Olympics, Australia, 1956

Nefertiti, America's Cup, 1962

George **Skadding** c.1905–

No Harm Intended

The White House kicked him off a tour with Franklin D. Roosevelt in 1944 because one Skadding picture, taken for the Associated Press, made the President look haggard. Skadding said he hadn't meant to trouble Roosevelt, who was at the time besieged with criticism that he was no longer physically able to run for another term. "It's not my fault. I just shot the picture," Skadding said. "Some idiot in L.A. picked it." Both before the war and after, however, Skadding served as an officer of the White House News Photographers Association.

President Harry S Truman holding a king salmon he didn't catch, Puget Sound, Olympia, Wash., 1945

President Harry S Truman with British Prime Minister Winston Churchill as he arrives at Blair House, Washington, D.C., 1952

Ian **Smith** c.1921–c.1987

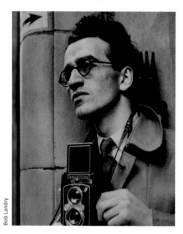

A Quick Study

This son of Edinburgh, Scotland, got his first camera at the age of eight, a box Brownie. After graduation, he was teaching languages and history for a couple of years when he decided to take courses in photography. In 1944 he worked as a still photographer for the classic British film *A Canterbury Tale,* and that same year he joined the LIFE lab in London as an assistant. By the following year he was on staff.

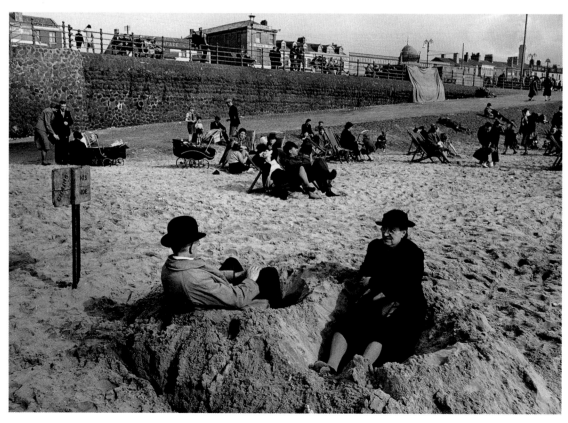

Blackpool beach, England, 1945

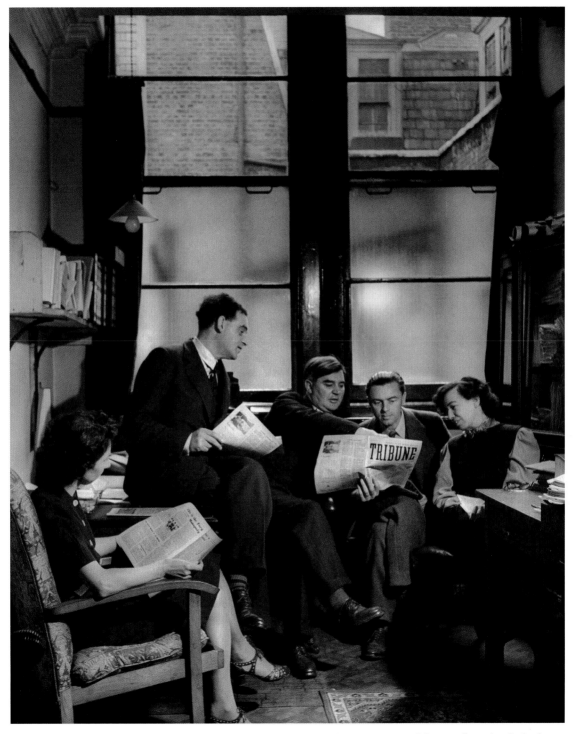

Tribune staff meeting, England, 1945

W. Eugene **Smith** 1918–78

Passion

"Magnificent. He had all of the requirements . . . He evoked drama and emotion. He told what was going on. He was exciting. He was madly artistic, from a pure, painterly point of view. He had those painterly characteristics of a good artist. He was impossible as a person, because he was so sure of himself and so indignant when anybody didn't allow him to do what he wanted." So stated former LIFE photographer and editor David Scherman. And what Smith wanted was nothing less, as he himself put it, than to "sink into the heart of the picture." Gordon Parks said that he thought Smith "had a wonderful sense of humanity." But it was clear to anyone who knew him at all that Smith would do whatever was necessary to get a picture or a layout just the way he thought it ought to be. His surpassing concern for the rights of all people—indeed, for humanity—rendered his pictures and photo essays sublime.

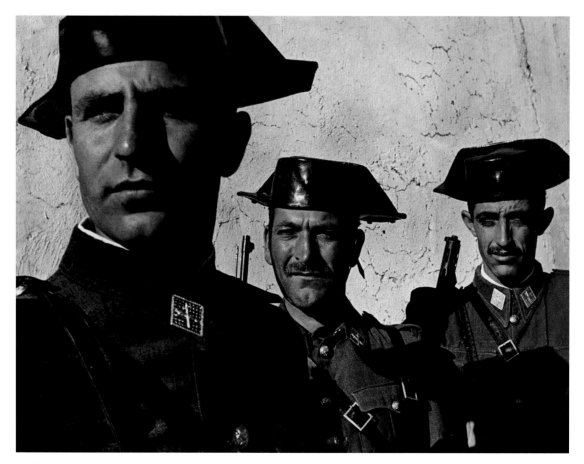

Members of Francisco Franco's Guardia Civil, Deleitosa, Spain, 1951

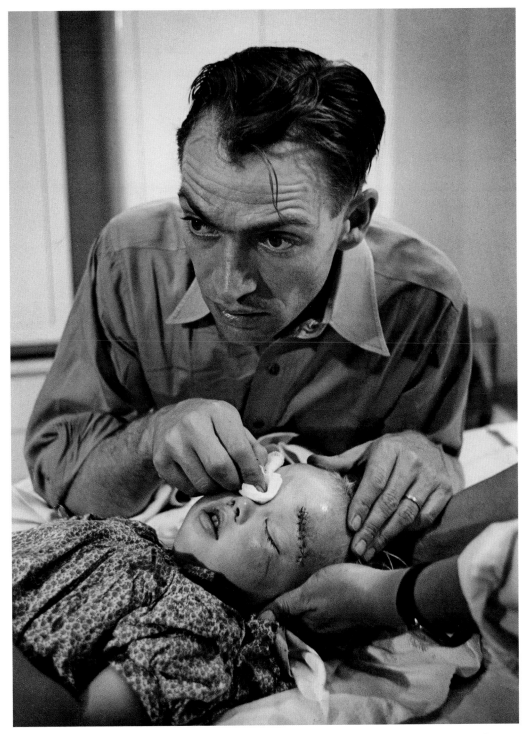

"Country Doctor" Ernest Ceriani, Kremmling, Colo., 1948

During World War II, he became known to the troops as "Wonderful" Smith because of his apparent fearlessness during a string of harrowing Pacific island invasions. Said Shelley Mydans, "He always wanted to be in front of the first soldier in combat." Then, in the initial assault on Okinawa in April 1945, a Japanese shell fragment tore through his cheek and mouth. Smith would not pick up a camera again until May 1946, when he took a picture of two children behind his home. *The Walk to Paradise Garden,* a symbol of mankind's long-awaited emergence from the darkness of Depression and war, became one of the best-known photographs of the century.

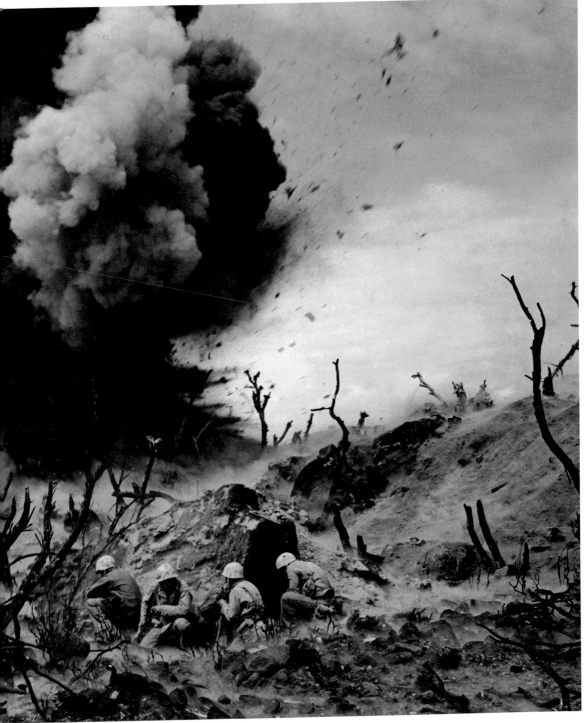

Marines blowing up a Japanese blockhouse, Iwo Jima, 1945

Charlie Chaplin on the set of his film *Limelight*, 1952

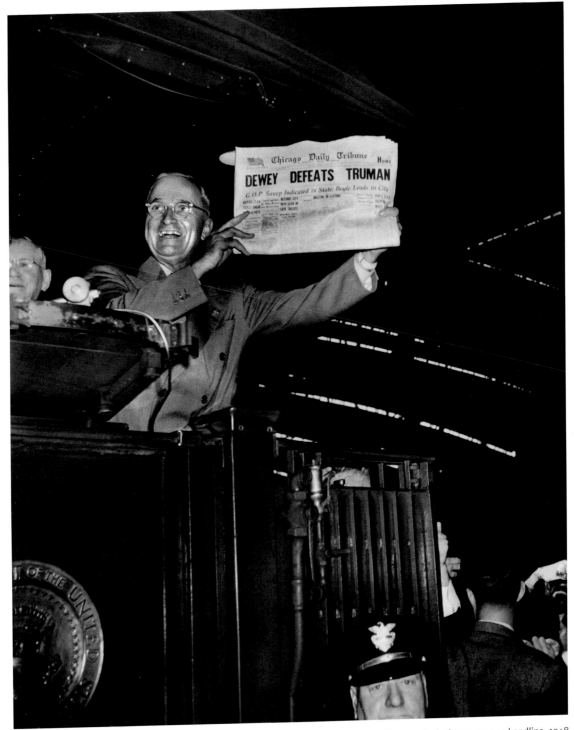

Victorious presidential candidate Harry Truman displaying erroneous headline, 1948

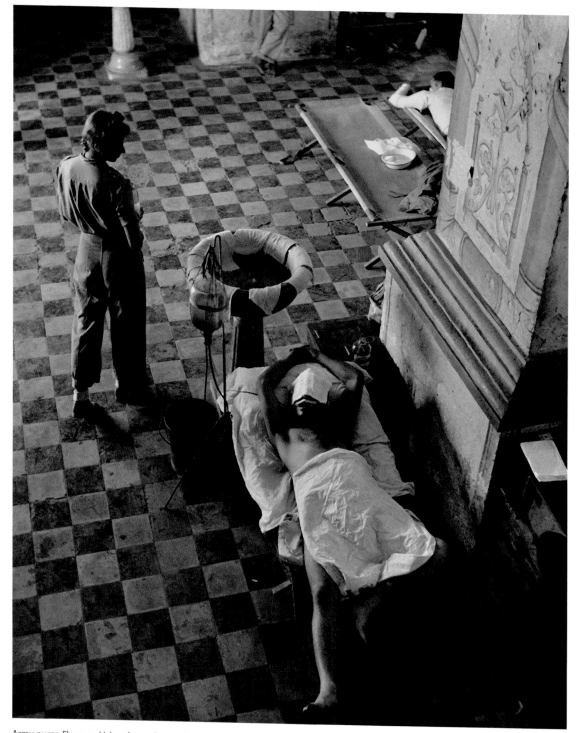

Army nurse Florence Vehmeier and wounded GI in a makeshift hospital, Leyte, the Philippines, 1944

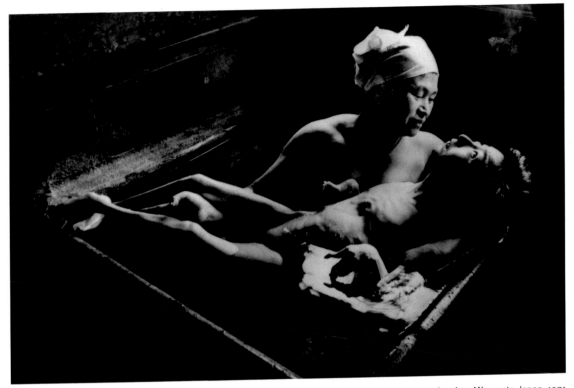

Woman bathing her daughter, a victim of mercury poisoning, Minamata, Japan, 1971

It has been called photojournalism's *Pietà*. In 1971, Smith and his wife, photographer Aileen Mioko, moved to the Japanese village of Minamata for three years. This coastal fishing enclave had been riddled with disease after a chemical company dumped mercury into the water, poisoning much of the local diet. Here, Tomoko Uemura, who was born blind, mute and with deformed limbs, is bathed by her mother. Many regard this as the first photograph to awaken the world to ecological abuse.

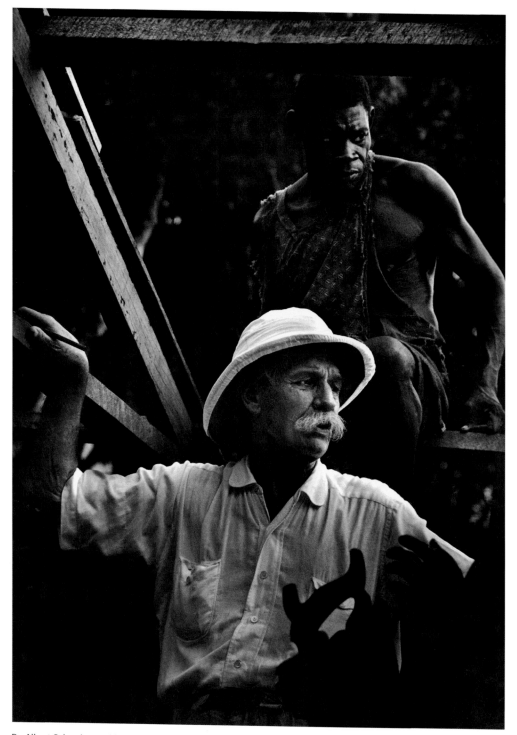

Dr. Albert Schweitzer, with a carpenter, at the site of his hospital in Gabon, 1954

The Walk to Paradise Garden, 1946

Howard **Sochurek** 1924–94

The Pursuit of Perfection

Sochurek was never satisfied with his own work. "When I finish a story, I usually feel I am just about qualified to begin it because I have learned so much." As Gen. Douglas MacArthur's photo assignment officer at the end of World War II, he got to take only one exposure of Emperor Hirohito. LIFE had several options but ran Sochurek's shot. After the war he was just one year away from a Princeton degree when, despite the expectations of his family, he went to work as a newspaper photographer instead. LIFE hired him to cover the war in Korea; even though he lacked training, he parachuted out of a C-119 behind enemy lines. When his mother fell ill, Sochurek left his post in Indochina to see her. Robert Capa filled in for him—and was killed by a land mine. "I felt I was responsible," Sochurek said. "That was my beat he was covering." Sochurek had also been with Ernie Pyle moments before the World War II journalism legend was killed.

Grade school, New York City, 1962

Rhythmic class, Moscow, 1958

Chicago, 1965

Jets over Los Angeles, 1956

Student Virginius B. Thornton receiving tolerance training before a sit-in, Petersburg, Va., 1960

Robert Frost, England, 1957

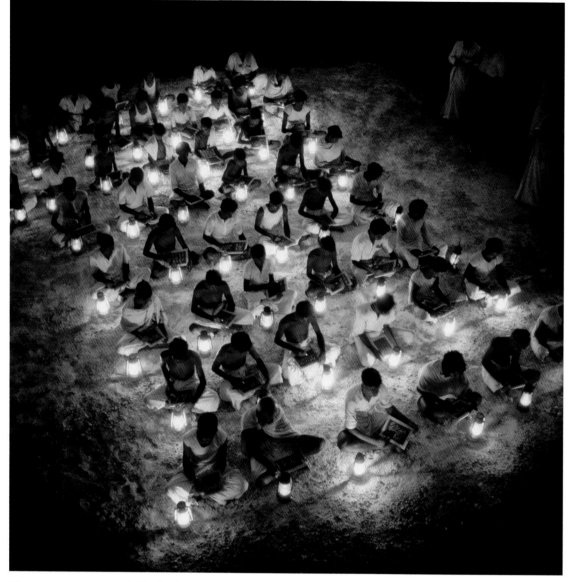

Villagers at a government-subsidized night school, India, 1953

Champion smoke-ring blower William Patterson, Detroit, 1950

Peter **Stackpole** 1913–97

Hans Knopf

A Word from the Wise

His mother was a painter. His father was a sculptor: "When my father saw me with this little camera at his stone yard, he said, 'You don't need that thing.' He reached in his pocket and took out a pencil and made a sketch of me in no time, and said, 'This is all you need.'" But his father had only himself to blame for introducing his son to the legendary Edward Weston. "I was spellbound looking at his work because it was so clear and precise, with beautiful forms and beautiful values . . . when I showed Weston some of the pictures I had taken of building the San Francisco–Oakland Bay Bridge, he encouraged me. Ansel Adams did too." This attention proved to be heaven-sent, and Stackpole became one of LIFE's original quartet of photographers, and a very fine one, indeed. He could see a picture, and react, instantly. "I never photographed a subject more than one or two exposures. Then I'd go on to something else," he said. "I don't admire photographers who use motors."

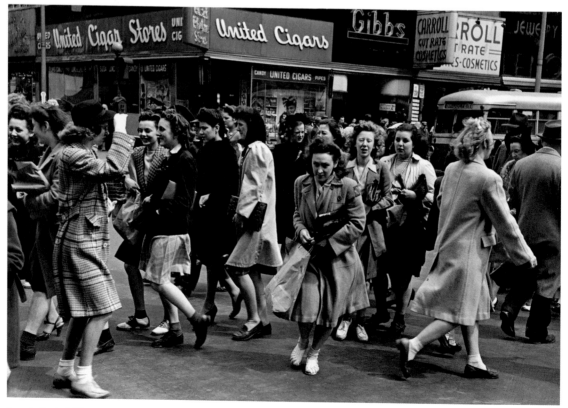

A work day in Bridgeport, Conn., 1943

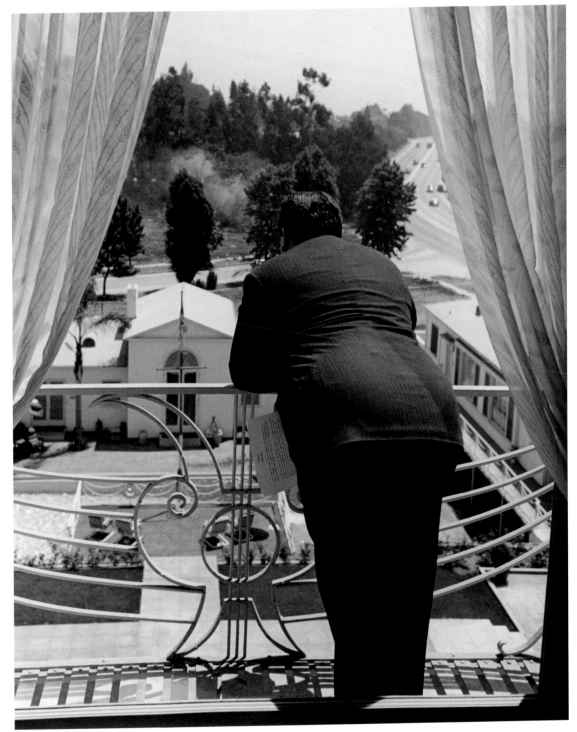

Alfred Hitchcock at the Wilshire Palms, Los Angeles, 1939

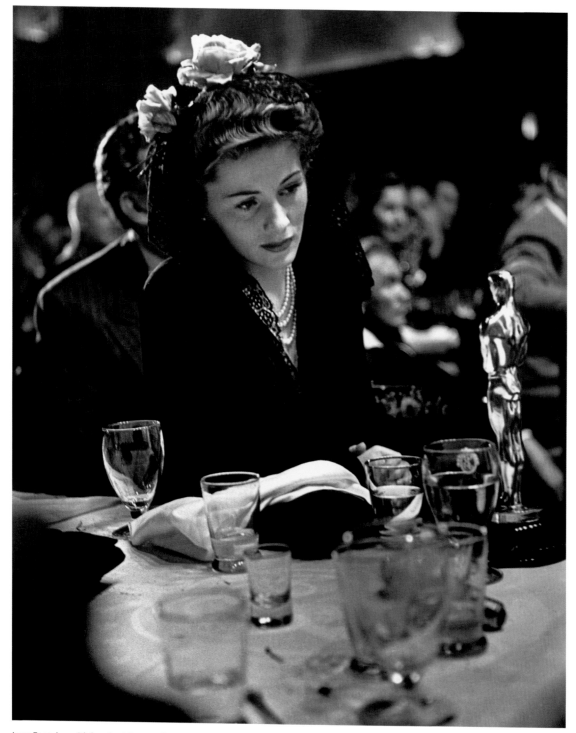

Joan Fontaine with her Best Actress Oscar for *Suspicion*, Hollywood, 1942

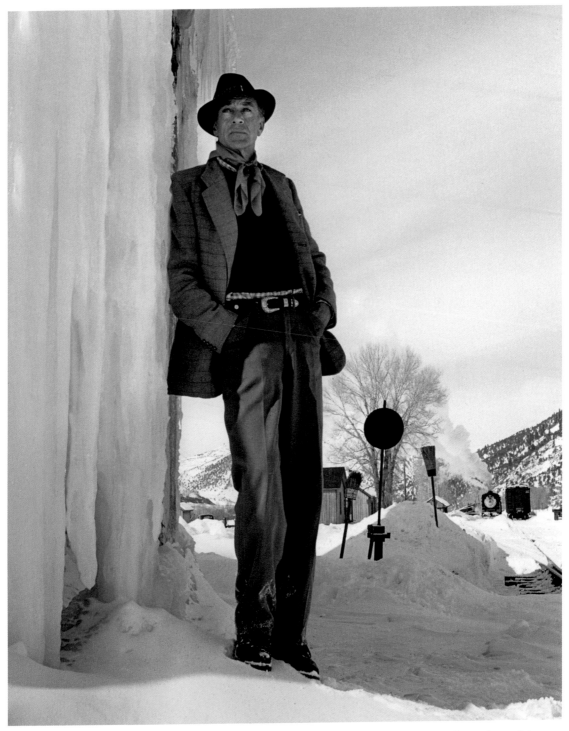

Gary Cooper, Aspen, Colo., 1949

Shirley Temple wearing her first long dress at her 11th birthday party, Bel Air Country Club, Los Angeles, 1940

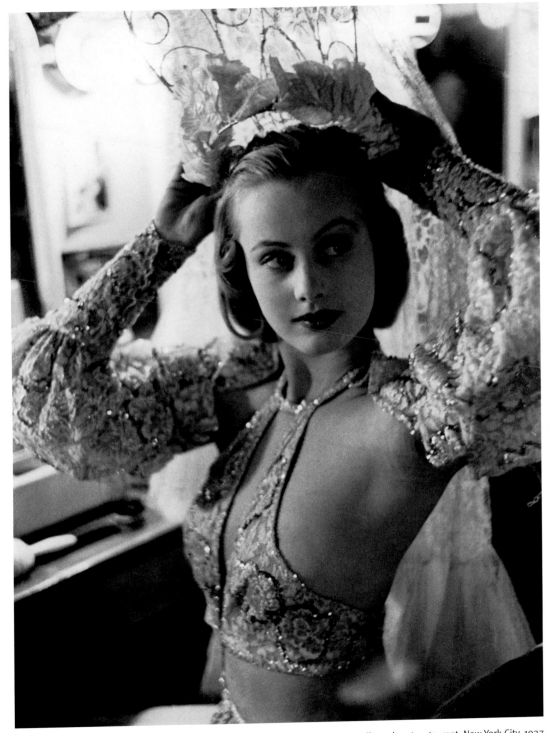

Chorus girl Hope Chandler, 16, at the Paradise cabaret restaurant, New York City, 1937

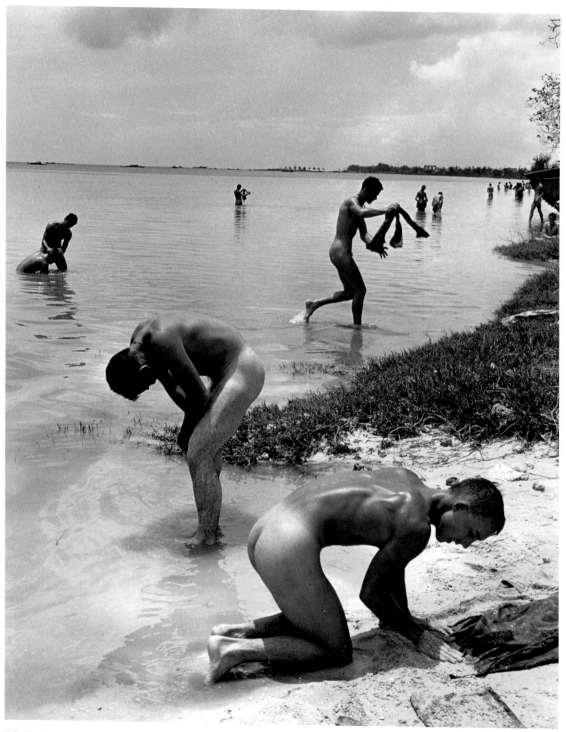

U.S. Marines, Saipan, 1944

During the fierce fighting in Saipan, Stackpole barely escaped a pair of counterattacks. On a significantly lighter note, this image, one of a dozen in a February 15, 1937, LIFE piece on how wives should comport themselves in the bedroom, had this caption: "Two excellent purposes are served by rolling down stockings . . . Economically, a husband is pleased by the absence of runs; romantically, he is gratified by his wife's graceful method of displaying her legs." (The prior issue devoted four pages to a corset show.)

June St. Clair of the Allen Gilbert School of Undressing, New York City, 1937

"Flygirl" pilot of the U.S. Women's Air Force Service, 1943

Colonel James Stewart, on his return from WWII, at his father's hardware store, Indiana, Pa., 1945

Charles **Steinheimer** 1914–96

Iro Harper

An Eye for Detail

During the Depression, a psychology degree, even from Stanford, was of little value, so Steinheimer and his friend Hart Preston went down to Mexico to take pictures. LIFE ran a long feature based on their work and immediately hired both of them. But, in the end, Steinheimer's education paid off. "If you take good pictures of people, you take pictures of their involuntary musculature," he explained. "My early psychology training led me to investigate the voluntary and involuntary muscular structure of the body. It's so apparent, if you look for it. Genuine emotions are expressed . . . I spot a posed picture every time." Eventually he wearied of photography, believing his style revealed so much that it invaded his subjects' privacy and, further, that all the traveling strained his personal relationships (he would have five marriages). Later, as an electronics engineer, Steinheimer helped develop the video camera.

Watching cartoons in a movie theater, San Carlos, Calif., 1946

Daughters of the American Revolution at their annual convention, Chicago Historical Society, 1942

Charles Steinheimer

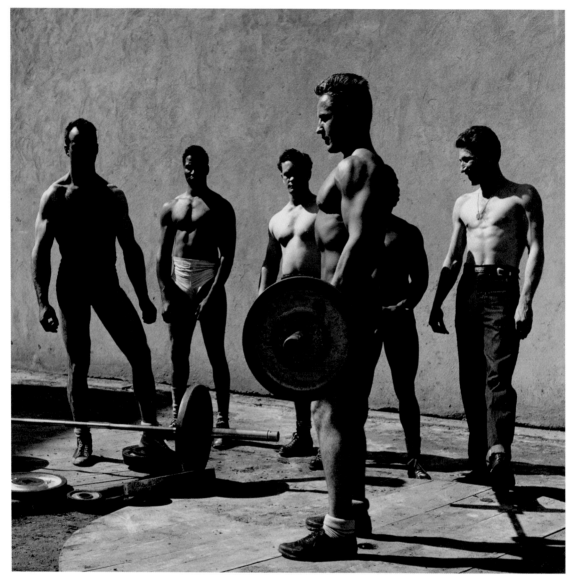

Prisoners in San Quentin State Prison, California, 1947

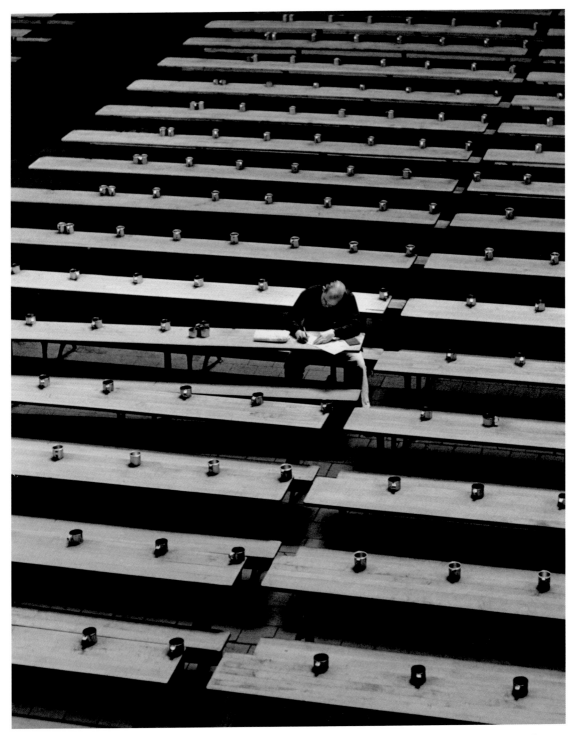

Inmate writing home in mess hall, San Quentin, 1947

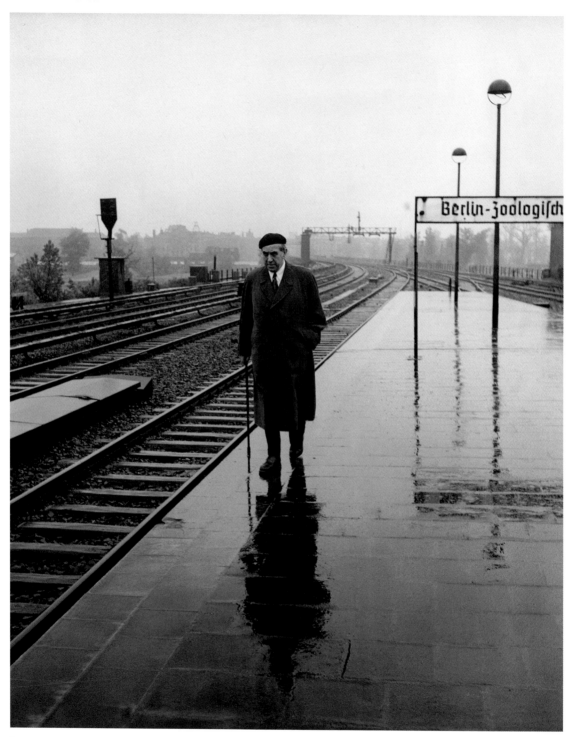

Ernst Reuter, socialist mayor of West Berlin, 1949

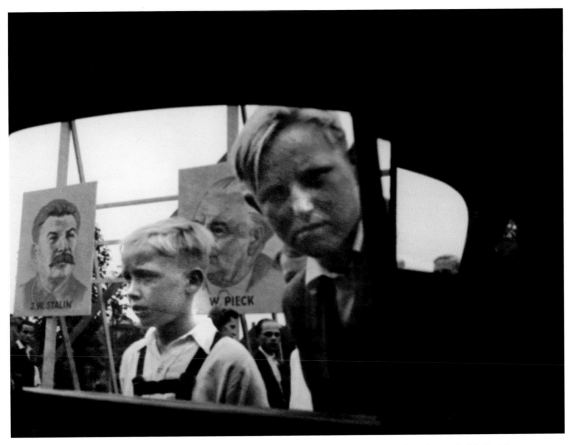

Envious kids peering into a car, shouting, "From America! Look!" Leipzig spring trade fair, East Germany, 1950

George **Strock** 1911–77

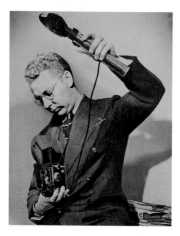

Bringing the Battle Home

An established crime and sports photographer, Strock joined LIFE and went off to the war in the Pacific. Initially he cabled editors that he saw so little action he was ready to quit and open a peanut stand. Other photographers did leave, but Strock stayed on for the Battle of Buna, which cost more than 3,000 Allied lives. On that malarial New Guinea island, Strock scrambled alongside the soldiers. They couldn't bathe because the water smelled of the dead. They couldn't bury the dead because of the fighting. At the time, censors banned showing any dead American soldiers, but LIFE raised the point with the government, and FDR himself decided the public was growing complacent and should see some of the reality; thus "Three Dead Americans" ran in LIFE.

Draftee getting smallpox and typhoid inoculations in the first peacetime draft, Fort Dix, N.J., 1940

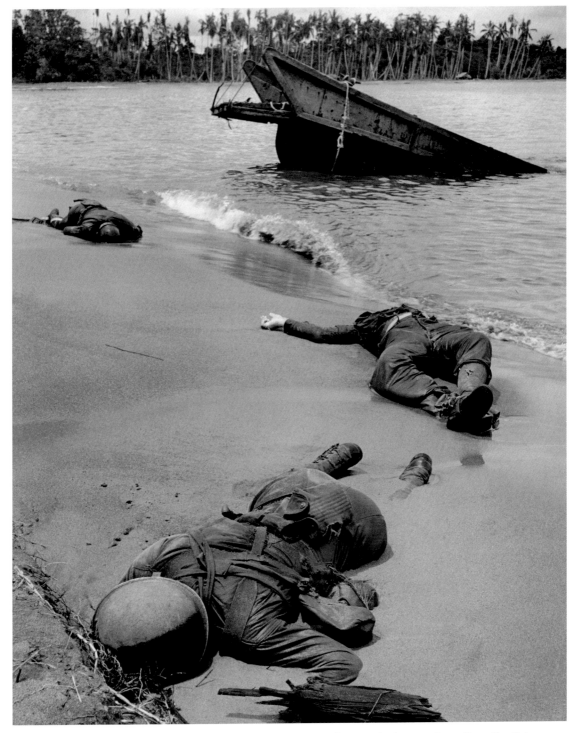

Three dead Americans, killed during the fight to take Buna Beach from the occupying Japanese forces, Papua New Guinea, 1943

Shipyard welders, who worked seven days a week to aid war production, Tampa, 1941

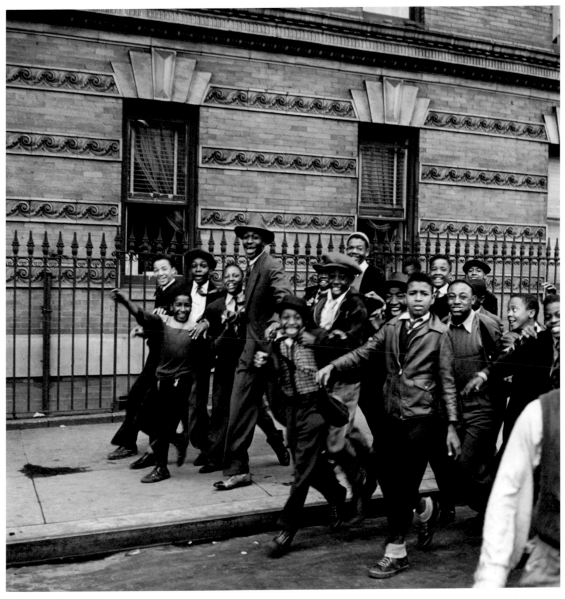

Pitcher Satchel Paige with fans, New York City, 1941

William J **Sumits** 1914–2006

Picture Taker and Technician

Bill Sumits grew up in Virginia and Tennessee and Alabama and Missouri, which means, if nothing else, that he was a lad imbued with many of the flavors that make up America. His interest in photography began Hollywood-style when he was hired as an errand boy for the Eastman Kodak store in Kansas City in 1930. Time spent in the darkroom there was encouraging, although there was a brief detour toward aeronautical engineering. The final direction became clear with the advent of LIFE in 1936; Sumits bought some developing equipment and turned to photography in earnest. After a decade of advertising and PR shoots, he received some assignments from LIFE that worked out, then he joined the staff. A few years later, in 1950, he became a technical researcher of new gear and processes. In 1953 he was named chief of the photo lab, and served in that all-important position with considerable distinction.

Deer antlers on the ceiling of Gordon Castle, Fochabers, Scotland, 1948

Along the Thames, England, 1951

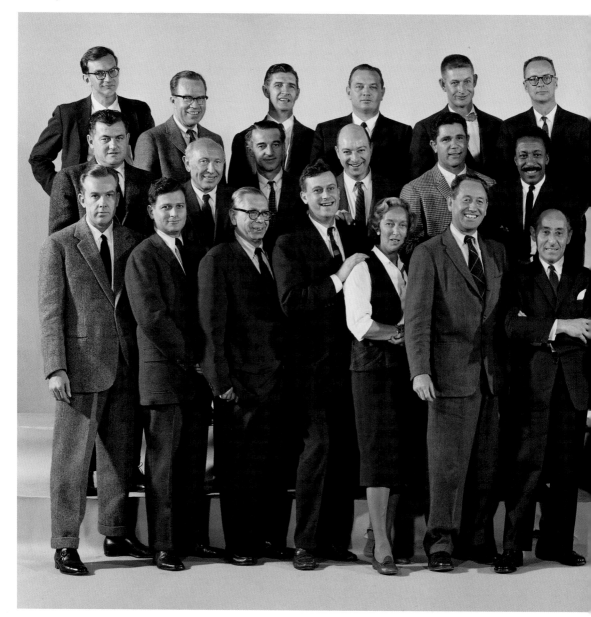

LIFE staff photographers, 1960

Grey Villet Edward Clark Loomis Dean Joe Scherschel Stan Wayman Robert W. Kelley

Hank Walker Dmitri Kessel N.R. Farbman Yale Joel John Dominis Gordon Parks

James Whitmore Paul Schutzer Walter Sanders Michael Rougier Nina Leen Peter Stackpole Alfred Eisenstaedt

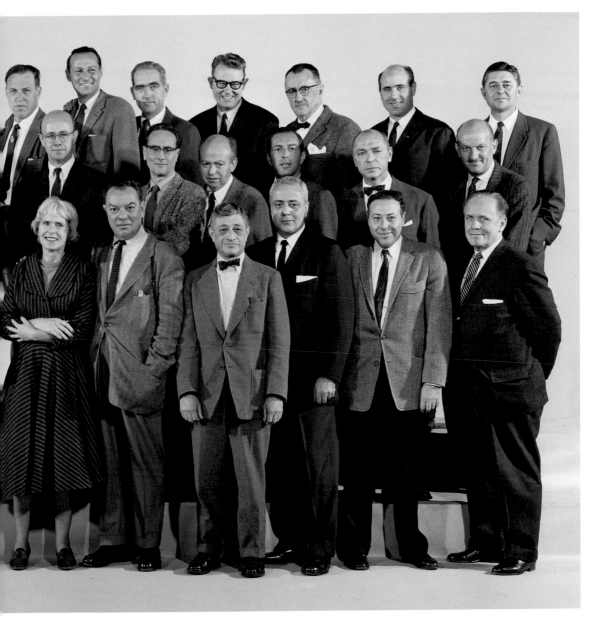

J.R. Eyerman Ralph Crane Leonard McCombe Howard Sochurek Wallace Kirkland Mark Kauffman George Silk

James Burke Andreas Feininger Fritz Goro Allan Grant Eliot Elisofon Frank Scherschel

Margaret Bourke-White Thomas McAvoy Carl Mydans Al Fenn Ralph Morse Francis Miller

Burk **Uzzle** 1938–

Seeker of Eloquence

The grind of newspaper photojournalism nearly turned Uzzle off the trade. "I had my young eyes opened by the impersonal blood and guts of news photography," he wrote. "I was running the gamut every low man on the totem pole runs—country clubs to mass murders." He eschewed the gimmickry of special lenses as an obstacle to true communication with the viewer. "You see a fleeting perfection of form merging with a significant substance, and you make a clicking noise only a hair's breadth away," he wrote. "You have then judged something, reported something, ostensibly truthfully . . . And when you made a clicking noise you said something eloquently if you are skilled." Uzzle shared his vision of Vietnam, his home state of North Carolina, and both the ordinary and eccentric aspects of American life. In recent years, when a news magazine cut photographers' pay rates, he used his fame to rally other photojournalists in protest.

Hugh Hefner inspecting a Playboy Bunny outfit, Chicago, 1965

Woodstock Music Festival, Bethel, N.Y., 1969

Paralyzed skier Jill Kinmont, along Puget Sound, 1964

A farm during spring, North Carolina, 1967

Teacher Edna Bodden taking students on a field trip to a local grocery store, New York City, 1964

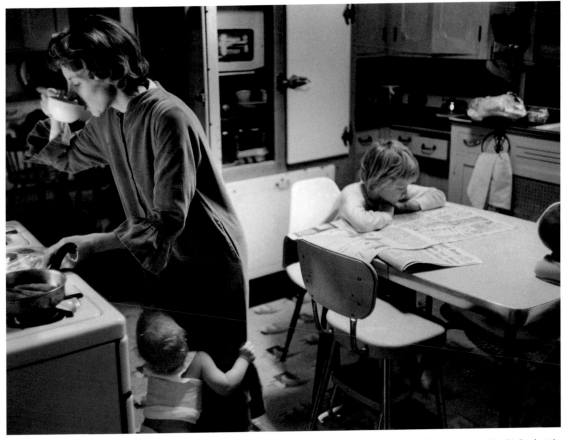

Housewife Virginia Newcombe, St. Paul, 1962

The picture at left is from a delightful piece called "A Big Break for Poverty's Children," in which Uzzle portrayed what is possible in a good program. Here, the kids are on an expedition to buy lettuce for the class turtle. Above, a typical housewife, a.k.a. "The World's Busiest Short-order Cook," begins her day with "the first of 42 cups she will brew during the week. She will also flip over 36 hamburgers, put together 64 sandwiches . . ." At right: an intimate moment.

Twelve-year-olds Sally Stephens and Tom McAllister, Santa Monica, 1962

William **Vandivert** 1912–90

Height of Dignity

A Chicago native, Vandivert covered a wide swath of the Midwest until LIFE sent him to England for what was supposed to be a six-month tour in 1938. World War II altered his plans. From the first night of the Blitz, Vandivert was out on London's docks, and for the next two and a half years he recorded the horrific bombing and magnificent stoicism of the English. (He was proud that his picture of a Welsh girl in head bandages got her the specialized surgery she required.) He followed the fighting across the globe and covered China's Northern Silk Route before returning to Europe and showing the world the first pictures of Hitler's bunker.

The Blitz, London, 1940

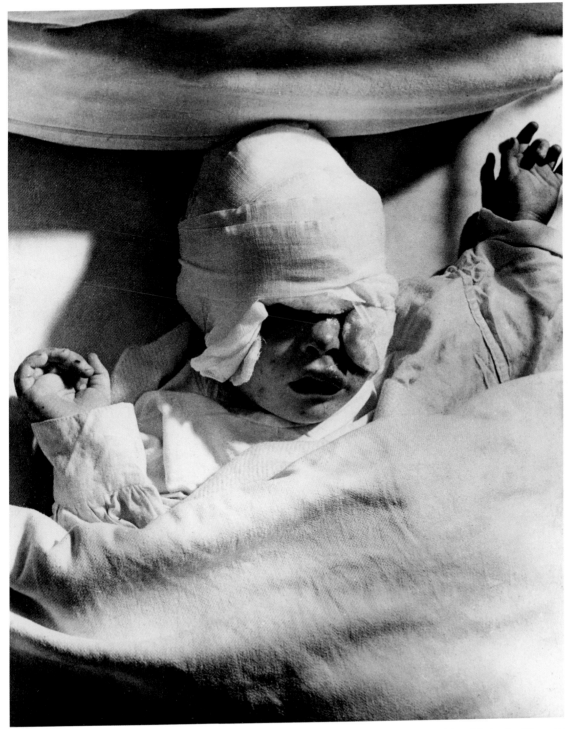

Margaret Curtis, injured during the Blitz, 1940

Midwinter squall, North Atlantic, 1943

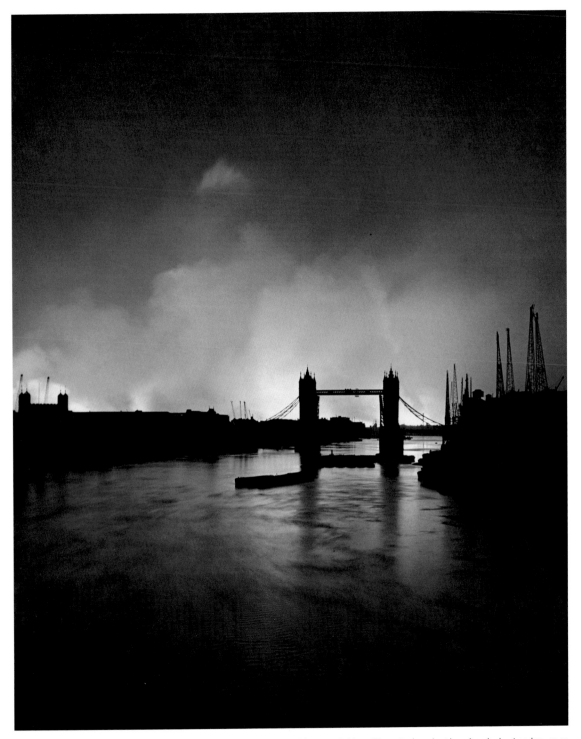

"False sunset" during the Blitz, with Tower Bridge silhouetted against burning docks, London, 1940

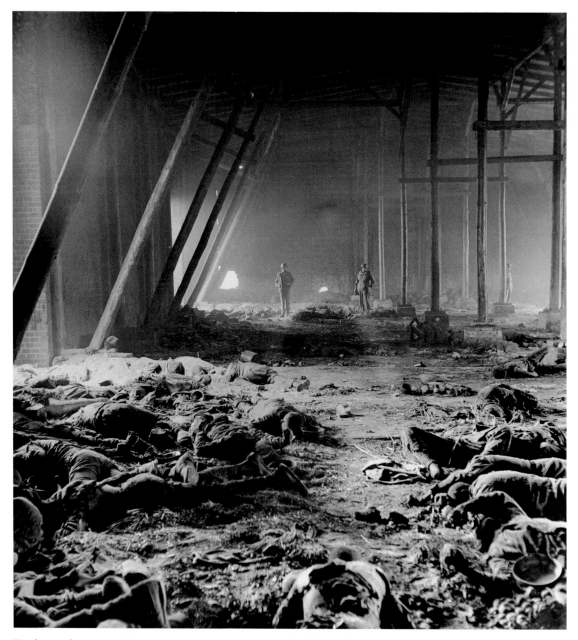

Warehouse where concentration camp prisoners were massacred, Gardelegen, Germany, 1945

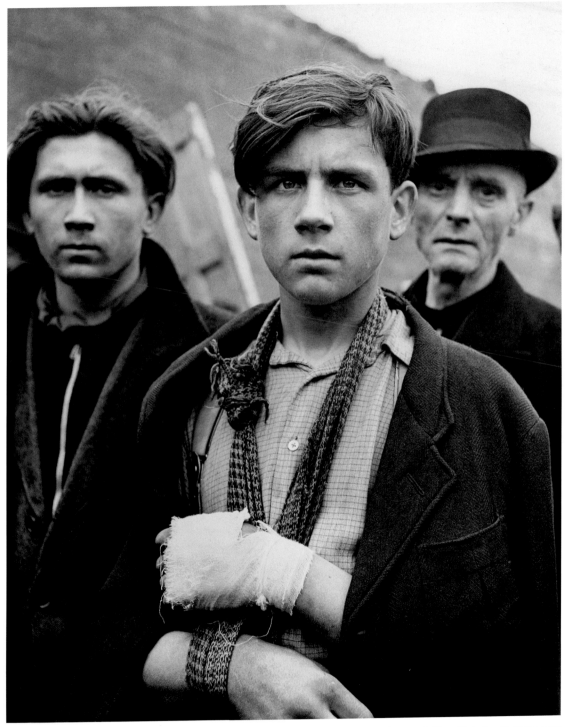

German civilians, Wehofen, Germany, 1945

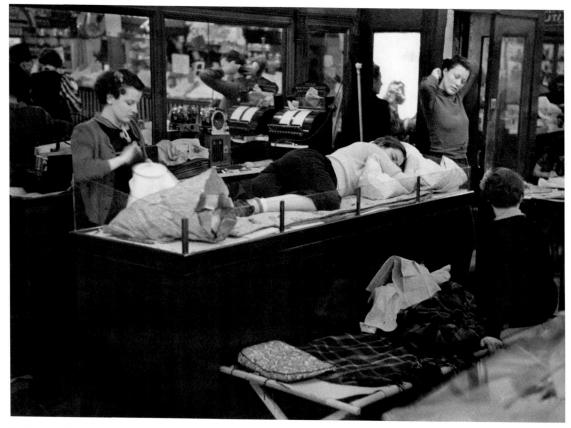

Woolworth strike, Detroit, 1937

These two photos from 1937 reflect two different strikes, and LIFE's very different approaches to them. At right, 60,000 people attend a "great gathering of labor in Cadillac Square," part of what is considered by many the most important strike in American history. The picture above is from an installment of "LIFE Goes to a Party." The story reads, "The newest type of camping excursion is attended not by children of the rich but by members of the working classes . . . Youngest, prettiest, most prevailingly feminine group . . . were the 110 girls in Detroit's main Woolworth store who . . . spent six days in the store. Camp broke up when the girls were granted a 5¢ per hour increase . . . Sleeping on counters like this is part of the fun on the six-day Woolworth camp outing."

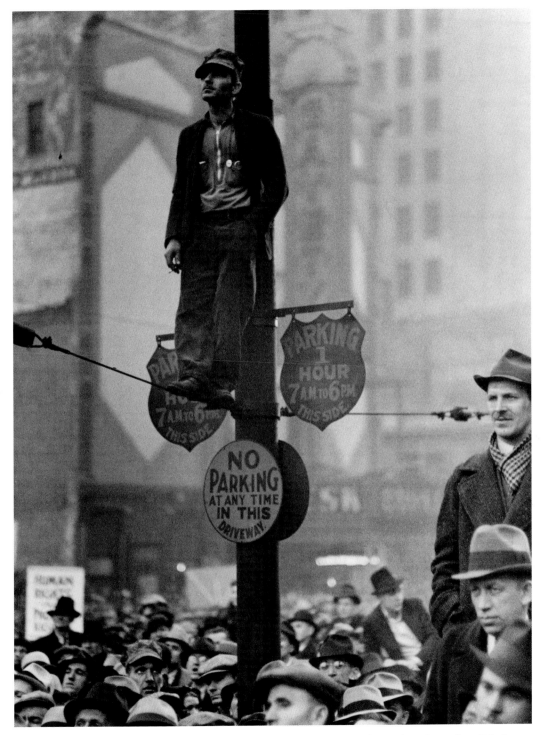

Automotive union workers, Detroit, 1937

Grey **Villet** 1927–2000

The Fly on the Wall

Villet was raised in the market center of a sheep-farming district in South Africa, and while enrolled at the University of Cape Town, he took up photography "mainly for an excuse to stop loafing." Then off to England, where for a while he stood outside the Registry Office in London snapping pictures of newlyweds as they emerged, in hopes they would order prints. Villet, of course, would evolve into an exceptional photographer, one with a yen to get something "as real as you can get it . . . I hate to set up stuff. I'd much rather let people act as they are, and reflect that. If I've got the patience, that'll give me a better picture than anything I can dream up." Villet also shunned elaborate lighting arrangements because "people do not behave as naturally." What must accompany this approach is an instinct for what makes a good picture, and his was razor sharp. Bill Eppridge summed up Villet nicely: "I liked his ability to take an idea and turn it into a candid photograph. It's that type of work that I have always respected."

Chain-store owner Victor Sabatino questioning employee Herman Horowitz, Chicago, 1962

Levi Smith loading his grandson Sandy's popgun with a willow frond, Vermont, 1966

Sailors battling Hurricane Edna's 100-mph gusts, Montauk Point, N.Y., 1954

Patrolman Peter Witkus encountering a sculpture of Turkish belly dancer Nejla Ates in Central Park, New York City, 1955

Lawyer Sarah Vogel with farmers facing bankruptcy, Wing, N.D., 1982

Patient at the Chronic Hospital, St. Louis, 1959

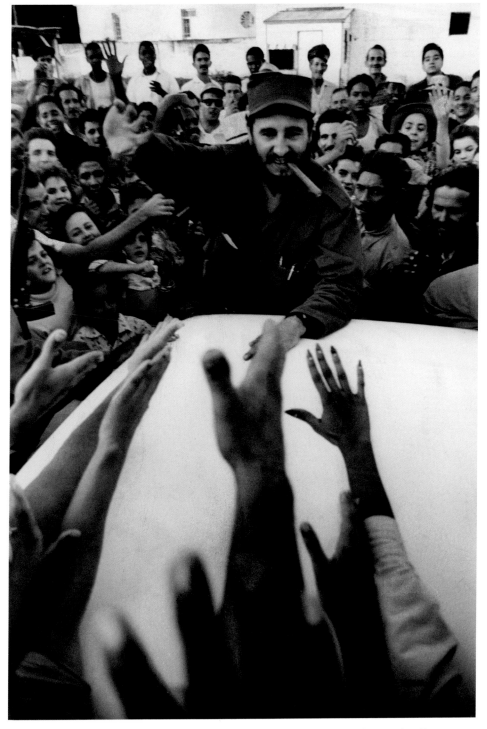

Rebel leader Fidel Castro greeting a village crowd on his victorious march to Havana, 1959

Hank **Walker** 1922–96

Stalking the Witch-hunter

Politicians were just another kind of celebrity to Walker:
"If you can appeal to that ego, they usually let you do the
story." During the McCarthy hearings, when the witch-
hunting senator continually flourished papers he claimed
held the names of 41 State Department communists, Walker
tried to expose the documents with a long lens. "I took a
couple of pictures and McCarthy stopped dead." The hearing
came to a halt as the committee chairman demanded
Walker's film, but he had switched the rolls. (Later he
would find the real pictures of the list unintelligible.)
The episode may not have stopped the McCarthy rampage,
but it showed the live television audience an ugly glimpse
of the man. "I'll never forget that," Walter Cronkite said.

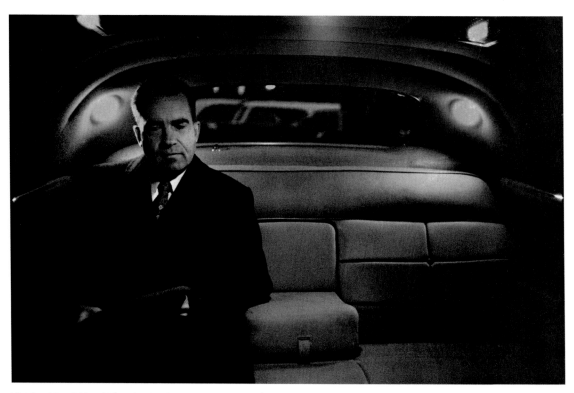

Vice President Richard Nixon leaving the White House during President Eisenhower's hospitalization for a stroke, 1957

Senator Joseph R. McCarthy having cough syrup and coffee, Washington, D.C., 1950

Dwight D. Eisenhower, overcome with emotion after his speech at an 82nd Airborne luncheon, Chicago, 1952

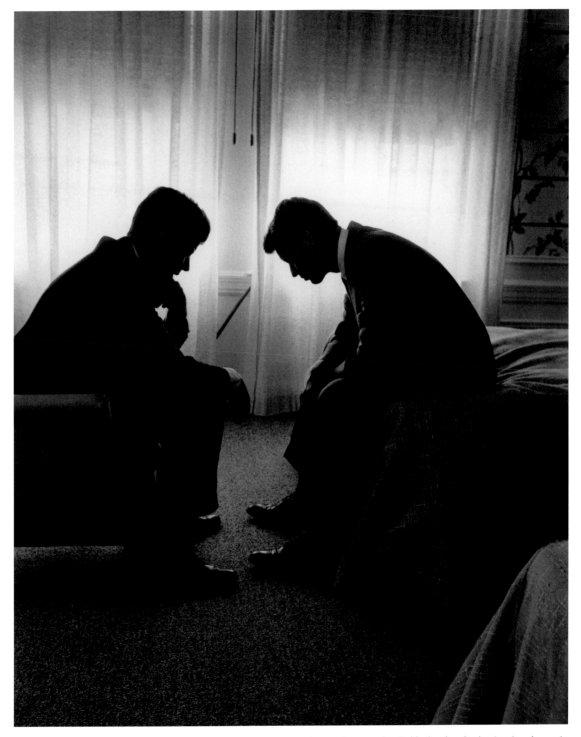

Presidential candidate Jack Kennedy with brother and campaign organizer Bobby in a hotel suite, Los Angeles, 1960

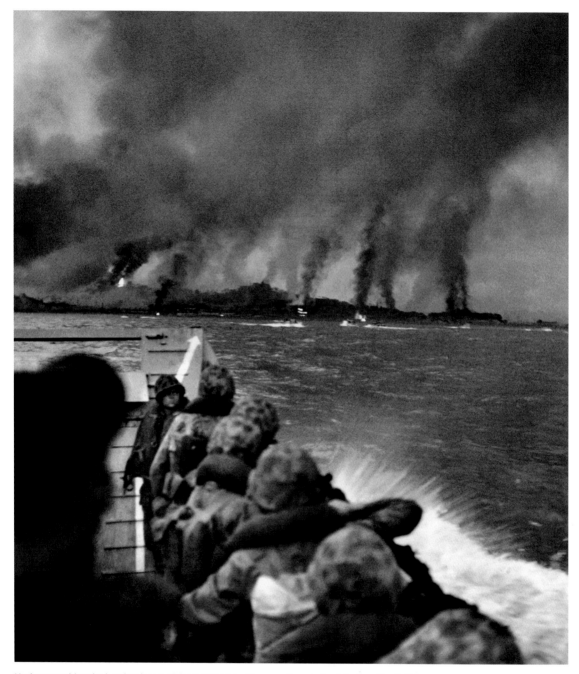

Marines watching the bombardment of the beach where they are about to land, Inchon, South Korea, 1950

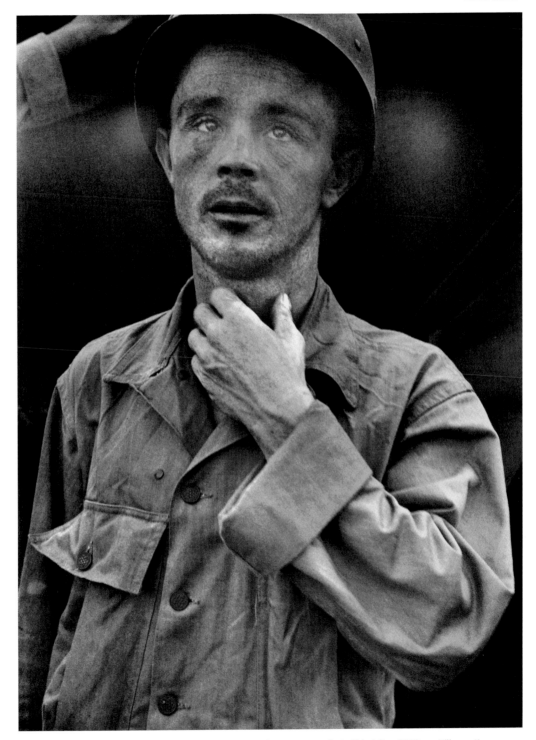

Army Corporal Roy L. Day Jr., after surviving the massacre of 26 of his fellow POWs on Hill 303, Korea, 1950

Prince Mashhur ibn Saud of Saudi Arabia, Washington, D.C., 1957

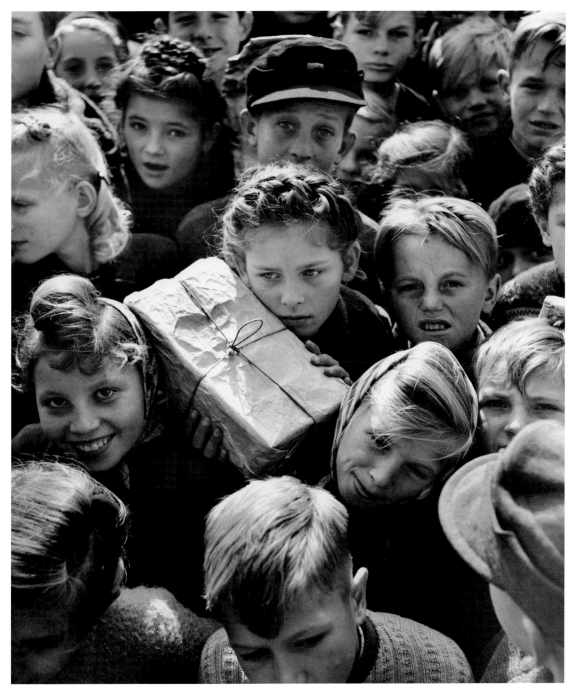

Children with gifts from the Berlin Airlift, 1948

Stan **Wayman** 1927–73

Animal Tracker

Growing up in the Everglades, Wayman and his brother would hunt raccoons with their redbone hound, and sell the pelts to pay for photography supplies. The boys used an outhouse as a darkroom to develop their pictures of the swamp's egrets and snakes. In his earlier years at LIFE, Wayman spent a lot of time on the beaches of Cape Canaveral waiting out rocket launches, then his skills took him around the world, covering war and politics. He ran three miles a day for months to train for an Arctic assignment on white wolves—and when he got there he wished he had run 10 miles. Not all his subjects were exotic: "Concentration Camp for Dogs" exposed emaciated and abused dogs that dealers sold to laboratories. The piece elicited a tremendous response from an outraged public. Animal groups gave Wayman the Albert Schweitzer Medal—and a great deal of credit for the passage of the 1966 Animal Welfare Act.

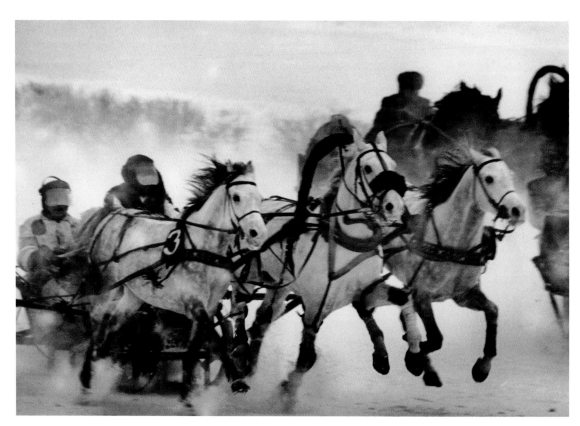

Troika race, Moscow, 1963

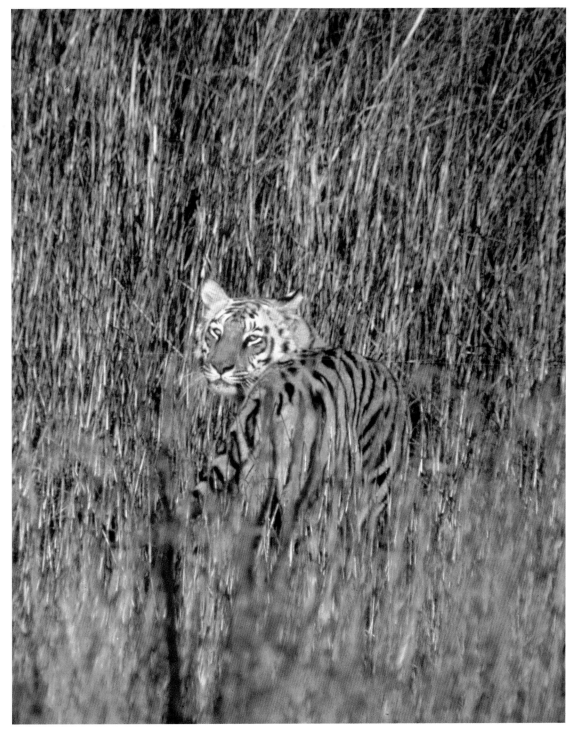

Tiger at dusk, Kanha National Park, India, 1965

Hearing of John F. Kennedy's assassination, New York City, 1963

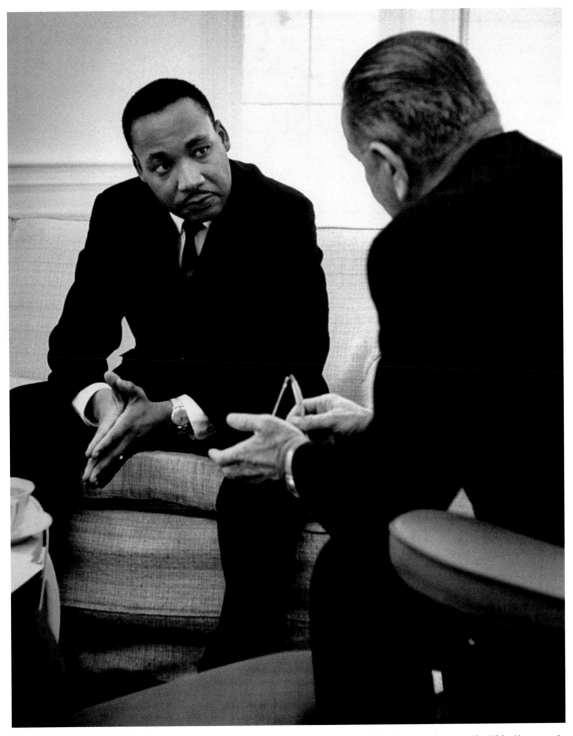

The Reverend Martin Luther King Jr. with President Lyndon Johnson at the White House, 1964

James **Whitmore** 1926–c.1966

The Closer the Better

As a newspaper photographer, he knew how to get close to the action. He had already worked in 44 countries before he became a LIFE staffer. At the 1953 border riots in Trieste, a grenade went off near him, killing several policemen. When Whitmore got back to his hotel room, he discovered that the grenade's head and fuse assembly had been blown into the folds of his torn overcoat. Once, at a Vatican ceremony, he found himself so entrapped by throngs that to extricate himself and his film, he kicked the shins of a Swiss Guard who promptly ejected him by passing him over the heads of the crowd. Whitmore went on to become an art director for *Encyclopaedia Britannica*.

Palmiro Togliatti speaking at the Communist Conference, Rome, 1955

Police car burned by students during riots in Trieste, Italy, 1953

Hans **Wild** 1914–69

Pix and Pints

A failed bookkeeper and avid tinkerer, he started at LIFE in the London darkroom. When Nazi bombs started falling, he jumped to action, taking pictures of the fresh and shocking ruins. At times he would pass himself off as a doctor to get close to the scene, only to find that the censors killed all his shots. "I was taking pictures by the fires' light and getting singed, soaked and scared," he said. "The scares came when ardent and very nervous Home Guards tried to break my cameras and bayonet me, and when sheltering crowds thought I was a spy." Wild's friendliness got him out of many scrapes, and the night typically ended in a pub. He noted that the excitement of working those stories for the magazine was "enough to compensate for stories on an Average Family."

England, 1940

Children putting on a vaudeville show, Aldgate, London, 1943

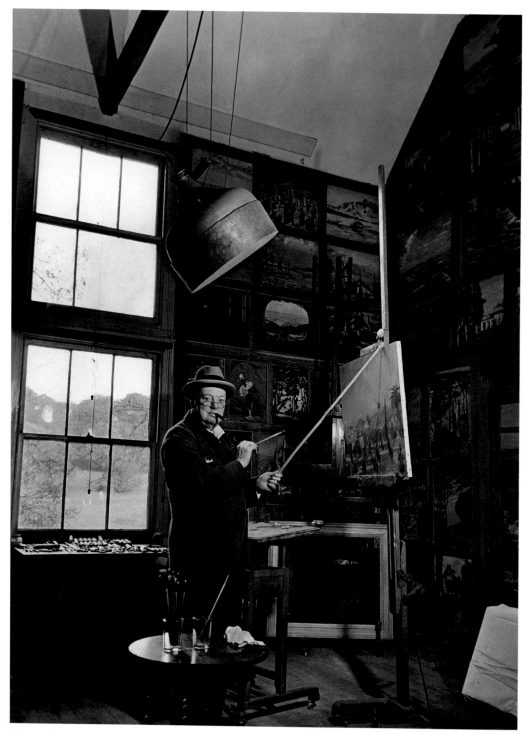

Winston Churchill, Chartwell, England, 1946

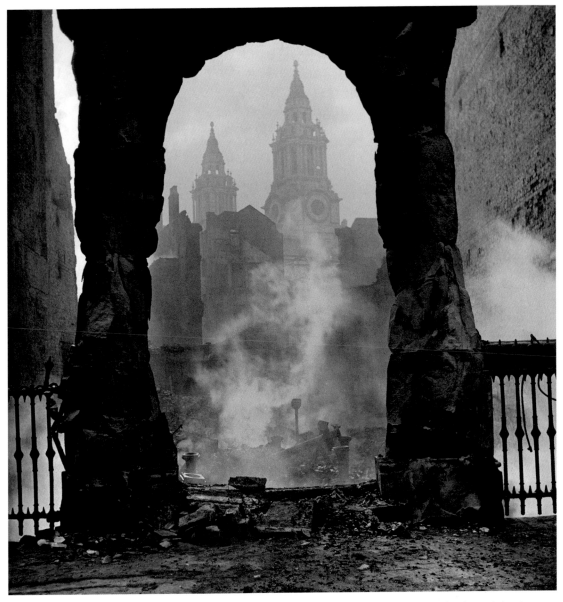

St. Paul's Cathedral, after a bomb attack, London, 1941

Jack **Wilkes** c.1907–

Old School Tie

A disabled Twentieth Century Fox cameraman named Clarence Albert Bach ran a photography high school near Los Angeles called Fremont, which produced several LIFE photographers, including George Strock, John Florea and Bob Landry. Jack Wilkes, who had arrived in the United States from his native Wales when he was just a tyke, was among that select group. Like so many of his era, Wilkes covered WWII for LIFE, and saw much fighting in China as he roamed with his frequent collaborator, writer Theodore H. White.

Wu Tang-shen, 66, doing a Charlotte stop, Peiping, China, 1946

Chinese infantryman, 1945

John **Zimmerman** 1927–2002

Sports Superstar

In *The Digital Journalist,* Peter Howe, a former LIFE director of photography, had this to say about Zimmerman's skill in working with his subjects: "He was like a fly fisherman gently luring his prey through his intense understanding of its nature. He made them feel that his ideas were their ideas; he was respectful without fawning, calm but determined, and exuded a quiet self-confidence. He was how I want to be when I grow up." Of course, Zimmerman's specialty was sports. In fact, if all his *Sports Illustrated* covers had run consecutively, they would have taken up more than two years of the magazine's history. Many of his innovations are today considered de rigueur.

Kurt Thomas, 1979

Lew Alcindor of the Milwaukee Bucks shooting against the San Francisco Warriors, 1969

The Mariners' Episcopal Church being slowly moved across Woodward Avenue to its new location, Detroit, 1955

Off to buy clothes, 1953

Index

Index